The Exhibitionists

Steven Miller

Art Gallery NSW

A history of Sydney's Art Gallery of New South Wales

Published by Art Gallery of New South Wales
Art Gallery Road, The Domain
Sydney 2000, Australia
artgallery.nsw.gov.au

A catalogue record for this book is available from the
National Library of Australia
ISBN: 9781741741544

Managing editor: Emma Driver*
Text editor: Linda Michael
Design: Dominic Hofstede (Mucho)
Archive support: Claire Eggleston*, Eric Riddler*, Vivian Huang*,
Robyn Louey*
Rights & permissions: Polly Gillman*
Photography: Diana Panuccio*, Jenni Carter*, Felicity Jenkins*,
Christopher Snee*, Mim Stirling*; additional photographers indicated
in captions or image credits list
Proofreader: Helen Koehne
Production: Cara Hickman*
Prepress: Spitting Image, Sydney
Printing: Printed in China by Australian Book Connection
* Art Gallery of New South Wales

The Art Gallery of New South Wales is a statutory body of the
NSW State Government

Front cover: *Mieko Shiomi cello sonata* 1972 performed by Charlotte Moorman
on the roof of the Art Gallery of New South Wales, 1976. Photograph: Kerry Dundas
Back cover: Aerial view of the Art Gallery of New South Wales and the Sydney
Modern Project construction site in the Domain (bottom, centre), August 2021.
Photograph: Craig Willoughby, SKYview Aerial Photography

Distribution:
Thames & Hudson Australia
Thames & Hudson UK
University of Washington Press USA

This publication has been supported by the Gordon Darling Foundation

Contents

Acknowledgements

Many people contributed to the research, production and publication of this book. It would not have been possible without their assistance.

I was fortunate to have a group of generous and knowledgeable readers who tackled the entire manuscript and made invaluable comments. Within the Art Gallery of New South Wales, Director Michael Brand and head curator of Australian Art Wayne Tunnicliffe added this onerous task to their many others with collegial grace and enthusiasm. Former staff and trustees who had lived through the events described, including Anne Flanagan, Renée Free, Diana Heath, Frances Lindsay, Victoria Lynn, Joanna Mendelssohn, Bernice Murphy, Gael Newton and Barry Pearce, were able to enlighten, expand and correct when and where necessary. They were generous enough to allow my interpretation of events to stand, even if this did not chime with their own at times, concerned only to save me the embarrassment of factual errors. Joanna Capon, though not strictly speaking a member of staff, must be added to this supportive group. Artist Peter Simpson and art historian Eileen Chanin proved to be the rigorous and questioning readers I knew they would be. Others who read particular sections of the text and helped improve them included Andrew Andersons, Tony Bond, Darryl Collins, Robert Lindsay, Jackie Menzies, Leon Paroissien, Hetti Perkins, Cara Pinchbeck, John Richardson, Jill Wran, Jane Wynter, and the Unbound Collective of artists Ali Gumillya Baker, Faye Rosas Blanch, Natalie Harkin and Simone Ulalka Tur. Any errors that remain in the text are mine alone.

Throughout the entire process of writing and revising, I relied heavily upon Daniel Thomas and Hannah Fink. I commenced the project having just edited with Hannah an anthology of Daniel's selected writings on art, *Recent past: writing Australian art* (Art Gallery of New South Wales, 2020). The three of us worked closely together on that anthology and to some extent this history continued our partnership. Daniel Thomas was the first curator at the Art Gallery of New South Wales, commencing in 1958 as a professional 'assistant'. He worked at the Gallery for twenty years and was eventually appointed senior curator of Australian art before going on to become the inaugural head of Australian art at the National Gallery of Australia, then director of the Art Gallery of South Australia. His knowledge of the Gallery and its institutional history, as well as of Australian art in general, is unmatched. Hannah Fink is an elegant and sensitive writer with experience in art publishing as an author and former editor of *Art and Australia*, and she and Daniel became my dependable and entirely frank sounding boards for the publication, not only for content but also for design.

General research assistance was given unstintingly by my colleagues in the Gallery's library and archive, Claire

Eggleston, Vivian Huang and Robyn Louey. Eric Riddler, in particular, brought to the project his unique skills and knowledge, tracking down and identifying images from collections all over Australia and verifying dates and minor but important factual details. My other colleagues Anne Gerard-Austin, Yin Cao, Analiese Cairis, Melanie Eastburn, Carolyn Murphy, Michelle Raaff, Malgorzata Sawicki, Bianca Tomanovic, Natalie Wilson, Sally Webster and Nick Yelverton assisted with questions concerning their areas of activity within the Gallery.

Former politicians Bob Carr and Peter Collins, who had worked closely with director Edmund Capon, generously allowed me to interview them. They also gave encouragement when the task of writing about the recent past seemed particularly challenging. Further assistance from those outside the Gallery was given by Laura Rayner, Jane Van Balen and Lorraine Kypiotis, education outreach coordinator at the National Art School.

I worked solidly on this history during the nationwide lockdown necessitated by the COVID-19 pandemic. Many of the Gallery's volunteers, similarly locked out of the building, helped transcribe historical correspondence and minute books that were already digitised, deciphering the often-illegible handwritten documents. Special thanks go to Mara Ashmore, Ruth Atwood, Lindy Batchelor, Georgine Blythe, Lorraine Boyer, Sue Dadswell, June Donsworth, Coralie Fergus, Robyn Flick, Alisa Halkyard, Jess Hanning, Eve Harrison, Sharon Hay, Vere Kenny, Dorothea Labone, Susan Ma, Deb Oong, Tricia Small, Ann Sutherland, Margaret Symes, Francine de Valence and Annie Woodham.

It was always intended that the illustrations for this book would tell the story as much as the text. A huge number of images from the Gallery's institutional archive were digitised in preparation for the publication, allowing the selection included here. Those not used in this publication will be available through the Gallery's online collection. This would not have been achievable without a special commitment to the publication by Gallery photographer Jenni Carter and her team, including Diana Panuccio, Christopher Snee and Felicity Jenkins. Diana Panuccio, in particular, has become the de facto photographer for the Gallery's National Art Archive, graciously fulfilling our requests to have photographs, plans, objects and many other strange items from the Archive digitised.

Images were sourced from outside the Gallery as well, and I would like to thank the photography studios at the State Library of New South Wales, the State Library of Victoria and the National Library of Australia. Norm Ricaud, reprographics officer at the State Archives of New South Wales; Kathy Hackett, photography librarian at the Museum of Applied Arts and Sciences in Sydney; Gregory Jallat from the Phillips Collection, Washington; and Victoria Jenkins from London's Tate Gallery Archive all gave personal and much-needed assistance identifying and supplying images, as did Lou Klepac and Mal Damkar of Beagle Press and Anne McCormick from Hordern House, Sydney. Polly Gillman, the Gallery's rights and image-licensing coordinator, facilitated this challenging part of production with her typical efficiency and unflappability.

The many tasks involved with producing a publication, after the text is written and images sourced, were skilfully managed by Emma Driver, who kept me and others on track without ever adding to our anxiety levels. Miranda Carroll, Julie Donaldson, Cara Hickman, Ujin Lee and Simone Bird all helped guide the transformation of the manuscript into an attractive and readable book. Holly Bennett, the Gallery's creative and content coordinator, suggested the book's title.

I was particularly fortunate to have a dream editor in Linda Michael. Her extensive curatorial experience working in Australian art, as well as her editorial expertise, allowed us to work together efficiently and productively. Her suggestions always sharpened and improved the text, and the publication would be a much weaker one without her involvement. In the final stages of production, Helen Koehne proofread the text.

The difficult task of designing the book was taken on by Dominic Hofstede, creative director of the international design studio Mucho. At the beginning of 2021, Mucho was chosen to create a new visual identity for the Art Gallery as it celebrated its 150th anniversary and prepared for the completion of the Sydney Modern Project in 2022. I feel particularly honoured that this history is the first major publication designed by the studio for the Art Gallery, using the new visual identity. This was not an easy book to design, with its dense text and range of images. Dominic Hofstede's thoughtful and sympathetic approach to the task, always open to ideas and to testing design suggestions from me that he probably knew from the start would not work, have produced a publication that both the Gallery and I are proud to have as a marker of this important sesquicentenary.

Finally, I would like to thank the Gordon Darling Foundation for its financial support of the publication. Although the Art Gallery of New South Wales holds a unique place in the life of the city of Sydney and of the state of New South Wales, its history is of national significance, critical to the wider story of Australian visual culture. The support of the Gordon Darling Foundation, I believe, is a clear recognition of this.

Steven Miller

A note to readers

The director of the Art Gallery of New South Wales from 1945 to 1971, Hal Missingham, thought that a true history of the Gallery would be, above all, a history of its collections. He regretted that his own Gallery memoirs contained very little about 'artists and their art', and was filled instead with anecdotes about personalities, the building and its administration. But these were the things that had absorbed his energies for twenty-six years. 'When a history of the fine collections housed in the Art Gallery of New South Wales comes to be written,' he quipped, 'it will not be by the director – he will be much too busy signing sick-leave forms.'[1]

The history presented here is also not the one Missingham had hoped would be written, with a sustained focus on art and the Gallery's collections. It too is about the people and events that have shaped the Gallery, not only during his directorship from 1945 to 1971, but also from the Gallery's foundation in 1871 up until the present, drawn from the material that has absorbed me as its archivist for more than thirty years. The Art Gallery of New South Wales is fortunate to have a rich institutional archive, well cared for over the years by curators, registrars and then professional archivists. It is an archive as characterful as the people who created it. Some of its contents are playful, some subversive, and much is procedural, but all has been of interest to me as an archivist and hopefully will be to others as well.

Popular television programs such as *Who do you think you are?* suggest a growing interest in social history as revealed by the archive. Another of these programs is titled *Who has been sleeping in my house?* and in this history I ask the same question of the Art Gallery of New South Wales. For more than eighty years there was a small caretaker's cottage at the back of the building, where successive generations of the Casey and Hall families literally slept at the Gallery. They are an important part of the institution's history, along with art acquisitions and exhibitions, and I have included their stories wherever possible. Perhaps it is not unique to Sydney, but an overlapping of the institutional and the intimate, the public and the domestic, is a distinctive feature of this history. In order to capture this, I have structured this book broadly according to a chronology of events, with a few breakout chapters devoted to particular themes or objects, such as the Gallery's Visitors' Book. The Art Gallery of New South Wales stands on Gadigal Country: the initial chapter considers how the Gallery might counter the histories of erasure to which cultural institutions, often unwittingly, have contributed.

It is a tremendous act of trust on behalf of the Gallery's director, Michael Brand, to allow one voice the opportunity to narrate the Gallery's history in this its 150th year. I hope I am not presumptuous in echoing the words of Conrad Martens, written when he was commissioned to paint the very first work for the Gallery's collection: 'I beg leave to say that I shall have much pleasure in executing the same and that I feel much flattered.'[2]

Citations and the Art Gallery's name

All original sources cited in this text are from the archival collections of the Art Gallery of New South Wales, unless otherwise noted. Minutes of the meetings of the trustees are referenced according to the date of the meeting. These are also given a page number, as it has been the practice of the Gallery to bind multiple years of minutes into a single, paginated volume (for example, AGNSW Minutes, 26 Sep 1894, p 128). Correspondence was registered in series: CF (early general correspondence), CFG (general correspondence), CFGvt (government correspondence) and BF (British and foreign correspondence). Along with the date of correspondence and the sender and recipient details, series numbers are given when these have been assigned (for example, Letter from Thomas L Devitt to Frederick Eccleston Du Faur, 7 Dec 1894, BF33/1894).

The Art Gallery of New South Wales has been known by a number of names. When the New South Wales Academy of Art first purchased works for a public collection, these were purchased for 'the Art Gallery'. In 1880 the Governor Lord Loftus officially dedicated a building in the Botanic Gardens, previously used as the Fine Arts Annexe to Sydney's International Exhibition, as the 'Art Gallery of New South Wales'. In 1883 this name was changed to the 'National Art Gallery of New South Wales', which became official when the Gallery was incorporated by Act of parliament in 1899. However, before Federation and for many years after, the Gallery was often referred to simply as the 'National Gallery'. In 1958, under a new Act, the Gallery became the 'Art Gallery of New South Wales', which it has been known as ever since. Appropriate historical names are used throughout this text. However, for simplicity 'the Gallery' is often used to refer to the Art Gallery of New South Wales at various times in its history.

Note on language use
This text often quotes from original sources. These sometimes contain words, terms and descriptions that reflect the social values of the period in which they were written. They are not included to offend and they do not reflect the views of the author.

Notes
1 Hal Missingham, *They kill you in the end*, Angus and Robertson, Sydney, 1973, p i.
2 Letter from Conrad Martens to Frederick Eccleston Du Faur, 21 Aug 1874, inserted into the AGNSW Minutes, 1874–78, p 36.

1 Resilience and defiance
A gallery on Gadigal Country

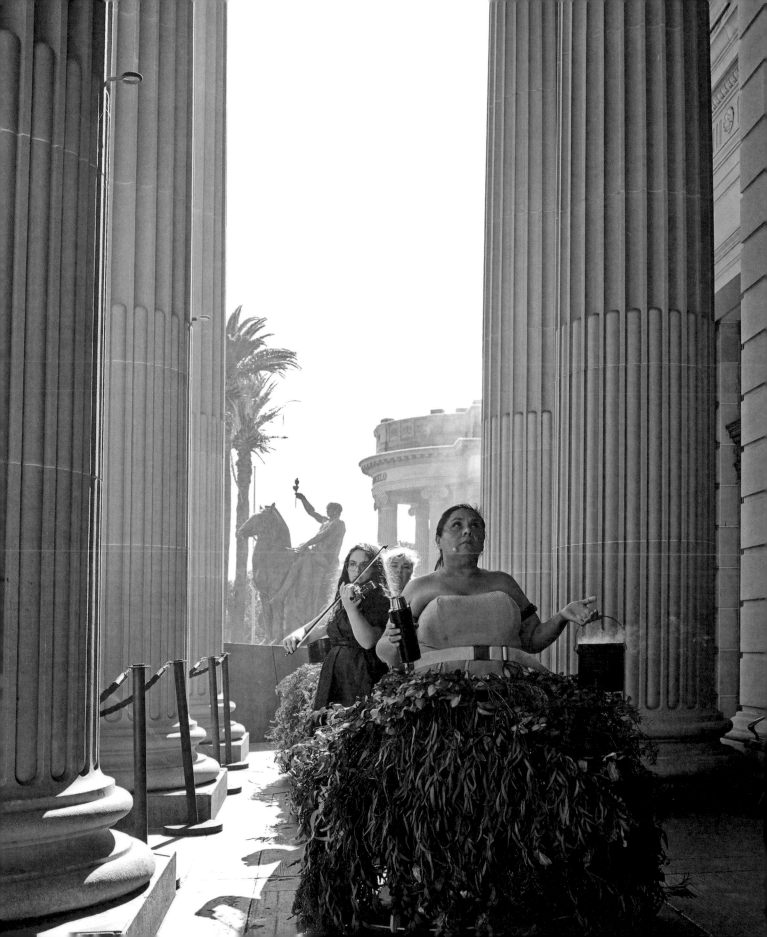

> Where stands that Art Gallery there stood a mimi fifty years ago ... Where sits the merchant ... there sat a kangaroo, one man's life back.

Gilbert Parker, Canadian novelist, 1892

In 1894 the director and five trustees from the Art Gallery of New South Wales visited the annual exhibition of Sydney's main art society. After a lengthy inspection, they purchased ten works. They had been visiting these exhibitions as a group for three years, but their 1894 purchases were the most extensive selection to that date and arguably the most important. Sydney Long's *By tranquil waters* 1894 was acquired on the condition that the artist 'cut down the lower portions of the picture giving it more definition'.[1] In the forthright opinion of the trustees, twenty-three-year-old Long, born in the same year that the Gallery was founded, was talented but not yet entirely the master of his craft. Alice Norton and Edith Cusack, also in their twenties, had their first works purchased for the collection. But what most interested the trustees at this exhibition was a large canvas by Tom Roberts. The newspaper critics judged it 'the great picture of the year – *Shearing at Newstead* – and the trustees of the Art Gallery have purchased it for £275. It is a work of high artistic value and will worthily perpetuate the artist's memory.'[2] Better known as *The Golden Fleece* 1894 it remains a popular work in the Gallery's collection and has been on display ever since.

Having worked as Gallery archivist for more than thirty years, I am often familiar with the historical details of how works were acquired. More recently, however, I have returned to the archive in search of overlooked aspects of these histories. This is the result of a challenge made to the Gallery and its modes of remembering by a group of four Indigenous women working out of Adelaide, known as the Unbound Collective. In 2019 they staged one of their *Sovereign acts* performances at the Gallery.[3] These performances are acts of 'repatriation', where the unnamed Indigenous subjects held in institutional collections are returned the dignity of their names, and where those whose very memory has been erased by the establishment of these institutions are recalled.

In preparation for their Sydney performance, the Unbound Collective mined the archive for traces of an Indigenous connection to the Gallery's site, collections and history. What was both found and not found became the basis for their performance, a synthesis of text, image and song. This began outside the Gallery with a smoking ceremony honouring the ancestors, including legendary figures like Bungaree, who for a time lived in the Outer Domain where the Gallery was eventually established. 'The old people are not absent, nor are they silent,' curator Clothilde Bullen said, 'they are returned to a living presence through the Unbound Collective's performance of sovereign love.'[4] The four artists then moved inside, carrying small projectors and singing as they went.

Previous page: Simone Ulalka Tur leads the procession of the Unbound Collective into the Art Gallery of New South Wales during its 2019 performance *Sovereign acts IV: Object*, with Ali Gumillya Baker, Faye Rosas Blanch and Natalie Harkin.

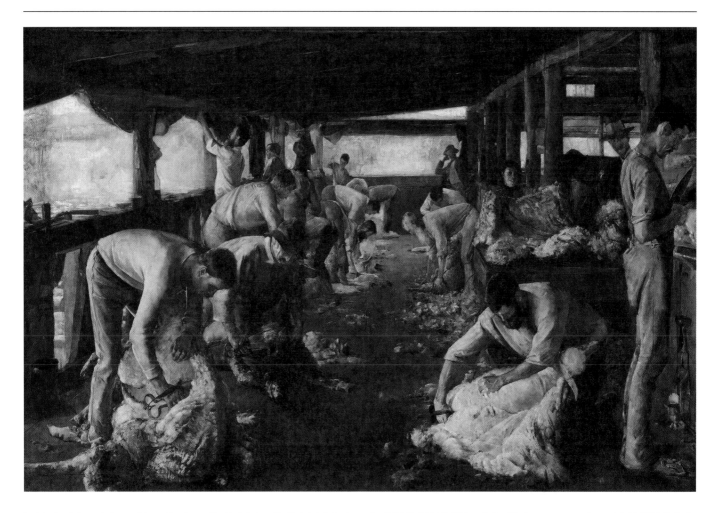

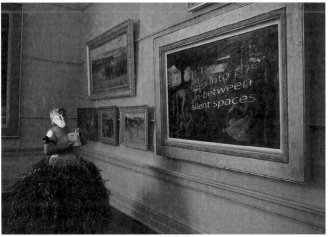

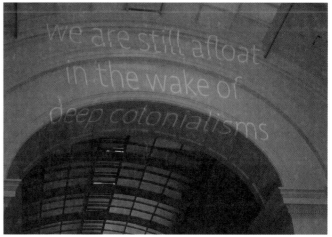

Above, top: Tom Roberts *The Golden Fleece* 1894 **Above:** Ali Gumillya Baker from the Unbound Collective projects text on to *The Golden Fleece* 1894 by Tom Roberts (left) and on to the arches of the Gallery's old courts (right) during the 2019 performance *Sovereign acts IV: Object.*

On the walls and high ceilings of the Gallery's old courts, they projected text and images, disruptive but at the same time spectral and ephemeral. These gave a counterpoint to the values and histories embodied in the imposing colonial architecture and the canonical Western works on the wall.

One text defiantly sailed over the arches: 'we are still afloat in the wake of deep colonialisms'. None of the Gallery's founders could have imagined this reality. Like most nineteenth-century colonists, they believed that the original inhabitants of Australia were a dying race. In fact, they began to collect portraits of them as a historical record before this occurred. One of the first was by Tom Roberts, acquired in 1892, his painting *Charlie Turner* 1892. One reviewer noted that 'its value will grow year by year with the gradual disappearance from our midst of the original possessors of the soil. It thus has a permanent, if melancholy interest, which justifies its inclusion in our national collection.'[5] Two years later, at the same exhibition from which *The Golden Fleece* was acquired, paintings of four 'types of NSW Aboriginals' by BE Minns were purchased. Once again, it was noted that these 'delicate water-colours reproduce with fidelity the traits of a decaying race'.[6]

Rather than being such records of vulnerability, these images are in fact a testament to the resilience and endurance of First Nations cultures. The three men and one girl painted by Minns were all from Bermagui on the South Coast of New South Wales. The men were named Merriman, Coonimon and Droab. Their descendants still live on traditional lands, which today are managed by the Merrimans Local Aboriginal Land Council. In 1984, 200 hectares of land on the northern shore of Wallaga Lake were returned to the community under the New South Wales *Aboriginal Land Rights Act 1983*. 'The original possessors of the soil' have not only survived but have also fought to have their unbroken connection to Country recognised and enshrined in law. In 2012 the Art Gallery of New South Wales acquired a suite of prints by one of these descendants, the artist Cheryl Davison, whose works depict South Coast creation narratives that have been passed down to her by her ancestors: 'we are still afloat in the wake of deep colonialisms'.

Why should these connections matter to a book such as this one, which marks the sesquicentenary of the establishment of the Art Gallery of New South Wales in 1871? Wherever there has been settlement and expansion in Australia there has also often been an erasure or, if not, a forgetting. The Gallery, in marking this anniversary, wants to remember. The Unbound Collective projected an invitation onto *The Golden Fleece* at their Sydney performance: 'step into the in-between silent spaces'. Those silent places, once entered into, are remarkably rich with counter facts and histories.

Tom Roberts's *The Golden Fleece*, for instance, is said to show hard-working bushmen creating the wealth – the legendary but also literal 'golden fleece' – that made the 'young' Australia prosperous enough to recreate Old World institutions such as the Art Gallery of New South Wales. But there was another world beyond the walls of the shearing shed at Newstead. Tom Roberts hints at it with his head of Charlie Turner. Turner was probably one of the locals living in the Riverina region when Roberts painted an earlier version of *The Golden Fleece*, his *Shearing the rams* 1888–90 (National Gallery of Victoria).[7] The wealth being created in 'this distinctly Australian picture ... strikingly representative of the life of the country', was made at the expense of Charlie Turner and his people and it was a wealth from which Indigenous people were largely cut off.[8]

The Exhibitionists

Cultural historian Humphrey McQueen claims that 'the mainland areas where Roberts painted Aborigines had all been battlefields. His squatter hosts were the beneficiaries of dispersals, to use the polite term for mass murder. West of Duncan Anderson's Newstead station, Major Nunn had, in 1838, mounted the extermination campaign known as the Myall Creek massacre.'[9] Works like *The Golden Fleece* do not tell the whole story, though they have been valorised by our cultural institutions as defining images of national identity.

Nor are past histories complete in their telling of public galleries' engagement with our First Nation cultures. Edwin Pareroultja's *Amulda Gorge* was the first work by an Indigenous artist that the Art Gallery of New South Wales acquired, in 1947, soon after it had been painted.[10] Prior to the 1940s, it is said, Aboriginal works of art were found only in

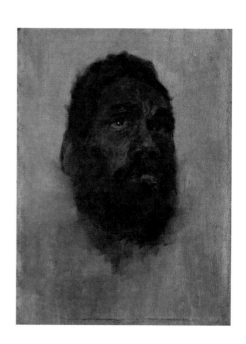

Left: BE Minns *Heads of Australian Aboriginal people (a. Merriman, King of Bermagui; b. Coonimon, Bermagui; c. Droab, Bermagui)* 1894 Above, clockwise from top left: Cheryl Davison *Guunyu* 2007, *Bangu* 2007, *Gulaga* 2007
Right: Tom Roberts *Charlie Turner* 1892

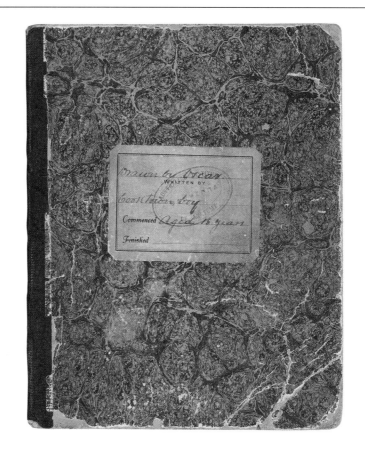

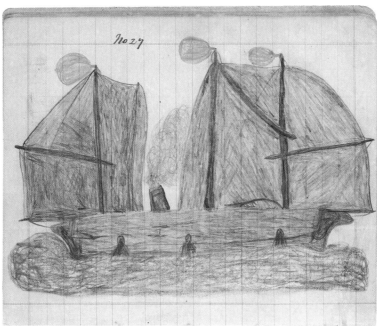

Cover of *Oscar's sketchbook* 1890s and
drawing no 27 *Another Cooktown steamer*

The Exhibitionists

museums and natural history collections as anthropological artefacts, and so the Gallery acted according to the lights of its time. But research in the archive shows that works of art by Indigenous artists were offered to the Gallery long before 1947.[11]

On 29 April 1897 drawings by Mickey of Ulladulla were tabled at a meeting of the trustees under their routine monthly art deliberations and priced at ten pounds.[12] Purchase was declined. The drawings were probably those that had been exhibited at the World's Columbian Exposition in Chicago in 1893, as they were offered by John Rainsford of Temora.[13] In February 1902 'figure sculptures on rock' from Moree were offered for loan and again declined.[14] In July 1913 Charles Bage, one of the Felton Bequest trustees at the National Gallery of Victoria, sent up to Sydney a sketchbook with 'Drawn by Oscar, Cooktown boy, aged 18 years' written on the cover. Created by a young man from Far North Queensland, it was filled with drawings that gave a rare record of life in the late 1800s from an Indigenous perspective. Gother Victor 'Vic' Fyers Mann, director of the National Art Gallery of New South Wales at the time, returned it and the sketchbook languished in the ethnographic collections of the Australian Institute of Anatomy until rediscovered in the early 1990s by the National Museum of Australia.

Throughout the nineteenth and early twentieth century, First Nation Australians and their art were not unknown to mainstream colonial culture but seem to have been consciously and conveniently 'hidden in plain view'.[15] The concept of *terra nullius* is now rejected for the fiction it promotes about the land and the connection of Australia's original inhabitants to it. The *Sovereign acts* performances exposed other variants of the myth that persist, including a notion of *cultura nullius*, which confines First Nations people to a shadowy existence on the margins of mainstream society.

It is interesting to wonder if things would have been different had the Gallery's first director, Eliezer Levi Montefiore, been at that meeting in 1897 when the drawings by Mickey of Ulladulla were offered. He had died four years earlier, after just two years in office. His sketchbooks and writings suggest that First Nation Australians were clearly in his sights. Perhaps being Jewish and on the margins of mainstream Anglo-Christian culture gave him more insight and empathy than was common at the time.[16] His sketches record genocide; when living in Adelaide, he made a drawing entitled *Bushmen preparing to fire on a camp of Aboriginal people*. Visiting Sydney, he recorded the spectacular view down the harbour from Vaucluse with the view framed by Indigenous figures looking out upon it.[17] It was a complex and rich culture that he wrote about in 1869 when he sent a boomerang to the Société d'ethnographie de Paris with an explanation of its cultural significance and practical use.[18]

Drawings by Eliezer Levi Montefiore, from top: *Bushmen preparing to fire on a camp of Aboriginal people* c1850, loose sketch; *From Vaucluse* c1840, from *Album: portrait studies and pencil sketches of New South Wales*, c1840–50

The last trustee meeting that Montefiore attended at which works of art were purchased was in September 1894, when *The Golden Fleece* was acquired. He died a month later. A small sculpture was also acquired at that meeting, by the now little-known Alexander Glen Reid. It was titled *Defiance* and the newspaper reviews noted that it showed an Indigenous man 'of lithe and agile form, with a boomerang in his hand, modelled with care and marked by spirited execution'.[19] I like to think that this was Montefiore's own last choice for the Gallery. For many years, the statue stood in the Gallery's entrance court. When Sir Edgeworth David complained that colonial Australia was fixated on European models of beauty and strength and asked 'why we had no statue representing the original owners of the soil ... not one of the men whom we have dispossessed', a 'WJH' wrote to the press about *Defiance*, reminding readers that it was 'for many years in the Australian Court'. It was made out of plaster and he suggested that 'it would be fitting if the figure were reproduced in bronze'.[20] This did not happen and in 1959 the sculpture was donated to the Parramatta Youth Council Art Group. Its present whereabouts are unknown. All that survives is a tiny image from a proof-sheet of a photograph probably taken just before the work was donated.

Reid's statue was, of course, a white person's view of an Indigenous subject. We do not know how much agency the man depicted had in the creation of the work. But the powerful gesture of throwing a boomerang, which Reid interprets as a symbol of defiance, speaks to the resilience of the world's oldest living culture. It was made when there was increasing discussion in the press about the long tradition of Aboriginal rock carvings and paintings. *The native tribes of Central Australia*, by Baldwin Spencer and FJ Gillen, was published in London in 1899. Richly illustrated with photographs, it led to a rethinking of the origins of art. A copy was purchased for the Art Gallery library shortly after publication.

Despite this growing awareness of the antiquity of cultural production in Australia, when the Gallery decided to decorate its facade with sculptural panels illustrating the 'epochs of art' (Assyria, Egypt, Greece and Rome), the furthest back that could be imagined was Assyria. King Ashurnasirpal II built his palace at Kalhu (Nimrud) nearly 2900 years ago and this scene was depicted on the first of the panels. It is known that the oldest firmly dated rock paintings in Australia were executed 28,000 years ago, making the Assyrian reliefs, many of which are today preserved in the British Museum, seem almost contemporary in comparison. A panel recently commissioned from Karla Dickens, a cross-cultural Wiradjuri

The central photograph of this proof sheet is the only surviving visual record of the sculpture *Defiance* c1894 by Alexander Glen Reid, taken shortly before the work was deaccessioned from the collection of the Art Gallery of New South Wales in 1959.

The Exhibitionists

artist born in Sydney, will sit before them to greet visitors over the Gallery's entrance.

Dickens's concept for the facade, *To see or not to see* 2019, is an exploration of her female and cross-cultural Wiradjuri identity and the continuing legacy of colonialism. Artist Dora Ohlfsen had been commissioned to complete a panel for this same space in 1913, but it was never realised. Dickens said that her work

> is about women and invisibility, something just as much an issue today as it was in Dora Ohlfsen's time. The year of her commission in 1913 was the year my grandmother Myrtle was born. She and her family were constantly hiding or being hidden, forced to mask their Indigeneity. The issues she faced continue as the legacy of Aboriginal women today, and it's important to me, and to all New South Wales Aboriginal artists, to have this chance to speak.[21]

The Art Gallery of New South Wales sits on Gadigal Country. But this was not recognised when the Gallery was established in the Domain in 1885, and for most of its subsequent history. The work that Karla Dickens has made for the facade of the Gallery is also a challenge to the institution 'to see' the Gallery as a site of Indigeneity that is already on Country and to find ways to reactivate this from now on.

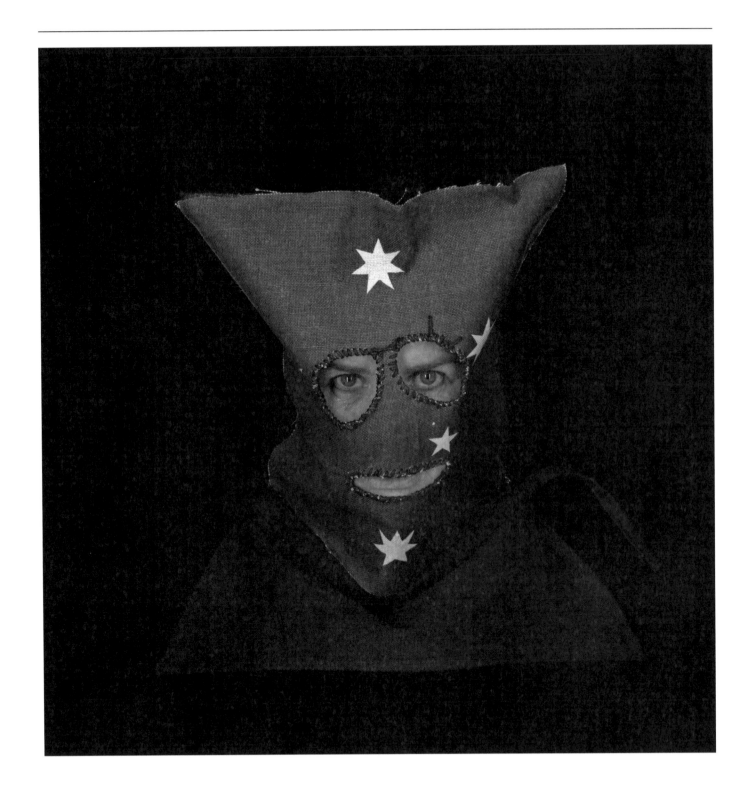

Karla Dickens *Looking at you VI* 2017. Dickens's handmade textile hoods and photographs from 2017 form the basis of her commission for the facade of the Art Gallery of New South Wales.

The Exhibitionists

Epigraph

Gilbert Parker, *Round the compass in Australia*, Hutchinson & Co, London, 1892, p 347.

Notes

1 AGNSW Minutes, 26 Sep 1894, p 128. The exhibition was the *15th Annual Exhibition of the Art Society of New South Wales*.

2 'Art Society's Exhibition: First Notice', *Sydney Morning Herald*, 28 Sep 1894, p 3.

3 The artists are Ali Gumillya Baker, Faye Rosas Blanch, Natalie Harkin and Simone Ulalka Tur. *Sovereign acts IV: Object* was performed at the Art Gallery of NSW on 29 March 2019 for the opening of the exhibition *The National: New Australian Art*.

4 Curator Clothilde Bullen on the Unbound Collective, the-national. com.au/artists/the-unbound-collective/sovereign-acts-iv-object, accessed 6 Oct 2020

5 'The Art Society's Exhibition', *Sydney Morning Herald*, 2 Sep 1892, p 2.

6 'The Art Society's Exhibition', *Sydney Morning Herald*, 2 Sep 1892, p 2.

7 'I was asked in the train if I had ever painted Aborigines. I painted one in the Riverina, one in Sydney and several in Queensland. I thought they would have been an interesting record of a passing race. The one in the Sydney Gallery was the only one which was bought; the rest are lost and I do not know where they are.' 'Then and now: Changes in art. Tom Roberts impressed', *The Daily Telegraph*, 8 Jun 1926, p 11. The Art Gallery's portrait of Charlie Turner may be the Riverina portrait or one of the others.

8 'Art and artists: Mr Tom Roberts's', *Table Talk*, 30 May 1890, p 7.

9 See Humphrey McQueen, 'Tom Roberts – panel portraits', Humphrey McQueen website, https://www. surplusvalue.org.au/McQueen, accessed 15 Jun 2020.

10 Prior to this, the National Art Gallery of South Australia was the first Australian public gallery to buy a work by an Indigenous artist, in 1939. They purchased a work by Albert Namatjira, as did the Art Gallery of Western Australia in 1946.

11 There is also a longer history than previously thought of works being exhibited. At the 1873 *conversazione* of the New South Wales Academy of Art, it was reported that 'Some magnificent specimens of the hats and cloaks of the natives were exhibited in the gallery upstairs'. 'Small talk', *Sydney Punch*, 14 Nov 1873, p 4.

12 They were offered again at the trustees meeting on 19 May 1897 where the price of ten pounds was stipulated.

13 He was the Clerk of Petty Sessions at Temora and lived at Milton for some time, very close to Ulladulla. He, along with George Ilett, assisted the Board for the Protection of Aborigines with the exhibition in Chicago.

14 AGNSW Minutes, 21 Feb 1902, p 427. The work was offered by JSS Keet.

15 See Paul Irish, *Hidden in plain view: The Aboriginal people of coastal Sydney*, NewSouth Publishing, Sydney, 2017.

16 There are other examples of Montefiore's sensitivity to people from other cultures in his sketchbooks. His drawing of a Chinese man carefully notes the man's name, both in Chinese characters and transliterated into English.

17 Whether these were original drawings by Montefiore, or ones he copied from another artist, is not as significant as the fact that he chose to include them in his sketchbooks.

18 'Ethnographie australienne: M. Montefiore offre à la Societé un boumerang, arme australienne sur l'emploi de laquelle il donne des explications', *Revue Ethnographique*, vol 1, 1869, pp 259–69.

19 'Art Society's exhibition', *Sydney Mail*, 6 Oct 1894, p 696.

20 WHJ, 'Stone Age Aboriginals', *Sun*, 20 Oct 1921, p 6.

21 'Art Gallery of NSW redresses history with announcement of new facade commission for its iconic entrance', Art Gallery of NSW press release, 8 Mar 2020.

2 The Academy
The New South Wales Academy of Art, 1871–75

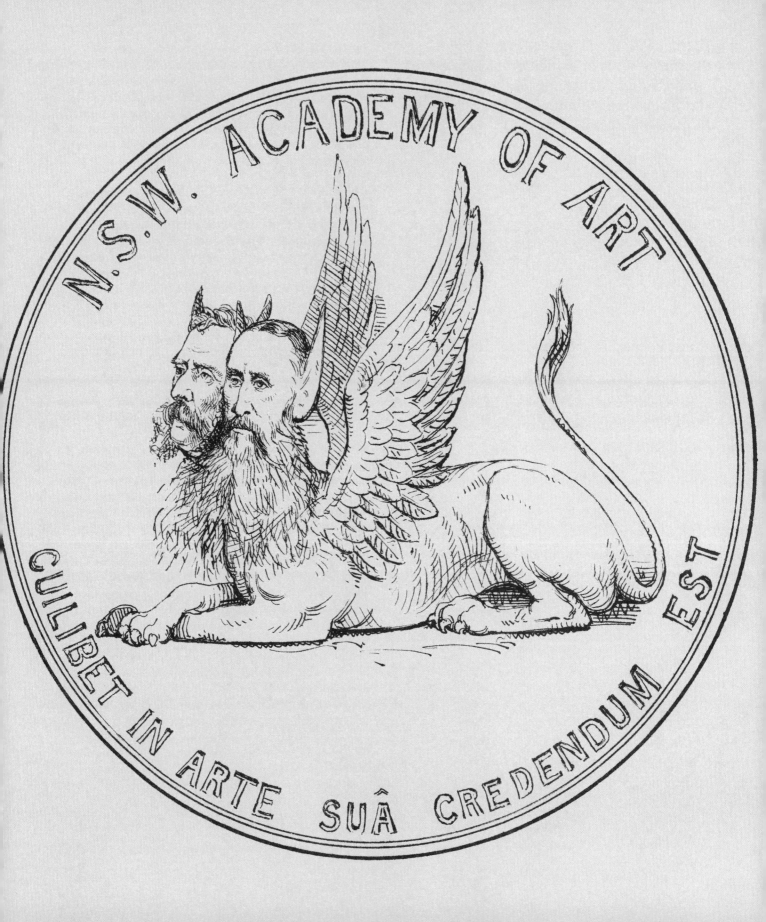

N.S.W. ACADEMY OF ART

CUILIBET IN ARTE SUÂ CREDENDUM EST

The nucleus of our present gallery was vitalised by a yearly exhibition of the work of a small band of struggling local artists. It was a faint beginning, but it was instinct with life.

May Manning, artist, 1895

In 1883 *The Year's Art*, a widely distributed publication advertising itself as a 'concise epitome of all matters relating to the arts', announced that it would widen its coverage beyond the United Kingdom to include the British Dominions and the United States of America. This expansion was the suggestion of 'Mr EL Montefiore from Sydney' and consequently the very first gallery included was the Art Gallery of New South Wales. A summary of its history was given:

> In 1870 the New South Wales Academy of Art was founded, received state recognition in 1873 by a grant of £500, and purchased some watercolour drawings, forming the nucleus of the collection in the present gallery. In 1875 the grant was increased to £1000, which was voted annually to 1879, when the first Australian International Exhibition was held in Sydney. At that time the grant was made £5000, to be voted annually. The Academy, having accomplished its end, was merged into the Art Gallery, and this was opened by Lord Loftus on September 22, 1880.[1]

Apart from ascribing dates that are a year earlier than the actual events, this was a concise summary of the first decade of the Gallery's history. The New South Wales Academy of Art, an art society from which the Gallery organically developed, was founded in 1871 and given a grant of public money for art purchases in 1874. A 'Fine Arts Annexe' was built during the 1879 Sydney International Exhibition and officially re-dedicated as the 'Art Gallery of New South Wales' when the exhibition closed in 1880.[2]

Described as a 'hastily built shell at the Botanic Garden gates', the Fine Arts Annexe had been constructed of iron and timber in just four months between August and November 1879.[3] Modest in appearance, it nonetheless became the first freestanding public gallery exclusively devoted to art in Australia and a symbol of the exceptional progress that had been made by the Academy of Art in just under a decade. The optimism it represented is evident in Montefiore's request to be included in *The Year's Art*. Sydneysiders took their Gallery in the Botanic Garden as evidence that their city was no longer 'indifferent to the interests of arts' and that it was beginning to keep pace with its rival, Melbourne.[4]

Since the gold rush of the 1850s, Melbourne had been Australia's largest and wealthiest city and the undisputed cultural capital of the country. An art gallery was begun there in 1861 and a dedicated space for its collection of casts,

Previous page: *Sydney Punch*, 25 June 1875, imagines a seal for the New South Wales Academy of Art, which had recently received government funding to purchase works of art. The seal features the two 'inseparable' founders of the Academy, Eliezer Levi Montefiore (back) and Frederick Eccleston Du Faur (front).

The Exhibitionists

medals and ceramics was opened as early as December 1864. However, this shared crowded premises and an administration with the Public Library and National Museum, all housed under the one roof on Swanston Street.

Montefiore knew firsthand what a significant achievement Sydney's independent art gallery represented. From 1853 he had been based in Melbourne, where he was active in the establishment of the gallery there. When an act of incorporation in 1869 united the Library, Museum and Gallery under one board of fifteen trustees, Montefiore was appointed to a subcommittee with responsibility for the Gallery.[5] He was a lively member of the committee and sometimes acted as Chair. We know, for instance, that it was Montefiore who pushed the board to purchase work by local artists.[6] It was also Montefiore who suggested that Eugene von Guérard be made painting instructor at the National Gallery School. His last meeting as a trustee was early in 1871. The *Argus* reported that although 'he will shortly leave Melbourne … he has consented to not wholly withdraw himself from the affairs of the National Gallery'.[7] As events unfolded, he had little time to devote to Melbourne once he moved to Sydney. His unwavering focus for the next 23 years was the establishment of the Art Gallery of New South Wales.

Only a few weeks after Montefiore arrived, the *Sydney Morning Herald* advertised a meeting to form an 'Academy of Art in New South Wales':

Decorative header for an article in the *Illustrated Sydney News*, 22 February 1888, illustrating *Wedded* 1882 by Frederic Leighton, purchased by the Gallery in 1882, and *The captive* 1882 by John Everett Millais, purchased in 1885

We have been requested to call attention to a meeting advertised to take place at 4 o'clock this afternoon in the hall of the Mechanics' School of Arts … The intended institution, like the Victorian Academy of Art, is understood to be designed for the promotion of the study of various departments of the fine arts and for an annual exhibition of works of art in Sydney.[8]

The meeting was called by Edward Reeve, founding curator of the Nicholson Museum at the University of Sydney. Around thirty-five people attended. Thomas Mort, 'a gentleman well known as a sincere promoter of art', took the Chair.[9] Mort had opened his home with its private art gallery to the public around ten years earlier. It had not been an entirely happy experience and Mort used this occasion to bore his audience with tales of 'little children poking sticks' at his *objets d'art*. Doing anything for art in Sydney would be 'very uphill work', he said, but he 'would be the last man in the world to throw cold water' upon such a worthy project.[10] Fortunately for the fledgling Academy, Mort and Reeve had only limited and initial involvement with its establishment. Others were to ensure its success.

Reeve thought that the thirty-five present at that initial meeting constituted too small a group to do anything other than establish an Academy in principle and circulate a draft constitution. It was here that Montefiore intervened. He had been a founder of the Victorian Academy of Art with Abram-Louis Buvelot and Eugene von Guérard and assured

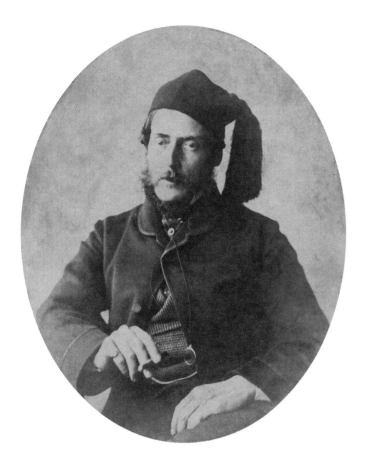

Photograph of Montefiore by an unknown photographer, probably taken around 1842, when he arrived in Adelaide, from an *Album of original sketches in pencil, sepia and watercolour, with photographs*

those present that this had been established with only twenty members. He offered the practical suggestion of forming a working committee to draw up a framework for the effective functioning of the Academy. This committee met a few weeks later and drew up the Rules, being five constitutions and seven laws based on the draft constitution that had been circulated at the first meeting. At the next full meeting of the Academy these were adopted, and officers were appointed: Mort as president, Montefiore vice-president and Reeve secretary.[11]

Reeve resigned as secretary in 1873 and left the Academy in a huff when it refused to pay him an honorarium of £40 from its total annual income of £120.[12] Frederick Eccleston Du Faur, a founding council member from June 1871, then volunteered to act as secretary and treasurer.[13] By this time Alfred Stephen had replaced Mort as president. With Montefiore as vice-president and Edward Combes as a councillor, this small group of four were the true founders of the Art Gallery of New South Wales. A cartoon in *Sydney Punch* showed a fictional corporate seal for the Academy: Montefiore and Du Faur, its 'working spirits', as a double-headed sphinx. They were so often together that 'the professional artists nicknamed them the Siamese twins'.[14] As the inscrutable sphinx the pair presumably concealed how the Academy had achieved success in such a short time, including financial support from the government.[15] Its secret was in mobilising influential men with parliamentary experience to the cause – figures like Stephen and Combes.

Both Stephen and Montefiore had been born in the West Indies. Though Stephen was older by nearly twenty years, he died within a week of Montefiore in 1894. The Gallery was like a Joseph to them, the child of old age that they came to love before all others. In 1873 Sir Alfred left the bench of the New South Wales Supreme Court as chief justice after thirty-four years of service. He became president of the New South Wales Academy of Art when he was in retirement.[16] Having made himself in Australia he felt the duty to return this privilege through public service.

A well-known public figure, Stephen had originally immigrated to Tasmania – then known as Van Diemen's Land – in 1825 and subsequently become involved in 'the political, official and social life of all the colonies'.[17] When he arrived in the colony his father had entertained dim hopes for him, writing to his friend Lieutenant-Governor Arthur, 'he is a pleasant, lively, talkative youth, who has neither thought nor read deeply upon any subject ... He is coming out to Van Diemen's Land to live by the Law.'[18] Although in his seventies when made president of the Academy, Stephen brought to the role an energy that characterised his entire career. 'Elasticity' was a frequent descriptor applied to him in the press. His insistence on getting things done, rather than 'mere idle talk', shows that the irrepressible lad, who had been made to learn

The Exhibitionists

John Lane Mullins *School of Arts* c1881, from a photographic album of
Views of Sydney and its streets 1868–81

knitting to keep him quiet, was still very much in the old man. His insignia, presented to the Gallery after his death, records some of the honours bestowed on him during his lifetime.

Eliezer Levi Montefiore came to Sydney to manage the Pacific Fire and Marine Insurance Company. His older brother Jacob was the founding chairman of the company and a leading figure in Sydney's commercial and political life, as well as being a member of the Legislative Council. Eliezer became the company's manager. His entire career had been spent working for various members of the family in shipping and general insurance, first in Adelaide (1842), then in Melbourne (1853) and finally in Sydney (1871). But it was art that was his real passion. He exhibited in the inaugural show of the Victorian Society of Fine Arts and was a founder of the Victorian Academy of Art. As trustee of the National Gallery of Victoria, he found himself 'one Jewish insurance manager amongst four knights of the realm, seven members of Parliament and a Church of England clergyman'.[19]

The prominence that Montefiore achieved in public life is remarkable given the reality of ingrained cultural anti-Semitism throughout colonial Australia. Even in progressive South Australia, where he first settled, the small Jewish community, numbering just fifty-eight when he arrived, was constantly monitoring itself for anything that might offend its fellow citizens and ignite anti-Semitic fires.[20] Montefiore's 'cheery, gracious personality', as well as his intelligence and kindness, endeared him to people at all levels of society.[21] When he died, his daughter donated more than 140 of his personal documents to the State Library of Victoria. These further reveal the man. Women particularly enjoyed his friendship. Georgina Kennedy, the wife of the governor of Queensland, confides her anxiety about her 'unhappy brother' who had followed her out to Melbourne but then severed contact. Another governor's wife, Emma Loftus, writes that she and her husband had waited in the gardens of Sydney's Government House until eleven o'clock that evening, hoping that Montefiore would join them to sketch the exceptional moon. When Lady Loftus returned to England, she kept up the correspondence, giving news of her husband's poor health, the English weather and the terror created by the Jack the Ripper killings.[22]

Edward Combes and Frederick Eccleston Du Faur had both come to Australia in search of gold. Unlucky

This illustration, probably by Eliezer Levi Montefiore, often appeared in the press above articles concerning the New South Wales Academy of Art. Along with an interest in painting, sculpture and photography, many of the founders of the Academy were active in the exploration of New South Wales, to which this illustration alludes.

The Exhibitionists

on the goldfields, they eventually worked professionally as engineering draughtsmen, Du Faur for the Surveyor-General's Office until he resigned as chief draughtsman in 1881 and Combes as mining engineer for the New South Wales government. In 1872 Combes entered parliament where he became a prominent voice advocating for the Gallery in the Legislative Council. Having trained in France, in 1878 he was appointed executive commissioner to the Exposition Universelle in Paris. His diary shows that Montefiore's brother, Édouard-Levy Montefiore, a banker there with excellent connections in the art world, was an important support to him in this role.[23]

The love of French culture was a significant bond between the Gallery's founders. Du Faur, Montefiore and Combes were fluent French speakers. Du Faur was related to the Comte (Germaine) Du Faur of Pibrac on his father's side. Montefiore had studied in Belgium and was appointed Belgian Consul when in Adelaide.[24] When Montefiore died, the London shipping magnate Thomas Devitt regretted that he had not

Above, left to right: Freeman Brothers *Sir Alfred Stephen CB, GCMG, MLC* 1893; Freeman Brothers *Frederick Eccleston Du Faur FRGS* 1893. **Right:** Achille Simonetti *Edward Combes CMG* c1883 (detail)

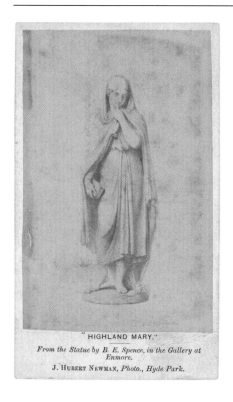

"HIGHLAND MARY."

From the Statue by B. E. Spence, in the Gallery at Enmore.

J. Hubert Newman, *Photo., Hyde Park.*

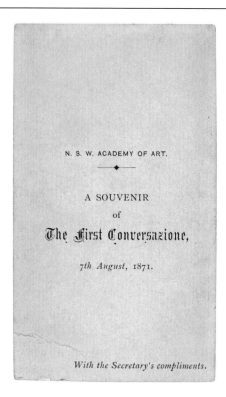

N. S. W. ACADEMY OF ART.

◆

A SOUVENIR

of

The First Conversazione,

7th August, 1871.

With the Secretary's compliments.

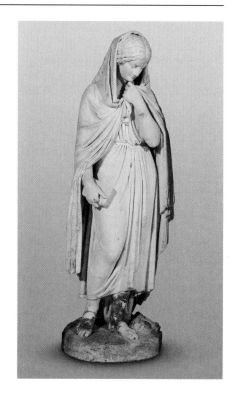

been honoured 'in the form of a knighthood years ago'.[25] He had, in fact, received a Belgian knighthood in 1883, but this counted for little in the dominant Anglophone culture of Australia. The magisterial and visionary report that Combes wrote for the New South Wales government on technical education made it clear that, in his view, French schools and systems were far in advance of English and American ones.[26] Culturally for these three, France too represented an ideal in art. At the very first event organised by the Academy, Montefiore passed around photographs of the Louvre – received 'by the last mail from Europe' – which had been damaged by fire in events related to the suppression of the Paris Commune. For the Gallery's founders, 'anything more utterly desolate it is scarcely possible to imagine'.[27]

That opening event of the Academy was a *conversazione* held at the Sydney Exchange on 7 August 1871. It included music, food, an exhibition and an occasional address by Charles Badham, professor of Classics at the University of Sydney. The paintings and curiosities exhibited were lent by Academy members. Thomas Mort gave an indication of why the public were not flocking to his personal gallery in Darling Point. He exhibited a 'very pleasing picture (in water colours) by a niece ... and a very clever pencil drawing of a bold cat and a cross cat by another niece'.[28] If even a third of the attributions that William Wallis, an Academy councillor,

supplied for works he had lent were accurate, he would have had a personal collection rivalling the princely ones of Colonna and Doria Pamphili in Rome. He exhibited paintings 'by' Velásquez, Caravaggio, Van Dyck, Joshua Reynolds, Guido Reni, Titian and Murillo.

However, the work that was given pride of place at the *conversazione* was not an Old Master:

> the cynosure of all eyes was EB Spence's large marble statue of the 'Highland Mary' of Burns which occupied the post of honour at the west end of the apartment ... This exquisite statue – a *replica* of which was bought by the Queen for her gallery at Windsor – was purchased by District-Judge Josephson, from Spence himself, for £700 in London.[29]

The work later entered the collection of the Art Gallery of New South Wales with other sculpture donated by Judge Joshua Josephson shortly before his death.[30] A memento given to guests at the *conversazione* reproduced it on a small card.

Memento of the first *conversazione* held by the New South Wales Academy of Art on 7 August 1871, reproducing the sculpture *Highland Mary* 1854 by Benjamin Spence (above, far right), which was bequeathed by its owner, Judge Josephson, to the Art Gallery of New South Wales in 1892

Around six hundred people attended the *conversazione*, with a cartoon in *Sydney Punch* illustrating the diverse audience, from the pompous 'critics of art' to those who came merely to socialise. Lord Belmore, the governor, kept the crowd waiting: 'The guests were assembled and seated in expectation of an immediate lecture; the Doctor was there, manuscript in hand, but still there was a waiting, for Vice-Regality came not, but sent a message to say it had not done its dinner and could not start till nine.'[31]

New members were enrolled in the Academy that evening. Photographer Myra Felton was one. She became a paying member of the Academy from its foundation and remained one until it dissolved, the only woman in a small group of six.[32] Felton's father Maurice had been an artist but had died when she was seven. She treasured his 'fancy self-

Cartoon from *Sydney Punch*, 7 August 1871, commenting on the diverse audience present at the first *conversazione* of the New South Wales Academy of Art

portrait' and bequeathed it to the Gallery upon her death. Unfortunately, it was then lent to the State Library, where it has remained ever since. Myra Felton's earliest art studies were with British artist Marshall Claxton, while he was briefly in Sydney between 1850 and 1854. As soon as she was able, Felton went to work to support her mother and family. She opened her own studio in 1859 and is celebrated as one of the first independent professional women photographers in the colony. But, typically of women artists working at the time, little of her work survives. A delightful watercolour from late in her life has been tentatively titled *Spiritualist (possibly the artist) on a Sydney rooftop*. Along with art, religion was Felton's consuming interest. Her published novel *Eena Romney* was reviewed as 'a little domestic story of a highly religious character'.[33] A contemporary remembered that her religious beliefs 'made her wear frocks that were almost comic ... and extraordinary hats. But she was brave and had the courage of her convictions.'[34]

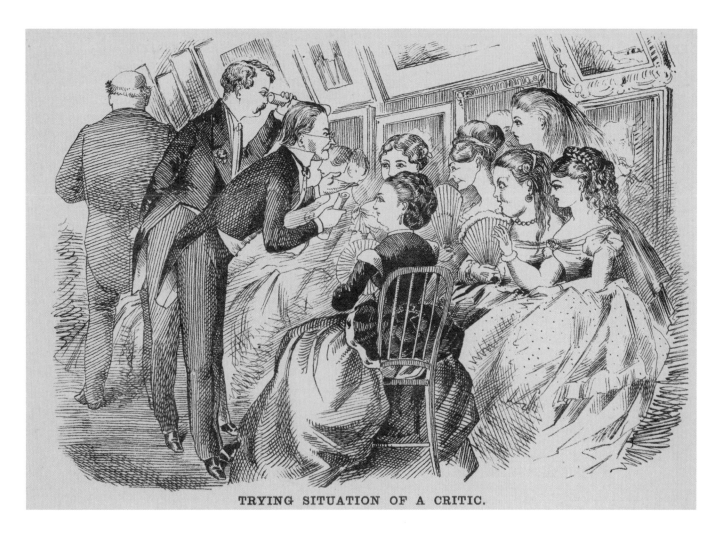

TRYING SITUATION OF A CRITIC.

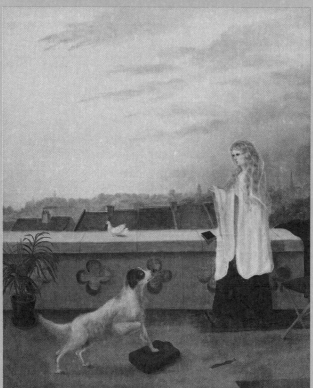

Above: Maurice Felton *Fancy self-portrait* 1840
Right: Myra Felton *Spiritualist (possibly the artist) on a Sydney rooftop* 1910

The Exhibitionists

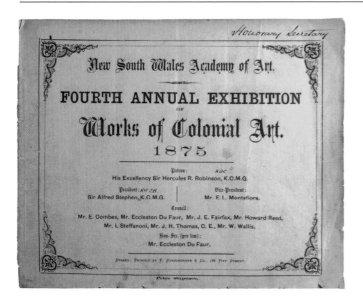

New South Wales Academy of Art.

FOURTH ANNUAL EXHIBITION
OF
Works of Colonial Art.
1875

Patron:
His Excellency Sir Hercules R. Robinson, K.C.M.G.

President:
Sir Alfred Stephen, K.C.M.G.

Vice-President:
Mr. E. L. Montefiore.

Council:
Mr. E. Combes, Mr. Eccleston Du Faur, Mr. J. E. Fairfax, Mr. Howard Reed,
Mr. L Steffanoni, Mr. J. H. Thomas, C.E., Mr. W. Wallis.

Hon. Sec. (pro tem):
Mr. Eccleston Du Faur.

In 1872 Felton showed two untitled portraits at the very first exhibition organised by the Academy.[35] She had opened her own art academy around 1869 and her pupils showed work at the annual exhibitions from 1874 to 1877 and in the student exhibitions of the following years.[36] These annual exhibitions of 'colonial art', which at the time meant contemporary art from Australia and New Zealand, were the principal focus of the Academy in its early years. A history of the Gallery published by the *Illustrated Sydney News* to mark the centenary of European colonisation in 1888 claimed that it was a 'want of a local habitation' that led the Academy to focus its efforts on 'the holding of annual exhibitions, opened to artists in all the colonies, at which medals, certificates and money prizes were awarded'.[37] This was not entirely true. It had always been an aim of the Academy to support living artists where possible and providing opportunities for them to sell their work was an important way of doing this.

In order to facilitate these exhibitions, the Academy organised the collection of works, negotiating the complicated web of customs and tariffs that were in place between the colonies, hired a venue, published a catalogue and collected revenue on sales, which was then forwarded to exhibiting artists.[38] These exhibitions were 'ticketed', with an entrance charge of one shilling for adults and sixpence for children under twelve. They proved incredibly popular and were open

Above: Cover of the catalogue to the 1875 annual exhibition of the New South Wales Academy of Art **Right:** Eliezer Montefiore (left) and Edward Combes (right) attending an exhibition of the New South Wales Academy of Art c1875

from nine to five and again in the evenings from eight to ten. 'It is no easy matter in the colonies to collect between two and three hundred new pictures, exclusively the work of colonial artists and amateurs,' one reviewer noted, adding 'there are some pictures hardly worth showing at all. Some of which one can only say that they are pretty ... and a few are really praiseworthy.'[39] It was hoped that new members would sign up to the Academy as a result of these exhibitions, but this proved challenging. 'The Academy ought, relatively to our population and wealth, have twice the number of members of those who support the similar institution in Melbourne,' one member complained. 'We have scarcely a *tenth*.'[40]

Conrad Martens, the most senior artist in Sydney at the time, suggested an Art Union as another way of supporting artists. The first one was held in conjunction with the annual exhibition of 1877. Money raised from subscriptions was allocated across a series of prizes of different values. Winning monies were to be expended only on works of art from that exhibition. The regulations noted that 'each subscriber of one guinea will be entitled to one chance at the drawing of prizes'.[41] Such Unions had proved popular and profitable in London, Edinburgh, Glasgow and Melbourne.

Certificates and money prizes were also awarded to artists at the annual colonial exhibitions. At the fourth exhibition in 1875, a silver medal was awarded to the thirty-nine-year-old WC Piguenit for his *Mount Olympus, Lake St Clair, Tasmania,*

Silver medal awarded to WC Piguenit at the 1875 exhibition of the New South Wales Academy of Art for his oil painting *Mount Olympus, Lake St Clair, Tasmania, the source of the Derwent* 1875 (illustrated below). The painting was presented by fifty subscribers to the Art Gallery of New South Wales in 1875.

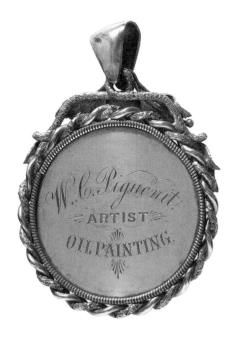

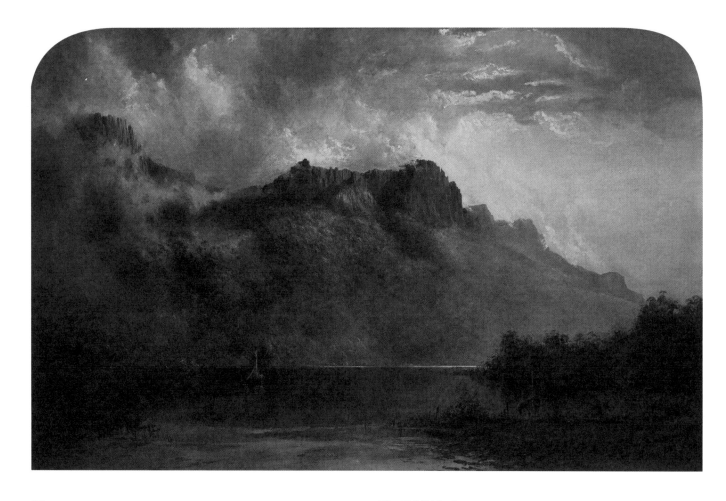

The Exhibitionists

the source of the Derwent 1875. He had been born in Hobart and was well known to Academy president Sir Alfred Stephen, who had patronised young artists like Piguenit during his time in Van Diemen's Land. At the same exhibition, the Academy's gold medal for watercolours was awarded to Conrad Martens for his *View on the Apsley Ranges, New England* of 1874. In one of those felicitous twists of history, these two medal-winning works of art became the foundational Australian oil painting and the foundational Australian watercolour of the Gallery's collection. The Piguenit was purchased by a group of fifty subscribers and presented to the Academy. The watercolour by Conrad Martens was a commission, painted 'for the proposed Gallery of Art in Sydney'.[42]

This proposed 'Gallery of Art' became a possibility only in 1874. Du Faur remembered no intention to found a gallery in the early days of the Academy, whose dual purpose was 'the study of various departments of the Fine Arts and the periodical exhibitions of works of art'.[43] Interestingly, however, just a few weeks after its formation in 1871, an editorial in the *Sydney Morning Herald* speculated:

> It is scarcely the right time now to consider the appropriation of public money for the purchase of pictures. Such a proposition would meet with but a savage reception from some members of the Assembly. But eventually the value of art education may be made apparent as to bring the Assembly to vote a sum of money sufficient for the formation and maintenance of a modest gallery.[44]

One member – not of the Assembly but of the Legislative Council – was determined to see this happen. At the second Annual General Meeting of the Academy in 1873, Edward Combes 'proceeded, in an able and argumentative speech, to urge that members bend all their energies on the gradual establishment of a picture gallery in Sydney for the instruction of art students and showed how cheaply this might be done. He pointed out the immeasurable superiority of Melbourne to Sydney in this respect.'[45] Cunningly, in the following year Combes arranged for a parliamentary vote of £500 that had been earmarked for the Australian Museum to be transferred to the Academy 'toward the formation of a Gallery of art'.

Montefiore was absent when the Council of the Academy met on 17 July 1874 to discuss how the £500 would be spent. Without him present, the other councillors decided to buy 'copies, of first-rate character, of some of the most celebrated paintings by the ancient masters'.[46] Montefiore was appalled and wrote to Du Faur the following day telling him that a special meeting must be called to reconsider the decision. At this meeting the earlier resolution was rescinded and it was resolved instead to buy 'original watercolour drawings

and that the question of purchasing oil paintings be left for consideration at a future time when the votes of parliament are more liberal'.[47] Five 'trustees' were appointed to administer the money and these decided to set aside fifty pounds for the commission of a watercolour by Conrad Martens, with the remaining money to be sent to the Agent General in London 'for any purchases which may from time to time be made by a Selection Committee appointed by the Trustees'. Six watercolours by British artists were eventually acquired.[48]

The commission to Martens was a gracious gesture typical of Montefiore. Martens was seventy-three at the time and in very poor health. His letter accepting the commission is a moving document. He writes with the spidery hand of old age: 'I beg leave to say that I shall have much pleasure in executing the same and that I feel much flattered.'[49]

Next page, top: Conrad Martens *Apsley Falls* 1874 was the first work acquired by the Gallery. **Next page, bottom:** Letter from Conrad Martens thanking the Gallery for the commission to paint *Apsley Falls* 1874

Epigraph

May L Manning, 'Art in Australia', *Magazine of Art*, 1895, p 216.

Notes

1 *The Year's Art 1883*, Sampson Low, Marston, Searle & Rivington, London, 1883, p 174.

2 The Sydney exhibition had representation from twenty-three nations. Because it was not universal it is not officially recognised today by the Bureau of International Expositions.

3 'The National Art Gallery', *Daily Telegraph*, 23 Jun 1884, p 3.

4 'The Art Gallery of New South Wales', *Illustrated Sydney News*, 20 Nov 1880, p 10.

5 Montefiore was appointed on 3 Feb 1869.

6 There is a letter from Sir Charles Gavan Duffy to Montefiore expressing regret that he would not be present at a board meeting of the trustees of the Melbourne Gallery, Library and Museum to support Montefiore's proposal to spend a portion of the Gallery's grant on works by colonial artists. MS13020, State Library of Victoria, Melbourne.

7 'News', *Argus*, 18 Feb 1871, p 4.

8 'The New South Wales Academy of Art', *Sydney Morning Herald*, 24 Apr 1871, p 4.

9 'Academy of Art', *Evening News*, 25 Apr 1871, p 3.

10 'Academy of Art', *Evening News*, 25 Apr 1871, p 3.

11 The council included JH Thomas, James AC Willis, Thomas Hodgson, C Badham, William Wallis, Lewis Steffanoni and Robert Tooth. This was not the first art society in the colony. The Society for the Promotion of the Fine Arts, founded by Sir Charles Nicholson, had held exhibitions in 1847, 1849 and 1857. The NSW Society for the Promotion of Architecture and the Fine Arts and the Pen and Pencil Society were both in the process of forming at the time of the founding of the Academy. The NSW Society of Arts was dissolved so that its members could join the Academy.

12 Reeve asked for this amount as payment for his out-of-pocket expenses in performing the Academy's business. The Council disagreed and first allowed him two pounds a month from petty cash and later three pounds. Du Faur claimed that Reeve kept some of the Academy's monies when he resigned on 7 October 1873. Reeve said that the pressure of work forced him to resign from the Academy. Noel Hutchison argues that tensions concerning the nature of the art school planned by the Academy also contributed to the resignation. See Noel Hutchison, 'The establishment of the Art Gallery of New South Wales: politics and taste', BA thesis, University of Sydney, 1968, p 40.

13 Frederick Eccleston Du Faur, 'The National Gallery of New South Wales', *Journal of the Institute of Architects of New South Wales*, vol 1, no 3, Jul 1904, p 119.

14 William Moore, *The story of Australian art*, vol 1, Angus and Robertson, Sydney, 1934, p 161.

15 *Sydney Punch*, 25 Jun 1875, p 1. The two Latin phrases, which are incorporated as an extended motto on the seal, carry the sense of 'true art conceals the means by which it is achieved' (*ars est celare artum*) and 'any expert in their own art should be believed' (*cuilibet en arte sua credendum*).

16 It is a pity that JM Bennett's *Sir Alfred Stephen: third chief justice of New South Wales* (The Federation Press, Sydney, 2009) barely touches upon Stephen's crucial involvement in establishing the Art Gallery of NSW and, when it does, most of its information is incorrect. Bennett does not include Stephen's activities promoting art among his core 'retirement interests'.

17 'Sir Alfred Stephen's autobiography', *Leader*, 22 Mar 1890, p 36.

18 Martha Rutledge, 'Sir Alfred Stephen', *Australian Dictionary of Biography*, vol 6, 1851–90, R–Z, Melbourne University Publishing, Melbourne, 1976, p 180.

19 Rodney Benjamin, 'Eliezer Montefiore (1820–94): Artist, gallery director and insurance pioneer; the first significant Australian Jewish artist', *Australian Jewish Historical Society Journal*, vol 17, no 3, Nov 2004, p 328.

20 See I Getzler, *Neither toleration nor favour – the Australian chapter of Jewish emancipation*, Melbourne University Press, Melbourne, 1970, pp 11–13.

21 Thyra Gebbin, 'Mr EL Montefiore and the Sydney Art Gallery', *The Cosmos Magazine*, vol 1, no 3, 30 Nov 1894, p 139.

22 1883 letter from GM Kennedy; 1885 letter from EA Loftus; 1889 letter from EA Loftus, La Trobe Library Collection, State Library of Victoria, Melbourne, MS13020.

23 See Edward Combes's diary, 1878, State Library of NSW, Sydney, MLMSS2736.

24 Leopold I, King of the Belgians, made this appointment on 23 Oct 1850 but it was not official until later ratification by Queen Victoria and Lord Palmerston.

25 Letter from Thomas L Devitt to Frederick Eccleston Du Faur, 7 Dec 1894, BF33/1894.

26 See Edward Combes, *Report on technical education*, Charles Potter, Government Printer, Sydney, 1887.

27 'Academy of Art: first conversazione', *Sydney Mail*, 12 Aug 1871, p 754.

28 'Academy of Art', *Sydney Mail*, 12 Aug 1871, p 754.

29 'New South Wales Academy of Art', *Sydney Morning Herald*, 8 Aug 1871, p 2.

30 The statue was bequeathed by Judge Josephson in 1892. It was deaccessioned by the Gallery in 1958. It was then purchased by Lady Lloyd Jones, who eventually donated it back to the Gallery in 1982.

31 'The Academy of Art', *Sydney Punch*, 12 Aug 1871, p 2.

32 The others were John Alger, Dr Le Gay Brereton, VW Giblin, JH Newman and H Prince.

33 'New publications', *The Daily Telegraph*, 22 Oct 1887, p 9.

34 'Notable women: Early Sydney life', *Sydney Morning Herald*, 11 Jun 1936, p 17.

35 No 40 Portrait (oils) and no 41 Portrait (crayons).

36 In the *4th Annual Exhibition* (1875) the pupils were Miss Jane Horniman and Miss Clara Horniman. In the *5th Annual Exhibition* (1876) the pupils were Miss Eichler and Miss Solomons. The last of the annual exhibitions was held in 1877. 'Annual exhibitions have since been confined to works by students in New South Wales, for whose encouragement medals, certificates of merit and money prizes have been awarded.' *9th annual report of the New South Wales Academy of Art*, 1880, p 1.

37 'The history of the Art Gallery of New South Wales', *Illustrated Sydney News*, 22 Feb 1888, p 14.

38 The first four annual exhibitions of the Academy were also incorporated in part or full into the Agricultural Society's Annual Exhibition in Alfred Park.

39 'Academy of Arts', *Sydney Mail*, 22 Apr 1876, p 535.

40 A Sydneyite, 'Colonial works of art', *Sydney Morning Herald*, 24 Apr 1876, p 3.

41 Letter from FB Gibbes to Frederick Eccleston Du Faur, 22 May 1877, CF36/1877.

42 'Fourth Annual Exhibition of the Academy of Art', *Sydney Morning Herald*, 9 Apr 1875, p 6.

43 Du Faur, 1904, p 119.

44 'Monday, May 15th, 1871', *Sydney Morning Herald*, 15 May 1871, p 4.

45 'New South Wales Academy of Art', *Sydney Morning Herald*, 4 Jul 1873, p 2.

46 AGNSW Minutes, 17 Jul 1874, p 8. At this meeting Howard Reed proposed that 'an original painting by a modern artist' be considered, but then he withdrew the motion.

47 AGNSW Minutes, 23 Jul 1874, pp 9–10. In Melbourne a similar debate occurred concerning how best to spend the £1000 voted by the government in 1864 to the 'Commission on the Fine Arts'. A compromise was reached, and it was decided to spend the bulk of the grant on original works, purchase some copies and, following the suggestion of James Smith, a work by an artist resident in Australia.

48 Oswald Brierly, *A fresh breeze off Revel* c1875; Henry Brittan Willis, *Cattle piece, a scene on the Wye* 1873; John Henry Mole, *The road to the peat bog, near Barmouth, North Wales* 1874; Josiah Whymper, *The mill, Arundel* 1874; Paul Naftel, *A stream from the Dochart, Perthshire* 1875; Thomas Richardson, *Eagle Crag and Gate Crag, Borrowdale, Cumberland* 1875.

49 Letter from Conrad Martens to Frederick Eccleston Du Faur, 21 Aug 1874, inserted into the AGNSW Minutes, 1874–78, p 36.

3 The dance hall
Finding premises, 1875–79

Now that the Academy has a local habitation, we have no doubt that its career of usefulness may be materially extended in many ways.

Sydney Morning Herald, 1875

The 'want of a local habitation', which the *Illustrated Sydney News* said characterised the Art Gallery of New South Wales in its foundational years, was not unique to Sydney's art museum. The Metropolitan Museum of Art in New York was founded on 13 April 1870, exactly one year and eleven days before the Art Gallery of New South Wales. It too began without a collection and without a building. Indeed, many major world museums were established in the 1870s, and begun as art associations or academies, as was the case in Sydney.[1] The need for permanent accommodation became essential for the New South Wales Academy of Art when works of art were bought with public funds from 1874.

The Chamber of Commerce at the Sydney Exchange, where most of the annual exhibitions of the Academy had been held, was only a temporary venue. Council meetings of the Academy had been hosted in the boardroom of the Free Public Library, but the Library was protective of its spaces and had earlier rejected a request to establish a permanent office for the Academy in its 'vaults'. The Australian Museum was equally resistant to giving over a portion of its building. So, in April 1875, it was decided to take out a lease on Clark's New Assembly Hall on Elizabeth Street. This was a three-storey residence 'considered fine in its day, where Mr John Clark taught the young people in the forties, fifties and onward the arts of deportment and dancing'.[2] When he was not teaching

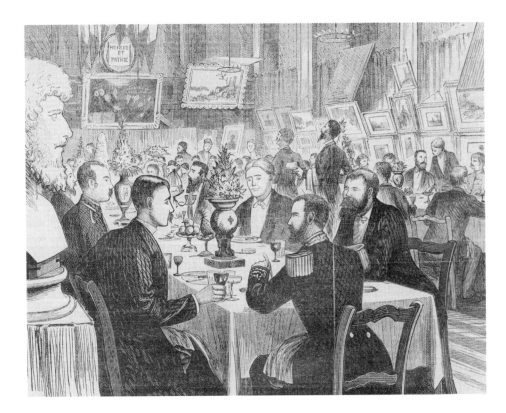

Previous page: An artist's impression of the interior of Clark's New Assembly Hall when it was being rented as premises for the New South Wales Academy of Art, from the *Illustrated Sydney News*, 23 March 1878
Right: The French consular dinner hosted by the New South Wales Academy of Art in Clark's New Assembly Hall during the 1879 Sydney International Exhibition, from the *Australian Town and Country Journal*, 6 December 1879

The Exhibitionists

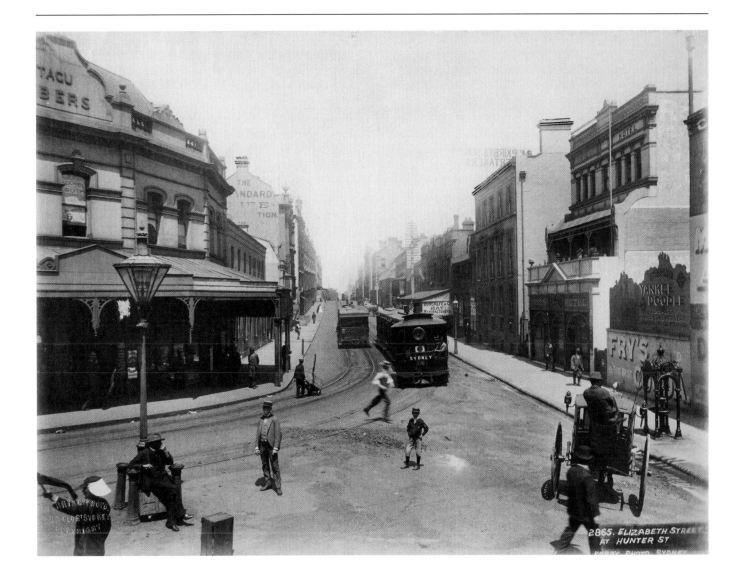

Kerry & Co Photographers *Elizabeth St at Hunter St* c1880, from *Album of Sydney streets and buildings* 1861–c1900. Clark's New Assembly Hall, which was the Gallery's first premises, is the three-storey, flat-fronted building visible on the right.

young people deportment, 'Brother Clark' hosted meetings of his freemason brethren at the hall, presiding as provincial grand senior warden.

Both the Metropolitan Museum and the Art Gallery of New South Wales had dance studios as their first premises. In Sydney, the Academy confined its small collection and its activities to the *salle de danse* on the top floor, with ground floor rooms given over to art classes or sublet to the Royal Society of New South Wales. A sketch from the *Illustrated Sydney News* shows this top floor as a light-filled space with a mezzanine gallery at one end. The walls had 180 metres of hanging room, with clerestory windows placed high above the works of art. These could be shuttered when needed and the room was lit by gaslight, as can be seen in an 1879 engraving of an Academy-hosted dinner there. A line drawing from Joseph Fowles's *Sydney in 1848* shows the exterior of a building clearly labelled 'J. Clark Professor of Dancing'.[3] However, Clark's Assembly Hall was replaced by Clark's New Assembly Hall around 1857, on the site of the Royal Society Building at 5 Elizabeth Street. Fowles depicts the earlier building.

A three-year lease was taken out on the building at an annual rent of £250, with Du Faur and Montefiore personally guaranteeing the contract. An 'inaugural exhibition' was opened on 3 June 1876 and remained open until March of the following year.[4] The public was given free admission on Fridays and Saturdays from noon to four o'clock.[5] Members

The dance hall

of the Academy and students had daily access from nine in the morning. The inaugural show was in fact a collection exhibition that had new pieces added to it when they were acquired. It included the foundational watercolours that had been purchased in 1874 and some works by the 'late Miss AE Ironsides [*sic*]'. In July 1877 the *Sydney Morning Herald* reported that 'at the rooms of the Academy of Art in Elizabeth Street there are now on view three large pictures painted by Miss Adelaide E. Ironside, the late young Australian, whose death at Rome, where she was studying her art, was a source of regret to her many friends here. The subjects of these paintings are the "Marriage in Cana", the "Adoration of the Magi" and the "Pilgrimage of Art".'[6]

The reviewer noted that these pictures had been 'hung together on the south wall' making a small, dedicated display devoted to the artist. Despite its modest size, this exhibition by an Australian artist and by a woman was the first solo exhibition held by the nascent Art Gallery of New South Wales. It is a moment in history that the Gallery now celebrates, even if the ensuing years could hardly be viewed as building upon this legacy.

Ironside is a fascinating figure who is thought to have been the first Australian-born artist to study in Europe. Her letters to and from key figures in the nineteenth-century art world, including critic John Ruskin and sculptor John Gibson, show her to be the intellectually curious, impetuous, and politically and spiritually adventurous person that so many of her contemporaries admired. Her short life of thirty-six years was entirely shaped by her sense of artistic vocation.[7] One cannot but admire her mother as well, who supported her in realising this vocation despite the personal cost: 'Mamma cares little for Italy, she longs for the free sea city, and the beautiful wild nature of Australia, but then she is not an artist.' For Adelaide, however, 'Italy, my dream, is the soul's home'.[8]

The marriage at Cana of Galilee 1861–63 was painted in Rome and is one her most important works. She was ill when

The Exhibitionists

painting it, with the tuberculosis she died from four years later in 1867. Gibson cautioned her mother 'to make her go to bed ... and don't let her get at the picture anymore'.[9] But she was consumed with the work she described simply as her '*nozze*'. Her politics were there – an ardent republican, she based the face of the bridegroom on Garibaldi – her sexuality as well, if such a crude characterisation can be applied to the mystery that still surrounds an artist known to have crushes on important women in her life, including the harpist Caroline Clark. But above all it is her spirituality that makes this a remarkable painting. The subject is the biblical story of the first miracle worked by Jesus at a marriage feast in Cana, where he turned water into wine at the request of his mother. In Ironside's painting, the standing figures of Jesus and Mary are mirrored by the typological bride and bridegroom seated behind, symbols that can be interpreted on a number of levels, including that of the soul and its divine calling.

For one who said many times that she was wedded to her art, with all the 'thorns' that this might entail, this is a moving image of the high vision of artistic vocation. *Marriage at Cana* remained on loan to the Gallery until the 1880s, eventually making its way to St Paul's College at the University of Sydney. In 1992 the College generously donated the painting back to the Gallery, 115 years after it was first exhibited in Clark's New Assembly Hall.

One painting purchased by the Academy that was unable to be exhibited in the dance hall, because it was too large to fit through the doors, was Ford Madox Brown's *Chaucer at the court of Edward III* 1847–51. This was purchased directly from the artist for £500 in 1876. That year, it became evident that the government would continue to make two allocations of money annually to the Academy, one for its activities (the maintenance vote) and one for art purchases (the statutory endowment).[10] Five Academy members were designated as 'trustees' and charged with spending the money.[11] At the prompting of Combes, who was in England at the time, the entire 1876 statutory endowment was spent on the Ford Madox Brown.

It was a remarkably ambitious purchase for a gallery that had barely been established, with no permanent home and a collection of thirteen watercolours and twelve oil paintings. Two years earlier, Montefiore had thought that a work by an artist like Ford Madox Brown would be beyond the Gallery's means and that it should therefore direct its 'attention to purchasing the works of *rising* artists of merit'.[12] Others, including JH Thomas, believed that Australians, obsessed with 'bucolic and mercantile pursuits', had no capacity to judge quality in art and should therefore restrict purchases to copies of Old Masters for the purpose of art instruction.[13] This 'sneering at the art knowledge of the Australian colonies', as Montefiore described it, only fired the ambitions of men like Combes and Montefiore.[14] The Madox Brown painting, which was hung at the Australian Museum when it arrived in Sydney, was the Gallery's first major international art acquisition.[15] It signalled that the Sydney gallery would essentially be a gallery of contemporary art, using its limited means to purchase works by promising young artists.

Those artists were largely believed to be non-Australians. The Academy's support for local artists involved organising exhibitions so that they could sell their work, and awarding

Left: Adelaide Ironside *The marriage at Cana of Galilee* 1861, reworked 1863
Right: Cartoon using the painting *Chaucer at the court of Edward III* 1847–51 by Ford Madox Brown (see overleaf) to satirise contemporary politics in the colony of New South Wales, from *Sydney Punch*, 6 January 1877. Labelled 'Chaucer (Mr W——m F—— reading his Tragedy', the cartoon depicts the reader as Agent General William Forster, a former premier and treasurer. Forster was known as both a poet and a critic of Sir Henry Parkes's poetry, and had just published an ambitious book of historical poetry, *The weirwolf*. Henry Parkes (opposition leader) appears as Edward III. The others might be John Robinson (Premier), bearing the staff at left; Joseph Docker (Minister for Justice and Public Instruction), standing between Forster and Parkes; John Fitzgerald Burns (Postmaster), sitting in throne to the right of Parkes; Thomas Garrett (Secretary for Lands), sitting at Parkes's feet; and Alexander Stuart (Treasurer), wringing his hands below the throne at right.

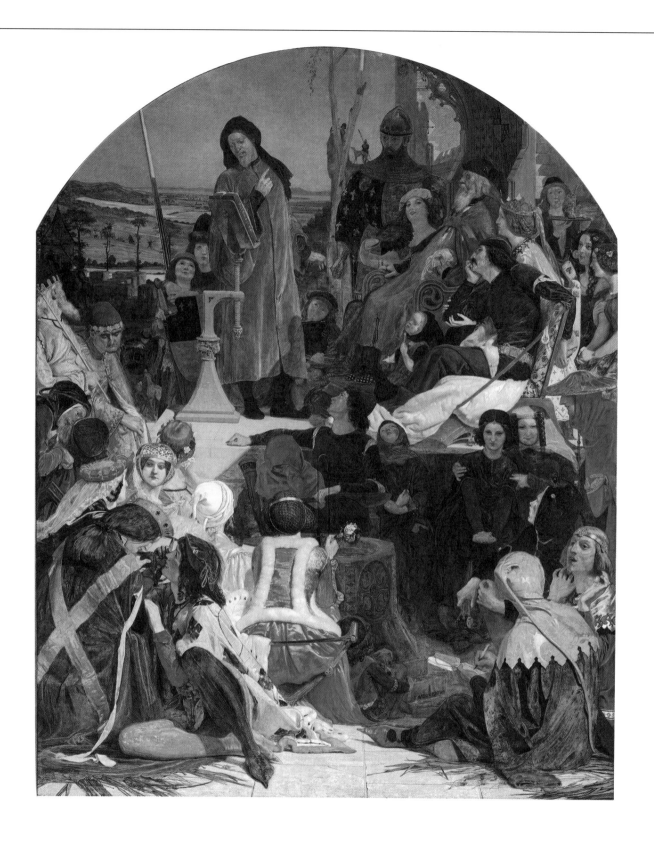

Ford Madox Brown *Chaucer at the court of Edward III* 1847–51

The Exhibitionists

them medals, certificates of merit and money prizes rather than buying their works for a national collection. Even in 1882, when the Gallery received its first bequest of £1000 from the 32-year-old Charles Smith, it was decided to spend the entire amount on works purchased in London. John Russell, who had returned home 'after studying art under Professor Legros of London', questioned this decision. He thought the money would be better spent encouraging local talent.[16]

Russell also thought that young Australian artists should 'go to nature', 'Australian scenery and incident being so widely different from that of other lands', rather than copy European prototypes. The first two Australian oil paintings acquired by the Gallery were such examples of artists going to nature. In addition to WC Piguenit's *Mount Olympus, Lake St Clair*, presented by subscribers in 1975,[17] a painting by JW Curtis, *Winter morning, Mount Disappointment*, was purchased from the Academy's *Sixth Annual Exhibition of Works of Colonial Art*.[18] English-born Curtis immigrated to Australia in the 1860s. His works were often criticised for being 'too sombre' and a reviewer described *Winter morning, Mount Disappointment* as 'a large and dreary scene ... there is enough coldness in it to chill a room. The scene is no doubt correct; but the dead blue and white of the trees and the snow are not sufficiently relieved to make the picture agreeable.'[19] These dark, brooding landscapes were often the first Australian works purchased by public galleries. Adelaide, for example, was given *Evening shadows, backwater of the Murray, South Australia* 1880 by HJ Johnstone in 1881. Both Johnstone and Curtis were greatly influenced by Louis Buvelot, the most important landscape painter in Victoria in the 1870s. The National Gallery of Victoria in 1864 acquired *The Buffalo Ranges* by Nicholas Chevalier, an artist who had dominated Victorian landscape painting in the previous decade.[20]

Russell's comments about imitation concerned the copying of original works of art, but they also tapped into the continual debates around the Gallery's expenditure on copies. The very first purchases of the New South Wales Academy of Art were casts of antique sculptures. These were essential props in art instruction and Russell himself would have used them in his training. A long-term ambition of the Academy was to establish a school of design in Sydney modelled on that of South Kensington in London. From money raised through subscriptions, it sent the considerable amount of fifty pounds in October 1871 to 'Signor Brucciani of Covent Garden'. Domenico Brucciani sold casts to museums, libraries and art schools around the world, with Melbourne owning a large selection.[21]

In 1872 the Sydney School of Design was launched with Montefiore as general inspector, Thomas Hodgson as superintendent of studies and Edward Reeve as registrar. But, as Alfred Stephen recalled, 'being unable to obtain the

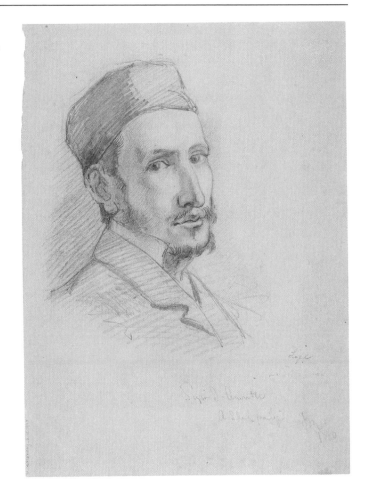

Frank Mahony *Signor G Anivitti: a sketch from life* 1880

The Exhibitionists

necessary accommodation for opening classes, the council was compelled to stow the models away in a warehouse, and thus for some years the school project remained in abeyance'.[22] It was only when the Academy leased Clark's New Assembly Hall that they were able to open 'a school of design, modelling and sculpturing' in May 1875, with 'the valuable assistance of MM Anivitti and Simonetti'.[23] Achille Simonetti and Guilio Anivitti were friends who had trained at the Accademia di San Luca in Rome. They immigrated to Australia together and arrived in Brisbane in 1871. Although they were both appointed teachers at the Academy, it was Anivitti, as drawing instructor, who had the most interaction with pupils.[24]

By 1878, thirteen men and twenty-five women were studying with him. His delightful letters in the archive provide glimpses of the struggles he faced. When it was suggested that he change the days on which his night classes were held, so that musical events could be staged, he wrote 'from what I hear from my pupils it is quite impossible to give up for us the Tuesdays and Thursdays, as some of them being bank clerks cannot come on the Monday night'.[25] The smell from the drains was so strong at night that he suggested teaching at his home instead: 'The pupils refuse to come any longer in the present room, and I have the greatest difficulty to keep them from leaving altogether.'[26] He wanted to establish a life class 'for the most advanced students' and other classes in perspective, anatomy and history, which 'could be easily arranged if some of the literate gentlemen in Sydney did deliver lectures about'.[27]

However, it seems that some artists resented 'the Italians' taking all the jobs in Sydney. S Pearce Fuller wrote from Melbourne that he was thinking of moving north. He had trained under John Ruskin and Ford Madox Brown. 'I am doing fairly well here,' he wrote, 'but there are altogether too

many artists here to get anything like a good living.'[28]
Du Faur wrote back:

> Sydney can scarcely be said to have any real
> qualified Masters for painting at all. Sr Anivitti at
> the Academy is very good for teaching from the
> round but is not a colourist. JC Hoyte has recently
> taken up his abode with us and one of his pupils
> to whom I have spoken testifies highly in his
> favour, but he has as yet little success in obtaining
> pupils and less in sale of pictures. Louis Frank is
> also amongst us and tells me he finds it difficult
> to dispose of works here, which sell readily in
> Melbourne. I should certainly not advise any
> artist, doing moderately well elsewhere, to come to
> Sydney in hopes of bettering himself.[29]

Pearce Fuller abandoned his plans, as 'nothing less than offers of about £200 to commence with would suit my ideas. My average here is never less than £350 a year.'[30]

Anivitti might not have been a colourist, but he was held in high regard by his students, as Frank Mahony's tender portrait of him suggests. Mahony was the student who had most success as a professional artist later in life. Student Amandus Julius Fischer became a future Archibald entrant.[31] Very little of Anivitti's own work survives. His contributions to the 1876 annual exhibition of the Academy were lampooned by *Sydney Punch* as ineptly painted. The article also took aim at Chester Earles, the president of the Victorian Academy of Art, and Montefiore, who had included three works in the amateur section.

The lease on Clark's New Assembly Hall expired on 30 April 1878. The Academy wanted to purchase the property for £3250 and asked the government for permission to use £1000 from the parliamentary vote towards the purchase, with the remaining funds borrowed on mortgage. They were certain that this could be repaid from leasing to the Royal Society and through commercial revenue raised by musical concerts.[32] The government refused. The Academy, now with a growing collection to accommodate, was in the same uncertain place it had been three years earlier. In the midst of this uncertainty the government suddenly announced that if 'the Trustees cannot secure a renewal of the lease on favourable terms, or fail to obtain another suitable building, there would appear to be no other alternative than to remove the pictures to the Museum.[33]

Epigraph

'Social', *Sydney Morning Herald*,
7 May 1875, p 6.

Notes

1 The museums include the South
 African National Gallery (1871),
 Stedelijk Museum Amsterdam
 (1874), Philadelphia Museum of Art
 (1876), Museum of Fine Arts Boston
 (1876), Art Institute of Chicago (1879)
 and Musée Guimet, Paris (1879).

2 Mary Salmon, 'Lawyers' row: old
 Elizabeth Street, Sydney', *Evening
 News*, 20 Nov 1912, p 4.

3 Joseph Fowles, *Sydney in 1848: a
 facsimile of the original text and
 copper-plate engravings of its
 principal streets, public buildings,
 churches, chapels, etc., from
 drawings by Joseph Fowles*, Ure
 Smith, Sydney, 1966.

4 Other exhibitions had been held
 before this 'inaugural' one, including
 a *Loan Exhibition of Watercolour
 Paintings by English Artists*
 (6–15 Aug 1875*), Sketches and
 Photographs from the Two Artists'
 Camps of Govetts Leap and the
 Valley of the Grose* (10–16 Nov 1875)
 and the *5th Annual Exhibition of the
 New South Wales Academy of Art*
 (11 Apr – 24 May 1876).

5 Later this was changed to
 Wednesdays and Saturdays from
 noon to dusk.

6 'Miss Ironside's pictures', *Sydney
 Morning Herald*, 17 Aug 1877, p 4.

7 See Kiera Lindsey, 'Grave-paved
 stars: comparing the death of two
 artists in nineteenth-century Rome',
 European Journal of Life Writing,
 Jul 2020.

8 'The fairest daughter of Sydney:
 Adelaide Ironside', *Catholic Press*,
 3 Feb 1900, p 4.

9 Quoted in Kiera Lindsay, 'Deliberate
 freedom: using speculation and
 imagination in historical biography',
 Text, special issue 50, Oct 2018, p 7.

10 Between 1874 and 1876 there was
 a lot of confusion about how much
 money had been voted to the
 Gallery, what it was to be used for
 and who had the authority to spend
 it. There was also confusion about
 the powers of the Council of the
 Academy and the trustees appointed
 to spend government grants. The
 paperwork became so extensive
 that Du Faur threatened to resign
 as honorary secretary. The annual
 report for 1876 shows the confusion:
 'the Government, recently voted a
 sum of £500 for art purposes; the
 specific application of this vote has
 not yet been determined, whether
 applied towards the erection of an

art gallery, towards the purchase
of works of art, or towards art
instruction.'

11 In 1874 Du Faur, Montefiore,
 Stephen, Combes and James Fairfax
 had been appointed trustees. In
 1876 it was the same group, with
 JH Thomas replacing Combes who
 was in England.

12 EL Montefiore, 'Academy of Art:
 to the editor of the Herald', *Sydney
 Morning Herald*, 18 Nov 1874, p 6.

13 JH Thomas, 'National Gallery of
 Art: to the editor of the Herald',
 Sydney Morning Herald, 21 Nov
 1874. A notice that the Sydney
 Gallery intended to purchase copies
 of Old Masters was reported in
 the international *Art Journal* and
 subsequently artists wrote offering
 their services, including Henry Duke,
 who had recently copied Vincenzo
 Foppa's *Adoration of the Magi* for
 St George's Anglican cathedral in
 Cape Town, South Africa.

14 EL Montefiore, 'Mr JH Thomas
 and copies: to the editor', *Sydney
 Morning Herald*, 23 Nov 1874, p 5.

15 The trustees did not like where
 the painting was first hung. After
 negotiations, Charles Robinson,
 secretary at the Museum, agreed
 to their proposal to hang the work
 'in the upper room of the new
 wing, instead of in the space on the
 ground floor as previously arranged.'
 Letter from Charles Robinson to
 Frederick Eccleston Du Faur, 3 Mar
 1878, CF4/1878.

16 John Russell, 'Our Art Gallery: to
 the editor', *Sydney Morning Herald*,
 12 Aug 1882, p 9. The two works that
 were eventually purchased from
 the bequest were James Seymour
 Lucas, *The Armada in sight* 1880 for
 525 guineas and James Sant, *Lesbia*
 c1884 for 100 guineas. The Lucas
 was deaccessioned and sold at
 auction in August 1996.

17 It was actually presented to the
 NSW Academy of Art. Until 1880,
 when all the possessions of the
 Academy were formally donated to
 the 'Art Gallery', art was confusingly
 purchased from public funds for the
 'Art Gallery' and sometimes donated
 by members of the Academy to the
 Academy.

18 This work was deaccessioned and
 sold in 1946.

19 'Art exhibition: Academy of Art
 Sydney', *Sydney Mail*, 14 Apr 1877,
 p 455.

20 Unusually, the first Australian
 purchase by the Queensland Art
 Gallery was not a landscape but the
 figure study *Care* c1893 by Josephine
 Müntz-Adams, purchased in 1898.

21 In 1876, 430 autotypes were
 purchased in London by Mr Cave
 Thomas for teaching purposes.
 Cave Thomas was the brother of
 Sydney-based JH Thomas, who
 believed money should be spent on
 copies of European masterworks
 so that Australian taste could be
 informed and elevated. The trustees
 were furious with this 'injudicious'
 purchase, about which they had not
 been sufficiently consulted. They
 believed that the price paid was too
 high, some works were too large
 for study purposes and all would be
 expensive to frame. They proposed
 keeping only twenty and disposing
 of the rest. Also, art instructor Guilio
 Anivitti had already purchased
 similar autotypes in Sydney.

22 'Art: difficulties in new countries',
 Sydney Morning Herald, 24 Jan
 1888, p 7.

23 'Academy of Art', *Sydney Mail*,
 8 May 1875, p 593.

24 Anivitti had been giving lessons at
 his studio since arriving in Sydney
 in May 1874. He was involved in
 a movement to establish an art
 teaching academy which was active
 in the winter of 1874. The presence
 of NSW academicians at these
 meetings suggest that he could have
 been, or at least seen himself as, a
 de facto Academy instructor before
 the school officially started.

25 Letter from Guilio Anivitti to
 Frederick Eccleston Du Faur, 26 Nov
 1878, CF33/1878. Night classes were
 held from seven to nine o'clock, but
 Anivitti had them extended to nine-
 thirty to cover time lost in setting
 and packing up.

26 Letter from Guilio Anivitti to
 Frederick Eccleston Du Faur, 20 Mar
 1878, CF6/1878.

27 Letter from Guilio Anivitti to
 Frederick Eccleston Du Faur, 5 Sep
 1878, CF19/1879.

28 Letter from S Pearce Fuller to
 Frederick Eccleston Du Faur, 1 Nov
 1879, CF21/1879.

29 Letter from Frederick Eccleston
 Du Faur to S Pearce Fuller, 25 Nov
 1879, p 135a of the Gallery's first
 letter book.

30 Letter from S Pearce Fuller to
 Frederick Eccleston Du Faur, 2 Dec
 1879, CF28/1879.

31 The grandson of Amandus Julius
 Fischer was the earthworks artist
 John A Fischer, who exhibited at
 Sculpturscape '73. Edward Bartley,
 Auckland-based contributor to
 Academy exhibitions, was a great-
 grandfather of *Field* artists John
 White and Tony McGillick.

32 The Royal Society wrote that if the

Academy bought the property, it
would undertake to purchase it
immediately from them and allow
them to remain as tenants.

33 Letter from William Plunkett to
 Sir Alfred Stephen, 2 Apr 1878,
 CF7a/1878.

4 The Annexe

A temporary gallery in the Botanic Garden, 1879–82

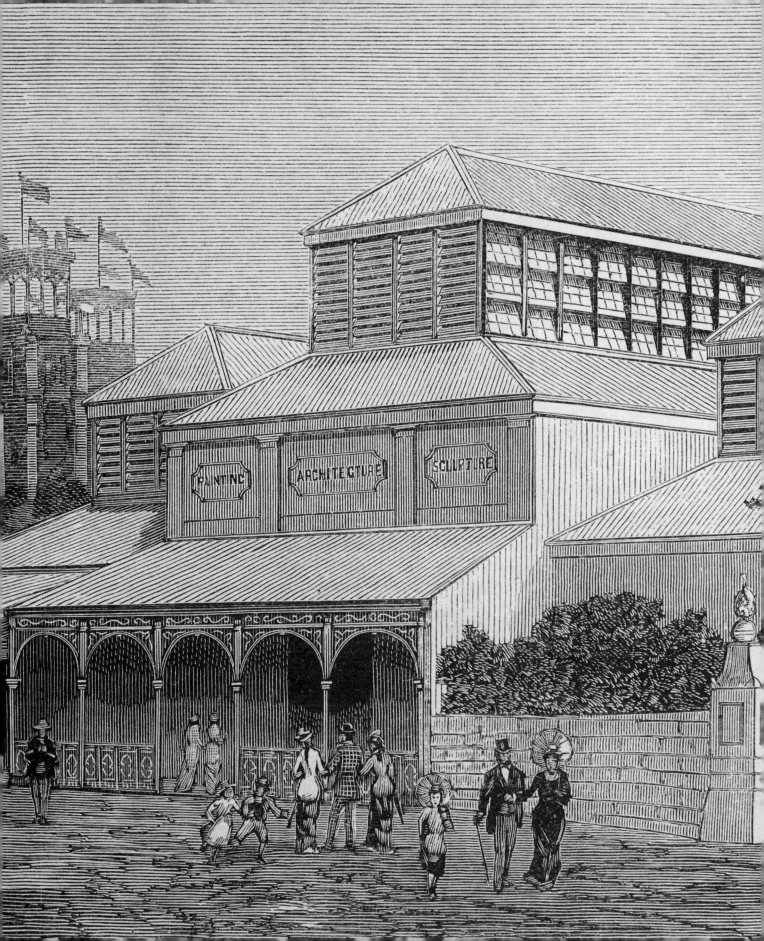

Unquestionably one of the most attractive features of the International Exhibition is the Art Gallery. Everybody goes there, and everybody enjoys the visit. In the first place it is a novelty; in the next, it is good.

Editor, *Sydney Morning Herald*, 1879

The threat of taking the Academy's collection and entrusting it to the Australian Museum was a hollow one. Relations between the two institutions were good. *Chaucer at the court of Edward III* 1847–51 by Ford Madox Brown was already on display at the Museum and for some time there had been plans to build a combined Museum, Gallery and Library on its College Street site. In 1873 the Council of the Academy approved a proposal by Colonial Architect James Barnet for a combined complex similar to the one in Melbourne. The 1877–78 annual report of the Academy noted with 'greatest satisfaction' that there was 'every probability of the early commencement of the proposed Picture Gallery as an annexe to the Museum'.[1] However, the Library objected to a shared building and this idea was subsequently abandoned. The Academy then looked to Sydney's imminent International Exhibition for an alternative solution to their accommodation needs.[2] In the meantime, the Royal Society of New South Wales purchased Clark's New Assembly Hall and renewed the Academy's tenancy, even reducing the rent.[3]

Previous page: Artist's impression of the exterior of the art gallery built for the 1879 Sydney International Exhibition, showing the towers of the Garden Palace in the background. This wood engraving was reproduced in the *Official record of the Sydney International Exhibition*, published in 1881. **Below:** Colonial Architect James Barnet's proposed design for a combined Library, Museum and Art Gallery, from the *Sydney Mail*, 14 June 1879 **Right:** JT Richardson *Garden Palace, Sydney* 1879–82. The Fine Arts Annexe is situated almost in the middle of this watercolour, facing on to the tree-lined avenue.

The Exhibitionists

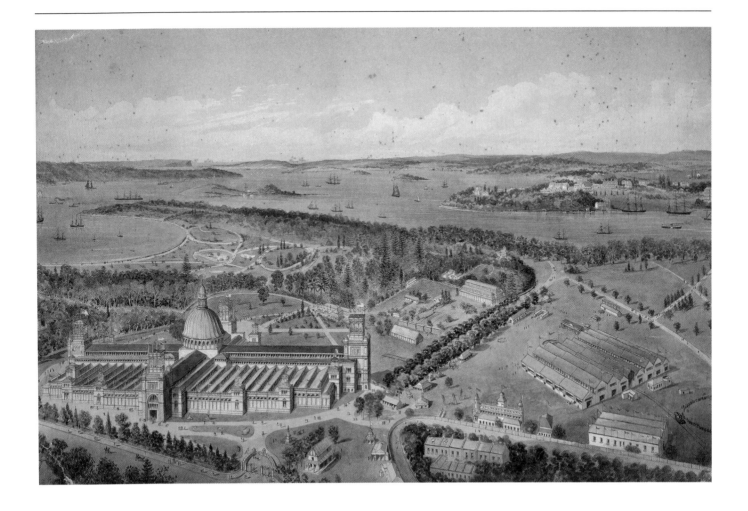

At first it was planned to include Fine Arts within the enormous Garden Palace designed by Barnet for the International Exhibition. However, on 12 August 1879, just a month before the exhibition's opening, Montefiore wrote to executive commissioner Sir Patrick Jennings detailing why the Garden Palace was an unsuitable venue for art. Its defects included poor natural light and a colour scheme that 'however tasteful in itself' would jar with the 'delicate tones of oil and water color paintings'. Limited space would require 'the hanging of many exhibits on the upper part of the walls', and works were at risk from 'the transit of large numbers of visitors'. Montefiore urged 'the erection of a building, however simple in itself, which may be free from the objections which we have pointed out'. He did not see a problem if this building opened later than the Garden Palace and was sure that its cost could be offset by charging an entrance fee.[4]

Behind this seemingly polite letter lay weeks of extraordinary political manoeuvring on the part of Montefiore and Du Faur. They had previously detailed these defects to Barnet, but this only led, in Du Faur's words, to 'acrimonious correspondence' with 'no definite results'.[5] When the French exhibits came into the harbour aboard *Le Rhin* on 4 August, Montefiore and Du Faur boarded the ship and told Captain Mathieu, the French commissioner, of their frustrations. When they showed him the allocated area for Fine Arts within the Garden Palace, he informed the Sydney commissioners that as 'they had not provided the space and special lighting for which his Government had stipulated', he would 'decline to open his hatches, until such stipulated accommodation was provided'.[6] They also secured similar support from the German commissioner Franz Reuleaux, a mechanical engineer with considerable international exhibition experience.[7] Reuleaux even drew up a preliminary design for a dedicated arts pavilion that could be erected, suitably lit, for less than £5000.

On 28 August Jennings gave permission for this building to go ahead on 'the forcing-grounds that lay between the Inner Domain and the Botanical Gardens'.[8] This position was nestled near the entrance to the Botanic Garden, with the facade opening on to Fig Tree Avenue leading up to the

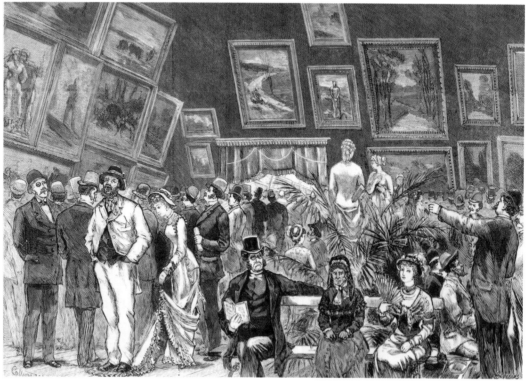

The Exhibitionists

Garden Palace and the bulk of the building extending back into the Garden. The greenhouses and other structures for growing seedlings were located here, as was the old kitchen garden for Government House, hence the reference to 'forcing-grounds'. On the same day that permission for construction was given, the ground was marked out by William Wardell as the selected architect, and a contract signed by John Young as builder, effectively bypassing the colonial architect and the General Committee with a separate Fine Arts Annexe as a fait accompli.

Although Wardell was the architect of the building, he does not seem to have counted it among his significant projects.

The structure of the building, with a central nave and two side aisles, had an ecclesiastical flavour to it, like the churches that were Wardell's specialty. It was part of a suite of ancillary buildings, including refreshment rooms, that John Young completed in record time using new arc lighting and a roster of three eight-hour shifts a day. But bad weather and last-minute modifications to the structure to make it of more substantial character caused delays. When the main exhibition officially opened on the 17 September, the Fine Arts Annexe was incomplete.[9]

Its official opening on 10 November was programmed as a major exhibition festivity, with the Governor Lord Loftus in attendance. Montefiore, Du Faur, Combes and a few hired labourers worked nonstop to hang and catalogue more than seven hundred works in the two days before the opening. This coincided with a procession through the city of 'friendly societies' to celebrate the Prince of Wales' birthday.[10] More than twenty thousand people participated. Loftus drove down to the Fine Arts Annexe to inspect the building and

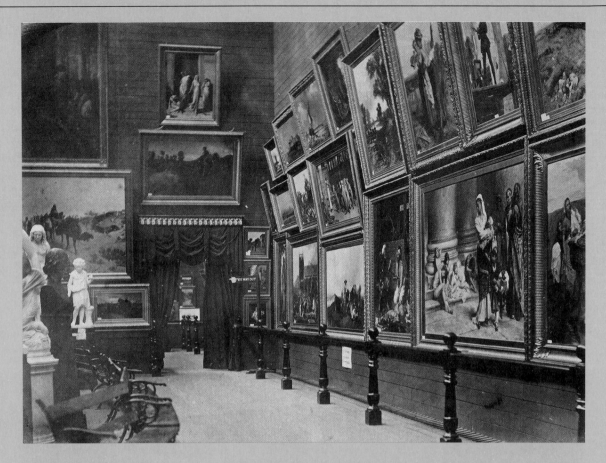

The Exhibitionists

collections. He then was taken to the main Garden Palace where 'he proceeded to view the ethnological court in the north-eastern gallery', which had opened to the public on the same day. The court had been arranged 'to show the various characteristics of the implements, weapons and adornments of the various races and tribes, arranged in geographical order'. Adjacent to it were housed photographs, watercolours and other works of art that could not be accommodated in the Annexe.[11] Both the Ethnological Court and the Fine Arts Annexe were then officially declared opened by Jennings.[12]

The Fine Arts Annexe quickly became popular. A 'lion' of the International Exhibition was how the *Daily Telegraph* described it, noting that it could be 'uncomfortably crowded'.[13] It was located near one of the three entrances to the main exhibition, with a range of cafes and restaurants nearby.[14] A novelty was the requirement to leave objects that could damage the works of art at the door, where the visitor would

Left, above: Richards & Co *British court in the art section, in the Sydney International Exhibition* c1880, from the album *The International Exhibition 1879–1880 illustrated by original photographs*. This photograph shows the oil painting *Non angli, sed angeli* 1877 by Keeley Halswelle reproduced at left, a work purchased by the Gallery from the exhibition. **Above:** Eugene von Guérard *Milford Sound, New Zealand* 1877–79. This painting was exhibited in the Austrian Court of the 1879 Sydney International Exhibition.

be given a 'medal bearing a number which corresponds with the number placed on the umbrella or stick'.[15] Montefiore's advice to charge an entry fee was not followed and the Annexe was free with general admission.

The building itself was about half an acre in size and divided into nine galleries. The exhibits from Great Britain were shown in three central galleries; on the left were two galleries for France and one for Belgium, and on the right were galleries for Austria, Germany and New South Wales. Montefiore's strong connections to Belgium accounted for this small country having its own gallery. France was given place of honour after Britain, and the official French consular dinner was hosted by the New South Wales Academy of Arts in Clark's Assembly Hall. The New South Wales court included just over one hundred works by professional artists and amateurs, more than half of which were works on paper.[16] All the art shown was for sale, apart from a small group of works on loan from Queen Victoria in the British courts and some private loans in the New South Wales court.[17]

The Gallery, which had earlier had its purchasing budget raised to £5000 by parliament, bought 12 oils and 12 watercolours from the British court, six oils from the German court, five from the French, and three each from the Austrian

Left: This ceramic plate, c1870, with an illustration based on *Nymphen schmücken Pan* (Nymphs adorning the statue of Pan) by Angelica Kauffman, was presented to the Gallery by the German government after the 1879 Sydney International Exhibition.
Below: Photograph of the far end of the central hall of the Gallery, formerly the Fine Arts Annexe, c1880. Among the many works visible are the bronze incense burners by Hashimoto Eijirō donated by the Japanese government (centre of left wall). Opposite them are two Sèvres vases with painted designs by Antonio Baldisseroni on a base of ground lapis lazuli mounted on oxidised brass frames, donated by the French government.

The Exhibitionists

Right: Alfred Tischbauer *Interior of the Art Gallery of New South Wales* c1882, showing one of the side galleries flanking the central hall of the Gallery (the renamed Fine Arts Annexe). Tischbauer offered '4 paintings of Art Gallery interior' for sale to the trustees in 1915. All were rejected. Two were exhibited at the *7th Annual Exhibition of the Art Society of New South Wales* in 1886.

Right, below: Photograph of the watercolour room of the newly renamed Gallery, showing entrances to the casts room and the central hall c1880. On 2 October 1880, the *Sydney Mail* reported 'the walls are completely draped, and the arrangement of the thirty-three watercolour drawings owned by the trustees ... is seen at once to be remarkably good ... In the centre of the room stands Bruce Joy's statue *First Flight*.'

and Belgian, along with six pieces of statuary. Another dozen British drawings were acquired from the 'Graphic Court' in the main Garden Palace. The most expensive purchase was *Non angli, sed angeli* 1877 by the Scottish artist Keeley Halswelle.[18] Other purchases considered major at the time were *Ismenie, nymph of Diana* 1878 by Charles Landelle, *Flowers and fruit* 1877 by Jean-Baptiste Robie and *The juggler* 1873 by Fritz Beinke. An interesting group of Orientalist oils and watercolours were purchased by Landelle, Jean-François Portaels and Edward Goodall, but these were all subsequently deaccessioned under director Hal Missingham. The Beinke was the only German work to survive his purge of the collections and virtually none of the sculptures purchased at this time were kept.

A few works shown at the exhibition entered the Gallery's collection at later dates. The most important of these was Eugene von Guérard's *Milford Sound, New Zealand* 1877–79, originally exhibited in the Austrian court with two other oils by the artist.[19] It had also been shown at the Paris Exposition Universelle in 1878. It was purchased for the Art Gallery of New South Wales nearly one hundred years later in 1970. *Govett's Gorge* 1879 by Charles Hern was acquired shortly after the exhibition closed on 20 April 1880.

Works were also donated to the New South Wales government. The French and German commissioners presented various pieces of porcelain. One of these was a plate, decorated in the middle with an image of nymphs adorning a statue of Pan. This was one the first works by a female artist to enter the Gallery's collection, although its design was only based on a painting by Angelica Kauffman. The first fully authored work was by Julie Lorain Sondon. Her painting of a 'Spanish gypsy' was presented to the Gallery in 1876 by George Montefiore, brother of Eliezer Montefiore. It had been exhibited in the annual exhibition of the Academy three years earlier. George Montefiore knew Sondon personally, as they were both based in Belgium. A student of the Belgian Orientalist Jean-François Portaels, Sondon specialised in portraits of 'exotic' subjects, including of the Moroccan Jewish community. Sadly, her painting was later deaccessioned from the Gallery's collection.[20]

The Japanese government presented items 'of almost every conceivable and inconceivable form. Some were of a description which has been made rather familiar to Europeans of late, but others – many others – were new, grotesque, and *outré*.'[21] A large group of Meiji bronzes, ceramics, lacquerware and cloisonné metalwork was eventually divided and donated to the Museum of Applied Arts and Sciences and to the Art Gallery, where the selection became the foundation of its Asian collections.[22] Some pieces were earmarked for the Gallery even before the exhibition closed. Academy member Henry Dangar believed them to be

purchases and wrote to Du Faur that 'making one of my flying visits to the Japanese Court I saw some things which had been bought for the Gallery – most of which I think have been well selected, but amongst them is a large bronze of very inferior quality'.[23]

When the International Exhibition closed, Barnet was keen to see the Fine Arts Annexe demolished, as its erection in the first place, without his consent, was a sensitive issue. He informed the Academy that ample space would now be allocated in the Garden Palace for its collection.[24] Once again, the trustees circumvented his authority and persuaded the government to allow them to keep the Annexe, which they took possession of on 2 July 1880. It was closed for a few months to allow the removal of a partition wall to create one large gallery for oil paintings. The walls were then painted in raw umber up to the cornice, with panelling above in shades of brown. The ceilings were done in blue–grey, with crossbars of deep blue. Ford Madox Brown's *Chaucer at the court of Edward III* 1847–51 was brought from the Australian Museum and given pride of place at the end of the new gallery for oil paintings. This was entered through a watercolour room, with walls completely draped. Off to the sides were galleries devoted to plaster casts, works on paper, a joint boardroom and library, and accommodation for a caretaker. The refurbishment and rehanging impressed all when Lord Loftus officially dedicated the building as the 'Art Gallery of New South Wales' on 22 September 1880.

On 7 October, Du Faur tended his resignation as honorary secretary of the Academy, writing 'my own opinion ... is that the Academy has now fulfilled its objects and that there is no longer any reason for the continuation of its existence'.[25] Council agreed and at the 9th Annual General Meeting on 11 November it disbanded the Academy, transferring all its assets to the Art Gallery. The only outstanding issue to resolve was that of the Academy art school. The Council was unsure if 'in future such art instruction shall be directly supervised and controlled by the Department of Public Instruction, or whether the Trustees of the Art Gallery shall undertake its management'.[26] Instructor Giulio Anivitti, who was very ill at the time, saw his livelihood disappearing and wrote to Du Faur,

> I shall be a great looser [*sic*] in the end, after so long having struggled to keep up the school.
> In regard to the other position I used to have (nominal one) as curator of the Art Gallery can I hope at less [*sic*] that the Trustees will favourably consider my claim to it ... I am at present with a family to keep and I feel very much worried about this matter.[27]

Teaching continued for a time in the new building, where rooms were set aside for students. The demands of running a public art gallery, however, soon sidelined the art school. The Art Society of New South Wales had been formed in July 1880, with a permanent home in the Garden Palace. The art classes that it offered made the need for art instruction at the Gallery less pressing. Anivitti wrote his last letter to Du Faur just prior to losing most of his students. Clark's New Assembly Hall had been conveniently located at a tram terminus, whereas the new gallery was remote and potentially unsafe in the evenings, particularly for women. Its dedicated classroom was too dark and the cast room, where his students worked making studies from the antique, had become a haunt for

> the lazy lot of people sleeping in the Domain.
> Their appreciation of the statues is very low
> indeed from the vulgar remarks they pass on
> them, that no educated well-bred person could
> coolly sit down to draw and study the great works
> of the antique, without being altogether disgusted
> with the vulgarity of the visitors.[28]

Assembling a collection of art was important, Anivitti noted, but so too was doing everything to sustain those who desired to make 'art their profession ... posterity will one day give us thanks for our interest in them'.[29] When he wrote this letter Anivitti knew that he was dying. On 11 March 1881 he returned to Italy, reluctantly leaving his wife and two daughters in Sydney.[30] He died of tuberculosis in Rome on 2 July 1881.

The Academy's refusal to relocate to the Garden Palace after the Sydney International Exhibition proved fortunate. On the 22 September 1882 a fire completely destroyed the grand exhibition building. Bookshop owner and publisher James Tyrrell was a boy at the time. He remembered the Garden Palace as Sydney's major landmark, 'an elaborate sort of palatial museum, with all the marks and prospects of permanence'. But as he watched with his family from the end of a jetty on Johnstons Bay, 'all of it – turrets and domes and spires and pillared halls and their contents of records and exhibits – went up in that mass of flame and smoke'.[31]

JC Hoyte *The burning of the Garden Palace, seen from the North Shore* 1882

The Exhibitionists

Epigraph
'The Art Gallery', *Sydney Morning Herald*, 15 Nov 1879, p 3.

Notes

1 *7th annual report of the New South Wales Academy of Art*, 1878, p 23.

2 The exhibition park was planned for one of three sites: in Moore Park, in Victoria Park adjoining the University of Sydney or the Inner Domain. As any proposal for a major gallery connected with the Museum or Public Library 'would probably be the work of several years', the trustees asked that 'after the closing of the Garden Palace, the trustees may obtain the temporary possession of the structure now in course of erection near the Botanical Gardens.' *8th annual report of the New South Wales Academy of Art*, Oct 1879.

3 Letter from Dr CA Leibius to Eliezer Montefiore, 23 May 1878, CF12/1878.

4 Letter from Eliezer Montefiore to PA Jennings, 12 Aug 1879, CF17/1879.

5 Frederick Eccleston Du Faur, *Notes respecting the origin and progressive development of the building of the National Art Gallery of New South Wales*, unpublished manuscript, 5 Aug 1909, p 1.

6 Du Faur 1909, p 2.

7 See 'Late items', *Sydney Mail*, 30 Aug 1879, p 347.

8 'Events', *Daily Telegraph*, 23 Aug 1879, p 4.

9 Report of the executive commissioner in *Official record of the Sydney International Exhibition*, Thomas Richards, Government Printer, Sydney, 1881, p lxx.

10 'Friendly Societies demonstration', *Sydney Morning Herald*, 11 Nov 1879, p 5.

11 Report of the executive commissioner in *Official record of the Sydney International Exhibition*, Thomas Richards, Government Printer, Sydney, 1881, p lxxxvii. It seems that the artworks sent in as competition pieces might largely have been confined to this area. A New Zealand artist, William Henry Raworth, complained to Du Faur that he had sent in '*four* for competition with full particulars in accordance with the printed regulations and *only one* appears in the Official Catalogue and *that one* has been removed from the Competition Exhibits in the Garden Palace to the Art Gallery'. Letter from WH Raworth to Frederick Eccleston Du Faur, 15 Mar 1880, CF10/1880.

12 'The Sydney International Exhibition: Opening of the Art Gallery', *South Australian Advertiser*, 19 Nov 1879, p 5.

13 'Events', *Daily Telegraph*, 15 Dec 1879, p 2.

14 The other two entrances were near the Garden Palace on Macquarie Street and at the entrance to the Domain, near the gates to St Mary's Cathedral.

15 'The Sydney International Exhibition: by a visitor', *Maitland Mercury*, 22 Jan 1880, p 6.

16 The works of art sent from Victoria were not shown in the Fine Arts Annexe but in the main Garden Palace. The press reported, 'It was decided by the Victorian Commissioners that the art exhibits sent from Melbourne should not be placed in the art gallery, but that they should be used to beautify the Victorian court'. 'The Sydney International Exhibition', *Age*, 3 Oct 1879, p 7.

17 The British works on loan included *The Queen receiving the sacrament* by Charles Robert Leslie, *Marriage of the Prince of Wales* by William Frith and two works by Nicholas Chevalier, *Opening of the Vienna International Exhibition* and *Royal procession, St Paul's Cathedral*.

18 It was acquired for £630.

19 *Plains in Victoria* and *Hills in Victoria*.

20 Eliezer Montefiore was the son of Isaac Levi, a merchant of Barbados and Brussels, and his wife Hanna, a cousin of the philanthropist Sir Moses Montefiore. He was one of at least four boys.

21 'The Sydney Exhibition', *Illustrated Sydney News*, 17 Apr 1880, p 7.

22 Over twenty works currently in the collection were part of this gift. See Carol Morrow, 'Meiji period ceramics from the Sydney International Exhibition of 1879', MA thesis, University of Sydney, 1998.

23 Letter from HC Dangar to Frederick Eccleston Du Faur, 22 March 1880, CF13/1880. He suggested that Commissioner Harno Sakato be asked to swap the inferior bronze for 'what you have not yet obtained, a good bit of Kioto porcelain', or else 'that hideous black bronze in the enclosed space ... it is a better specimen of bronze work'. He ended the letter with the rhetorical question, 'Neither Fairfax nor I received any notice of meeting about these Jap things. May I ask who were the selection committee?'

24 Du Faur 1909, p 5.

25 Letter from Frederick Eccleston Du Faur to Sir Alfred Stephen, 7 Oct 1880, CF45/1880.

26 *9th annual report of the New South Wales Academy of Art*, 1880, p 2.

27 Letter from Giulio Anivitti to Frederick Eccleston Du Faur, 18 Aug 1880, CF37/1880.

28 Letter from Giulio Anivitti to Frederick Eccleston Du Faur, 27 Aug 1880, CF43/1880.

29 Letter from Giulio Anivitti to Frederick Eccleston Du Faur, 27 Aug 1880, CF43/1880.

30 His estate was left to his wife in 'full confidence on her motherly love that she will educate my two children at the best of her means'. Anthony Bradley, 'Anivitti, Giulio (1850–1881)', *Australian Dictionary of Biography*, vol 6, 1851–1890, A–C, Melbourne University Publishing, Melbourne, 1969, p 39.

31 James R Tyrrell, *Old books, old friends, old Sydney*, Angus and Robertson, Sydney, 1952, p 14.

5 The 'art barn'
Moving to the Domain, 1882–93

We have a fine painting of it in our Art Barn – I beg pardon – Gallery in the Domain.

Sydney Mail, 1884

The destruction of the Garden Palace in 1882 by fire made world news. *Le Temps* estimated the loss of the building and its contents at half a million pounds sterling.[1] The artist Ford Madox Brown read about the fire in the *London Daily News* and thought that his painting *Chaucer at the court of Edward III* had been destroyed. He wrote to the Sydney trustees that the picture had taken up 'five years of my early manhood, from 25 to 30' and that it was the masterpiece of his early career. Nonetheless, he offered to repaint it 'identical in size and composition for 1,200 guineas'.[2] Fortunately for the Gallery, its collection, housed in a separate building at some distance from the Garden Palace, was safe.

The paintings destroyed were works from the *3rd Annual Exhibition of the Art Society of New South Wales*. The Society had been using the Garden Palace as an exhibition venue since its foundation in 1880. Also destroyed were those artefacts that the governor visited on the same day that he officially opened the Fine Arts Annexe, the 'implements, weapons and adornments' from the Ethnological Court, many of them lent by the Australian Museum. In 2016 artist Jonathan Jones based his Kaldor Public Art Project *barrangal dyara (skin and bones)* on the history of the Garden Palace from an Indigenous perspective. A large part of his cultural heritage as a Wiradjuri/Kamilaroi artist perished in that fire. For his installation, fifteen thousand ashen shields of various shapes common in south-east Australia traced the floor plan of the Garden Palace and recalled the rubble that was strewn across the site in the aftermath of the fire. At the heart of the floor plan, in the area originally under the great dome, Jones planted a meadow of native grasses in which voices speaking various Indigenous languages could be heard naming the items destroyed. This remarkable work was not only an elegy to loss, but also a celebration of the power, complexity and resilience of Indigenous cultures.[3]

Only a few days after the fire, Colonial Architect Barnet wrote of his concern for the adjacent gallery: 'I would point out that this is a very temporary construction, being supported on uprights of wood ... the inside walls and partitions are of Oregon, and mostly covered with canvas, rendering the timber more inflammable.' He advised that a fireman be put on duty day and night and that a direct telephone connection be made with the fire department, with these as temporary expedients until a more permanent brick structure could be built.[4] Artist Nicholas Chevalier read about the fire in the British press. He hoped that the government would 'now be alive to the wisdom of providing you with a

Previous page: Aerial photograph of part of Jonathan Jones's installation *barrangal dyara (skin and bones)* 2016 in the Botanic Garden as Kaldor Public Art Project 32. The thousands of shields made for the project traced the original ground plan of the Garden Palace. **Right:** An illustration from the *Illustrated Australian News*, 6 April 1889, showing the large Sunday attendances

The Exhibitionists

building of a character less liable to destruction by fire'.[5] One person, writing to the press as 'Delays Are Dangerous', was more worried about the termites who had 'taken possession of the building' and were doing their job so well that the floors bounced on the weekends when large crowds put pressure on the failing support posts.[6]

The government was, in fact, amenable to providing a more suitable building, but before anything could be done the Gallery became embroiled in a wide-ranging debate concerning the role of religion in public life and the accessibility of the state's cultural institutions. Since its opening in 1880, the Gallery had become incredibly popular, with nearly 160,000 people visiting in 1881. Sydney's population at the time was less than 300,000. Despite these attendances, parliamentarian Henry Copeland believed that the Gallery's opening hours – Monday, Wednesday and Saturday from ten to six o'clock and Tuesday, Thursday and Friday from noon to dusk – were not accommodating to the working classes. He proposed opening on Sunday afternoons.

Copeland was known as an advocate of workers' rights. He campaigned for the eight-hour day and was opposed to the closure of pubs on Sundays.[7] The churches mustered all their forces to oppose Copeland's 'desecration of the Sabbath'. They found an unusual ally in Premier Sir Henry Parkes. Whether this was out of conviction or out of his well-known antipathy towards Copeland is uncertain. When Parkes argued that only a few people were supportive of a Sunday opening of the Gallery and that 10,000 people had petitioned against it, Copeland collected 24,000 signatures in favour. This was despite the director of the Botanic Garden refusing to allow the collection of supporting signatures within the Garden, where the Gallery was located.[8]

The speech Parkes made in parliament against Sunday opening was mocked as 'a piece of maudlin sentimentality ... the honourable gentleman never so far forgot himself before'.[9] The arguments put forward by the churches were also dismissed as specious by the press, which pointed out that the Museum and Public Library had been open on Sundays for the previous four years without morality and religious observance suffering. Sunday opening was not intended to keep anyone from church, as it would only occur between two and five o'clock in the afternoon. Most importantly, it was argued, this change would benefit the working classes 'who cannot see the pictures on any day but Sunday. The pictures are as much theirs ... and no man or set of men can find justification in depriving them of what is their privilege and unalienable right'.[10]

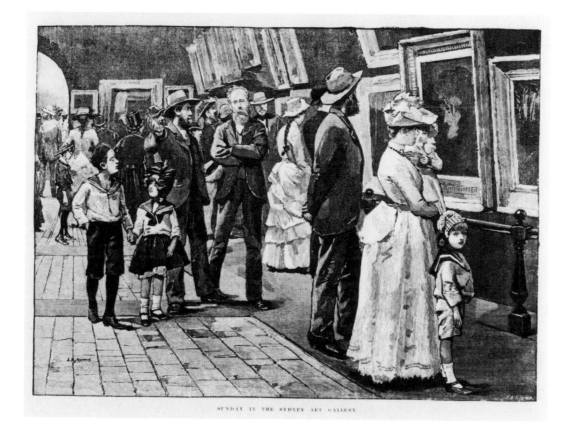

SUNDAY IN THE SYDNEY ART GALLERY.

The 'art barn'

When parliamentarians eventually voted, forty-one were in favour and twenty-four against.[11] The first Sunday opening on 15 October 1882 attracted nearly four thousand people. Copeland's prediction that this small change would consolidate the Gallery's reputation as an institution serving all citizens proved correct. In the following year attendances doubled: 157,409 came on weekdays and 105,452 on Sundays. Sydney was said to be leading the way in promoting culture in an egalitarian way through its 'People's Gallery'.[12] This contrasted sharply with the Metropolitan Museum of Art in New York. There, founding director Luigi Palma di Cesnola opposed all calls to open the museum based on 'the people's right' of access to collections. Although the city had provided the building and a portion of the running expenses, the private financing of the collection meant that it 'belonged to the trustees' and Cesnola argued that they had the right to do with it what they liked. It was only after a hundred thousand labourers petitioned the Museum, the government threatened to withhold building funds and cartoonists satirised the entitled trustees that the 'doors swung open

in June 1891 ... six full years after this was first sought', and nine years after they had opened in Sydney.[13] Closer to home, Sydney's innovation put pressure on other cities to follow suit. The Melbourne *Argus* suggested that its gallery remained closed on Sundays because of 'class prejudices and antediluvian ideas'.[14]

In March of 1883 Montefiore, Du Faur and Alfred Stephen visited George Reid, the Minister for Public Instruction, to discuss plans for the new Gallery. Their preference was for a 'distinct building', rather than one shared with another institution like the Library, located in a place that would accommodate expansion as the institution grew. Reid said that the government was already making plans but had not yet decided on the fundamental questions of 'whether it should be a separate and distinct building, the site and the plans and construction of the building' – meaning, in fact, that the government had decided nothing.[15]

The destruction of the Garden Palace had deprived Sydney of a major landmark. 'From the sea,' Parkes told parliament, 'it was a great adornment to the city.'[16] Parkes's preference was

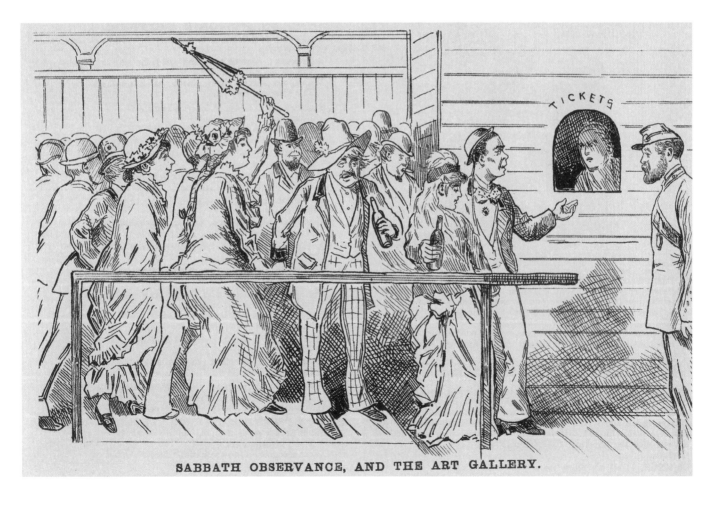

SABBATH OBSERVANCE, AND THE ART GALLERY.

for a combined Gallery, Library and Technological Museum on the site of the destroyed Garden Palace, with an 'elevation 296 feet by dome or tower, which shall form a conspicuous object of attraction in the approaches to the city from the sea on the one side and by land on the other'.[17] As soon as he signalled his intention to call for competitive designs, he was challenged in the press about the Gallery's location, its ornamental significance over its utility, and whether it should be joined with other institutions. The letters to various dailies demonstrated how well travelled many Australians were and how familiar with art galleries around the world. The Glyptothek and Pinakothek in Munich were suggested as models, as was the new art gallery in Turin and the Städel Museum in Frankfurt.

Throughout 1883 and 1884 the building and its site 'excited considerable discussion in and out of parliament'.[18] Harold

Stephen, a parliamentarian and nephew of Sir Alfred Stephen, wrote in August 1883 that it had been resolved to build the Gallery on the site 'now occupied by the District Court ... under the same roof will be located the Public Library, a School of Design and the Technological Museum'.[19] But nothing concrete had in fact been decided. One proposal, against which the trustees were unanimously opposed, was to upgrade the existing building by rebuilding its exterior walls in brick.[20] A map drawn by architect John Horbury Hunt in mid 1884 and marked 'Delineation of Various Sites for Art Gallery' revealed that by this time the Gallery was being planned as a 'distinct building', as the trustees had originally wanted, on one of four sites: opposite the Australian Museum on College Street, on the site of Hyde Park Barracks ('the Queen of sites' according to Parkes) and two other possible locations in the Outer Domain.[21]

Du Faur was resolute that a spacious site in the Domain, marked as preference '3' on the Hunt map and described as 'adjoining the steps leading to the Woolloomooloo wharf', was the only sensible one.[22] Copeland, who had engineered Sunday openings and was alert to all issues of accessibility, countered that this was the worst possible site after 'Fort Macquarie

Left: *Sydney Punch*, 16 September 1882, satirises the view that opening the Gallery on Sunday afternoons would lead to a decline in morals and religious observance, which the churches and others argued at the time. **Above:** John Lane Mullins *In the Domain looking towards St Mary's and the Museum* c1881, from a photographic album of *Views of Sydney and its streets* 1868–81

Left: John Horbury Hunt
Delineations of various sites for Art Gallery 1884, showing the four proposed sites for the Gallery outside the Botanic Garden, with the current site marked as preferred option '3'
Left, below: John Horbury Hunt
Present building and proposed completed Gallery 1885. Hunt's original building on the site was intended to become the basement of a completed Gallery, as the shaded area shows.

The Exhibitionists

or Shark Island'.[23] Others too believed that a gallery 'shoved away in the Domain' would be a gallery 'out of sight and out of mind'.[24] Trustee Henry Dangar thought the Domain site 'not sufficiently central' and that it would 'infringe upon the purpose for which the Gardens are intended'.[25]

While these debates were occurring, the trustees controversially engaged John Horbury Hunt as their architect rather than Colonial Architect James Barnet. Their relationship with Barnet had been strained over the construction of the Fine Arts Annexe. Their opposition to the sculptures by Tomaso Sani filling the spandrels of the Pitt Street colonnade of the General Post Office, a building designed by Barnet, was well known. They did not accept Barnet's view that these sculptures, personifying Telegraphy, Banking, Agriculture and the like, sat within a European tradition of realism and represented a turning point for Australian sculpture. They believed that Sani, who the *Bulletin* dubbed Signor Insani, should have designed panels with nobler subject matter, in low or half relief, following the contours of the architectural arches. They called for his 'Punch and Judy' sculptures to be chiselled off. Prominent critic James Green agreed, lamenting 'these dire perpetrations ... the one error of artistic judgement in Mr Barnet's long and honourable career'.[26]

The debate about the sculptures was reported in the British press, with the Art Gallery trustees said to be leading the campaign against Barnet. Frederic Leighton read about it and immediately wrote to Montefiore: 'Let me take this opportunity of expressing the satisfaction, I should rather say the relief, with which I hear that your efforts to save a great public building in your fine city from what I can only describe as a shameful disfigurement are likely to be crowned with success.'[27] Leighton's congratulations, however, were premature and the sculptures remain to this day. The trustees publicly said that they did not approach Barnet for designs because they knew how busy he was and that 'it would be a long time before they could get any plans from him'.[28] Parkes believed that Barnet should be used, but the new Colonial Secretary and Premier, Alexander Stuart, thought the trustees had the right to choose their own architect.

In mid September 1884 parliament confirmed '25 to 15 that the site for the new Art Gallery should be on the south-east corner of the Domain'.[29] A sum not exceeding £10,000 was set aside for a simple 'chamber, or gallery ... plain in its character and suitable for present requirements. It should also be so designed as to be capable of being added to hereafter'.[30] A floor plan was drawn up by Du Faur. This was then used by Hunt as the basis for his designs. These designs were approved on 14 November 1884 and construction began shortly after.[31] The Minister was keen to impress upon the trustees that although Hunt had been employed for this first stage of construction, he should 'not in any way be looked

Northern elevation of Hunt's 'art barn', 1968. Hunt's 1885 building remained in use until 1968, when it was demolished to make way for the 1972 extensions by architect Andrew Andersons. Photograph: Kerry Dundas

upon as the architect who is to be retained for this, or the future Art Gallery'.[32]

The art collections were moved from the Fine Arts Annexe in the Botanic Garden, a building that had served as the Art Gallery of New South Wales for five years, towards the end of 1885 and the Gallery was opened just two days before Christmas, honouring a commitment to be up and running by the year's end. The building consisted of a central hall 30 by 15 metres, flanked by six other galleries, two measuring 30 by 12 metres and four 30 by 10 metres. The roof had fourteen lateral sawtooth trusses on steel girders and was covered with corrugated iron. In the centre of the main gallery there were three sunken exits to be used in the event of crushes.

Once again, the fact that Sydney had its own dedicated building for art, albeit 'a nucleus round which the art gallery proper would be erected', was praised as a considerable achievement for the colony.[33] An opinion piece comparing

Sydney, Melbourne and Adelaide in the international journal *The Magazine of Art* remarked upon this. Although Melbourne's collection was housed 'in one of the stateliest buildings in the city', that building contained 'also the National Museum and Free Public Library' and art was displayed in only one gallery and along dreary corridors. 'Considering how much one hears of the great wealth of Melbourne,' it continued, 'the artistic visitor is apt to lament that more of the wealth does not flow in the direction of art'. Adelaide's collection had been well selected and was well displayed but merely occupied 'a large room in the Museum'.[34]

Below left: The cover of the *Illustrated Sydney News* on 16 January 1886 records the official opening by Governor Lord Carrington on 23 December 1885 of the first Gallery building on the current site. **Below right:** The cover of the *Illustrated Supplement to the Sydney Mail* on 21 January 1893 shows visitors to the Gallery listening to a lecture on Edward Poynter's *The visit of the Queen of Sheba to King Solomon*.

The Exhibitionists

The controversial sculptures by Tomaso Sani filling the spandrels of the Pitt Street colonnade of the General Post Office, a building designed by Colonial Architect James Barnet

The first public comments about the new gallery were not about its crude look, as the trustees had anticipated, but about toilets, beginning the noble tradition of lavatory lamentation that continues to this day. In February 1886 Hunt was asked to cost 'an additional water closet, three more urinals and a lavatory for women'. These were functional by December. By that time, negative comments about the building's exterior were circulating. With its massive, unadorned walls and sawtooth roof, it was described as 'the art barn' or 'the brick kiln'. 'If the public taste in art was being destroyed', parliamentarian John Macintosh told the Legislative Council, 'it was being done by this square shed, for it could be called nothing else'.[35] Henry Parkes, now out of office, criticised the new government for erecting 'a huge art barn in the Domain to serve the purposes of a National Art Gallery'.[36]

At the start of 1887 a building committee of trustees was established. The centenary celebrations of European settlement were imminent, and it was suggested that the Gallery be completed, or at least given a decent 'dressing', for the event. Sir Patrick Jennings, appointed a trustee two years before, campaigned for a huge complex of buildings, costing around £75,000 and designated 'The Centennial Memorial Hall'. This would house both the Art Gallery and the Technological Museum. Du Faur steadfastly opposed all plans for a grandiose building. A conservationist, who supported the preservation of the Grose River Valley and who was instrumental in establishing the Ku-ring-gai Chase National Park, he was particularly sensitive to the Gallery's parkland setting.

An architectural prototype for the Sydney Gallery, in his opinion, was William Playfair's National Gallery of Scotland in Edinburgh. Opened to the public in 1859, this building was an elegant, austere, low-lying neoclassical structure of the Ionic order that sat sympathetically within its semi-parkland setting. Hunt, however, had his own vision for the project, which would be his most significant building to date. As 'bad blood between himself and his clients' was, according to his biographer, 'a normal part of life', it was inevitable from the start that the project would not proceed smoothly.[37] Hunt's first design, completed in September 1885, was of the Centennial Memorial Hall type. The building covered over two acres and included a massive central dome and smaller domes over four corner pavilions. It was too large, too

William Henry Playfair *Edinburgh Castle and the proposed National Gallery* c1857

The Exhibitionists

John Horbury Hunt, first design for the National Art Gallery of New South Wales,
1885, and a front elevation of a modified design from the same year

The 'art barn'

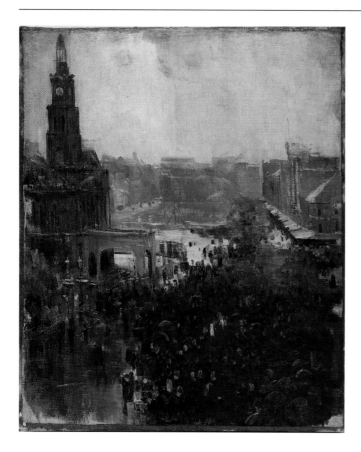

denied and slandered for twelve years', and demanded its support.[38] James Inglis, the Minister for Public Instruction, wanted a competition to finish the building and when Hunt intimated legal action he struck back, saying that he was considering moving the Gallery to an entirely new site, thus ending for good Hunt's claims as architect.[39] Julian Ashton had always preferred the old George Street Markets site across from Sydney's Town Hall and alternative uses for this central location were being discussed at the time. Arthur Streeton's *Fireman's funeral, George Street* 1894 shows it cleared pending construction.

When Joseph Carruthers replaced Inglis as the new Minister for Public Instruction in March 1889, he gave permission for Hunt to produce a series of drawings for the completed gallery. The building was not to cost more than £80,000 and Hunt's remuneration, or termination fee should the building not proceed, was fixed at £250. Hunt worked on a set of three separate designs for the Gallery, but it appears that these were not formally presented to the trustees. All thoughts of completing the building were abandoned in 1893 when Montefiore announced to the April trust meeting that the Commercial Bank of Australia had suspended services and frozen accounts. The Gallery had no access to funds until further notice from Treasury. The following month, Treasury told the trustees that because of the 'disastrous' banking crisis, the Gallery's statutory endowment would be reduced by £2000.

When some gilded coins were stolen from the 'ante-room of the Gallery' towards the end of the year, the event was seen as a direct consequence of the hardship many in the community were experiencing. The death of a worker while he was painting a ceiling compounded the sense of heaviness as 1893 drew to a close. Thomas Dunton was working on a platform suspended between two ladders when he fell from a height of 4 metres. The angle at which he landed made the fall fatal.[40] Tragically, Dunton's eldest son had been killed in a workplace accident just four years before. He was only fourteen. Father and son were buried together. The family lived in the working-class suburb of Newtown and Montefiore, conscious that their loss would be compounded by the current Depression, sought to assist. He arranged for a collection point to be established within the main gallery hall, 'where subscriptions for the family could be placed'.[41]

expensive and too bombastic. When asked to address these concerns, all he did was to reduce slightly the height of the building and its ornamentations.

Although the trustees had initially fought to employ Hunt over the colonial architect, by 1887 most of them were tiring of him. Montefiore, Du Faur and Stephen remained loyal, believing that he had the ability to deliver a fine building and, touchingly, that he was the type of person that needed to be saved from himself. They all knew him professionally and personally. Stephen, founding president of the Society for the Prevention of Cruelty to Animals, admired Hunt's tireless work for that Society. His office was in the same building as Montefiore's, so Montefiore was used to seeing the slightly comic figure, in clothes of his own designing, including boots with high heels to give him stature and a top hat with a ventilation bar around the crown, riding furiously to work on a bike fitted with a small collapsible drawing board. Du Faur had such confidence in his talent that he employed him to design his own house, Pibrac at Warrawee.

When Hunt became aware that some trustees were contemplating dismissing him, he joined the Institute of Architects of New South Wales, 'a body he had consistently

Arthur Streeton *Fireman's funeral, George Street* 1894, showing the cleared site of the George Street Markets alongside Sydney Town Hall. Some, including trustee Julian Ashton, argued that the Gallery should move to this location.

The Exhibitionists

Epigraph
HS, 'A time-honoured little vice', *Sydney Mail*, 26 Jan 1884, p 150.

Notes
1 *Le Temps* (Paris), 24 September 1882, no 7822.
2 Letter from Ford Madox Brown to the trustees of the Sydney Gallery, 20 Nov 1882, CF45/1882.
3 This work also countered the claim that First Nations cultures had no understanding of agriculture, upon which 'civilisation' is built. Such a claim was, and continues to be, made in various publications. Elyne Mitchell, for instance, in 1946 wrote: 'The aborigines, who collected grain from the grass to grind for baking, sowed no seeds, and no vegetation myths entered into their experience. The vegetation deities were symbols of the understanding on which, alone, civilization could be built – the understanding of continuous cultivation.' Elyne Mitchell, *Soil and civilization*, Angus and Robertson, Sydney, 1946, p 7. A version of this work, which includes the shields and audio interviews, is now in the collection of Gallery, donated by the artist and John Kaldor.
4 Letter from James Barnet to the Under-Secretary of Public Works, 28 September 1882, CF41c/1882 and letter from James Barnet to the Under-Secretary of Public Works, 30 Sep 1882, CF41d/1882.
5 Letter from Nicholas Chevalier to Frederick Eccleston Du Faur, 16 Nov 1882, CF43/1882.
6 Delays Are Dangerous, 'Art Gallery', *Sydney Morning Herald*, 5 Jul 1884, p 8; 'Mr Du Faur again brought under notice of the trustees the ravages of the white ant. It was agreed that the matter be reported to the Minister.' AGNSW Minutes, 3 Mar 1884, p 188.
7 Martha Rutledge, 'Henry Copeland', *Australian Dictionary of Biography*, vol 3, 1851–1890, A–C, Melbourne University Publishing, Melbourne, 1969, p 458.
8 During the Sydney International Exhibition a similar debate had occurred, with those in favour arguing that this would allow 'working men and their families … to profit themselves with this great show'. However, 'after long and anxious discussion', this 'novelty' was voted down. Report of the executive commissioner in *Official record of the Sydney International Exhibition*, Thomas Richards, Government Printer, Sydney, 1881, p xlix.
9 'Opening of the Art Gallery on Sunday', *Newcastle Morning Herald and Miners' Advocate*, 5 Sep 1882, p 2.
10 'The opening of the Art Gallery on Sunday', *Evening News*, 31 Aug 1882, p 2.
11 See the letter from G Miller to Frederick Eccleston Du Faur, 11 Oct 1882, CF36/1882. This includes an enclosure listing all the 'ayes' and all the 'no's'.
12 'Our records testify that for twenty years past, Saturdays, Sundays and Public Holidays have shown an influx through our turnstiles of the masses, mainly mechanics, artisans and other workers with their families, four times in excess of those with more leisure on the other weekdays … with our limited population, we could not have registered the entry of over five millions of visitors during that period.' Speech by Frederick Eccleston Du Faur on the occasion of the laying of the keystone of the portico of the Gallery, 22 March 1902, inserted into AGNSW Minutes, 1898–1903.
13 Elizabeth McFadden, *The glitter and the gold*, The Dial Press, New York, 1971, p 238.
14 'The Sunday Question: a letter to the editor', *Argus*, 1 Nov 1882, p 10.
15 'Deputation: new art gallery', *Sydney Morning Herald*, 19 Mar 1883, p 4.
16 Henry Parkes, NSW parliamentary debates (1881–82), 5 Oct 1882, p 737.
17 Parkes, 1882, p 737.
18 'Site for Art Gallery', *Daily Telegraph*, 17 Sep 1884, p 4.
19 Harold WH Stephen, 'Sydney sketches: the Art Gallery. Part 1', *Shoalhaven Telegraph*, 30 Aug 1883, p 2.
20 AGNSW Minutes, 14 Feb 1884, p 185.
21 The Cook Park site already had a bowling green located on it and there was some concern that a single-storey gallery, if located there, would be dwarfed between St Mary's Cathedral and the Australian Museum. The site 'at the top of King Street', which was often reported as the one 'which appears to find most general favour', was variously described as located where Hyde Park Barracks stood or on the land 'now occupied by the District Court, the Immigration Department, and the Colonial Architect's Office'. 'Notes of the day', *Sydney Morning Herald*, 24 Jul 1884, p 89.
22 'Site for the Art Gallery', *Daily Telegraph*, 17 Sep 1884, p 4; 'At the risk of a charge of egoism, I must add that I fought strongly in favour of our present site', speech by Frederick Eccleston Du Faur on the occasion of the laying of the keystone of the portico of the Gallery, 22 March 1902, inserted into AGNSW Minutes, 1898–1903.
23 'Site for the Art Gallery', *Daily Telegraph*, 17 Sep 1884, p 4.
24 Frank Clune, *Saga of Sydney: the birth, growth and maturity of the mother city of Australia*, Halstead Press, Sydney, 1961, p 247.
25 'The New Art Gallery: to the editor of the Herald', *Sydney Morning Herald*, 23 Jun 1883, p 7.
26 JG de Libra (James Green), 'Post office carvings', *The Daily Telegraph*, 21 Jul 1890, p 6. At the height of the controversy in 1883, Green thought the subject matter of the carvings was acceptable but their execution poor.
27 In 1885 the English magazine *The Builder* carried a cover story entitled 'A colonial discussion on art'. Letter from Frederic Leighton to EL Montefiore, 27 Oct 1884, State Library of Victoria, Melbourne, MS13020.
28 'Art Gallery', *Sydney Morning Herald*, May 10, 1884, p 8.
29 'Summary', *The Daily Telegraph*, 19 Sep 1884, p 1.
30 Letter from G Miller to Frederick Eccleston Du Faur, 26 May 1884, CF21/1884.
31 When WJ Trickett was appointed Vice President of the Gallery trustees in 1915, it was noted that in 1884 he had been 'instrumental in locating the present site of the Gallery and secured the first vote for commencing the present structure', AGNSW Minutes, 28 May 1915, p 458.
32 AGNSW Minutes, 3 Oct 1884, p 210.
33 'National Art Gallery: completion of the building', *Evening News*, 11 May 1896, p 7.
34 'The chronicle of art: art in September', *The Magazine of Art*, October 1887, p iii. The piece observed that the nude *Chloé* by Lefebvre had been consigned to such a high hanging space by the 'old ladies' that it was virtually out of sight.
35 'The Post Office carvings', *Sydney Morning Herald*, 8 Apr 1886, p 5.
36 'Interview with Sir H Parkes', *Daily Telegraph*, 14 Dec 1885, p 5.
37 JM Freeland, *Architect extraordinary: The life and work of John Horbury Hunt 1838–1904*, Cassell Australia, Melbourne, 1970, p 108.
38 Freeland 1970, p 112.
39 Details of the competition are included among the correspondence CFG91/1889.
40 'Fatal accident', *The Australian Star*, 23 Sep 1893, p 6.
41 Minutes of the monthly meetings, 26 Sep 1893, p 90. Further information about Thomas Dunton was supplied to Steven Miller by his great-great-grandson, David Boyce, in 2020.

6 Sinister influences at work

Challenges in collecting, 1894–1901

J.R. ASHTON.

There is a French proverb which says that he who excuses himself accuses himself.

John Daniel 'Jack' Fitzgerald, parliamentarian, 1894

Eliezer Montefiore and Alfred Stephen died within a week of each other in 1894, and Edward Combes the following year. Montefiore's brother wrote from Paris that 'to me, the death of my brother is a great severance of the ties of a lifetime'.[1] It was also a severance for the Gallery. Du Faur characterised it as the Gallery putting aside its youth on attaining its majority. His co-founders had seen the institution established on its current site in the Outer Domain, but it was still housed in a building intended as a basement. Only Du Faur saw impressive buildings gradually encase the 'art barn' and give to the Gallery that physical face of permanence that we know today. He said that he and Montefiore had often speculated 'as to whether we, or either of us, would live to see this commencement of the permanent Gallery,' adding 'the lot has fallen to me alone'.[2]

The next twenty years, until the start of the First World War, were turbulent ones for the Gallery as it negotiated its increasingly established role in public life. Questions concerning its accountability and relevance were raised by the public, as well as by government and artists. It was Du Faur who directed the Gallery in these years. He supervised the thirteen-year building project with extraordinary determination and ability, drawing upon his experience as chief draughtsman in the Lands Office. As if to underline the new dynamic, the Gallery did not have a director at this time.

After Montefiore's death, George Collingridge and Colin McKay Smith both applied for his position. Smith had been an early art adviser to the Gallery in London. George and his brother Arthur were artists and founders of the Art Society of New South Wales. George was educated in France, reputedly admitted to the Parisian Académie des Beaux-Arts by the influential French landscapist Jean-Baptiste-Camille Corot. His appointment would have continued the Gallery's strong Francophile tradition. While Collingridge and Smith applied for the Gallery's 'directorship', at the same time George Layton applied for its 'secretaryship'. Layton alone was appointed.[3]

This appointment shifted power firmly into the hands of the trustees. George Layton, 'Secretary and Superintendent' of the Gallery for ten years, is a shadowy figure from its early history.[4] When he died in 1905, artist Antonio Dattilo Rubbo offered the Gallery an unfinished portrait of him, noting that 'no other portraits, not even photographs, exist'.[5] The archival records also give only the sketchiest sense of Layton's personality. In 1890 his own brother put a notice in the newspapers seeking information about him. The family knew that he had immigrated to Melbourne in January 1852, presumably in search of gold, and was then employed in shipping in Brisbane.[6] After this, contact ceased. In Brisbane,

Previous page: Julian Ashton's impression of visitors to the 'art barn', with several looking intently at *The defence of Rorke's Drift 1879* 1880 by Alphonse de Neuville, purchased by the Gallery in 1882 (illustrated on page 147)

The Exhibitionists

Layton worked as an accountant, but was declared insolvent in 1878. The Sydney International Exhibition of 1879 gave him an opportunity to start again, as secretary to the Queensland commissioner.

When he was appointed to the Gallery fifteen years later, a short notice in the *Daily Telegraph* claimed that his appointment 'was a foregone conclusion', as Layton, 'an elderly gentleman', had managed the Gallery's affairs when Montefiore was overseas and had 'discharged his duties in a satisfactory manner'.[7] It was hardly an effusive endorsement. Layton's 'satisfactory manner' probably made his working relationship with the assertive Du Faur possible. Both were sixty-two at the time. Du Faur was respected, but few felt for him the affection that Montefiore had enjoyed.[8]

This became apparent when the Gallery commissioned sculptor Theo Cowan to make a marble bust of Du Faur in 1897 for £105. Edward Clark challenged the commission in parliament, asking 'what special services have been rendered by the President that he should be recognised in such an exceptional manner at the public expense?' Clark said that the purchase revealed 'the extravagant and inequitable administration by the trustees of the National Art Gallery'.[9] Jacob Garrard, the Minister for Public Instruction, defended the commission, arguing that Clark was merely 'actuated by personal antipathy to Mr Du Faur'.

This was not the first time that the motives of the trustees had been questioned. At the beginning of 1894 another, more serious, accusation had been made in connection with artist trustee Julian Ashton. He had been appointed to the board in 1889 to replace Alfred Stephen. Prior to his appointment, two of Ashton's watercolours had been purchased for the collection, both for less than forty pounds. After his appointment, a further four works were acquired for £550. The Minister for Public Instruction was questioned about these purchases in parliament by the socially progressive 'Jack' Fitzgerald, who thought they represented a conflict of interest. Fitzgerald also accused Ashton of manoeuvring his own appointment to the board by getting members of the Art Society of New South Wales, of which he was president, to petition for this and asking his good friend Sir Henry Parkes to approve the appointment. 'It seems to me,' Fitzgerald told parliament, 'that rather a sinister influence is at work in connection with the Art Gallery'.[10]

Fitzgerald's charges were serious, and the records show that they were not entirely unfounded. None of the other trustees was informed about Ashton's appointment before its announcement as a fait accompli. Parkes, a personal friend of Ashton's, had recommended it. Some saw the portrait that Ashton then painted of Parkes as a thank you for favours bestowed.[11] Astonishingly, the Gallery purchased it for £250.[12] Fitzgerald listed all of these 'irregularities' in his speech

Theo Cowan *Frederick Eccleston Du Faur FRGS* 1897

to parliament. He claimed that Ashton, on being elected a trustee, had promised 'that he would not remain a competing artist'; that is, an artist selling work through art society exhibitions. However, three works purchased after Ashton's appointment were all from 'a competitive exhibition'.[13] The Gallery was embarrassed by these very public charges of improper conduct. Ashton too felt the pressure and during the Royal Art Society exhibition of 1894 let it be known that 'he had withdrawn any of his exhibits ... from sale so far as the Trustees of the National Gallery are concerned'.[14]

The perception of Ashton's unethical conduct cast a long shadow. Five years later, in 1899, when the Gallery was about to be incorporated by an Act of parliament, Ashton resigned. He knew that his position as a trustee would 'possibly block the passage of the "Incorporation Bill" through the Legislative Council'. Accepting his resignation 'with great regret', the trustees expressed their appreciation of his 'loyal and unselfish service'.[15] To their surprise, immediately after he resigned, Ashton asked the trustees to purchase his painting *The dawn* for £250, almost as a parting sweetener. 'Declined', they wrote underneath the submission, with a resolution immediately alongside it that the whole issue of purchasing works by artist trustees be debated at the next meeting.[16]

JULIAN ASHTON.

Although Julian Ashton was a trustee for only ten years, fellow artist Arthur Streeton spoke of the Gallery as 'the program begun by our veteran Julian Ashton'.[17] Ashton was a skilful self-promoter, so this perception is perhaps understandable. He convinced William Moore, author of the first history of Australian art, that the Australian collections of the Gallery had been acquired largely on his initiative. 'After Julian Ashton was appointed a trustee in 1889,' Moore wrote in his 1932 *Story of Australian art*, 'he had a rule passed, that out of the government grant a sum of not less than £500 a year should be spent on Australian works. It is due to this measure that the Australian collection in the Sydney Gallery is the largest and most representative in the Commonwealth.'[18]

When Ashton was vice-president of the Art Society of New South Wales, he did put pressure on the trustees to set

Above: 'Not without an enemy or two. He made them by his habit of saying acidly unpleasant things with the benignity of a Bishop' was the caption to this Will Dyson cartoon of Julian Ashton from the catalogue to the 1907 annual exhibition of the Society of Artists. **Right:** Arthur Streeton *'Still glides the stream, and shall for ever glide'* 1890

aside £500 each year for Australian works. These were to be purchased only from the Society 'no matter what standard was produced'.[19] The trustees were angered by a situation that they thought compelled them 'to protect native industry in art matters'.[20] Added to this, the Society requested that six of its members help choose the works.[21] Eventually Montefiore promised that '£500 yearly would be spent on Australian pictures, provided,' he added, 'the works were sufficiently good'.[22]

Ashton also told Moore an anecdote about the purchase of Streeton's *'Still glides the stream, and shall for ever glide'* in 1890, the year it was painted. When he was in Melbourne, his travelling companion Montefiore wanted to purchase *Essex oyster fishers* 1888 by the English artist Ernest Waterlow. Ashton thought the work 'sentimental, but my brother trustee was strongly of the opinion that we should buy it and we parted rather coolly that evening'. Ashton then went to the Victorian Artists Society where he saw the Streeton. The next day:

> I asked Mr Montefiore to come with me ... I showed him Streeton's picture, but he did not seem impressed. I said I would agree to the purchase of the Waterlow for 156 guineas if he would agree to the purchase of the Streeton for £70. He consented to my proposal and the first picture by a Victorian artist was added to the collection of the National Art Gallery, Sydney.[23]

Events were not so simple. The Waterlow was one of a group of four international purchases made from the exhibition of the Royal Anglo-Australian Society of Artists in 1890 (not in 1888 as recorded by Moore), two months after the Streeton purchase. Streeton's *'Still glides the stream'*, claimed by Ashton as a watermark moment for Victorian artists achieving recognition in Sydney, was purchased along with *The dry season* c1889 by Victorian-born J Llewellyn Jones.[24] In fact another two works, by British-born Melburnians John Ford Paterson and WB Spong, were also acquired from the same exhibition. And some of the Gallery's earliest purchases had been by British-born artists based in Melbourne, such as JW Curtis, George Walton and HJ Johnstone.

Although the Gallery's foundational purchase in 1874 had been a watercolour by Conrad Martens, international works subsequently dominated acquisitions. In 1883, Alfred Stephen's nephew wrote that 'the Sydney Art Gallery is superior to any other in Australia, and that the purchasing of pictures has been wisely conducted'.[25] However, he regretted the 'paucity of works by colonial artists'.[26] Four years later a writer for the international magazine *The Journal of Art* remarked that 'local art is not prominent in the gallery'.[27] When the Sydney photographic company Kerry & Co

published 50 'gems' from the Gallery in 1894, most of these were non-Australian.

During the ten years of Ashton's trusteeship, from 1889 to 1899, Australian art certainly increased in visibility. George W Lambert, Sydney Long, Frederick McCubbin, Arthur Streeton, Tom Roberts, Walter Withers, Gordon Coutts, David Davies and E Phillips Fox all had their first major works purchased. Women artists were not overlooked, with foundational purchases of works by Edith Cusack, Emily Meston, Jessie Scarvell, and Ashton's students Alice Muskett, Ethel Stephens and Margaret Fleming. Nonetheless, up until the First World War, Australian works of art accounted for roughly only one-third of all purchases.

The Gallery's international art advisers in London and Paris supplied all the other works.[28] These advisers had been appointed as early as 1874: Nicholas Chevalier, Colin McKay Smith and Cave Thomas in London and Édouard Montefiore in Paris.[29] The London committee was larger and more established; the French more distinguished. Montefiore's brother Édouard, a banker in Paris and an amateur artist, was remarkably well connected. Throughout the 1880s he was supported by print expert Philippe Burty and the publisher and collector Charles Ephrussi. It was Burty who coined the term 'Japonisme' to describe the vogue in Japanese art then current in Europe. The Art Gallery's archive still preserves the elegant two-volume publication of etchings by Édouard

Montefiore based on drawings by Eugène Fromentin, with a foreword by Burty.[30]

Charles Ephrussi is the man in a top hat standing with his back to the viewer in Renoir's *Luncheon of the boating party* 1881. He was a part owner of *Gazette des Beaux-Arts*, the most important art-history magazine in France at the time. He is also the inspiration for the figure of Swann in Marcel Proust's *Remembrance of things past* and more recently a central character in Edmund de Waal's *The hare with amber eyes*. Although it appears that Charles had been assisting Édouard with his purchases in the 1880s, it was only in 1891 that he was officially appointed. The poisonous Dreyfus affair in 1894 meant that Ephrussi assisted the Gallery for just under five years.[31] Both he and Édouard, as prominent and successful Jews, became the victims of anti-Semitic attacks. What the archive lacks, rather than what it contains, is a testament to their plight. A previously vibrant chain of correspondence about potential purchases becomes a trickle after 1894.[32]

With such notable advisers, it is sometimes wondered why the Sydney Gallery did not acquire its first major impressionist painting until 1935.[33] Édouard Montefiore did, in fact, ask the trustees if they would like impressionist works to be placed under consideration, but in 1894 they resolved 'with reference to a letter from Monsieur E Montefiore Paris as to the purchase of works of the impressionist school, the Trustees are of opinion that they should be avoided'.[34] When this was

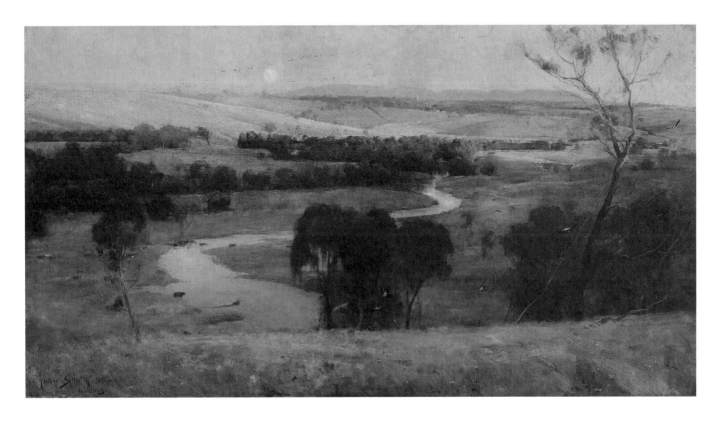

written, the Paris buyers had around 25,000 francs available to them for purchases. Monet had finished his Rouen Cathedral series and his dealer Durand-Ruel sold these in 1895 for 15,000 francs each. Regret for lost opportunities is inevitable when all these factors are known. However, the Sydney Gallery was not alone in undervaluing experimental French work at the time. Kenneth Clark, speaking directly to the Australian experience, reminded an audience in 1949 that 'the Louvre itself failed to buy Cézanne, or the best Renoirs, and for years the only Seurat in a French public gallery was presented to it by an American'.[35]

The personal collection of Charles Ephrussi included works by Monet, Manet, Degas, Renoir, Pissarro and others, but when buying for a public gallery on the other side of the world he did not want to take risks. His 1894 purchases were nearly all by Paris Salon medal-winners or artists who had won the Prix de Rome. 'I have passed all the morning in going about with my fellow selector M. Ephrussi, and we are certainly satisfied with what we have done,' Édouard wrote. 'I think the Trustees will be pleased. I find that not only can one select better at a dealer's than at the Salon, but that also one can often get paintings at a lower price than that asked for by the

artists themselves.'[36] Many of the artists purchased in 1894 are unknown today, though they were highly regarded at the time.

A sense of their importance can be gathered from the correspondence of Vincent Van Gogh. Gauguin said, 'Vincent and I generally agree very little, especially about painting. He admires Daudet, Daubigny, Ziem, and the great Rousseau – all people whom I cannot bear.'[37] Félix Ziem was in fact selected for Sydney in 1894 but swapped at the last moment for a work by Jules Goupil. Van Gogh wrote, 'I wish I could make blues like Ziem.'[38] He also had an etching of Goupil's *A young citizen of the year V* 'hanging in my room in London for a long time'.[39] A pastel by Émile Lévy and a pencil and wash drawing by Charles Renouard were also purchased.[40] Van Gogh admired both artists. He wrote that he was struck by the figure of a girl by Émile Lévy, 'Japonaise' when he saw this reproduced from the 1884 Salon.[41] For many years he had instructed his brother Theo to purchase drawings by Renouard if he came upon them: 'I have followed Renouard's work pretty regularly, and for many years I have saved up what he did for *L'Illustration*.'[42] An oil by Gustave Jean Jacquet was not purchased, but a black-and-white photograph was sent to the trustees for consideration. Van Gogh had sent the same photograph to his brother: 'A few days ago I sent you a photograph, "Young Girl with a Sword" by Jacquet, as I thought you would like to have it.'[43] The one painter Van Gogh did not approve of, among those whose work was purchased in 1894, was Charles Delort.[44] His opinion might have been

Above: Jean Patricot *Charles Ephrussi* 1905 Right: Title page of the two-volume publication of etchings by Édouard Montefiore based on drawings by Eugène Fromentin, with a foreword by Philippe Burty

The Exhibitionists

coloured by traditional Dutch–Belgian rivalry, as he thought Delort a 'bad historical painter' who paints pictures 'designed for the worthy Belgians'.[45]

British purchases were subject to greater scrutiny than those made by the Paris buyers. Some did not 'meet the taste of the Colonists', which the London buyers felt they so confidently knew.[46] Early acquisitions of large, proto-cinematic oils with military, biblical, historical or classical subjects had proved popular.[47] But when London adviser Arthur Greening proposed spending a thousand guineas on a copy of William Frith's *The Derby Day* 1856–58, Montefiore was appalled. Writing to the artist Alfred East to ascertain whether he would be interested in becoming a London art adviser, the trustees confided that they believed the standard of recent purchases had not been up to earlier acquisitions, such as *The defence of Rorke's Drift 1879* 1880 by Alphonse de Neuville (purchased 1880), *The visit of the Queen of Sheba to King Solomon* 1890 by Edward Poynter (purchased 1892), *Chaucer at the court of Edward III* 1847–51 by Ford Madox Brown (purchased 1876) and *Wedded* 1882 by Frederic Leighton (purchased 1882).[48]

One of the Gallery's first London buyers, Colin McKay Smith, wrote to the press about purchases made in the 1890s. Although he thought Goupil's *La villageoise* 'artistically respectable', it was 'trivial'. Two-thirds of all money spent, he argued, was 'frittered away in worse than worthless selections'. 'The trustees of the National Art Gallery of New South Wales,' he concluded, 'have proved themselves incompetent for the work they have undertaken.'[49] The trustees dismissed this criticism as sour grapes: 'as an unsuccessful applicant for the secretaryship of the National Art Gallery of New South Wales in the vacancy which followed the death of the late Mr EL Montefiore', Smith's comments should 'be regarded with suspicion, as coming from a disappointed suitor'.[50]

One of the last events that Montefiore attended at the Gallery before his death in October 1894 was the opening of an exhibition showcasing an intercolonial exchange of paintings from the Sydney, Melbourne and Adelaide galleries.[51] He had lived and worked in all three cities and so the project was close to his heart. As politicians and others were debating the pros and cons of a federated Australia, Montefiore's exhibition was 'a movement towards the federation of art in Australia' that prefigured constitutional unification.[52] When constitutional unification finally occurred, the Gallery played an unexpected role. Queen Victoria had donated to Australia the table, inkstand and pen used when she signed the official documents giving royal assent to Australia's Federation and the Gallery was entrusted with the care of these precious 'Commonwealth Memorials'.[53] They were placed on display from September 1900 until used for Commonwealth ceremonies the following year.

Jules Adolphe Goupil *La villageoise* (*The village girl*) 1878

The Gallery's archive preserves the journal of the senior caretaker at the time. He normally filled it with mundane details about the 'washing of statues', the dusting of frames and sweeping of floors. But on 1 January 1901 there is the entry:

> Commonwealth table and inkstand, also four gold chairs and a double chair, taken from the National Gallery to the Pavilion to be used in the Commonwealth Celebrations, for signing the Federal Australian documents on. Mr EG Blackmore CMG took charge of the two pens used to sign the Commonwealth documents. The Gallery stand, which seats about sixty, was completed and decorated with green bush from the Gardens, yellow and blue bunting, flags etc. Heavy thunderstorm about pm. Flag stolen.[54]

Epigraph
JD Fitzgerald, Hansard, Legislative Assembly, 28 Feb 1894.

Notes
1 Letter from Édouard Montefiore to Frederick Eccleston Du Faur, 20 Dec 1894, BF36/1894.
2 Address by Frederick Eccleston Du Faur, 'Opening of the first completed portion of the National Art Gallery of NSW', 24 May 1897.
3 A permanent salaried secretary had been employed by the Gallery since 1886, when Du Faur resigned as honorary secretary. WP Warton was the first. Layton temporarily replaced him in 1889. When Montefiore became the Gallery's full-time salaried director in 1892, Layton's position was nominally obsolete, but he stayed on 'until another job was found for him'. AGNSW Minutes, 6 Sep 1892, p 53.
4 In 1901 Layton's salary was doubled, reflecting a change of perception of his role from a merely secretarial one to more of an executive one. The title of the position was also changed to 'Secretary and Superintendent'.
5 Letter from Antonio Dattilo Rubbo to Frederick Eccleston Du Faur, 21 Jun 1905, CFG100/1905.
6 'Long lost relatives', Australian Town and Country Journal, 22 Nov 1890, p 40.
7 'The National Gallery', Daily Telegraph, 16 Nov 1894, p 4.
8 Du Faur's biographer claimed that his detached manner 'failed to engage the public, his colleagues and his family in a relationship that accorded him any marked degree of affection'. Joan Webb, Frederick Eccleston Du Faur: man of vision, Deerubbin Press, Sydney, 2004, p vi.
9 Hansard, Mr EM Clark to the Minister for Public Instruction, Questions in Parliament, 29 Jul 1897.
10 Hansard, Legislative Assembly, 28 Feb 1894.
11 It is generally thought that the portrait occurred because the parliamentary draughtsman, Alexander Oliver, who was a friend of Ashton's, suggested to Parkes that his portrait be presented to the Art Gallery to begin a national portrait collection.
12 Julian Ashton painted two 'replicas' of this work. When the trustees offered to loan the painting to the prime minister's office in 1913, they received a letter: 'The action of the Trustees in loaning the portrait was appreciated, but the artist commissioned, painted two replicas, one without authority.' The Gallery's

original version of the Parkes portrait was donated by the Gallery to the Sir Henry Parkes National Memorial School of Arts in 1961.
13 Ashton denied that he had made any commitments concerning being a competing artist, but a number of artists, including Piguenit, wrote to the press that they had been at the meeting when he 'distinctly stated' this.
14 AGNSW Minutes, 18 Sep 1894, p 126.
15 AGNSW Minutes, 19 Jan 1900, p 201. The letter referenced in the Minutes was dated 22 Dec 1899. It is missing from the archive.
16 AGNSW Minutes, 23 Feb 1900, p 216. It was not until 1902 that the trustees purchased another work by Ashton, a modest watercolour for ten guineas at the Royal Art Society of NSW.
17 'Mr Streeton criticises National Gallery', The Sydney Morning Herald, 20 Oct 1936, p 10.
18 William Moore, The story of Australian art, vol 1, Angus and Robertson, Sydney, 1934, p 189.
19 Noel Hutchison, 'The establishment of the Art Gallery of New South Wales: politics and taste', BA thesis, University of Sydney, 1968, p 40.
20 AGNSW Minutes, 17 Apr 1885, p 229.
21 Art Society of New South Wales 5th annual report, 1885, p 6.
22 Art Society of New South Wales 9th annual report, 1889, p 5.
23 Moore 1934, p 234.
24 Both the Sydney and Melbourne galleries could be parochial in their interests and not inclined to acquire work by artists from other colonies. Eugene von Guérard and Louis Buvelot, personal friends of Montefiore, sent paintings to the annual exhibitions of the NSW Academy of Art, with Buvelot writing of his 1877 inclusion: 'I shall be happy if this work of mine obtains the approval of your Committee.' Letter from Louis Buvelot to Frederick Eccleston Du Faur, 19 Mar 1877, CF20/1877. The work was no 20: Afternoon, from One Tree Hill, near Beechworth. In 2003 this work was offered by Sotheby's in the sale Fine Australian and International Paintings, 26 Aug, lot 166, as Near Beechworth (One Tree Hill Ovens District Beechworth). Eugene von Guérard exhibited at the 3rd Annual Exhibition of the Academy in 1874, showing no 7, Track on the Mitta Mitta River, Victoria and no 9, Wilsons Promontory, the southern-most point of the Australian continent. Neither artist was represented in the collection of

the Art Gallery of NSW until 1954 and 1967 respectively. Tariffs and shipping costs were another barrier. When E Binet of Tasmania offered to sell three paintings by John Glover to the Gallery for £100 in September 1895, the trustees wrote back 'Cannot recommend expense to be incurred to send these pictures for inspection'.
25 Harold WH Stephen, 'Sydney sketches: the Art Gallery. Part II', The Shoalhaven Telegraph, 6 Sep 1883, p 2.
26 Harold WH Stephen, 'Sydney sketches: the Art Gallery. Part I', The Shoalhaven Telegraph, 30 Aug 1883, p 2.
27 'The chronicle of art: art in September', The Magazine of Art, Oct 1887, p iii.
28 See Heather Johnson, The Sydney art patronage system 1890–1940, Bungoona Technologies Pty Ltd, Sydney, 1997, p 20.
29 Édouard Montefiore is listed in French dictionaries of art as Édouard-Lévy Montefiore. It is difficult to give an entirely precise account of advisers and their appointment dates but, up until the First World War, these were the principal advisers: in London, Nicholas Chevalier (1874, 1876–97), Colin McKay Smith (1874, 1876–86), Oswald Brierly (1886–90), Thomas Lane Devitt (1887–c1907), George Howard, Earl of Carlisle (1890–c92), Arthur H Greening (c1891–c1903), Alfred East (c1897–1906), John Longstaff (1911–21), AG Temple (1911–c14), George Frampton (1919–21) and Frank Brangwyn (1919–21); and in Paris, Édouard Montefiore (1876–c96), Charles Ephrussi (1891–c95) and Philippe Burty (c1880–90). In 1921 the London Advisory Board was disbanded, only to be reconstituted in 1925.
30 Vingt-cinq dessins de Eugène Fromentin, avec facsimile d'après des croquis du maitre, reproduite à l'eau-forte par E L Montefiore, texte biographique et critique par Ph. Burty, Librairie de l'Art, Paris, 1877. Montefiore donated a copy of this publication to the Gallery in 1894.
31 The Dreyfus affair was a political scandal involving anti-Semitism and a miscarriage of justice when Captain Alfred Dreyfus was convicted of treason for allegedly communicating French military secrets to the Germans. Dreyfus was eventually exonerated.
32 The autonomy of the Paris art advisers was significantly reduced

in 1896 when the trustees resolved that 'no works be purchased on the Continent unless with the concurrence of the London Committee'. AGNSW Minutes, 23 Apr 1896, p 269.
33 Camille Pissaro Peasants' houses, Eragny 1887. The National Gallery of Victoria had made more significant and earlier purchases, including Cézanne, La route montante (1881), acquired 1937; Monet's Gros temps à Étretat (1883), acquired 1913, and Vétheuil (1879), acquired 1937; and Pissarro's Bords de la Viosne à Osny, temps gris, hiver (1883), acquired 1927, and Boulevard Montmartre, matin, temps gris (1897), acquired 1905.
34 AGNSW Minutes, 24 Apr 1894, p 111. Noel Hutchison sees this moment marking 'the virtual stagnation of the collection as far as revolutionary initiative in acquisition was concerned'. Hutchison, 1968, p 4.
35 Sir Kenneth Clark, The idea of a great gallery, National Gallery of Victoria, Melbourne, 1981, p 15. This was a reprint of a lecture Clark gave at the National Gallery of Victoria in 1949.
36 Letter from Édouard-Lévy Montefiore to Devitt, 3 Oct 1894, BF24/1894.
37 Quoted in The complete letters of Vincent Van Gogh, vol 1, Thames and Hudson, London, 1958, p XLIV.
38 Letter from Vincent Van Gogh to Theo Van Gogh, c1888. The complete letters of Vincent Van Gogh, vol 2, Thames and Hudson, London, 1958, p 526. The Goupil (La villageoise 1878) is still in the collection of the Gallery.
39 Letter from Vincent Van Gogh to Theo Van Gogh, 21 Oct 1877. The complete letters, vol 1, p 144.
40 Émile Lévy, Enfants à la pomme 1890, deaccessioned 28 Sep 1948; Charles Renouard, Queen Margherita of Italy distributing alms.
41 Letter from Vincent Van Gogh to Theo Van Gogh, c1885. The complete letters, vol 2, p 349.
42 Letter from Vincent Van Gogh to Theo Van Gogh, c1885. The complete letters, vol 2, p 339.
43 Letter from Vincent Van Gogh to Theo Van Gogh, 13 Apr 1874. The complete letters, vol 1, p 20.
44 Charles Edouard Delort, L'arrivée a l'auberge, deaccessioned 26 Nov 1946.
45 Letter from Vincent Van Gogh to Theo Van Gogh, c1888. The complete letters of Vincent Van Gogh, vol 3, Thames and Hudson, London, 1958, p 91, and letter from Vincent Van

Gogh to Theo Van Gogh, 20 Apr 1888.
The complete letters, vol 2, p 551.

46 Letter from Arthur Greening to EL
 Montefiore, 29 Sep 1893, BF26/1893.

47 Otto Weber's *The first snow on the
 Tyrolean Alps* 1866 (118.5 x 222.7 cm),
 purchased by the National Gallery of
 Victoria in 1868, was a favourite work
 for students to copy, as was Peter
 Graham's *Rising mists* 1887 (117.3 x
 169.4 cm) in Sydney, purchased 1888.

48 AGNSW Minutes, 28 May 1896, p 285.

49 Copy of a letter by C McKay Smith
 to the *Daily Telegraph*, 13 Apr 1897,
 stuck into the AGNSW Minutes,
 together with a reply prepared by
 George Layton, published on 26 Apr
 1897.

50 AGNSW Minutes, 26 Apr 1897, p 402.

51 *Loan Collections of Oil Paintings
 Exhibited at the Sydney, Melbourne
 and Adelaide National Galleries*,
 1 Sep 1894 – [May?] 1895.

52 *Seventh edition of the catalogue
 of the National Art Gallery of New
 South Wales*, The Trustees, Sydney,
 1899, p 5.

53 'Commonwealth memorials', *Sydney
 Morning Herald*, 15 Sep 1900, p 9.

54 *Caretaker's journal*, National Art
 Archive, Art Gallery of NSW, 1901.
 The table and other items donated
 by Queen Victoria are now part of
 the collections of the Parliament
 House, Canberra.

7 A temple to art
Building a permanent gallery, 1890–1914

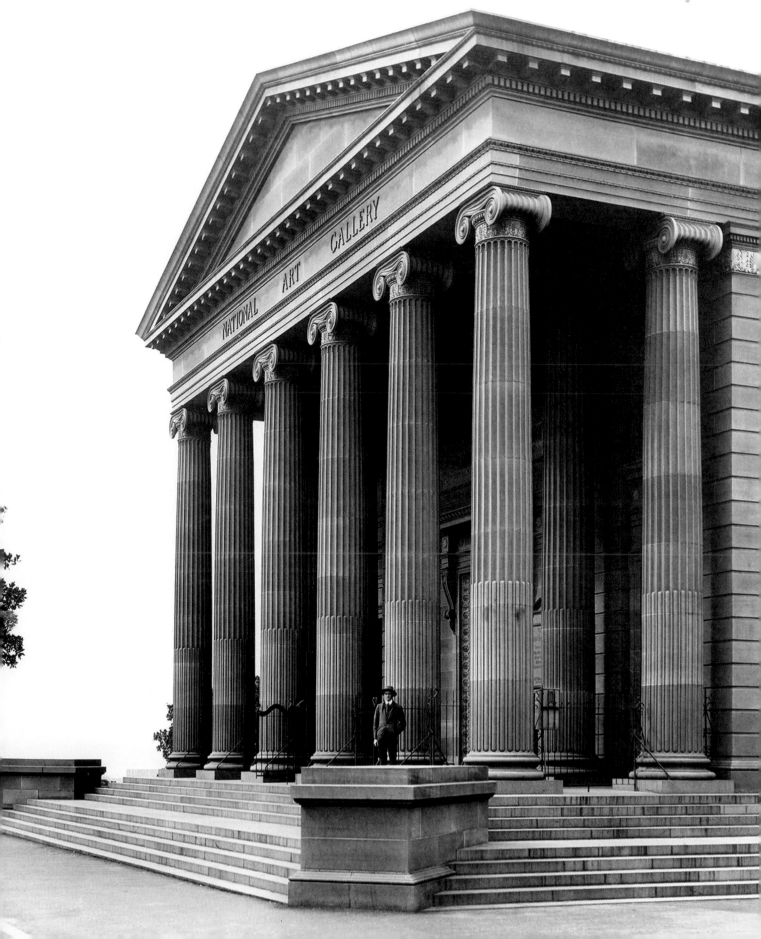

I claimed that the architecture of our 'Temple to Art' should be strictly classical; and instanced the Edinburgh Gallery as an example which we might closely follow. While accepting the type, Mr Vernon has given us a building with much marked originality, and that it would be very difficult for anyone to point to a false line therein.

Frederick Eccleston Du Faur, President of the trustees, 1902

An entry in the Gallery caretaker's journal, bordered in black so that it appears more prominent than one registering the Federation of Australia only a few weeks earlier, reads: 'Her Majesty the Queen breathed her last at 6.30PM on Tuesday January 22nd 1901.' Victoria was eighty-one and had reigned for sixty-three years. Her death, according to the press, 'was felt like an electric shock by millions'.[1] The first completed portion of the Gallery's major suite of historical buildings had been dedicated on her birthday in 1897, as a memorial plaque placed high on the gallery wall records. A few months earlier she had become the longest reigning British monarch. But even this record was short according to the superscript on the plaque: *Ars longa*, the first part of the aphorism *Ars longa, vita brevis* – art is eternal, life short.

These were the first words written in the minute book begun by the New South Wales Academy of Art in 1871 and a more exultant version of the same – *Ars victrix* – was carved in stone above the Gallery's front door. The *Ars longa* aphorism was also reworked by artists into their designs for the first corporate seal of the Gallery. David Souter used *Ars aeterna est* (art is eternal) and another artist, possibly Tom Roberts, *Non nobis solum sed in omnia tempus* (not merely for ourselves but for all time). Only Thea Proctor dispensed with a motto altogether.[2] This seal became necessary when the Gallery was incorporated by Act of parliament in 1899.[3] The Act set the number of trustees at thirteen – where previously there had been only five or six – to be appointed for life.[4] It outlined the responsibilities of the Gallery to the Minister and guaranteed an annual endowment for the purchase of works of art. Now officially the 'National Art Gallery of New South Wales', a name which it had been using since 1883, the Gallery became a statutory body able to receive and disburse monies and hire and dismiss staff, who were public servants under the Act.[5] Thus the day-to-day running of the Gallery was effectively transferred to the trustees, who were constituted as 'a body corporate by the name of "The Trustees of the National Art Gallery of New South Wales"'.

Incorporation occurred while the Gallery was being completed and building remained the priority of the trustees for the next ten years. In 1890 Walter Liberty Vernon, an English architect who had immigrated to Australia for health reasons, replaced James Barnet as colonial architect. He met with the trustees the following year and presented plans in October 'for a proposed extension and elevation' to the Gallery. These do not survive in the archive. Du Faur thought

Previous page: Portico of the National Art Gallery, 1906, showing the plinths at either side of the stairs leading to the Gallery, which were intended for equestrian bronzes. Photographer unknown Left: Memorial tablet, resting on top of the door lintel, commemorating the opening in 1897 of the first completed portion of the Gallery as designed by Walter Liberty Vernon

The Exhibitionists

them hardly less infected by 'domes, turrets and pinnacles' than Hunt's early overblown designs.[6] Vernon subsequently modified his designs and told journalists that the building would be 'as strictly classical as possible'.[7]

The trustees knew they were navigating dangerous waters and that it was necessary 'to clear away any doubt as to the claims of Mr Horbury Hunt'.[8] As Hunt insisted that he had not been paid his termination fee of £250 as agreed, the trustees advised the Department 'to call upon Mr Hunt to furnish new plans within the limits of the original vote (£80,000)'. Hunt then submitted three complete schemas for the building. These were the plans he had begun work on in 1890, before the economic crash, and he wrote on the bottom of one that these 'several sheets of drawings have been in my office for over five years'.[9] All incorporated a dominant central block, with hyphens and end pavilions.

Schema 'A', his preferred and most detailed option, consisted of a set of nine plans. Estimated to cost £125,000, this gallery was the most classical of the three. Its portico had six belted Tuscan columns, with similar columns fronting the hyphens. Brick rather than sandstone was envisaged as the building material. The main galleries were elevated to allow an enormous basement throughout. Schema 'B', costing £90,000, consisted of four plans for a domed gallery, its end pavilions topped with pyramids. Schema 'C', the cheapest of the three at £70,000 and the most hybrid, included Romanesque and Gothic elements, with three domes sitting on drums with

Three proposed corporate seals commemorating the Gallery's incorporation by Act of parliament in 1899, designed by (from left): DH Souter, Thea Proctor and Tom Roberts [?]

arcaded and canopied peristyles. All were more characterful as pieces of architecture than Vernon's initial design, but it was doubtful that any of them could be completed within the allocated budget. Some design features, such as their fenestrated facades, were problematic given the current thinking about good gallery design (with which Du Faur was very familiar) recommended no windows and lighting from roof lanterns.

All three of Hunt's schemas were reviewed and rejected at an extraordinary trust meeting on 28 November 1895. At another extraordinary meeting on 2 December, Vernon's modified designs were declared 'suitable for purpose'. In March 1896, Hunt was paid his termination fee of £250. It could not have happened at a worse time in his life. His wife and soulmate, Elizabeth, had died a year earlier. He was on the verge of bankruptcy and his library, said to be 'his only solace in his latter years, for he had few friends', was sold piecemeal to keep him afloat.[10] A few months later he was sacked as architect of Newcastle Cathedral which, with the Gallery, was to be the culmination of his life work as an architect. In 1904 he died a pauper, with everything he possessed contained in one small metal box.

The contract for the construction of Vernon's building was awarded to the Howie Brothers, who began work on 13 April 1896. An article in May said that the company had 'about 40 men at present on the contract, which they expect to have completed, and ready for occupation, before the end of the year'.[11] The facade of Vernon's gallery was extended by 8 metres from where the 'art barn' was located, with the building set on a Bowral trachyte base 2½ metres high. The golden Sydney

The Exhibitionists

sandstone was sourced not from the Inferno or Purgatorio quarries in Pyrmont, but from Paradiso.[12] The workmen were so proud of it that they used the Gallery as a showpiece on their union banner, representing the first union in the world to win the eight-hour working day. Bricks came from the Carrington Brick Company, cedar from H. McKenzie Ltd Timber and Joinery Merchants, oregon for the floors from the Federal Timber Company and all general stores from Scott, Sibbald & Co in Bond Street.[13] The glass lanterns sitting on the roof that allowed natural light into the galleries below were done by James Sandy & Co, whose work could be admired at the new bar in the Tattersall's Hotel and at the Lyceum Theatre.

The building might have been ready for occupation in December 1896, but it was not opened to the public until 24 May of the following year, when Governor Viscount Hampden presided over the opening ceremony. At this stage it was a simple rectangular structure with two identical galleries (Court 7) and a smaller one used as a temporary boardroom (Court 6) sitting immediately behind the facade. Alongside was a larger gallery (Court 8), divided into three internal spaces by arches sitting on pairs of Ionic columns. After the official opening, construction began immediately on Court 9, the largest unbroken exhibiting space in the suite of galleries, and Court 10, a replica of Court 8. By 1900, *International Art Notes* reported 'one wing of the building, about one fourth of the whole structure, is at present completed, and gives rich promise of future beauty … The interior is divided into four halls, each 100 feet by 30 feet, communicating with each other by pillared archways. The lighting is almost perfect, designs for the roof having been furnished by London correspondents after careful study of all the latest improvements in European galleries. The walls are coloured a chill neutral green shade, which makes an excellent background.'[14]

Left: John Horbury Hunt, Designs A, B and C for the proposed National Art Gallery of New South Wales, 1895 **Above:** Banner made for the Operative Stonemasons Society, 1904

The entire southern elevation of the gallery was completed in 1901 with the opening of a long picture gallery (Court 12), with two domed sculpture galleries at each end (Courts 11 and 13). On 24 March 1902 the keystone of the pediment above the entrance portico was laid.[15] The portico was modified from Vernon's 1896 design, which had involved paired Corinthian columns, half-fluted, standing on blocklike piers. It was an arrangement reminiscent of Sidney Smith's Tate Gallery, designs for which had featured prominently in the 1894 *Art Journal*. The portico built was hexastyle, with six Ionic columns supporting a pediment, the tympanum of which was left rough for decoration. The two end columns were coupled with similar columns behind them.

Vernon's entrance vestibule was his masterpiece. Its two central bays were designed with coupled Ionic columns carrying arches supporting semi-glazed domes. The apsidal ends, with richly coffered semi-domes, included ornamental niches for statues between a colonnade of Ionic columns with shafts of polished Kempsey marble. Although facade and vestibule were completed in 1902, they were not made available to the public until the floor of the main hall was raised to the level of the new entrance. This took more than four years to achieve and generated a stream of acrimonious correspondence to the press about the spending of public monies on projects closed to public use.

While this was being done, a basement gallery was opened on 31 October 1904, intended for the display of applied arts and for the Gallery's collection of plaster casts and replicas. From the very start, reports of 'serious damp stains' gave an indication of the trouble that was to blight this otherwise fine space.[16] Sir James Fairfax, then the longest serving trustee

First completed portion of the National Art Gallery of New South Wales, c1897. Vernon's building sat forward by 8 metres from Hunt's original building. Photographer unknown

Section on A·B·

Above, top: Walter Liberty Vernon, Section drawing for the new sculpture galleries, 1898 **Above:** Court 13 being constructed, 1900 (left) and *Interior of Court 13,* c1901 (right). Photographers unknown

A temple to art

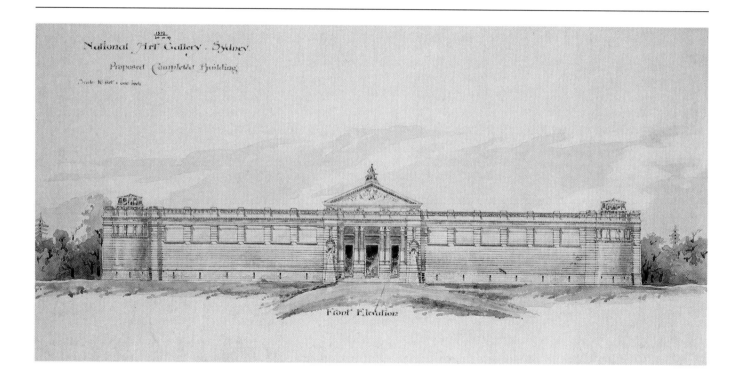

with Du Faur, proposed that an international exhibition of applied arts be held to mark the opening of the basement gallery. At first it seemed that the Victoria and Albert Museum in London would lend works and Fairfax pledged to defray all freight expenses. However, only copies were finally offered.[17] It then seemed a possibility that the famous British book illustrator Walter Crane would put together a show of works from the British Arts and Crafts movement. But this too was abandoned, with Crane writing that plans would need to be postponed because of his pressing commitments to the St. Louis World Fair.[18]

The foundation of the New South Wales Society of Arts and Crafts, just two years after the basement gallery was opened, was fortunate timing, as the Gallery became a regular purchaser from its annual exhibitions. In fact, when John Longstaff was invited to write a report on the Gallery and its collections in 1922, he was 'astonished at the progress that had been made' in this area of collecting. He encouraged the Gallery to widen its collecting further to include furniture, adding that this 'opens up a delightful field for the woman worker'.[19] Nearly all of the works purchased from the Society of Arts and Crafts were by female artists, including Ada Newman, Vi Eyre, Edith Bell-Brown, Ethel Atkinson, Amy Vale, Elisabeth Söderberg, Mildred Lovett, Emily Leist, Mildred Creed, Delia Cadden, Winifred Betts, Rhoda Wager, Cleone Cracknell, Bernice Edwell and Margaret Alston. It was only in the late 1930s that the Gallery began to draw back from

the systematic collecting of Australian decorative arts. The trustees informed a collector who offered his services while in London 'that as at present the Board was not interested in the Applied Art side of the Gallery'.[20]

The fine staircase that led down to the basement court was described by one newspaper as 'a monumental piece of "day-labour" extravagance, the exact cost of which no man knoweth'.[21] It was constructed entirely of Rockley, Fernbrook, Borenore and Molong marbles quarried in regional New South Wales.[22] The cost of the staircase was in fact not monumental as it had been constructed with prison labour from the Bathurst Gaol, 'executed under the shade of the gallows', as one paper dramatically described it. Its inclusion in a 'shrine of art', the same article continued, had turned the Gallery 'into a Chamber of Horrors'.[23] The Marble and Slate Workers' Union protested to the attorney-general about the competition that prison workers posed to unionised labour. He replied that marble had been worked at the Bathurst Gaol since 1891 and that he did not believe that the fourteen men currently employed were competing with skilled workmen. William Ferrier, who was trades overseer in the gaol,

Above: Walter Liberty Vernon, Proposed design for the National Art Gallery, Sydney, 1896 **Right, above:** Basement court, National Art Gallery, Sydney, c1909. Photographer unknown **Right, below:** Amy Vale *Bowl with lillypilly design* c1897, Margaret Alston *Book cover for 'Hand and Soul' by Dante Gabriel Rossetti* c1923, Delia Cadden *Vase with cicada design* 1917

The Exhibitionists

A temple to art

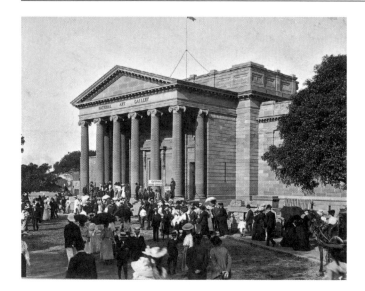

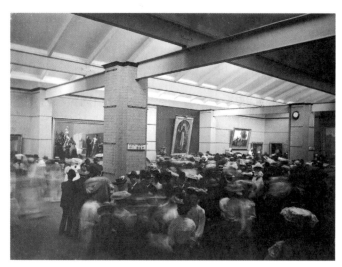

Sundays of the viewing, when the Gallery was opened for only three hours in the afternoon, more than 30,000 people came each day. The crush was so great that the front doors had to be closed a number of times. A team of police was also deployed. Pedlars of postcards, crack-pot evangelists and pickpockets worked the crowds outside the Gallery. Many photographs and other mementos showing the 1906 facade, without the northern wing completing it, survive today.

Plans to complete this northern wing were approved in late 1907 and the building was finished on 20 February 1909. The final piece of construction was not a gallery but an elegant domed room that served as the administrative hub of the Gallery for many years, combining boardroom, staff offices and library. No major building works occurred for another sixty years. Neither of the two designs Vernon made in 1902 for a grand entrance court was ever seriously considered. The cost of construction was prohibitive for what was essentially a reception area that added little to the Gallery's hanging capacity.[25]

During the showing of Holman Hunt's *Light of the world*, Gother Victor Fyers Mann, the Gallery's recently appointed 'secretary and superintendent', reluctantly removed Herman Richir's Salon painting *Après le bain* 1905 from the entrance court. It showed a naked young woman sitting on a bank near a pond, presumably having just finished bathing. Some viewers thought it 'provocative'. Alex Maxwell wrote that it 'stirred in me feelings that were not easily kept down. That was the strongest temptation I met with in all Sydney. I could have written to one of the papers, but I deemed this the most straightforward and manly way. A friend of mine, who was with me, said that it was a work of art and therefore allowable. Such pictures cannot be thus excused in my estimation.'[26]

Mann immediately returned it to display after the exhibition of Hunt's painting and for many years it was one of the first works visitors encountered on entering the Gallery. When Roman Catholic Archbishop Kelly complained about the debasing influence such 'nudities' and 'sensuous postures' had upon the impressionable young, Mann (forgetting Maxwell) claimed that 'of the numerous visitors to the gallery not one has ever … hinted that we were exhibiting pictures that were offensive'.[27] When others wrote to the press in support of 'the high-minded views of the distinguished prelate', Mann countered, 'we have several nudes in the gallery, but I do not think the nude is indecent … I admit that some people think it is indecent. Artists do not.'[28]

supervised work on the Gallery's staircase. Everybody was satisfied with the final product, the attorney-general noted, as the Gallery's choice had been between 'a wooden staircase made by free labour and a marble one made in Bathurst Gaol'.[24]

The new entrance to the Gallery via the portico, and the raised central court behind, were opened to the public in July 1906. It had been hoped that they would be ready four months earlier, when Holman Hunt's *Light of the world* 1853 was placed on display for twenty-five days during March and April. This 'sermon in a frame', as it was often dubbed, represented Christ bringing light to a darkened world, knocking on a closed door, rusted and overgrown with weeds. A record number of 302,183 visitors came to view it, at a time when the population of greater Sydney was 530,000. On the last three

The Exhibitionists

'Vic' Mann, as his friends called him, certainly included himself among this group of enlightened artists. Although professionally trained as an architect, he had studied art in 1885 under Julian Ashton, probably encouraged by his friend Charles Conder. Elected an Associate of the Institute of Architects of New South Wales in 1886, he was awarded its gold medal for draughtsmanship and design the following year. After three years of architectural practice in Brisbane, he returned to Sydney where he continued his art studies with Arthur Streeton and Tom Roberts and was a regular visitor to their camp at Sirius Cove.[29] He became secretary of the Art Society of New South Wales and exhibited regularly, as well as with the Society of Artists. Although art historian Richard Haese describes him as 'modest and undemonstrative' – perhaps his public persona – the Gallery archive reveals someone capable, confident and occasionally combative.[30]

The grandson of Sir Thomas Mitchell, he had had a privileged upbringing. As head of the Gallery, his forthright opinions occasionally got him into trouble.[31] He challenged Archbishop Kelly's pontification that art would be nothing without the protection and patronage of religion, by replying,

it is interesting to reflect that the greatest names in the history of European art attained eminence at a period when the Papacy had become a synonym for license, treachery and corruption. The 'religious protection' of Alexander VI or Julius II is an irony which Dr Kelly may be acquitted of perpetrating.[32]

It was Du Faur who personally appointed Mann as acting secretary and superintendent on the death of Layton in 1905. Mann had been employed on various projects associated with the Gallery for at least ten years.[33] The other trustees unanimously confirmed the appointment, but the governor withheld consent, as he believed it was in breach of public service protocols. Seven others were then interviewed and as 'not one of the applicants were suitable', the trustees demanded that Mann's appointment be ratified.[34] This occurred on 14 September 1905. Interestingly, at the same time there was a suggestion that Mann's title of 'secretary and superintendent' be changed simply to 'director', but the trustees rejected this proposal.[35]

When the Public Service Board finally allowed a change in designation to 'director and secretary' in 1912, they noted that this 'implies qualifications of the very highest order'.[36] There is no doubt that Mann possessed the qualifications and qualities required. He was well connected and kept himself abreast of

art developments overseas, although he was not necessarily in sympathy with them. As the previous generation was resistant to impressionism, he was equally critical of post-impressionist 'novelties'. His good friend Charles Bage, a Felton trustee at the National Gallery of Victoria, sent him photographs from Roger Fry's *Second Post-Impressionist Exhibition* at London's Grafton Galleries while the exhibition was still being shown, demonstrating that Australia was never a 'quarantine culture' as has been claimed by some cultural historians.[37] Bage also promised to lend Mann the catalogue to the recent *Exhibition of Works by the Italian Futurist Painters* at the Sackville Gallery, adding that it was 'an extraordinary piece of tomfoolery'.

Mann was sent overseas on a buying trip for the Gallery in 1914 to see this tomfoolery at firsthand. He was charged with visiting 'the International Art Exhibition at Venice' and purchasing 'works of Art if found suitable'.[38] He spent most of his time in England, Scotland and France, visiting galleries and art schools. His attempt at a major purchase of a John Singer Sargent fell through and he returned with a suite of minor works, studies by art students and black-and-white drawings by Phil May. The outbreak of war prevented him from going to the Venice Biennale. His most daring purchase was a small bronze version of Rodin's *The kiss*.[39] Mann probably saw the group of eighteen Rodin sculptures that were displayed at the Victoria and Albert Museum in October 1914.

When it was publicised that Rodin was gifting these 'to the nation' in memory of the British and French alliance during the war, he thought that the sculptures would be distributed widely and that a work might be presented to the Sydney Gallery. However, he was informed that 'it was a definite gift to the Victoria and Albert Museum'.[40]

The significance of the recently declared war was not understood at first, as is evident from Mann's correspondence with the Gallery. By August 1914 Britain had declared war on Germany and Austria-Hungary and the First Australian Imperial Force was formed on 15 August in response. Mann was sent a cable the week after: 'Under existing circumstances use own discretion as to returning.'[41] In September he said that he might remain in Europe until November or December as he had 'been asked to act on the Selection Committee in London for designs for the mural decorations to the Commonwealth Buildings'. Once again, the trustees advised: 'use own discretion'.[42] Mann still hoped to make Venice 'by sea' and sent another cable 'return November, going Glasgow, Rome now possible, fare already paid.' It was only when the Gallery informed him that 'Treasury Authority expired October' that he found the impetus to return.[43]

Entrance court, National Art Gallery, Sydney, c1906, with Herman Richir's painting *Après le bain* 1905 at far left. Photographer unknown

Epigraph
Speech by Frederick Eccleston
Du Faur on the occasion of the
laying of the keystone of the
portico of the Gallery, 22 Mar 1902,
inserted into the AGNSW Minutes,
1898–1903.

Notes
1 'The death of Queen Victoria',
*Newcastle Morning Herald and
Miner's Advocate*, 24 Jan 1901, p 4.
2 After the 1899 *Library and Art
Gallery Act* was passed, tenders
for designs for a corporate seal
were invited. Prizes of five pounds
(first) and two pounds ten shillings
(second) were offered. The closing
date for submissions was 21 Feb
1900. Designs were received from
James Henry Osborne (1), CH Hunt
(1), DH Souter (2), Tom Roberts (1),
George Sands (3) and Thea Proctor
(1). First prize was awarded to Souter
and second to Hunt, but this was
rescinded at a Trust meeting on
16 Mar 1900, where it was decided
that the business 'be brought up
again'. The matter then got deferred
throughout 1900 and 1901 and seems
to have then been forgotten.
3 *Library and Art Gallery Act 1899*,
no 54, New South Wales.
4 Selected by the Art Society of NSW
and the Society of Artists.
5 When Lord Loftus re-dedicated
the Fine Arts Annexe in 1880 it was
known simply as the Art Gallery
of NSW. This was changed to the
National Art Gallery of NSW on
19 Sep 1883 on the approval of the
Minister. See Letter CF41/1883. The
Gallery was commonly referred to
simply as 'The National Gallery'
even after Federation, as many
commercial postcards show.
6 Du Faur 1909, p 10.
7 'National Art Gallery: completion of
the building', *Evening News*, 11 May
1896, p 7. 'With reference to the
withdrawal of Mr Vernon's original
plans, and the substitution therefore
of those considered today, the
President reported several
interviews with Mr Vernon, at
which he had urged the preparation
of plans in simple classic style –
without towers, or cupolas &c –
referring, e.g. to the Edinburgh
Gallery as being more appropriate
to the surroundings of the Gallery, in
garden grounds, not contiguous to
other buildings.' AGNSW Minutes,
2 Dec 1895, p 240.
8 AGNSW Minutes, 1 Nov 1895, p 231.
9 Written on plan ARC1.76.7, National
Art Archive, Art Gallery of NSW.

10 'Obituary', *Art and Architecture*,
vol 2, no 2, Jan–Feb 1905, p 42.
11 'National Art Gallery: completion of
the building', *Evening News*, 11 May
1896, p 7.
12 Told to Steven Miller by mount
cutter Bill Lamont, c1990. However,
this may be a Gallery legend, as the
Dantean descriptors related to the
difficulty levels in quarrying stone,
rather than to the actual quality
of the stone. At one stage there
was a quarry directly behind the
Gallery and the sandstone used for
Government House was said to have
been sourced there. See Edward
Stack, 'The Domain and Botanic
Gardens, Sydney', *Sydney Morning
Herald*, 9 Sep 1897, p 4.
13 'Floors of the two new courts,
south wing: It was resolved that the
Government Architect be advised
that the Trustees desired that the
new floors to be laid in Jarrah timber
– or failing that in tiles.' AGNSW
Minutes, 15 Dec 1897, p 508.
14 *International Art Notes*, no 3, Oct
1900, p 255.
15 The stone was laid from a platform
11 metres above ground level.
16 AGNSW Minutes, 26 Aug 1904, p 135.
17 Letter from James Fairfax to George
Layton, 26 Jun 1902, BF17/1902.
18 Letter from Walter Crane to George
Layton, 1 Aug 1903, BF30/1903.
19 Report by John Longstaff, 19 Feb
1922, glued into the ANGSW
Minutes, 1916–23.
20 AGNSW Minutes, 24 Jan 1936,
p 1525. Also in 1937, the trustees
noted that they were 'not collecting
any more applied arts and have
considered handing over our works
to the Technological Museum'.
AGNSW Minutes, 26 Feb 1937, p 1626.
21 'The National Art Gallery: a new
court opened', *Sydney Morning
Herald*, 1 Nov 1904, p 5.
22 See RT Baker, *Building and
ornamental stones of Australia*,
Government Printer, Sydney, 1915.
23 'Prison-worked marble', *Australian
Star*, 24 Feb 1902, p 6.
24 'Prison labour', *Sydney Morning
Herald*, 24 Feb 1902, p 3.
25 One design included a sunken pond,
but as humidity already posed a
conservation risk to the Gallery's
collection, there was little support
for such an innovation. When
work on most of the historical
building was completed, the Gallery
commissioned Bertram Mackennal
to make a bronze relief of Vernon
in 1914. This was deaccessioned
and donated to the Public Works
Department in 1926.

26 Letter to Frederick Eccleston
Du Faur from Alex Maxwell, 27 Jul
1906, CFG126/1906.
27 'Art and Dr Kelly', *Sydney Morning
Herald*, 13 Jan 1914, p 9.
28 'Offensive pictures', *Sun*, 15 Jan 1914,
p 11, and 'Archbishop Kelly and the
National Gallery', *Daily Telegraph*,
11 Mar 1914, p 6.
29 The Mitchell Library preserves a
photograph from 1896 that shows
Tom Roberts and Mann painting at
Sirius Cove, FL3293128.
30 Richard Haese, 'Gother Victor
Fyers Mann', *Australian Dictionary
of Biography*, vol 10, 1891–1939,
Lat–Ner, Melbourne University
Publishing, Melbourne, 1976, p 395.
31 As when he was referred to the
Crown solicitor in 1919 for allegedly
making disparaging remarks about
the work of BE Minns.
32 'Art and Dr Kelly', *Sydney Morning
Herald*, 13 Jan 1914, p 9.
33 For instance, he compiled the
catalogue to the 1896 interchange
exhibition of pictures with Brisbane,
as Layton was ill at the time. He was
employed full-time from February
1896 'to carry on the Secretary's
duties'.
34 AGNSW Minutes, 21 Jul 1905, p 240.
35 AGNSW Minutes, 14 Jul 1905, p 232.
36 AGNSW Minutes, 7 May 1912, p 216.
37 See such publications as John
Frank Williams, *The quarantined
culture*, Cambridge University Press,
Melbourne, 1995; and Geoffrey
Blainey, *The tyranny of distance*,
Sun Books, Sydney, 1966. Letter
from Charles Bage to Gother Mann,
28 Nov 1912, CFG368/1912. The
exhibition was shown from October
to December 1912.
38 AGNSW Minutes, 27 Feb 1914, p 347.
39 This reduced bronze version of
Le baiser, conceived in 1886,
was cast by the Barbedienne
Foundry between 1910 and 1914.
The Gallery deaccessioned the
work on 18 February 1983 and sold
it through auction to raise funds
for a Kandinsky watercolour. This
antipodean kiss encouraged the
London gallery Arthur Tooth & Sons
to offer the full-size marble version,
now in the Tate Gallery London,
to Sydney in May 1939 for £5500.
'We already have a small bronze by
Rodin of the same subject in our
collection,' they wrote back, 'and as
the price of this work is altogether
beyond us we can only regret that
we are not in a position to purchase
it.' AGNSW Minutes, 23 Jun 1939,
p 1953.
40 AGNSW Minutes, 23 Apr 1915, p 452.

41 AGNSW Minutes, 21 Aug 1914, p 397.
42 AGNSW Minutes, 11 Sep 1914, p 402.
43 AGNSW Minutes, 25 Sep 1914, p 406.

8 Exporting art
Promoting Australian art overseas

There is no escape from the admission that the London Art World has had a surprise in the strength and finish of the Australian painting.

Cheltenham Looker-on, 1898

Vic Mann did eventually get to the Venice Biennale on behalf of the Gallery in 1926, twelve years after his thwarted wartime attempt. He hoped he would see Australia's inclusion among the exhibiting nations. The United States of America had exhibited first in 1924 and Mann believed it important that Australia also be included. His friend Selwyn Brinton, international arts reporter for *The Studio* and *The Connoisseur*, agreed. With his assistance an official invitation was elicited from Giovanni Bordiga, the president of the International Exhibition Commission, inviting Australia to participate in the XVth Biennale in 1926. Mann communicated this invitation to the Royal Art Society of New South Wales, the Society of Artists and the Victorian Society of Artists. As freight was expensive, he tried to secure support from the Prime Minister's Department. He received a polite reply, 'after careful consideration it has been decided that this is not a matter for the Commonwealth'.[1] It took another twenty-eight years before Australia was officially represented in Venice.[2]

The cost of freight, along with confusing legislation concerning tariffs and disagreements about the selection of works, made the organisation of multi-artist survey exhibitions for overseas particularly challenging. No other activity was more time-consuming and divisive, and always with contested benefits. Before Federation, the two most important international exhibitions for Australian artists were the World's Columbian Exposition in Chicago in 1893 and the 1898 *Exhibition of Australian Art in London*. Chicago was the first world exposition to which the Gallery contributed work. It had made a few token gestures towards smaller international exhibitions before this, such as the 1886 Colonial and Indian Exhibition in London, where mounted photographs were included 'of the Fine Art Gallery of New South Wales; an album with photos of the works of art contained in such gallery, and a number of bound copies of the illustrated catalogue of pictures' but no actual works of art.[3]

Chicago was the largest world fair of the nineteenth century, attracting 27 million visitors. New South Wales was the only Australian colony that exhibited on a grand scale, sending 3816 boxes of raw materials, machinery, manufactures and fine art from 'the Art Society of New South Wales (competitive collection) and the National Art Gallery of New South Wales (loan collection)'. The initial selection of works from the Gallery included a group of landscapes from the 1880s, by artists such as Charles Hern, EB Boulton and CH Hunt.[4] These were among the Gallery's earliest Australian oil acquisitions, but by the 1890s they were already considered old-fashioned. Curator Daniel Thomas has argued that this was because they fell between the better-known colonial

Previous page: Julian Ashton *The prospector* 1889 (detail) **Right, above:** Kubota Beisen's illustration of *The prospector* by Julian Ashton from *Kakuryū sekai hakurankai: bijutsu hin gafu*, 1893–94

The Exhibitionists

romanticism of Conrad Martens and the assertive national school of the 1890s. 'Arthur Streeton's generation,' Thomas wrote, created the myth that 'Australian art before their own generation ... was something of a wasteland ... claiming, most tendentiously, that it was un-Australian.'[5]

The revised Chicago selection included thirteen oils and twelve watercolours.[6] Julian Ashton chose the works with Montefiore. He made sure that his own art was well represented. His painting *The prospector* 1889 clearly impressed printmaker Kubota Beisen, who illustrated the beautiful four-volume Japanese pictorial catalogue to the exhibition.[7] It is the only work he chose to represent Australia, translating it through a distinctive Japanese aesthetic. A guiding principle for the Chicago selection was that works should represent 'Australian scenery and character and bush life'.[8] Not surprisingly, Edward Poynter's *Visit of the Queen of Sheba to Solomon* did not qualify. The work had been recently acquired and Poynter sent an impassioned letter to the trustees:

> I am, indeed, very anxious that the picture should be seen there. It has never been really exhibited to

the public ... I venture to say that a success at the Chicago Exhibition would also add largely to its value (I do not mean commercially) as a work of art, by giving it the sort of renown which can only be gained, as it were, in a public arena.[9]

Requiring a much greater commitment from the Gallery than the World's Columbian Expo was the *Exhibition of Australian Art in London* held at the Grafton Galleries in 1898. It included 382 exhibits by 111 artists and is still the largest show of Australian art ever held in the United Kingdom, despite the 2013 Royal Academy exhibition *Australia* making a similar claim.[10] That more recent exhibition was a historical survey, whereas the 1898 show was an exhibition of contemporary work. It also represented thirty-nine women artists, a higher proportion than in any subsequent national survey exhibition. The trustees originally advertised for submissions from 'living Australian Artists of New South Wales, Victoria, South Australia and Queensland', noting that these would be supplemented by loans from the Sydney and Melbourne galleries only, as 'the Galleries of Adelaide and Brisbane possess nothing worthy of inclusion'.[11] When the

Society of Artists asked that New Zealand artists be included, this was rejected. Works by Australian artists living in Europe were eligible, provided they were 'executed in Australia'. This stipulation proved controversial, with the Gallery's agent in London, Thomas Devitt, writing that 'there is reason to fear failure' if the trustees insisted on this, but they did, as the exhibition was being organised 'entirely in the interest of the existing local Australian School'.[12] When Devitt further suggested that a few British artists be included to make the show more attractive to London audiences, this was politely declined.

Three quarters of the works exhibited were supplied by the artists themselves, with the rest being lent by the National Art Gallery of New South Wales (sixty-one), the National Gallery of Victoria (nine), the *Bulletin* magazine (twenty-nine) and a few private collectors (eighteen). Sydney philanthropist Dame Eadith Walker was the biggest private lender and without her financial backing the exhibition would not have occurred. She had been left a considerable fortune when her father died in 1886, which she subsequently used to support charitable and cultural projects. In December 1896 she wrote to the Gallery offering £740 towards the cost of organising the exhibition, 'provided the Trustees would accept the management of the Exhibition, and control both disbursements and receipts'.[13] If the exhibition was profitable, her contribution could be repaid.[14] The trustees hoped that this would be sufficient, but for contingency asked Minister Jacob Garrard for another £500. Although Garrard wrote that he supported the exhibition in principle, the government was 'not prepared to undertake any financial responsibility in connection with the proposal'.[15] The trustees then asked if they could use £500 from their purchasing funds for this purpose, later increasing this to £1000 when they discovered the cost of renting gallery space in London.[16] In the end the net cost of the exhibition was £1661. None of Walker's £740 was reimbursed to her and the trustees had to contribute £889 from their purchasing funds.

The largest expense was rent. The trustees made the mistake of telling their London agent to look for somewhere suitable 'to display 250 paintings in a central West End position', authorising him 'to complete the hiring at once'.[17] He booked the prestigious Grafton Galleries in Mayfair from 28 March to 7 May for £600. The trustees cabled that the rent was 'embarrassing' and asked for all negotiations to be cancelled, but it was too late.

The exhibition was conceived as a commercial one. Artists were asked to indicate the lowest price at which their works could be sold. Today the idea of a public gallery organising a commercial exhibition is considered to be a conflict of interest, but it was commonplace in the nineteenth century. All of the annual exhibitions of colonial art organised by the

Above: Cover of 1898 *Exhibition of Australian Art in London* catalogue, designed by English artist Alfred East. Arthur Streeton offered to design the catalogue cover but the trustees, to their embarrassment, had already asked East to do this.
Right: Exhibition of Australian Art at the Royal Academy, 1923, showing works by George W Lambert, E Phillips Fox, Hugh Ramsay and others. Photographer unknown

The Exhibitionists

Academy had been commercial. In fact, it is notable that the Sydney Gallery stopped showing commercial exhibitions when it moved to its current site at the Domain. For public galleries in the United Kingdom, including those at Leeds, Liverpool, Glasgow and York, commercial art society exhibitions were an important source of income well into the twentieth century.

More troublesome than the financial arrangements was the selection process. Artists were instructed to deliver works to the Gallery by December 1897, where they would be judged by the trustees with assistance from the Society of Artists and the Art Society of New South Wales. Two years earlier the Society of Artists had been formed as a progressive breakaway group from the Art Society. Tensions still existed. The Art Society wrote to the trustees that the breakaway group showed 'a strong spirit of antagonism to their (the parent) society'. It insisted that 'the selection of works from each society be left to the respective Committees, whose decisions should be absolute and final'. It was essential, the truculent letter ended, that the London manager of the exhibition be an independent dealer, who 'being free from local prejudices, might be expected to act justly in the interests of the numerous artists of Australia'.[18]

The interstate selection of works was managed by artists, including John Mather, Frederick McCubbin, Bernard Hall, John Longstaff and Godfrey Rivers. In Sydney, William Lister Lister and WC Piguenit represented the Art Society, and Tom Roberts and Sydney Long the Society of Artists.[19] On 12 January 1898 the works were ready to be shipped: '170 oil paintings (24 Syd gallery; 7 Melb gallery); 89 watercolour

drawings (20 Syd; 2 Melb); 2 pastel drawings; 52 black and white works (16 Syd); 4 miniatures on ivory; 9 pieces of sculpture (2 Syd). Total 326 works of a total value of £11,787.'[20]

Julian Ashton had almost derailed the entire process. The four artist selectors all complained that he said 'that the Artist Selectors, as Judges, would not give his pictures fair treatment and consideration'.[21] Ashton chose nineteen of his own works for inclusion, more than were selected for any other artist, and refused to submit these to the selection process. Such conduct meant that some interstate artists, such as South Australian Hans Heysen, were barely represented despite submitting a number of works. Bernard Hall and John Longstaff, both Melbourne selectors, included only one of their own paintings, in contrast to Ashton.[22]

Twenty-eight artists sent a letter to Minister Garrard demanding that Ashton 'be asked to resign' as a trustee on account of his actions.[23] When the Minister asked the Gallery for clarification, the trustees answered that it was not their position 'to sit in judgement on one of their colleagues'. The Minister demanded a clear answer to the accusations: first, did Ashton refuse 'to assist his colleagues in the choice of pictures' and second, did he 'not submit his pictures to the judgement of the Committee but in an *unfair manner* had his pictures accepted without being submitted to the said committee?' The trustees responded yes to both.[24] The Minister then said that if a trustee was 'unable to carry out his duties as such, he should resign'. Ashton should have then stood down from the board, but once again he managed to save his own skin by a calculated capitulation. He resigned his chairmanship of the Society of Artists and wrote that 'in future, he would carry out his duties as a trustee in every respect'.[25]

The London exhibition was not the sensation that many had hoped. Attendances were steady but not particularly notable. Only £141 was raised through 'gate money' and £33 from catalogue sales. Around a quarter of the works available found buyers. Women artists sold twenty-four works and the men twenty-five, although women's work accounted for only 15 per cent of the total sale revenue of £1085. Piguenit made the most sales. Even the so-called 'Heidelberg painters', Tom Roberts and Arthur Streeton, whose works in the exhibition were favourably reviewed, did not sell. English artist Alfred East purchased *A bush home* 1896 by David Davies.[26]

Interestingly, English reviewers were surprised to see that Australian artists were turning away from English sources and influences. One reviewer noted that 'with exception of one or two drawings ... there is nothing to suggest any tie between the colony and England'.[27] One of the most expensive works sold was *Sunset* 1900 by Tudor St George Tucker, bought by a French dealer.[28] By 1898 large numbers of Australian artists were studying in France rather than England, including many in the Grafton Galleries exhibition. The art critic for

The Times, Thomas Ward, wrote that the exhibition showed 'very little that recalls anything English; the broad, summary treatment, the firm and yet careful drawing, the manner of laying on paint are in origin French'.[29]

The Gallery subsequently participated in four other major exhibitions of Australian art in London (1923, 1961, 1963, 2013).[30] The 1923 *Exhibition of Australian Art in London* was held at the Royal Academy under the auspices of the Society of Artists. Elioth Gruner was the exhibition organiser and Gallery trustee Charles Lloyd Jones was responsible for the London committee. Most of the 235 works included were exhibited in Sydney before being sent to London, with the Gallery lending twenty-seven. Norman Lindsay's 'orgiastic scenes' were briefly delayed at customs and created a lot of press interest.[31] Sir William Orpen, who assisted in arranging the exhibition, said that they were not indecent, just 'vulgar' and 'badly drawn' with 'no sense of design and a total lack of imagination'.[32] It was at this exhibition that another of the Lindsay brothers, Lionel, was first noticed by London dealer and print expert Harold Wright, who purchased Lindsay's engraving *Pelican* 1923 for his own collection. Wright went on to become an important London buyer for the Gallery.

Increasingly the Sydney trustees were reluctant to participate in exhibitions that were both commercially competitive and lent from the collection. In 1936, when they sent 147 works to New Zealand for the opening of the National Gallery in Wellington, director JS MacDonald complained that these had been used as 'sales bait'. Trustee Sydney Ure Smith had sent other works for sale. MacDonald complained that 'these were placed among the pictures lent by this Gallery', and that as director he felt

> some resentment that the pictures owned and lent by the National Art Gallery of New South Wales should have been used as a background for pictures for sale which were collected in New South Wales by a trustee of this gallery. In my view this action cheapens the pictures we lent ... I am very much in favour of the interchange of pictures between galleries; but, this experience has had the effect of tempering my enthusiasm in that regard.[33]

Artists were often unhappy about the selection of work sent overseas. When the Gallery chose a small group of works for the 1937 exhibition *Artists of the British Empire Overseas,* organised as part of the coronation celebrations, Thea Proctor complained:

> I was surprised when a messenger from the Gallery returned my drawings this afternoon and

Hal Missingham and Kikuko, Princess Takamatsu with others at the opening of
Young Australian Painters in Tokyo, 1965. Photographer unknown

told me that two works of mine were being selected
from those in the Art Gallery. When I spoke to you
on the telephone last week, I had said to you that
I did not wish to be represented by works in the
Gallery. The two drawings I sent up for selection
are better than any of mine in the Gallery and an
artist is the best judge of her own work.[34]

Artists were particularly critical of the selection committee
for the first major survey of Australian art shown in the
United States, *Art of Australia, 1788–1941*.[35] This toured to 29
venues in America and Canada from 1941 to 1945. Because
of its size the exhibition was split into two, one section being
circulated by the National Gallery of Canada, Ottawa, and the
other by the Museum of Modern Art (MoMA), New York.
The Gallery's director Will Ashton chaired the committee
appointed by the Commonwealth government to manage the
exhibition, 'in consultation with Professor Theodore Sizer,
Director of the Yale University Art Gallery, who advised as to
the kind of work most likely to interest the American public'.[36]

More than 130 works were sent from public and private
collections, including eleven bark paintings from the East
Alligator River and two drawings by Tommy McRae. This
was the first time work by First Nations Australian artists
was included as art in a major international exhibition.
Margaret Preston wrote the introduction to this section of
the exhibition. Her painting *Aboriginal landscape* 1941 was

Lin Onus *Fruit bats* 1991

The Exhibitionists

purchased by Sizer for the Yale University Art Gallery.[37] Sizer thought that 'the great mistake we made in this exhibition is that there were not enough pictures for sale'.[38] The Metropolitan Museum in New York purchased Drysdale's *Monday morning* 1938 before Australian galleries began to take an interest in him.[39]

According to MoMA, the exhibition was 'one of the most popular shows we have ever sent on tour'.[40] At the Los Angeles County Museum, around 1200 attended the opening, including 'a large number from the local Australian colony'.[41] With the war in the Pacific, the exhibition began to be promoted as the work of our 'brother-in-arms from down under'. The director of the National Gallery of Canada wrote to Ashton, 'we watch with breathless interest the part the Commonwealth is playing in the great game and we feel certain that the flood of little brown rats will not be allowed to overflow the island continent'.[42]

Twenty-three years after this letter was received, the Art Gallery of New South Wales organised an important survey of contemporary Australian art for Japan, which included works by forty painters, printmakers and sculptors, all under the age of forty, three of them women and thirty-seven men. *Young Australian Painters* was opened in April 1965 at Tokyo's Keio Gallery by Kikuko, Princess Takamatsu. It was curated by the Art Gallery's director Hal Missingham for the Commonwealth of Australia, Kokusai Bunka Shinkokai (The Society for International Cultural Relations) and The Nihon Keizai Shimbun Press. After Tokyo, the exhibition moved to the Kyoto Municipal Art Gallery.

Sydney *Sun* critic, the artist James Gleeson, thought *Young Australian Painters* was 'a fascinating survey ... present[ing] a lively image of the wealth of individual styles ... The overall impression is one of great vitality'.[43] However, by 1965 Australian artists were increasingly forging their own connections overseas. The need for the Art Gallery of New South Wales to broker these relationships was receding. When Missingham asked Brett Whiteley about being included in *Young Australian Painters* he responded that although he would love to participate, 'I have absolutely no paintings that I can send ... Marlborough now have complete control over my work and they are planning a big travelling show of work from the last four years.'[44]

The early years of Edmund Capon's directorship coincided with the growth of diplomatic, cultural and economic links between Australia and China made by the Whitlam and then Fraser governments. Previously Daniel Thomas had curated and written the catalogue essay to the 1975 exhibition *The Australian Landscape 1802–1975: A Cultural Exchange with China*. This exhibition was organised by the Visual Arts Board of the Australia Council for the Department of Foreign Affairs and was shown in Peking, Nanking and Sydney.[45] The eighty-

five works selected came from collections Australia-wide. If the television and newspaper coverage of the exhibition accurately reflected Chinese interest in Australian art, this ended with Hans Heysen's *Summer* from 1909, despite the inclusion of more contemporary works.

Throughout the 1970s and 1980s exhibitions were organised to foster and strengthen ties between Australia and the rest of the world. The Gallery's contribution was often minor. A single painting by Jeffrey Smart was the only work lent to the exhibition of *Landscape and Image*, which toured Indonesia in 1978.[46] However, all twenty-six works in *Three Decades of Australian Landscape Painting from 1945*, an exhibition that travelled to the National Museum and Art Gallery of Papua New Guinea in 1982, came from the Gallery. The selection had originally been made for the New South Wales Trade Fair in Canton but found a more receptive audience in Papua New Guinea.

An exhibition that proved surprisingly successful in China was *A Century of Australian Landscape: Mood and Moment*, curated by Barry Pearce. It was originally planned in 1983 for Peking, Shanghai and Canton, but was subsequently shown also in Hong Kong and Manila. Managed by the International Cultural Corporation of Australia and organised by the Gallery, the exhibition included works from public collections throughout the country. Responding to a request from the Chinese for an exhibition of *traditional* landscape painting, Pearce selected a group of paintings from the Heidelberg School as the core of the show. The exhibition received over a thousand visitors a day.

In 1992 Minister for the Arts Peter Collins opened the exhibition *Strangers in Paradise* at the National Museum of Contemporary Art in Seoul, South Korea. Curated by Victoria Lynn, it was the major cultural component of Promotion Australia, a series of events organised by the Department of Foreign Affairs and Trade. The exhibition included fifteen contemporary artists whose work was not based on the familiar theme of the landscape. *Fruit bats* by Lin Onus, in which numerous sculptures of bats hang from a backyard clothes hoist, all painted in traditional ochre colours, combined 'humour and irony, the sacred and the mundane, the political and the sensory', and made a great impression upon visitors to the exhibition.[47] Lynn had previously included the work in her 1991 *Australian Perspecta*. Collins was convinced the work belonged in the Art Gallery of New South Wales and gently put pressure on director Edmund Capon to consider its acquisition.

Australia's contribution to the 47th Venice Biennale in 1997 was *fluent*, showcasing the work of Indigenous artists Emily Kame Kngwarreye, Judy Watson and Yvonne Koolmatrie. The curatorial team comprised Victoria Lynn, Brenda Croft and Hetti Perkins, who, as Croft recalled, had 'held the basic

concept of *fluent* for some years' prior to the exhibition.[48] The fluidity suggested by the title had resonance across many areas of the artists' work: art and craft, modernity and tradition, painting and sculpture, abstraction and narrative, the seen and unseen, the communal and the individual. The exhibition proved to be one of the most popular at the 1997 Biennale. Perkins joined the staff of the Art Gallery of New South Wales shortly after.

Although the Gallery made no loan of works to *fluent*, it did lend staff to the project. Victoria Lynn was the exhibition manager, bringing to the project her extensive knowledge of the international contemporary art world, invaluable at the Venice Biennale, as Croft acknowledged.[49] From the 1990s onwards the Gallery's part in promoting Australian art through international exhibitions involved releasing staff for

their particular expertise, as well as lending collection works. Tony Bond recalled that director Edmund Capon 'funded my salary to do the 1992–93 [Sydney] biennale and contributed to the 1999 biennale in Liverpool by supporting me and keeping my position at AGNSW'.[50] Such contributions echoed the Gallery's response to the commissioners of the World's Columbian Exposition in Chicago a century earlier, when it had been asked to assist with 'the promotion of Australia's peculiar artistic talents overseas'.[51]

Installation view of *Eel traps* (foreground) by Yvonne Koolmatrie and paintings (background) by Emily Kame Kngwarreye displayed in *fluent: Emily Kame Kngwarreye, Yvonne Koolmatrie, Judy Watson: Venice Biennale*, 15 June – 9 November 1997

Epigraph
'Advance Australia', *Cheltenham Looker-on*, London, 9 Apr 1898, pp 347–48.

Notes

1 Letter from P Deane, secretary to the prime minister, to Gother Mann, 23 Apr 1925, EFP1925, National Art Archive, Art Gallery of NSW.

2 See Kerry Gardner, *Australia at the Venice Biennale*, Melbourne University Publishing, Melbourne, 2021.

3 'Colonial and Indian exhibition', *Sydney Morning Herald*, 14 Apr 1886, p 4.

4 A full list of works initially selected, 'Pictures selected by the Fine Arts Committee to be sent as loan exhibits to Chicago', is attached to the correspondence from the NSW Commission, World Columbian Exposition, 82/1892.

5 Daniel Thomas, 'Introduction', in *Australian art in the 1870s*, Art Gallery of NSW, Sydney, 1976, pp 4–5. Some of these works were later deaccessioned by the Art Gallery of NSW and when Thomas curated this landmark exhibition in 1976, he borrowed a significant group of works from Victoria.

6 Oils (thirteen): Julian Ashton, *Portrait of Parkes*; Ashton, *The prospector*; Charles Conder, *Departure of the Orient – Circular Quay*; A Henry Fullwood, *The station boundary*; CH Hunt, *Evening*; W Lister Lister, *After the shower*; Frank Mahony, *As in the days of old*; Mahony, *Rounding up a straggler*; WC Piguenit, *The Upper Nepean*; Tom Roberts, *Charlie Turner*; Roberts, *Eileen*; Percy Spence, *The ploughman*; Mary Stoddard, *From earth to ocean*. Watercolours (twelve): Ashton, *Shoalhaven River*; Edward Bevan, *A preliminary puff*; Donald Commons, *The coast, Ben Buckler*; Charles Edward Hern, *Govett's Leap*; Fullwood, *Cathedral Rocks*; Fullwood, *Kangaroo Valley*; Fullwood, *Jervis Bay*; Albert Hanson, *Silvery seas*; Lister, *Stonehenge*; Lister, *Graham's Valley*; BE Minns, *Crescent Head*; Constance Roth, *Bathurst Plains*.

7 *Kakuryū Sekai Hakurankai: Bijutsuhin Gafu*, Ōkura Shoten, Meiji 26–27, Tokyo, 1893–1894, 1st ed.

8 'The Columbian World's Fair', *Argus*, 26 August 1893, p 4.

9 Letter from Edward Poynter to EL Montefiore, 13 Dec 1892, BF1/1892.

10 The published catalogue included 371 catalogue entries. Archival records prepared for shipping and insurance listed 215 paintings, 95 watercolours, 52 drawings and 9 sculptures. (Art Gallery of NSW exhibition file, EFC1898.1, National Art Archive). However, some single entries in the catalogue were for multiple works; for example, cat 272 for George Lambert was for '6 drawings', and cat 143 'Types of Aboriginals' by BE Minns was three watercolours. The index to the catalogue lists 114 artists, but David Davies was listed twice (under his Melbourne and Cornwall addresses) and Mary Stoddard three times.

11 AGNSW Minutes, 20 Oct 1897, p 485.

12 AGNSW Minutes, 15 Dec 1897, p 505.

13 AGNSW Minutes, 18 Feb 1897, p 379.

14 Four works from her own collection were lent to the exhibition, including two by Streeton.

15 Letter from Jacob Garrard to the exhibition committee, 3 Jul 1897, EFC1898.

16 £740 was eventually approved.

17 AGNSW Minutes, 14 Jul 1897, p 439.

18 AGNSW Minutes, 18 Aug 1897, p 454. Julian Ashton's name was mooted as a manager for the exhibition. In the minutes the trustees noted 'Do not engage Fletcher Weston, Confidential'.

19 The Art Society was angered that Julian Ashton was also a trustee and President of the Society of Artists, giving that Society three selectors. It asked that Albert Hanson be added on its behalf, but the trustees, by this time sick of the endless bickering that characterised everything the Art Society did, flatly refused.

20 AGNSW Minutes, 12 Jan 1898, p 513. This does not tally with the published catalogue which lists 215 paintings, 95 watercolours, 52 drawings and 9 sculptures by 114 artists.

21 AGNSW Minutes, 12 Jan 1898, p 516.

22 Prominent artists from the Art Society of NSW were also concerned only to promote themselves, with A Henry Fullwood exhibiting seventeen works and William Lister Lister fourteen.

23 AGNSW Minutes, 2 Mar 1898, p 530.

24 AGNSW Minutes, 30 Mar 1898, p 534.

25 AGNSW Minutes, 4 May 1898, pp 551–52.

26 The highest price of £300 was placed on Arthur Loureiro's large historical work *The death of Burke, the explorer* 1892. High prices were also placed on Tom Roberts, *A mountain muster* (£210) and *A breakaway* (£262.10).

27 The Architect, 'Australian pictures in London: not on the right track', *Daily News*, 18 Jun 1898, p 9.

28 Charles Sedelmeyer.

29 Thomas Humphrey Ward, 'Exhibition of Australian art', *Times*, 4 Apr 1898, p 15.

30 An interesting exhibition, *Eureka: Artists from Australia*, which was in no way comprehensive, was shown concurrently at the Serpentine Gallery and the Institute of Contemporary Arts (ICA) in London during 1982. None of the works were lent from the Gallery.

31 'Astounding pictures', *Belfast Telegraph*, 11 Oct 1923, p 7.

32 'Artists a variance', *Westminster Gazette*, 24 Jan 1924, p 4. Lindsay, clearly stung by the criticism, dismissed it in *Art in Australia* as 'the parochial chintz-patterned world of studio talk'. See Norman Lindsay, 'Lindsay's reply to Orpen', *Art in Australia*, no 6, 1 Dec 1923, p 15.

33 Letter from JS MacDonald to ED Gore, 20 Oct 1936, EFC1937.2

34 Letter from Thea Proctor to W Ifould, 5 Feb 1937, EFC1937.5, National Art Archive, Art Gallery of NSW.

35 Donald Friend withdrew his works, and the Contemporary Art Society declined an invitation for its members to submit works unless the committee was reconstructed.

36 *The Museums Journal*, Mar 1942, vol 41, no 12, p 300.

37 In 1982 Yale was induced to sell the work to the Art Gallery of South Australia.

38 Letter from Theodore Sizer to Peter Bellew, editor of *Art in Australia*, 18 Nov 1941, National Art Archive, Art Gallery of NSW.

39 The Met also bought Kenneth MacQueen's watercolour *Cabbage gums and cypress pines* 1940 and Elaine Haxton's gouache *Early colonial architecture* 1940. MoMA purchased William Constable's gouache *Design for an Aboriginal ballet, II* 1939 and Peter Purves Smith's oil *Kangaroo hunt* 1939.

40 Letter from Elodie Courter to William Ashton, 24 Jun 1942, National Art Archive, Art Gallery of NSW.

41 Letter from the Director of the Los Angeles County Museum to the Director of the Yale University Art Gallery, 31 Jul 1942, National Art Archive, Art Gallery of NSW.

42 Letter from the director of he National Gallery of Canada to William Ashton, 2 Apr 1942, National Art Archive, Art Gallery of NSW.

43 James Gleeson, 'Japanese exhibition', *Sun*, 4 Aug 1965, p 8.

44 Letter from Brett Whiteley to Hal Missingham, 9 Oct 1964, EF798.

45 Cultural Palace of the Nationalities, Peking, 2–17 Sep 1975; Kiangsu Art Gallery, Nanking, 23 Sep – 7 Oct 1975; Art Gallery of NSW, 14–30 Nov 1975.

46 This exhibition was curated by Bernice Murphy, then exhibitions co-ordinator (overseas exhibitions) at the Australian Gallery Directors Council, before she returned to the Gallery. It travelled to Bandung (27 Jul – 8 Aug 1978), Yogyakarta (19–22 Aug 1978) and Jakarta (29 Aug – 10 Sep 1978) and was titled *Pemandangan alam dan Khayal: lukisan-lukisan Australia ditahun-tahun 1970an*.

47 Bronwyn Watson, 'Paradise deglossed', *Sydney Morning Herald*, 27 Aug 1993, p 18.

48 Brenda Croft, 'Where ancient waterways and dreams intertwine', *Periphery*, no 34, autumn 1998, p 9.

49 Croft 1998, p 13.

50 Email from Tony Bond to Steven Miller, 22 Feb 2021.

51 Letter from Chicago commissioners to Frederick Eccleston Du Faur, 3 Dec 1892, CF120/1892.

9 Sydney lotus-eaters
Boom and bust, 1914–33

It is the apathy of the people living in this sub-tropical languor of Sydney that is to be blamed.

Arthur Streeton, artist, 1937

If Arthur Streeton is to be believed, the years between the two world wars marked a period of dramatic decline for the National Art Gallery of New South Wales. Visiting in 1920, he had only good things to say about the institution. This was, after all, the first gallery in Australia to recognise 'Australian artists and to purchase their pictures'.[1] His friend Tom Roberts also acknowledged it as 'the first to give me recognition'.[2] Its display of Australian art, in two dedicated galleries, was a model for the rest of the country: 'beautifully lit and arranged, Australian art is here a perfect delight'. The location of the Gallery could not be better, 'one of the finest natural positions in the world, and the Sydney folk have made the most of it. Their gallery resembles a kind of golden temple surrounded by grassy lawns and Moreton Bay trees.' Overall, this was an institution characterised by 'fine pictures, fine light, and fine arrangement'.[3]

Nearly twenty years on, however, 'the place looked hopelessly dull'.[4] It now fell far behind the National Gallery of Victoria, with its 'beautiful additions', and paintings lit by electric light. The Sydney folk and their golden temple of art had become 'lazy lotus-eaters' living in sub-tropical languor with their art 'in a hell-hole of Gehenna'. Director at the time, John William 'Will' Ashton, and vice-president of the board John Lane Mullins, were asked to respond to Streeton's remarks. They did not dismiss his criticisms out of hand but said that the real problem was one of funding, with Ashton adding, 'there is a track worn between the Gallery and the minister's room where we ask for money'.[5]

For the most part, requests for increased funding were unsuccessful. The Great Depression occurred halfway between Streeton's two opinion pieces in the press. The Gallery's statutory endowment for art purchases was reduced from £3750 in 1929 to £1000 in August 1930. Although the government wanted to keep public servants in employment, the maintenance fund for salaries also fell by over a thousand pounds. One unsuccessful proposal for dragging the Gallery out of its Depression doldrums was a 'Friends' group, which anticipated the establishment of the Art Gallery Society by twenty years. Trustees Sydney Ure Smith and James McGregor suggested that this could be based on subscriptions of 10 shillings per annum or 15 guineas for life, with the purpose of obtaining 'more funds for the purchase of works of art … and encouraging private individuals to assist the trustees by gifts and bequests'.[6]

The Exhibitionists

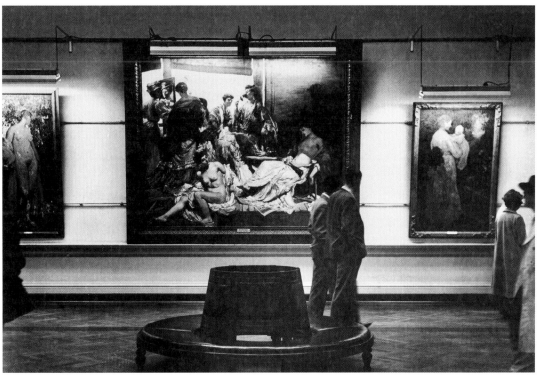

Lack of private philanthropy also retarded the Gallery's progress during the interwar years. Sydney had nothing to match Melbourne's 1904 Felton Bequest, which saw the staggering residue of £378,033 from Alfred Felton's estate placed into a trust for gallery purchases, as well as for charitable causes. Sir Thomas Elder's gift of £25,000 to the Adelaide gallery in 1897, for 'the purchase of pictures only', was the first major bequest to an Australian art gallery. Compared to these, Sydney's fortunes had been very modest. In 1895 Richard Wynne's estate was valued at over £82,000, but only £1000 was given to establish a landscape prize in his name.[7] Jules François Archibald, co-founder of the *Bulletin*, left a comparable estate of £89,000 in 1919. Once again, only one-tenth was dedicated to establishing the now famous prize for portraiture.

Throughout the nineteenth century, the government's statutory endowment to the Gallery had been generous, sitting at £5000 a year. Even during the economic depression of the 1890s this was only reduced to £3000. During the twentieth century, however, the trustees continually complained about the government's 'stinting of funds' which 'perennially handicaps' the institution and is an embarrassment for 'the National Gallery of the capital city of Australia's oldest and richest state'.[8] Funding remained at nineteenth-century levels, apart from further reductions during the Great Depression, right up until the Second World War.

If one thing came to symbolise government neglect, it was the absence of electric light throughout the building. Clark's New Assembly Hall on Elizabeth Street had been lit by gaslight, allowing exhibitions and other events to be programmed during the evenings. The Fine Arts Annexe had used electric light. But once the Gallery moved to its current site in the Domain it was without electric light for over sixty years. Vernon's historic courts had large glass lantern roofs, which reflected state-of-the-art practice when they were constructed. Light here was better than in the lower 'basement' galleries where Australian art was shown. Artist John Longstaff, in an official 1922 report, regretted 'that the work of our own artists should appear at a disadvantage'.[9] But even the Vernon courts could be dull on overcast days. Marion Mant was a regular visitor to the Gallery. When she noticed other visitors 'literally groping their way from picture to picture', she asked the attendant to turn on the lights. 'He broke into hearty and perhaps ironical laughter. "Lights!", he said, "There aren't any lights here. We haven't enough money to install them."'[10]

Lights had, in fact, been installed briefly in the entrance hall in February 1938, so that an exhibition of coronation robes and regalia could stay open to the patriotic public at night. This was also the first time an exhibition in the Domain had extended evening hours. Fluorescent tubes were later installed for the *Jubilee Exhibition of Australian Art* in 1951,

Above: Cobden Parkes, National Art Gallery: proposed completion of eastern wing, 1939 **Right, above:** Exterior view of the Gallery's conservation laboratory, c1933. Photographer unknown **Right:** Interior view of the Gallery's conservation laboratory, c1938. Photographer unknown

The Exhibitionists

Sydney lotus-eaters

but the lighting was not extended throughout the permanent courts. Director at the time, Hal Missingham, recalled that 'it was not un-heard of for the president or director to have to use torch-light when showing visitors around; and on one Royal Visit it was necessary to strike matches to see the paintings'.[11] A continual stream of letters to the press during the interwar years complained about lighting and this factor no doubt contributed to Arthur Streeton's assessment of the place as 'hopelessly dull'.

Streeton was also disappointed that the Gallery had not been completed to Vernon's original designs. For a brief period during the boom years of the roaring twenties it looked as though this might happen. But then the Depression put an end to all plans. As the economy slowly recovered, various suggestions for the completion of the northern elevation of the Gallery were revived. When George V died in 1936, after a twenty-six-year reign, the Society of Artists wrote urging that that Gallery be completed and that this new wing be dedicated as a memorial to the late King.[12] They also suggested it would be an ideal project to mark the sesquicentenary of European settlement in 1938. The building was planned in two stages, with a north-facing wing to be completed first and eventually linked to a suite of main galleries by an awkward connecting passageway. Architectural drawings show this stodgy proposed addition, typical of late 1930s architecture.

The project was never realised and the only building that did occur during the interwar years was a conservation laboratory erected at the rear of the Gallery. This was part of the government's capital spending to help ease the nation out of Depression.[13] It opened in 1933 and was the first dedicated art conservation laboratory in Australia, a concrete statement of the Gallery's proactive approach to the conservation of its collection.[14] The lazy Sydney lotus-eaters were very attentive to the care of art in the subtropical climate of their city and an interest in the general principles of conservation, along with the latest thinking about strategies, methods and innovations, runs as a constant theme throughout the Gallery's history.

When the Gallery was in temporary premises at Clark's New Assembly Hall, Edward Joseph Rubie, a director of Sydney Mutual Fire Insurance, wrote about 'a most serious subject' that had 'been urged on me by my last visit to the Hall'. He was concerned that sulfur fumes were changing the lead white in some paintings. 'There is too great a quantity of gas for the safety of the pictures,' he wrote. 'I believe that some of the half tones in the landscapes especially those with misty or morning effects originally pearly have become leaden by being exposed to too much gaslight.'[15] When the collections were moved to the Fine Arts Annexe in the Botanic Garden another problem arose and lest 'the heat in the art gallery should threaten to damage the pictures', water-cooling was applied to the roof.[16] Light levels were a constant challenge.

Édouard Montefiore reminded his brother Eliezer that 'it is not necessary probably to insist on the necessity of not exposing Lemaire's watercolour to too strong a light'.[17] Accidental damage by the public occurred from time to time, as a letter in 1895 from the father of thirteen-year-old Nellie Russell, apologising profusely for a break to the rope ladder on the sculpture *Romeo and Juliet* by Pietro Bazzanti, reveals.

Issues of light, temperature and accidental damage could usually be resolved by preventative measures. It was how Sydney dealt with works that were deteriorating through varnishing or poor-quality original materials that was more controversial and contrasted with other state galleries. Sydney's first regular 'art restorer' was the commercial framer Henry Callan, who was employed to restore and 'double-back oils in his usual manner'.[18] Restoration was confined to varnishing and filling in cracks, but, as a 1900 report noted, 'this treatment has proved only temporarily successful, the cracks quickly reappearing, with addition of fresh damage'.[19] A few works were sent overseas to their artist-creators, including *Their ever-shifting home* 1887 to Stanhope Forbes. Again 'these were returned to us apparently restored, but before long shewed signs of a renewal of the damage, and gradually became even worse than before'.

A subcommittee of trustees was formed in 1899 to investigate the 'restoration of cracked pictures'. It received an interesting submission from Alfred Murch, a picture restorer who claimed to have trained in London. Although Murch's credentials were probably fabricated, he was knowledgeable about artists' materials and did not accept, as some artists such as Edward Poynter were asserting, that the harsh Australian environment was to blame for the deterioration of works. For him it was more a problem of poor materials used by artists and the subsequent varnishing of works. Du Faur was sympathetic to Murch's views. He cited an oil painting by Edward Cook in the Gallery's collection, painted in 1842, noting that this had never been varnished and there was no other work in the collection 'of the same date in an equal state of perfect preservation'. He said that the Gallery had 'as equitable climatic conditions as any building in Sydney, I think I would say more equable', but environmental measures could not save works 'painted in false media or ruined by ignorant varnishes'.[20]

The first Gallery works then entrusted to Murch for conservation were done so under Julian Ashton's supervision. An element of rivalry is evident in their dealings with each other, with Ashton the professional artist resenting being told about materials and their correct use by a non-artist specialist. Ashton became increasingly critical of Murch and was heard to remark that some paintings should be reattributed to him because of the invasiveness of his procedures. Ashton encouraged trustee Bernhard Wise to write to Bernard Hall,

The Exhibitionists

Edward William Cook *Mont St Michel shrimpers* 1842

director of the National Gallery of Victoria, for advice. 'I am glad to say,' Hall wrote back, 'except for actual damages, we never call in the restorer ... My predecessor set his face against the restorer just as much as I do.'[21] Hall's predecessor had been artist George Folingsby. When he took over as director of the National Gallery of Victoria from Eugene von Guérard in 1882, he immediately ceased von Guérard's modest program of conservation.

Du Faur was angered by Wise's actions, as Hall had been contacted without the knowledge of the other trustees. Du Faur doubted he was acting on his own initiative, 'knowing how very little he has hitherto interested himself in Mr Murch's work and how seldom he has visited his studio'. Du Faur claimed that he had become 'the mouthpiece of Mr Ashton', who was constantly acting 'behind the backs of the trustees, his former colleagues'. Ashton used 'restoration' as code for 'repainting'. But Du Faur had watched Murch work over a long period and was sure that very little retouching had been done by him.

Around this time, Bernard Hall's non-interventionist approach began to be publicly criticised. He was accused of mismanaging the collection in Melbourne, leading to its irreparable deterioration.[22] Later, when Sydney was building its dedicated conservation laboratory, Hall faced another conservation crisis. A loan collection of seventeen paintings that had been sent to Western Australia was drenched in its packing crates by an unexpected storm. The crates were returned to Melbourne without being opened and when the works were finally unpacked the paintings were found to be covered in large opaque deposits. Hall began to restore the works himself but did further damage and eventually had to seek assistance from professional chemists.[23]

Prior to the opening of the Gallery's freestanding conservation laboratory in 1933, the 'restorer', as Murch was often called, had a workroom in the basement of the Gallery. At the centre of the room was a large table used for lining paintings, with a marble slab top that had come from the morgue at the Sydney Hospital. Murch died in 1910 of 'paralysis of the insane', the consequence of tertiary syphilis. After his death, what had been a very active and systematic program of conservation slowed and was largely managed by Thomas Hall. He had begun at the Gallery as an attendant but gradually went on to do 'frame repairs, gilding, etc as well'. He was assisted by his son William 'Billy' Hall. In 1920, when the senior attendant William Bartlett, who was known as the Gallery's 'custodian' and who had patented a method for hanging pictures that was widely used, retired, it was decided to replace him with 'an attendant who possesses a knowledge of frame-making and picture cleaning. Mr Hall, a returned soldier and son of the present conservator, was nominated for the position.'[24] Billy Hall took over completely from his father in November 1926.

Some works were found to be beyond repair and were destroyed, some were consigned to permanent storage or sold. The first sales of deaccessioned works occurred in the 1920s.[25] The funds raised, £150 in 1920 and £225 in 1926, were insignificant, but space was created on Gallery walls and in storage at a time when this became an issue for the management of the collection. The 1920 sale included a few British landscapes purchased in the 1880s, unidentified prints, copies of Old Masters, decorative arts, untitled portraits and works by immigrant artist Giuseppe Ferrarini purchased as a group in 1882. The 1926 sale was mainly of sculpture, including works that Henry Parkes had purchased from the Italian court of the 1879 Sydney International Exhibition and then presented to the Gallery. As an indication of how rapidly taste changes, these sculptures, by Giovanni Bastianini, Angelo Mencarelli and Gelindo Monzini, visible in nearly every nineteenth-century installation photograph of the Gallery, had even lost their attributions by 1926 and were simply catalogued 'by unidentified'.[26] They did not find buyers at the auction and returned to the collection until sold again under director Hal Missingham thirty years later.

The 1920 sale coincided with a visit by artist John Longstaff from London. He had been the Gallery's art adviser there since 1911 and was invited by the trustees to return to Australia to make a detailed report on the collection.[27] He submitted this in February 1922. It was not as detailed as the trustees had hoped. Longstaff made recommendations on the display of works and lighting in the galleries and particularly praised the Australian decorative art collections. He suggested a 'drastic weeding' of the European watercolours and the purchase of representative works by Lucien Simon, 'one of the greatest of modern Frenchmen', Ignacio Zuloaga, William Orpen, Augustus John, William Nicholson, Glyn Philpot and Ambrose McEvoy.[28] Clearly, he was on more confident ground when dealing with British art.

There were a number of these reports commissioned throughout the twentieth century. The most interesting was authored by Dugald MacColl in 1911, while he was keeper of the Tate Gallery in London. His focus was international purchases, not 'native artists with whose works I am unacquainted'. He apologised for speaking 'somewhat brutally' but said that the Gallery had had the misfortune of buying work during 'the hey-day of the Academy and the Salon' when

the mediocrities who compose the vast majority of such associations ... sold their pictures at absurdly inflated prices. The Whistlers and Manets were treated as Charlatans and could not get £100 for pictures that would fetch £10,000 in the market now. The Edwin Longs' obtained thousands for pictures that would not now bring £50 at auction.

The Tate and the Musée du Luxembourg in Paris were in a similar position and 'it is not unnatural,' he reflected, 'that an influence that has injured the chief public collections of Europe should affect also the New South Wales Gallery. The unfortunate result is that the Gallery seems to possess not a single picture of the first rank.'

After delivering this blow he concluded, 'the only way to get a good collection together instead of the present very poor one, is to commission someone of competence to buy for you, with full responsibility. Committee purchases are hopeless, it is better to take risks with one individual.'[29] This is exactly what the Gallery did when it appointed John Longstaff, empowering him to act alone and make purchases up to £1000 without consulting the trustees. After nine years and generally lacklustre purchases from the Academy and Salon (all works now deaccessioned), it reverted to a committee. Artists Frank Brangwyn and George Frampton joined Longstaff in 1920.

Vic Mann himself was sent on a European buying trip in 1926 and given £3000 to spend. He visited Venice and Paris with artists William Orpen and John Arnesby Brown, purchasing works by both of them. He was particularly eager to see the Venice Biennale, 'when all nations will be represented', as he had missed the 1914 exhibition because of the outbreak of war.[30] His purchases, however, give no idea of what was on offer that year. The German pavilion included work by Otto Dix, Lyonel Feininger, Lovis Corinth, Max Beckmann and a survey show of Oskar Kokoschka. The French had a group exhibition with Pierre Bonnard, Edgar Degas, Raoul Dufy and twelve works by Henri Matisse and 14 by Édouard Vuillard. A huge range of Italian work was on view, including a solo exhibition by Giovanni Segantini. In the Russian pavilion, the founder of the Futurist movement, Filippo Tommaso Marinetti, had curated a survey of Italian Futurism. Mann came away with prints and drawings by Belgian artist Félicien Rops and his student Armand Rassenfosse, two oil paintings by Venetian scenographers Italico Brass and Ettore Tito and a still life by Hungarian János Pentelei-Molnár.[31] His chief purchase in Europe was *Le vieux pont* by Corot.[32] He told the press when he returned that he was sure that the modern work he had seen on his trip 'will not last much longer', adding 'I endeavoured to obtain a few examples of these atrocities to exhibit in Australia as a moral lesson, but I was unsuccessful. I was told that they were too valuable to be lent.'[33]

Romeo and Juliet c1878 by Pietro Bazzanti on display at the National Gallery, Sydney, c1900. Photographer unknown

The Exhibitionists

Epigraph
'Art in a hell-hole of Gehenna',
Daily Telegraph, 13 Apr 1937, p 7.

Notes

1 'Arthur Streeton's art', *Sydney Morning Herald*, 21 Nov 1931, p 8.
2 Letter from Tom Roberts to Basil Burdett, 2 Jul 1928. MS1995.9/ARC129, John Young and Macquarie Galleries Archive, National Art Archive, Art Gallery of NSW.
3 Arthur Streeton, 'National art collections. a breezy criticism. Melbourne and Sydney compared', *Argus*, 21 Aug 1920, p 6.
4 'Mr Streeton criticises National Gallery', *Sydney Morning Herald*, 20 Oct 1936, p 10.
5 'Art in a hell-hole of Gehenna', *Daily Telegraph*, 13 Apr 1937, p 7.
6 AGNSW Minutes, 24 Mar 1933, p 1305.
7 Richard Wynne died on 15 June 1895 and directed that proceeds from an invested £1000 be used for a yearly prize 'to be known as the "Wynne Art Prize" to be paid and handed over to the Australian Artist producing the best Landscape Painting of Australian Scenery in Oils or Water Colours or the best production of Figure Sculpture executed by an Australian Sculptor'. The first Wynne Prize was awarded in 1897 to Walter Withers for *The storm.*
8 'Purchasing funds', *1929 annual report of the National Art Gallery of New South Wales*, p 4.
9 He made the practical suggestion of removing the copies of Old Masters, then hung in the Vernon courts, and replacing these with Australian works. Report by John Longstaff, 19 Feb 1922, glued into the AGNSW Minutes, 1916–23.
10 Marion Mant, 'Gloom and Depression', *Sydney Morning Herald* 12 Aug 1938, p 15.
11 Hal Missingham, *They kill you in the end*, Angus and Robertson, Sydney, 1973, p 119.
12 AGNSW Minutes, 28 Feb 1936, p 1529 and 27 Mar 1936, p 1535. The trustees had, many years before, decided that if this wing was completed it would be named in honour of George V.
13 It cost £5000 and was allocated from the Unemployment Relief Fund by the Minister for Labour and Industry.
14 Melbourne 'demonstrated a more cautious approach, with the presence of a single conservator well into the second half of the twentieth century, as was the case in Adelaide ... and other state collections'. Carl Villis, 'Preface', in Carl Villis and Alexandra Ellem (eds), *Paintings conservation in Australia from the nineteenth century to the present: connecting the past to the future*, contributions to the 11th AICCM Paintings Group Symposium, National Gallery of Victoria, Melbourne, 2008, p iv.
15 Letter from Joseph Rubie to Frederick Eccleston Du Faur, 26 Nov 1878, CF35/1878.
16 Letter from Franz Reuleaux, Commissioner for Germany, to Frederick Eccleston Du Faur, 21 Nov 1879, CF24/1879.
17 Letter from Édouard Montefiore to Eliezer Montefiore, 19 Oct 1894, BF28/1894.
18 Minutes of the monthly meetings, 28 Mar 1895, p 170. Before Callan, the Gallery often used Thomas Henry Fielding, who operated a business as a dealer in paintings from 170 Pitt Street, but also advertised himself as a 'picture restorer'. In March 1882 he wrote 'having completed the cleaning and restoring of "The Coming Storm" by Miles in the Art Gallery and it having been intimated to me that I could take out the cracks in the "Relief of Leyden" and the George Cole pictures, I have the honour to ask you when it would be convenient for me to do them. I was in the Gallery on Saturday last and I noticed that one of the rooms was closed to the public. I could easily effect the object there whilst the room is closed.' Letter from Thomas Henry Fielding to Montefiore, 20 Mar 1882, CF14/1882.
19 Report inserted into the AGNSW Minutes, 19 Jan 1900, addressed to Thomas Devitt, Chairman of the London Selection Committee.
20 Letter from Frederick Eccleston Du Faur to the board of trustees, 27 Jan 1905, pasted into the AGNSW Minutes, 1903–09. Elsewhere it is noted, 'Our Walls are 27 inches (3 bricks), no direct sunrays can reach our pictures, through outer and inner skylights, and the temperature ranges from extremes of 45 degrees [7°C] in Winter to say 85 degrees [29°C] in Summer, but rising and falling gradually, very rarely above 75 degrees [23°C] or below 50 degrees [10°C].' Report inserted into the AGNSW Minutes, 19 Jan 1900, addressed to Thomas Devitt, Chairman of the London Selection Committee.
21 Letter from Bernard Hall to Bernard Wise, 16 Nov 1904, pasted into the AGNSW Minutes, 1903–09.
22 See Alex Ellem, 'Danger and decay: A restoration drama concerning the National Gallery of Victoria 1899', in Villis and Ellem (eds) 2008, pp 11–23.
23 'Gallery pictures damaged: stains defy analysis', *Herald*, 3 Jun 1930, p 21.
24 AGNSW Minutes, 28 Apr 1920, p 304.
25 Through William Little Auctioneers, 22 Oct 1920, and James R Lawson Auctioneers, Feb 1926.
26 The list of works that were considered possible items for sale in 1926 was extensive and would have depleted the Gallery of nearly all of its works by Conrad Martens. Some trustees, however, objected to the plan to deaccession works and sell them at auction.
27 Longstaff was appointed in June 1911. The appointment included the payment of all travelling expenses and an honorarium at the rate of £100 per annum.
28 John Longstaff, 1922.
29 Report to the trustees by Dugald MacColl, 22 Jan 1911, inserted into the AGNSW Minutes, 1909–16, after p 123.
30 Letter from Gother Mann to the Under Secretary of the Department of Education, 15 Sep 1925, inserted into the AGNSW Minutes, 1923–29.
31 Rops had a solo exhibition at the 1926 Biennale and the drawings by Rassenfosse were purchased from an exhibition in the Belgian pavilion entitled *La scuola di Laethem-Saint-Martin*.
32 This work is now only attributed to Corot.
33 'Atrocities: modern art condemned', *Sun*, 28 Oct 1926, p 12.

10 Little evidence of lusty youth
Art wars, 1929–39

PHRYNE befone PRAXITELES.

Modern paintings ... so far we have kept them out of the Art Gallery and I hope we shall continue to do so.

Sir John Sulman, president of the trustees, 1930

"CATCH!"

Also in Venice for the 1926 Biennale, along with Gallery director Vic Mann, was Australian artist Will Ashton. Although 'once esteemed a rather daring painter himself', Ashton was 'haunted' by the modern art he saw in Venice. Everywhere, there were canvases 'horribly disfigured with paint' and for the first time he saw mixed media works of art 'having pieces of matches, scraps of carpet and bits of steel stuck on them here and there'.[1] Ashton became director of the National Art Gallery of New South Wales from 1937 to 1945. Needless to say, the years of his directorship were not adventurous ones for the Gallery.

He is characterised – unfairly – as the director who refused to show at the Gallery the most important exhibition of the interwar years, the 1939 *Herald Exhibition of French and British Contemporary Art*.[2] He was the director who failed to purchase from this exhibition works by Picasso, Van Gogh, Cézanne, Gauguin and other significant artists, when many were available 'for a song'. He was the director who then consigned these works to basement storage when they were stranded in Sydney during the Second World War, rather than show them on Gallery walls. Neither assertion is true, despite both having become commonplace in Australian art history.

The only city to show the entire *Herald* exhibition at the state gallery was Adelaide, where the exhibition began its tour and where the director, Louis McCubbin, was fully supportive of it.[3] Ashton had hoped that the show would be similarly shown in Sydney, but the Minister for Education ruled that admission charges benefiting a third party, here the Herald chain of newspapers, were not allowed. Charles Lloyd Jones, a trustee of the Sydney gallery, then offered the sixth floor of his David Jones' George Street department store.

The National Art Gallery of New South Wales did buy what it thought was a Gauguin from the exhibition, as the National Gallery of Victoria bought what it thought was a Van Gogh.[4] Sydney acquired eight works from the show, more than any other gallery in Australia, and expended most of its purchasing budget doing so, when both Adelaide and Melbourne had more to spend on acquisitions. Paintings by Derain, Camoin [Gauguin], Marquet, Steer and Tonks were purchased directly from the exhibition, while works by Léger, Hunter and Sickert were acquired later. The National Art Gallery of South Australia bought four works by Stanley Spencer, Morland Lewis, Henry Tonks and Charles Despiau. The National Gallery of Victoria, Australia's richest, bought a Félix Vallotton and the painting attributed to Van Gogh.

Previous page: Percival Ball *Phryne before Praxiteles* 1900 (detail) **Left:** Unk White, 'We collect your waste' cartoon in the *Daily Telegraph*, 4 June 1940 **Facing page, clockwise from top left:** Charles Camoin *La cabaretière* 1899, Albert Marquet *The Pont Neuf in the snow* late 1920s, André Derain *Landscape* c1928

The Exhibitionists

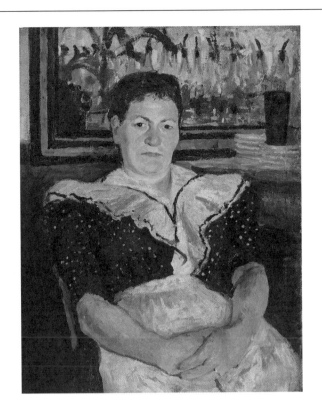

Both Sydney and Melbourne paid the same price for their fake Gauguin and fake Van Gogh, around £2200. This was not a bargain price and most of the works in the show by major artists, all well-known in Australia by this time despite few of their works having been shown in the country, were priced beyond the reach of Adelaide and Sydney. The two major Cézannes, *Portrait of Madame Cézanne* 1888–90 and *Bibémus* 1894–95, were priced at £14,000 and £13,800 respectively. Sydney would have had to commit its annual statutory endowment of £2500 for nearly five years to purchase such a work. Louis McCubbin had hoped to acquire a still life by Gauguin for Adelaide, preferably *Fruits sur une table* 1889, but he realised that 'the prices are too high as far as our Gallery is concerned'.[5]

Before the exhibition closed at David Jones, its curator Basil Burdett wrote to the Sydney trustees offering loans from the show. War had broken out in Europe and Keith Murdoch was anxious that 'some of the more important works should find asylum' at a public gallery, as it was unsafe to return them to their owners.[6] Ashton chose forty-two.[7] These were placed on display between January and June 1940. When they were then put into basement storage a full-blown 'gouty art battle' erupted, with the Sydney arts community dividing itself into the 'PBs' and the 'NBs', the pro-basementites and non-basementites.[8] Ashton was heckled by over two hundred artists, writers and musicians when he visited the Australian Writers Club to address a conference. Artists petitioned the Minister to intervene and ensure the Herald collection was rehung. It was, in fact, rehung a number of times and without the Minister's insistence, with works inserted into exhibitions the Gallery curated: in November–December 1940 as part of the *Exhibition of Continental Art*, from mid 1941 to mid 1942 in a general collection rehang, in November–December 1943 as part of the *'Subject' Pictures Exhibition*, and in October 1944 as part of *An Exhibition of French Art*.

The 1940 'art in the basement' controversy had a greater impact in Sydney than the actual showing of the exhibition during 1939. At the height of the controversy, the Minister told Ashton that he 'was under great pressure from the Cabinet, the Public, and Art Bodies, to either amend the present Art Gallery Act to enable him to replace some of the Trustees, [or] provide for a limit to the age of a Trustee to either 65 or 70 years of age, and tenure of appointment to 5 or 7 years'.[9] The Act was eventually amended so that trustees were appointed for a fixed term and an age limit of seventy years was set. Mary Alice Evatt, a modern art enthusiast, was made a trustee in 1943, in response to criticisms made during the show. She was the first woman appointed to an Australian art gallery board.

The curator of the *Herald* exhibition was the art critic and former Sydney gallerist Basil Burdett. He was working for the Herald and Weekly Times when he assembled the show in Europe, with the newspaper's financial backing and the support of chairman Keith Murdoch. It is interesting to reflect that this landmark exhibition, often compared to New York's Armory Show, would not have occurred if Burdett had been successful in his two attempts to become director of the National Art Gallery of New South Wales, firstly in 1929 and then again in 1936. On both occasions he was a strong contender. In 1936 it was only public servants who were initially considered: artists Douglas Dundas and Phyllis Shillito, then teaching at East Sydney Technical College, Rah Fizelle and the architect Ernest Osborn. When none of these proved suitable, the trustees widened their search, interviewing artists Will Ashton, Erik Langker, Douglas Pratt and the outsider Basil Burdett. Burdett received six votes, Ashton seven.[10] Artist Margaret Preston wrote to the trustees in support of the progressive Burdett.[11] She knew him well, as did many artists, from his time in Sydney when he established the New Art Salon in 1923 and, two years later, co-founded the influential Macquarie Galleries. His previous attempt to become director had been in 1929 when he lost to James Stuart MacDonald. George W Lambert voiced the feeling of many artists when he expressed his regret to Burdett had he not been appointed 'to the position which I feel you could have filled so well'.[12]

There is no doubt that Burdett would have made an excellent director. He had an equal interest in Australian and international art, the contemporary and the historical. He made friendships across a wide social spectrum and could charm the influential. He talent-spotted younger artists Russell Drysdale, Albert Tucker, Arthur Boyd, Peter Purves Smith, Eric Thake, Sam Atyeo and Danila Vassilieff. Under him, the National Art Gallery of New South Wales would not have been seen as a 'mausoleum to art' during the interwar years, which is how it is often characterised.[13] Murdoch wrote that this period was an ebullient time, 'with eager debates and discussions, adventurous writings, quick clearances of art books, exhibitions in all corners of all cities', but what it lacked was 'great art leadership and knowledge'.[14] Burdett would have provided this.

The man who was appointed in 1929 instead of Burdett also had the capacity for such leadership. James Stuart MacDonald came from a well-connected Melbourne family and prime minister Robert Menzies wrote that he received his first lesson in painting 'from Tom Roberts when he was a small boy perched on Roberts's knee'.[15] He studied first at the National Gallery School under Frederick McCubbin, then in London at the Westminster School of Art and for six years

Right, above: JS MacDonald *Self portrait* c1921 **Right:** Sample pages from the 1931 book *New South Wales Art Gallery pictures*, a groundbreaking publication for its time and the initiative of director JS MacDonald

The Exhibitionists

SONS OF CLOVIS

E. V. LUMINAIS (FRENCH, 1822–1896)

THE WHITE GLOVE

G. W. LAMBERT, A.R.A. (AUSTRALIAN, 1873–1930)

Plate 22.
A superb illustration claiming aesthetic consideration on account of its decorative qualities, its qualities of draughtsmanship and the interest of its historical subject matter. Its masses are well placed, and the structure of the whole is simple and sound. The colour is restrained and the tonal masses are well balanced one against the other.

Plate 23.
Perhaps the best designed of all Lambert's portraits. Distinguished by its dash and unity, its remarkable characterisation and handling. The concealment and placing, especially modelled of the face, complete the rhythm. In some absolute way the epitomise the type, but as Rigaud, with his unerring/unobtrusive technique crystallised his period.

in Paris. He was not as successful exhibiting in Paris as his friends Hugh Ramsay and Rupert Bunny, but was luckier in love, marrying fellow art student, the American Maud Keller in 1904. They moved to New York where MacDonald taught art history and wrote criticism for various art journals. When war broke out MacDonald enlisted, although he was thirty-six at the time, giving his profession as 'artist'.[16] On the 27 April 1915 he received wounds to his shoulder and ribs at Gallipoli, described in the military record as 'slight'. He spent a week in a hospital in Alexandria and then worked in the military records division until commissioned as a war artist.

While in France he became very ill with gastric complications. He complained of 'stiffness in head, digging in stomach, depression' and the report said that he was 'very nervy'. Chronic dyspepsia was diagnosed, but it was noted that he had 'suffocating feelings at nights, occasionally during day'. He continued to suffer from dyspepsia as an older man, along with bouts of depression. Like many others who returned from the killing fields of the First World War, he used alcohol to dull chronic anxiety. No account of MacDonald is complete without taking all of these factors into consideration. They explain, in part, his increasing combativeness after the war.

Director in Sydney from 1929 to 1936, MacDonald was innovative in this role. His 1931 publication *New South Wales Art Gallery pictures*, a large-format book illustrated with excellent colour prints, was the most attractive and engaging collection handbook produced in Australia at the time. He was passionate and knowledgeable about art publishing, having written one of the first monographs on an Australian artist in 1916, *The art of Frederick McCubbin*.[17] Further monographs followed on Penleigh Boyd (1920), David Davies (1920) and George W Lambert (1920), as well as contributions to general publications, such as Basil Burdett's *Australian landscape painters of today* (1929). The trustees, when interviewing for a new director in 1929, resolved that the person appointed must be a confident public speaker. MacDonald wrote and lectured widely, broadcasting the series *Adventures in art* for the then newly established Australian Broadcasting Commission. He proposed setting up an 'Art Reference Bureau' at the Gallery based on the Witt Library at the Courtauld Institute of Art in London, revealing his awareness of the best international resources. Under him, the Gallery initiated the first large-scale multi-lender retrospective exhibitions of Australian artists; Arthur Streeton (1931–32), Elioth Gruner (1932–33) and Hans Heysen (1935). Despite these achievements, MacDonald has become the *bête noire* of Australian art history, remembered for his 'insulting', 'immoderate' and 'intemperate' expostulations about modern art.[18]

Right, above: Freeman Brothers *Sir John Sulman* 1893 **Right:** Elioth Gruner hangs his solo exhibition with JS MacDonald, 20 December 1932

 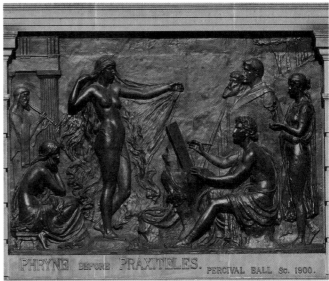

At the Gallery, MacDonald had John Sulman as president of the board of trustees. Frederick Eccleston Du Faur had died in 1915, after exceptional service to the Gallery for forty-four years.[19] Sulman almost matched his record, going on to serve in various official roles for thirty-five years. MacDonald said, 'no one but I realised the full extent of the service given by Sir John to the Gallery ... invariably thorough and unstinted'.[20] They were a well-matched pair. Sulman, like MacDonald, believed modern paintings 'the produce of incompetents or cranks, and why some few people buy them is beyond my comprehension. So far we have kept them out of the Art Gallery, and I hope we shall continue to do so.'[21] On the whole, they achieved their aim.

When MacDonald famously wrote that the 1939 *Herald* exhibition was the work of 'degenerates and perverts' he had already left the National Art Gallery of New South Wales to become director of the National Gallery of Victoria. The words were taken from his report on the paintings – 'nine exceedingly wretched paintings' – that the Contemporary Art Society suggested be purchased for the Melbourne Gallery. He ended his report declaring that 'if we take part by refusing to pollute our gallery with this filth we shall render a service to Art'.[22] Both Sulman and MacDonald believed that their campaign to keep Australian galleries free from degenerate modern art was a patriotic one, aimed at preserving Australian culture from imported maladies. MacDonald, in particular,

Percival Ball plaster cast for *Phryne before Praxiteles* 1899 and the final bronze relief on the facade of the Gallery

after experiencing the carnage of the futile European war, had no time for an art that he believed 'reflected a world getting over a very bad illness'.[23]

The claims of modern art's degeneracy were not new. Du Faur spent nearly six months in Europe during 1911 and said that he found 'little evidence of lusty youth among the younger artists'. In every gallery he saw 'a lifelessness that suggests impoverished blood'. He quoted leading French critics saying that younger artists, charged with the transmission of tradition, either had little knowledge of it, or *à chàque instant la trahissent* (betray it at every moment). They were attracted by the new tendencies, confounding *l'oeuvre de mode, avec l'oeuvre d'art* (the world of fashion with the world of art). This situation called for drastic action and Du Faur proposed 'that the Trustees, for the immediate future' stop buying easel paintings and 'lay themselves out generally, not absolutely, to utilising their accumulated funds for the external decoration of the Gallery'.[24]

For architect Sulman, this resolution had an obvious appeal. MacDonald recalled that Sulman's 'first important duty' at the Gallery 'was performed as a member of the subcommittee which decided to place the first bronze relief panel on the exterior'.[25] That panel was commissioned in 1899, the year Sulman became a trustee. British sculptor Percival Ball, who had been living in Australia because of his poor health, suggested filling the blank panels on Vernon's facade with bas-relief sculptures. His idea was to represent the various 'epochs of art', beginning with the Assyrian, through the Egyptian, Greek, Roman, medieval and ending with

Walter Liberty Vernon, View of completed Gallery, c1910

the Renaissance. Others had in mind the allegorical panels that Bertram Mackennal had successfully completed for the Parliament House in Melbourne and suggested an alternative scheme based on the arts and industries. Ball's suggestion met with greater support and in 1899 he completed a plaster cast for the third, rather than the first, panel in the sequence.

'Two naked women for the price of one', the Gallery's curator of prints and drawings in the 1970s and '80s, Nicholas Draffin, used to joke, 'how clever to start with that panel'. It shows the courtesan Phryne being sketched by Praxiteles, supposedly her lover at the time. Praxiteles used her as the model for his statue of the Aphrodite of Knidos, reputedly the first nude statue of a woman in ancient Greece. Ball's plaster cast of the panel was tested on the facade in November 1899 and the artist was then commissioned to take it to England for casting. Bronze was chosen over marble, as the latter was thought to be too reflective. Before casting, however, Ball made a few adjustments to his original design. In many ways this led to a diminishment of the work. It became crowded with male attendants and a musician. Praxiteles was made younger, less clothed and buffed, and the seated courtesan decidedly more bored. Compared with his original conception, the completed panel had less *fin de siècle* whimsy and grace.

It was intended that Ball should complete all six of the reliefs, giving an artistic unity to the whole. However, he died in London before even the first panel could be cast.[26] His brother supervised this in Somersetshire. Local foundries

in New South Wales believed that the trustees should have assigned the project to them and not have accepted Ball's claim that only a European company was skilled enough to complete it.[27] Sculptor James White could have managed the task in his Petersham studio. Ten years earlier, he had both sculpted and cast a life-size statue of William Bede Dalley for Hyde Park, and declared it the first use of the 'lost wax' process of bronze casting in Australia.[28]

Realising that the death of Ball had created opportunities for other artists to complete the panels, White sent in a plaster design for the preceding Egyptian panel.[29] The trustees stalled him as they debated how to proceed with the scheme. At the dedication of the first panel on 27 March 1903, Du Faur told those assembled that the trustees were considering commissioning a new panel every five years, drawing upon talent from an entire generation. By this time, the Gallery portico had been completed and the architect Vernon believed a more pressing need was the decoration of its tympanum with a statuary group.[30] His watercolour sketch of the completed gallery included this, executed in stone, along with bas-relief panels and even statuary along the roofline.

The trustees called for competitive designs for the Assyrian and Egyptian panels on 23 October 1903. The conditions required 'quarter full-size models' to be sent to Alfred East in London. It was non-Australian artists that they had in mind to fill the empty niches. In fact, they wrote to East encouraging him 'to induce M. Auguste Rodin and/or other

The Exhibitionists

eminent French sculptors to compete'.[31] French sculptors were widely considered superior to British ones, as one reviewer from the period noted, 'in sculpture we are behind the other nations, and notably behind the French ... There is a pedantry in most of the work of our sculptors ... Elegance of form and refinement of expression are aimed at rather than the rendering of the more brutal realities of life.'[32] Four submissions were received from Australia and another three from London. The identity of the artists was concealed from the trustees when they judged the competition.[33]

The Egyptian panel was awarded to Lady Feodora Gleichen for a relief of Queen Hatasu, or Hatshepsut, giving directions for the construction of her famous avenue of ram-headed sphinxes. It was noted that as a female artist Gleichen had chosen a strong female subject. A mid-career sculptor who exhibited regularly at the Royal Academy, Gleichen was posthumously made the first woman member of the Royal British Society of Sculptors. She operated her studio, inherited from her artist father, out of St James's Palace, where the family had originally been given grace-and-favour apartments by Queen Victoria.

The Assyrian panel was awarded to Gilbert Bayes for 'Assur Natsir Pal, King of Assyria'. Reviewers got their Assyrian kings confused and instead of writing of Ashurnasirpal II (884–859 BCE) and his palace at Nimrud, they said that the panel represented Sennacherib (705–681 BCE) viewing the progress of his palace at Kouyunjik (Nineveh), despite Bayes' clear inscription on the bottom of the work. Bayes was familiar with the sculptural reliefs and statues that had been brought from both sites to the British Museum and the legs of a lamassu are just visible in his panel. Both artists were asked to proceed with full plaster casts. A second prize was awarded to James White for 'Thothmes visiting the temple of Denderah'. The unsuccessful competitors were Theo Cowan for an Egyptian panel and John Robertson Tranthim-Fryer for an Assyrian panel.[34] The Sydney firm of Alex Sherriff & Sons in Annandale had also submitted designs for both panels.

Bayes and Gleichen modelled their full plaster casts in 1906. Bayes' was cast and shipped in the same year and installed in February 1907. Gleichen's was cast in 1907 and installed in 1908. The complexities of commissioning and then seeing works through to casting was time-consuming and expensive and so the trustees had little appetite for another competition to complete the final two panels. Artists, nonetheless, sent in submissions, including Harold Parker for a Roman panel in 1911, JC Wright ('recently from Scotland') for a Norman panel in 1912, Swiss-born Rosa Langenegger for a Romulus and Remus panel in 1914, and Theo Cowan for another Roman panel, *Antonia and the sculptor*, in the same year.[35]

Rather than continue with the epochs of art, the trustees in 1913 commissioned Australian-born Dora Ohlfsen, who

Two plaster casts of rejected designs for the facade of the Art Gallery: James White *Thothmes visiting the temple of Denderah* (present whereabouts unknown, as illustrated in the *Sydney Mail* on 11 January 1905) and a Roman panel by an unknown artist (National Art School, Sydney)

had been living in Rome since the turn of the century, to execute a work for the entrance portico, immediately over the front doors.[36] The rectangular panel, about 8 metres long and 1½ metres high, was to show a chariot race, with two 'relief heads which might represent Michelangelo and another ... to fill the square spaces at each end of the long panel', now turned into windows.[37] Had the commission been realised, these would have been the only works on the Gallery's facade by an Australian-born artist. However, there were disagreements from the start. In 1916 Ohlfsen argued that 'those two end panels should be used for decorative purposes and not for heads of Michelangelo and Leonardo da Vinci ... two enormous heads in relief will kill the principal panel'.[38] After making her fifth modification to the design she lashed out, 'once in plaster I cannot make any more changes. By the

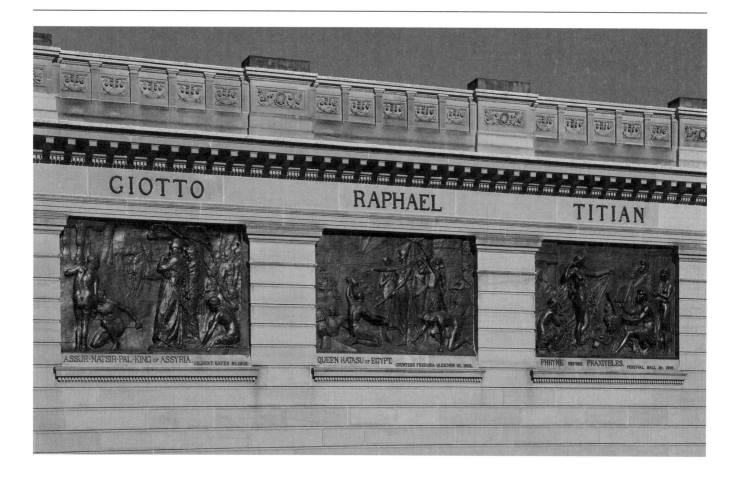

way, how many photographs did Countess Gleichen send out of that amateur abortion of hers?'[39] Because of the war, the cost of casting had also increased substantially from her initial estimate of £150.

On 26 September 1919 the commission was cancelled. Ohlfsen was devastated. 'I cannot tell you how amazed I am, nor how incomprehensible it all seems to me nor how unexpected,' she wrote to the Gallery's agent in London, noting that this would do 'very great damage to me as an artist'.[40] She appealed to the premier, as she knew that the trustees were spending thousands of pounds on finalising two large equestrian statues by Gilbert Bayes for the front of the gallery. She suggested ways of reducing costs and delaying casting, but the trustees were unmoved. When they learnt that she was planning to return to Australia, Sulman warned Mann, 'Miss Ohlfsen is a woman, and although she has no case, can cause mischief.'[41]

The two equestrian statues by Bayes had been commissioned in 1915 while Ohlfsen was still working on her panel. Initially, in 1912, the trustees had planned to place reproductions outside the Gallery, either of the so-called Marly Horses, then in the Place de la Concorde in Paris,

or of August Kiss's *Mounted Amazon* and Albert Wolff's *Lion fighter* from outside the Altes Museum in Berlin, at an estimated cost of between £4000 and £5000. The Marly reproductions were chosen, but when Mann was in Europe in 1914 he saw examples and thought them 'absolutely unsuitable'.[42] Bayes and Harold Parker were then approached to submit designs. Bayes was chosen, provided he change 'certain proportions of the horses and figures which appear defective'.[43] His quote for the two statues, including casting, was £3000. In 1918 the full-size plaster casts were exhibited in the quadrangle of Burlington House as part of the Royal Academy's Summer exhibition. The Gallery's annual report for 1919 noted that casting would be delayed due to an increase in cost. Bayes asked for an additional £1822, which was reduced to £1400 with further tendering. Both works were dated 1923, the year they were cast.

Above: Facade of the Gallery showing the completed bas-relief panels of *Assur Natsir Pal, King of Assyria* 1906 by Gilbert Bayes, *Queen Hatasu of Egypt* 1906 by Feodora Gleichen and *Phryne before Praxiteles* 1900 by Percival Ball
Right: Dora Ohlfsen *Chariot race* c1918, proposed design for bronze relief above the entrance doors to the Gallery, mocked up from photographs of the plaster model held in the Gallery

The Exhibitionists

Once the works were completed, a small crisis developed around where to place them. The plinths angled at each side of the Gallery's stairs were the intended location, but it was soon clear that the sculptures were too large and would dwarf the facade. Few trustees liked a positioning immediately in front of the two wings of the facade – where the statues currently are located – as it was believed that this would mar a view of the building and the bas-reliefs. When the Botanic Garden refused to locate the statues across the road from the Gallery in a landscaped garden, the trustees offered them unconditionally to the Department of Agriculture.[44] The department declined, as it did not have the funds to deal with them. Their current location is an exasperated compromise. Bayes was not happy. He wrote:

> from a sculptor's point of view, the alteration was to be regretted as the groups set at an angle as originally proposed, on the steps, with horses and riders looking slightly inwards, present the best view most usually towards the spectator; the plainer side of the groups being turned rather towards the wall.[45]

By November 1926, when the statues were finally set in place, the trustees were beginning to regret their 1912 resolution to spend less money on European easel paintings and more on the external decoration of the building. The names on the entablature were another problem, criticised for being misleading, as people read them as the names of the artists who had designed the bas-reliefs below.[46] Or they were said to provide 'a permanent daydream of old masterpieces, whose equivalent could never be seen inside the building'.[47] When the names were chosen, there was no ambition for the Gallery to collect Old Masters. This was a 'collection of contemporary art rather than of the older schools', as Dugald MacColl noted in his 1911 report.[48] Like similar names around the National Archives in Paris, a building familiar to Du Faur, they were a catalogue of luminaries in the world of visual culture. They were aspirational, intended more as a challenge to Australian artists rather than a wish list for future Gallery acquisitions.[49]

As late as 1965 there were calls for the names to be removed. Trustee and artist Douglas Dundas suggested that they be replaced by the names of 'notable Australian artists'. The trustees agreed in principle but could not decide on who

should be included 'as names,' they noted, do not 'always endure the test of time'.[50]

In the hope of seeing the facade panels completed, a pet project of Sulman's, in February 1927 Sulman offered to finance the Roman one. He had hoped to secure Bertram Mackennal, but the offer of fifty pounds for a plaster model and 'a price not exceeding £1000' for the full commission was not attractive enough. Mann suggested British sculptor William Reid Dick instead. Architect Sulman set the subject: 'the influence of Roman Art as shown in the use of the Arch in architectural and other works of construction'.[51] The sculptor's first sketch did not impress the trustees, who suggested he use an aqueduct rather than an amphitheatre to showcase the arch and incorporate the figure of Augustus, based on his statue in the Vatican. Dick modified his design accordingly and cleverly incorporated the raised right arm of Augustus from the statue, giving it to one of the attendants. Unlike Dora Ohlfsen, who politely modified her designs numerous times as asked, he made this one major change and then proceeded with the plaster cast.

The trustees were taken by surprise when their London agent wrote in November 1931 that the work was completed and 'Mr Reid Dick seems to have little doubt about the acceptance of his panel'.[52] Sulman, in fact, did not like it and told this to François-Léon Sicard, the sculptor who had designed the Archibald Fountain in Sydney's Hyde Park. But Dick was resolute, as the London agent made clear:

> The panel has been executed in the style of
> relief to which Sir John objected, both because
> he disliked the style and because it would not

Above, top: Gilbert Bayes *The offerings of war* 1923 being packed at the foundry in London for shipment to Sydney **Above:** Travel association poster design for the National Art Gallery of New South Wales, 1926. Artist unknown

The Exhibitionists

harmonise with the existing panels. Mr Reid
Dick was quite polite and friendly, however ... he
explained to me that he will *not* do a panel in low
'picture' relief and said that no first-class sculptor
in this country today will work in that relief ... he
may have a strong case if he wishes to press it.[53]

The panel was completed as the artist wished and unveiled
by the governor on 3 December 1931. Sulman died three
years later and with him all drive to continue the external
decoration of the building. MacDonald wrote his moving
obituary for *Art in Australia*:

Tracing through the minutes books for
information one finds them bristling with records
of helpful deeds undertaken by [Sir John] ...
usually the disagreeable tasks – bearding the
political lions, wincing and roaring in their lairs at
the merest hint (often imaginary) of derogation
from their authority: the thick-skinned, thin-
skinned human paradoxes. He was the first to
arrive at meetings; the last to go, striding, with lithe
steps, across the Domain ... His strong brain to the
last entertained a vigorous, clear and supple mind,
which, when it winged from its mortal control, left
the National Art Gallery of NSW the poorer.[54]

Plan for suggested approach to the Gallery, showing the position of the
Gilbert Bayes equestrian statues and the Shakespeare Memorial by Bertram
Mackennal, c1927. Source unknown

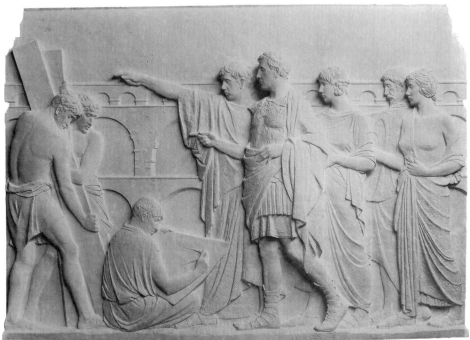

Early clay model for *Augustus at Nimes* by William Reid Dick (top), and final plaster cast of the bas-relief

The Exhibitionists

Epigraph
Letter from John Sulman to his children, 5 Jun 1930. John Sulman Papers, MSS4480 Mitchell Library, Sydney.

Notes

1 'Very modern art', *Register*, 25 Jan 1927, p 8.

2 The exhibition was sponsored by Keith Murdoch and the Melbourne *Herald* and so it has become known generally as the 'Herald Exhibition'. However, in Adelaide, Melbourne and Sydney, where the entire exhibition was shown, the name of the principal syndicated *Herald* newspaper was attached to the exhibition: in Adelaide *The Advertiser Exhibition of French and British Contemporary Art*, in Melbourne *The Herald Exhibition of French and British Contemporary Art* and in Sydney *The Daily Telegraph Exhibition of French and British Modern Art*.

3 The exhibition opened at the gallery on 21 Aug 1939 and remained on view for just under a month.

4 The Gauguin, catalogued as *La cabaretière* 1899 (no 42), was purchased by the Art Gallery of NSW in December 1939 for £2208.16.0. Its authenticity was questioned in April 1948 by the Société des Artistes Français, which wrote to the Sydney gallery claiming that it had been painted by Charles Camoin. The Van Gogh, catalogued as *Portrait of a man* 1886–87 (no 135), was purchased by the National Gallery of Victoria for £2196.5 on 31 October 1939. It was judged not to be by Van Gogh by the experts of the Van Gogh Museum, Amsterdam, in 2007.

5 Report to the Chairman of the Fine Arts Committee, 23 Aug 1939. State Records of South Australia, report 112/39, GRC19/19.

6 AGNSW Minutes, 15 Dec 1939, p 2044.

7 AGNSW Minutes, 22 Jul 1940, p 2127.

8 'Gouty art battles', *Daily Telegraph*, 19 Sep 1940, p 5.

9 AGNSW Minutes, 9 Oct 1940, p 2307.

10 Letter from Will Ashton to JS MacDonald, 4 Dec 1936, JS MacDonald Papers, MS4320, National Library of Australia, Canberra, 430/4/6.

11 AGNSW Minutes, 23 Oct 1936, p 1587.

12 Letter from George W Lambert to Basil Burdett, 28 Oct 1928, Macquarie Galleries Archive, National Art Archive.

13 Clive Turnbull, 'Sydney's art is exciting', *Daily Telegraph*, 25 Nov 1944, p 7.

14 Keith Murdoch, 'The question Australia asks', *Times*, 18 Feb 1921, p 27.

15 Robert Menzies, 'Introduction', in JS MacDonald, *Australian Painting Desiderata*, Lothian, Melbourne, 1958, p vii.

16 See his military record, National Archives of Australia, Canberra, B2455.

17 Released in May 1916 by Lothian Press, it preceded the less substantial *JJ Hilder watercolourist*, Tyrells, Sydney, 1916, by a month. The first monograph is thought to be Lionel Lindsay, *A consideration of the art of Ernest Moffitt*, Atlas Press, Melbourne, 1899.

18 'The pursuit of me has nonetheless shown no sign of abatement and the President [Keith Murdoch] has let slip no opportunity of censuring me, twisting my utterances, and branding honest expostulation (begotten of alarm) as "insulting", "immoderate", or "intemperate". With him to hold a contrary opinion is to be a miscreant.' JS MacDonald Papers, MS4320, National Library of Australia, Canberra, 430/7/40.

19 When the eighty-one-year-old Sir James Fairfax was nominated to replace him, it was a mark of respect for a fellow veteran founder of the institution. Fairfax died in office four years later.

20 JS MacDonald, 'Sir John Sulman FRIBA', *Art in Australia*, 15 Nov 1934, p 47.

21 Letter from John Sulman to his children, 5 Jun 1930. John Sulman Papers, MSS4480 Mitchell Library, Sydney.

22 JS MacDonald, *Report on suggested purchases from the Herald exhibition*, 30 Oct 1939, JS MacDonald Papers, MS4320, National Library of Australia, Canberra.

23 'Art today: scathing criticism', *Sydney Morning Herald*, 21 Sep 1929, p 16.

24 Frederick Eccleston Du Faur, Minute for special meeting of the Board of Trustees, 9 Aug 1912, inserted after p 229.

25 JS MacDonald, 'Sir John Sulman FRIBA', *Art in Australia*, 15 Nov 1934, p 47.

26 Interestingly, only the month before he died Ball wrote to the trustees from London saying that he had completed some sketches for the other panels and that 'the other three would represent Germany, France and England', suggesting he was reconsidering his original idea of the epochs of art. Letter from Percival Ball to George Layton, Mar 1900, BF10a/1900.

27 One of the firms that protested was Castle and Son. The trustees told the press that that they would willingly entrust this to a local firm but 'the absence of materials and experience, allied to the enormous price demanded, discouraged their commendable efforts in that direction'. 'The National Art Gallery', *Australian Town and Country Journal* (Sydney), 9 Dec 1899, p 36.

28 'Bronze casting in Australia', *Evening News*, 18 Aug 1899, p 3.

29 On 23 February 1900, a Signor Fosti also submitted three sketch models for the panels through Dr Marano.

30 AGNSW Minutes, 17 Jan 1902, p 423.

31 Letter to Alfred East, 11 Nov 1903, glued into the AGNSW Minutes, 1903–09.

32 B Kendell, 'British painters and sculptors at the Paris exhibition', *The Artist* (American edition), Aug 1900, vol 28, no 247, p 154.

33 First and second prizes of fifty pounds and twenty-five pounds were awarded to the successful competitors. If it was then decided to proceed with the panels a further £350 would be paid for a full plaster cast.

34 Although Cowan was an Australian her submission came through London.

35 Parker was not told that his panel had been unsuccessful until 1914, when it was returned to him. He wrote that in his view the agreement was that he should be paid fifty pounds for this unsuccessful panel. The trustees voted him twenty-one pounds as an honorarium instead. Langenegger 'had remained in Sydney solely owing to her negotiations with the Trustees in connection with the panel'. She too was paid an honorarium of twenty-one pounds.

36 See Eileen Chanin and Steven Miller, *Awakening: four lives in art*, Wakefield Press, Adelaide, 2015.

37 Letter from Dora Ohlsen to Gother Mann, 22 Aug 1913, BF193/1913.

38 Letter from Dora Ohlsen to Gother Mann, 6 Nov 1916, BF3/1917.

39 Letter from Dora Ohlsen to Gother Mann, 9 Jan 1917, BF7/1917.

40 Letter from Dora Ohlsen to F Graham Lloyd, 25 Nov 1919, BF15/1920.

41 Letter from John Sulman to Gother Mann, 23 Jan 1920, CF21/1920.

42 AGNSW Minutes, 24 Jul 1914, p 381.

43 AGNSW Minutes, 3 Jun 1915, p 464.

44 At this time, the Minister wrote to the Gallery saying that he hoped Bertram Mackennal's Shakespeare Memorial could also be located in front of the Gallery.

45 Letter from Gilbert Bayes to Gother Mann, 16 Nov 1916, BF88/1916.

46 'The one detail which detracts from the gravity and simplicity of the design is the placing of the names of great painters, sculptors, and architects around the frieze of the building and over the openings left for the bronze panels. Not only do the names injure the architectural effect, but they are absolutely meaningless, for the Gallery does not possess work by any of these old masters; and certainly misleading, for when the panels shall have been filled in, the general public will probably be of opinion that they represent work by Michael Angelo or Titian, as the case may be.' Julian Ashton, 'The National Art Gallery', *Daily Telegraph*, 1 Sep 1906, p 10.

47 Bruce Adams, 'Tailor-made for cultural limbo', *Sunday Australian*, 30 Apr 1972, p 22.

48 Report to the trustees by Dugald MacColl, 22 Jan 1911, inserted into the AGNSW Minutes, 1909–16, after p 123.

49 Forty-four names were intended. Thirty-two names are found on the existing elevations. Seven intended names are known from architectural drawings, the remaining five are unknown. Painters appear on the south half of the front elevation, and on the adjoining side elevation to the south. Sculptors appear on the north half of the front and were presumably intended for the adjoining side elevation to the north. Architects appear on the rear elevation.

50 AGNSW Minutes, 23 Apr 1965, np.

51 Memo of Gother Mann, 4 Feb 1927, CFG136b/1927.

52 Letter from WF Molloy to JS MacDonald, 8 Jan 1931, CFG11/1931.

53 Letter from WF Molloy to JS MacDonald, 18 Dec 1930, CFG267/1930.

54 MacDonald 1934, p 48.

11 The Visitors' Book
Distinguished or not

As the pages are turned the signatures grow fewer. Can to-day's visitors be less distinguished?

Sun, 1924

'Locked away in the Director's room is a treasure the ordinary visitor doesn't see', a 1924 newspaper article began. 'That is because it is marked "Distinguished Visitors". It is a fat and rather faded book, and as you turn its pages you find that the smaller the signature, the greater its interest." The Gallery's Visitors' Book is a fascinating marker of key moments in the institution's history and the characters that shaped and influenced that history. For the author of the 1924 article those small signatures of particular interest were, predictably, ones left by royalty: 'Under the date September 22, 1880, King George, who was then a midshipman, made his first entry ... Many years elapse, and then "Edward P." announces the King's eldest son.'

The 'book' was carefully assembled. The earliest pages are loose folios of signatures that were collected when the Fine Arts Annexe in the Botanic Garden was officially dedicated as the Art Gallery of New South Wales on 22 September 1880. These were bound into the volume and placed symbolically at the front. The very first signature is that of the governor's wife, Emma Loftus. She and her husband had arrived in the colony the month before and the official opening of the Gallery was one of their first duties. Everyone present was invited to sign; over 500 did on the day and 300 on the following.

Rebecca Martens, the eldest daughter of Conrad Martens, was the very first artist to sign, in 1880. Women artists such as Rebecca Martens, Myra Felton and Isa Rielly were regular exhibitors, as well as medal winners, in the annual exhibitions of the Academy.[2] Little of their work, however, has survived and even basic details of their careers are often difficult to confirm. Martens was among a large group of artists present at the dedication, including George and Arthur Collingridge, Lucien Henry, JC Hoyte, HH Calvert, Gordon Coutts, John Rae, Alfred Tischbauer and a Thomas Roberts from Melbourne.

As far as the Visitors' Book was concerned, artists were always considered distinguished enough to sign. This contrasts with the Archibald Prize in its early years, where artists were excluded from those 'distinguished in Arts, Letters, Science or Politics'. When Henry Hanke painted a self-portrait in 1934, he was challenged for not meeting the conditions of the prize. He was earning the dole as a relief worker and depicted himself dressed as a concreter. The *Bulletin* approved, as already the prize was attracting a boring

lot of generals in full regalia; law lords in all the glory of horsehair and silk; ladies in satin; captains

The Exhibitionists

name across it forever by bequeathing a public monument or institution, endowing a scholarship or the arts. But they carry money-grubbing into the grave with them.'[4]

At the time of his visits to the Gallery, Archibald was rewriting his will. He had been through a low point in his life, so paralysed by neuroses and depression that he was forcibly removed to Callan Park Hospital for the Insane in 1906.[5] He remained there for four years. When discharged, he concentrated all his energies on philanthropic projects. His estate was worth over £90,000 and his new will directed that it should be divided into fifty shares. After providing for family and friends, some shares were allocated to a prize for portraiture, some for a fountain in Hyde Park, others to the Sydney and Melbourne Hospitals and to a 'tobacco fund' for the inmates of Warrnambool Benevolent Asylum. The major portion was left 'for the relief of distressed Australian journalists'. Archibald never forgot the hardship that he had endured as a young journalist in Melbourne.

In 1915 Archibald was appointed a trustee of the Art Gallery and held office until his death in 1919. When the Society of Women Painters wrote to the Minister for Public Instruction asking that a woman be appointed a trustee, Archibald and the progressive parliamentarian JD Fitzgerald both supported the initiative; nine of the other trustees were firmly against it. The *Bulletin*, which Archibald co-founded, had a tradition of being liberal and egalitarian. But it could be equally racist and misogynistic. Archibald himself was a paradox, as his biography details.[6] His bequest to 'distressed journalists' is his forgotten, but greatest, legacy. For a century it assisted journalists with rent, medical and hospital bills, funeral costs and legal expenses. Ironically, in supporting a free press through its journalists, Archibald lived on through his bequest to promote, or at least explore, diverse values that he himself might not have shared during his lifetime.

If Tom Roberts was not in Sydney for the dedication of the Gallery in 1880,[7] he certainly visited in 1902, while making studies for his large commemorative commission *The opening of the first parliament of the Commonwealth*. In Sydney also during 1902 was artist Violet Teague. She was brought to the Gallery by Freda Du Faur, the president's pioneering daughter and 'Lady Alpine Climber' who caused 'a sensation in New Zealand' by climbing the three highest peaks of Mount Cook, the first woman to do so.[8] Teague signed the book again in 1908, when she exhibited as part of *Five Women Painters,* a precursor to the formation of the Society of Women Painters.[9] Arthur Streeton, returning to Australia after seven years abroad, signed in 1914 and again in 1922. Dora Ohlfsen, after a twenty-year absence, signed in 1912. The Royal Art Society of NSW had just included a display of her medallions and

of industry in their best tailorings; surgeons in operating vestments. Elbowing his way through the levee came an out-of-work artist in a battered old hat and a seedy overcoat, struck an attitude of defiance to a hard world – and won the prize! Archibald would have chuckled over that!'[3]

Jules François Archibald himself had signed the book twice, on 12 March 1914 and again on 20 August 1915. These must have been official visits, as he was a regular at the Gallery. Norman Lindsay recalled:

I remember a thing [Archibald] once said to me which defined that guiding principle in himself. It was during one of those walks which we often took through the Gardens to the Domain, for he loved passing an hour in the Art Gallery of NSW. Coming out, he waved his stick at the prospect of Sydney and said, 'Look at this place. It's full of rich men, and any one of them could write his

sculptures in its annual show and the Gallery purchased a quarter of the works exhibited.

Albert Namatjira signed on his first visit to Sydney in 1954, while en route to a royal reception in Canberra. In the previous year he had been awarded the Queen's Coronation Medal for services to the arts. He was met at the Gallery by assistant director Tony Tuckson, who took him to see the Archibald Prize, where Reg Campbell had a portrait of him hanging. He was polite about the work, but much more eager to view the Wynne Prize for landscape, in which he had exhibited ten years before. Namatjira was not the first Indigenous subject of an Archibald portrait. BE Minns had painted David Unaipon in 1924. Nor was Campbell's portrait of Namatjira the first. Rex Battarbee had painted him in 1938 and 1951.[10] A newspaper account of Namatjira's visit to the Gallery ended with the pointed comment: 'Next time he comes to Sydney ... maybe they'll have one of his paintings hanging.'[11]

It took more than thirty years before this happened. While Namatjira was in Sydney, the Anthony Hordern's Fine Art Galleries held an exhibition of works by nine Aranda artists, with Namatjira as guest of honour. The Lord Mayor opened the exhibition. No one represented the Gallery. Trustee Erik Langker was there on behalf of the Royal Art Society of

NSW. He told reporters that he was 'sorry the trustees did not come. I feel some of the works already purchased would have been an asset to our water-color section.'[12] The Gallery only possessed one work by an Aranda artist, Edwin Pareroultja's *Amulda Gorge*, acquired in 1947. 'Why hasn't the Gallery any Namatjira's?' the reviewer of the exhibition asked. 'The only reply the Gallery director (Hal Missingham) has ever given to my inquiries is, "It is the policy of the trustees to go only to properly constituted groups or society exhibitions. They do not attend one-man shows."'

This was incorrect, as the journalist pointed out, adding 'the truth is that the gallery trustees have their pets – but Albert Namatjira is not one of them'. Missingham admitted as much in a television interview, when he remarked that Namatjira's art was not good enough to hang in the Gallery, the 'mere' work of a 'full-blood Aboriginal, painting in the watercolour tradition of the white man'.[13] Painter Herbert McClintock, on 'hearing with dismay' Missingham's broadcast remarks, showed a greater sensitivity to Namatjira's

Below: Artists Albert Namatjira and Rubery Bennett listening to an art broadcast, 1954. Photographer unknown **Right, above:** Hubert Pareroultja *Tjoritja (West MacDonnell Ranges, NT)* 2020 **Right, below:** Vincent Namatjira *Stand strong for who you are,* the first work by an Indigenous artist to win the Archibald Prize, in 2020

The Exhibitionists

art when he countered that 'Namatjira's art springs from his love of his native haunts, the beauty of the land of his fathers'.[14] But as far as the Gallery was concerned, Namatjira's art was not 'authentically' Aboriginal enough to be collected.[15] One can only speculate on what Namatjira's reaction would have been had he been told then that sixty-six years later his great-grandson Vincent would become the first Indigenous artist to win the Archibald Prize, at the same time as his kinsman Hubert Pareroultja took out the Wynne Prize.

Although Albert Namatjira was the first Indigenous artist to sign the Visitors' Book, he was certainly not the first Indigenous visitor to the Gallery. Unfortunately, we do not know the name of the skilful 'young Aboriginal in the employ of Mr Harry Stockdale' who dazzled Archduke Ferdinand and his entourage on 27 May 1893.[16] The Archduke was on a world tour and in Sydney wanted to see a demonstration of sheep shearing, boomerang throwing and some art. The throwing was staged on the steps of the Gallery and as the boomerang flew within a whisp of the Archduke's head the assembled crowd gasped in shock. The Archduke's assassination in Sarajevo was the immediate cause of the First World War. How different would have been the history of the twentieth century if not for the skill of that unnamed boomerang thrower.

Robert Louis Stevenson visited three months before Archduke Ferdinand in 1893. Living in Samoa 'made him a kind of neighbour,' one journalist wrote, 'who might drop in at unexpected moments'.[17] Mark Twain, following Stevenson's directions to 'sail west and take the first turn left', signed as S Clemens on 25 September 1895.[18] When Paul Gauguin stopped off in Sydney during 1891 and in 1895 it is likely that he visited the Gallery, but it is doubtful he would have been asked to sign the VIP Visitors' Book because, as director Michael Brand has noted, 'at the time he wouldn't have been considered one'.[19]

Dame Nellie Melba, a VIP of the first order, signed twice, on 18 August 1909 and again on 8 August 1921. At the beginning of 1940, painter and dancer Loudon Sainthill brought to the Gallery members of the Ballets Russes who had been stranded in Australia because of the war.[20] Canadian Maud Allen, another type of dancer, visited on 3 April 1914. That night she performed her famous 'sensual' dance of Salome at the Palace Theatre, assuring Sydneysiders that 'there is nothing in her dances to hurt the most susceptible'.[21]

The elderly Henry Stanley and his wife, Welsh artist Dorothy Tennant, visited on 1 December 1891. By this time, Stanley's publications How I found Livingstone (1871) and Through the dark continent (1878) were best sellers. Another person who had spent time in Africa signed as 'Rev George Smith', and added after his name 'Rorke's Drift, Jan. 22–23, 1879'. As Smith stood before The defence of Rorke's Drift 1879 by Alphonse de Neuville, he told those gathered around him that he was the tall bearded figure in the painting, standing directly behind the line of fire, handing out cartridges from a bag slung over his shoulder.[22]

Above: The cover of the Visitors' Book and entries for 1893, showing the signatures of Robert Louis Stevenson and Archduke Franz Ferdinand
Right: Alphonse de Neuville The defence of Rorke's Drift 1879 1880

The Exhibitionists

The enormous painting was originally a commission from the Fine Art Society of London. Before the Society's 9th Annual Exhibition, it was taken to Buckingham Palace for Queen Victoria to admire. During the exhibition over fifty thousand people saw it. It then toured regional England before being purchased by the Art Gallery of New South Wales in 1882 for 2000 guineas.[23] Nicholas Chevalier was certain that this single work would ensure that 'the Sydney institution will be ahead of its rival in Melbourne'.[24] These proto-cinematic battle paintings proved immensely popular with the general public. The National Gallery of Victoria purchased *The 28th Regiment at Quatre Bras* 1875 by Elizabeth Thompson (Lady Butler) in 1884. It was voted Melbourne's favoured work by the visiting public in 1906. In Sydney, artist Lloyd Rees said that in his early childhood a print of *The defence of Rorke's Drift* 'absolutely moved me'.[25]

The Gallery's archive preserves a moving letter from the thirty-four-year-old Gonville Bromhead, one of the officers at Rorke's Drift, to his elder sister 'Lizzie', written three weeks after the defence. In the 1960s box-office sensation *Zulu*, Michael Caine played Bromhead, characterised as a pampered aristocrat.[26] Contemporary accounts, however, record that he was well liked by his men. We know that he suffered psychological trauma after the battle and sat paralysed for hours on a stone near the hospital, smoking continually. He confides to his sister, 'I am getting over the excitement of the fight and the sickness and fury at our loss.'

Recent research has uncovered evidence of war crimes at Rorke's Drift, including the killing of wounded Zulu prisoners by soldiers sent as reinforcements. De Neuville's painting depicts the Zulu warriors as an indistinct horde. They are dehumanised. This is contrary to the testimony of Reverend Smith when he visited the Gallery. He said that the

> bravery and recklessness of death of the Zulus was beyond belief. They would rush up to the parapet, leap up and clutch the muzzle of a rifle and endeavour to pull themselves up by it ... Our loss was 17 killed and 10 wounded. The loss on the Zulu side must have exceeded 500.[27]

Smith told the story of the battle to the Gallery attendants. Five of these – William Bartlett, Thomas Casey, HG Barringham, Thomas Hall and Angus Gray – all signed the

The Exhibitionists

Visitors' Book on 24 March 1902, when the keystone of the pediment was put in place above the portico. Although they may not have strictly been 'distinguished visitors', the Casey and Hall families, in particular, looked upon the Gallery as home. In fact, when old Mrs Casey died in June 1907 the press noted that she had passed away 'at her residence, the National Art Gallery in the Domain'. Fr Rohan, from nearby St Mary's Cathedral, rushed to her bedside to administer the Last Rites 'in the Gallery'.[28] This was because Margaret Casey lived on site in the caretaker's cottage.

She was the Gallery's first member of staff, employed by the New South Wales Academy of Art in 1875. She remained the Gallery's caretaker for thirty-two years. Probably illiterate – she made a mark in lieu of a signature on her son's birth certificate – she was also the breadwinner for her family. Her invalid husband died in 1879 at the age of sixty. He had been a warder at Darlinghurst Gaol, but accidentally shot himself in the jaw while playing a 'game of strength' with another warder. A sense of her resilience is evident in a photograph preserved in the Gallery's archive. She sits between marble busts of Gallery patriarchs Eliezer Montefiore and Frederick Eccleston Du Faur, with her four sons gathered around her.[29]

The family still tells stories of her no-nonsense approach to the shenanigans of wharfies and others who lived and worked in neighbouring Woolloomooloo and cavorted around her cottage at the back of the Gallery, 'a wilderness of long paspalum grass inhabited by metho-drinkers and at night a place to keep well away from'.[30] The proximity of the naval base also posed unexpected challenges. She was wary of the Sikh sailors serving in the Royal Indian Marines, some of whom signed the Visitors' Book on 21 January 1901. During celebrations for Australia's Federation, she was convinced that they stole her white bed linen off the line to reuse for their national costume.[31]

Ma Casey tirelessly promoted the interests of her four boys. In 1880 she had twenty-four-year-old Thomas appointed a 'messenger and to assist at the door'. Two years later, the Minister for Public Instruction approved 'the employment of Mrs Casey's two sons as extra attendants' to handle the crowds because of the introduction of Sunday afternoon openings.[32] In 1898 a letter written to the Public Service Board complained that the caretaker's cottage 'was nothing more than a home for the Casey family and that there were at present living in the caretaker's residence, Mrs Casey, Thomas Casey, James Casey, with their wives and families, and also that Joseph Miles, a son-in-law of Mrs Casey, was at present employed at the Gallery on Sundays and holidays, when he was earning perhaps £3.0.0 per week elsewhere.'[33]

Left, above: Margaret Casey and her four sons, c1900. Photographer unknown
Left: The final stone being placed in the pediment of the Gallery, 1902. Photographer unknown

When his mother died in 1907, Thomas Casey was appointed to her position 'with an allowance of £20 pa, with quarters, fuel and light, valued at £30'. The bonus of quarters, fuel and light was well earned given the nature of the work. A visitor to the Gallery who spoke to the attendants wrote about their working conditions: 'I understand that two men take it in turns, twelve hours on and the same off, this including Sunday makes 84 hours duty.'[34] At night two men were locked inside the building with kerosene hurricane lamps. Contact with outside was made through a 'speaker tube', similar to ones used on a ship between the captain and the engine room.[35] In 1916, when Thomas Casey asked for an increase to his salary, the first in twenty years, he noted that 'the position of Caretaker entails a week of 116 hours duty'.[36]

Lord Beauchamp signed the Visitors' Book twice in 1899. The first visit was only four days after he became governor of New South Wales, a post he held briefly between May 1899 and April 1901. One of his first duties was to give assent to the *Library and Art Gallery Act 1899*. Beauchamp enjoyed the company of artists and took a fancy to the handsome and charming Irish-born poet Victor Daley. Daley convinced him to give artists precedence at the first major Government House reception: 'It was an event of history. His Excellency was about to give his first levee, and at Daley's suggestion, the artists and poets were to get prior entry. They were to receive "white invitation cards". The aristocrats of Sydney Society were to receive "'blue invitation cards".'[37]

A loan exhibition of nineteen paintings, fifty snuffboxes, thirty-two Indian daggers and twenty sheaths from Beauchamp's personal collection was shown at the Gallery between January and August 1900 and was so well attended that a police officer was placed on guard to control the crowds and ensure the security of the loans. When a group of 'bohemian' artists invited him to their supper club, he accepted as long as it would be a night of 'no frills'. 'Beauchamp was full of fun,' one recalled, 'you could see that he felt for once he was free from the sickening officialdom that was crushing his soul.'[38] Before he left Sydney, he chose Tom Roberts to paint his official portrait.[39]

Thirty years separated Beauchamp's final signature in the Visitors' Book on 25 September 1930 from his first. He returned to Sydney for two months in 1930 as part of a round-the-world tour, telling the press that there was 'no better place for a holiday than Sydney'.[40] Many social events were organised for 'the genial Lord Beauchamp and his handsome "attaché" Mr George Roberts'.[41] In Australia, Beauchamp lived as openly as was then possible with Roberts as his lover. But his brother-in-law, the Duke of Westminster, was compiling a dossier on him. When he collected sufficient evidence of Beauchamp's immoral proclivities, he convinced his sister to divorce her husband and King George V, who did not want

Four views of the caretaker's cottage at the rear of the Art Gallery of
New South Wales, c1968. Photographs: Kerry Dundas

The Exhibitionists

to initiate criminal proceedings, to exile him. Beauchamp's children remained devoted to their father and refused to testify against him. The family and its disgrace provided the inspiration for Evelyn Waugh's novel *Brideshead revisited*. After his exile Beauchamp continued to visit Australia, where he felt at home and remained popular. He bought a house in Sydney and met a young Australian, David Smyth, who he 'appointed his secretary and who became his inseparable companion for the rest of his life'.[42] In 1951 Smyth presented Beauchamp's amusing and shrewd diary from his time as governor to the State Library of New South Wales. His last words in it sum up his frustrations, but also his affection for Australia and Australians: 'Things however in some way muddled along all right & no one seemed to think a change was in any way necessary.'[43]

A signature that one would expect to find in the Distinguished Visitors' Book on 22 October 1966 is that of President Lyndon B Johnson. He was the first incumbent American president to visit Australia, on a three-day, five-city tour to thank the country for its support during the Vietnam War. A state reception was organised at the Gallery, which director Hal Missingham described as 'a fiasco from the start'.[44] It was decided to make the austere classical facade of the Gallery 'more Australian' by shipping in boulders and native trees to hide the sandstone pillars. Koalas 'were brought in at the last moment, placed in gum-trees and prevented from climbing down by the same galvanized iron cones you see on ships' mooring to stop rats getting aboard. The whole thing was ... horrible beyond belief.'[45]

As it turned out, all this artistry was lost on Johnson and his wife Lady Bird. They had been heckled on Oxford Street. As they arrived at the Gallery they were met by another group of protesters, including the director's wife Esther 'with her anti-war badges pinned to her dress and holding aloft a tattered banner, on which was lettered the single word "NO"'.[46] The official party was rushed quickly inside the building. In the pandemonium the Visitors' Book was forgotten. Lavatories were more important to the flustered president. But when the building had been inspected by an advance party of bodyguards, they discovered none inside that the president could use. A partitioned-off corner of the boardroom was installed with a new handbasin in case the president needed to pee. 'My secretary,' Missingham recalled, 'never cared to use the basin to wash her hands from that time onward.'[47]

Above, top: Lord Beauchamp (seated right) at Government House, Sydney, with his staff, c1900. Photograph: Kerry & Co **Above:** 'Lord Beauchamp's heirlooms' on display at the National Art Gallery of New South Wales between January and August 1900. Photograph: Kerry & Co

The Visitors' Book

Above, top: George Molnar *'Trying to popularise the Art Gallery, I see'* 1966
Above: Unidentified man and a police officer carrying a protestor from a demonstration during US President Lyndon B Johnson's state visit to Sydney, 22 October 1966. Photograph: John Mulligan

The Exhibitionists

Epigraph

'Pictures should move', *Sun*, 16 Jun 1924, p 16.

Notes

1 'Pictures should move', *Sun*, 16 Jun 1924, p 16.

2 At the third annual exhibition in 1874 Rebecca Martens exhibited no 61, *View in Middle Harbour* (watercolour) and no 66, *Looking seaward* (watercolour). At the sixth annual exhibition in 1877 she exhibited no 95, *Land Spit, Middle Harbour* (watercolour) and no 101, *Bowenfels* (watercolour).

3 'Shadow shows: some first nights', *Bulletin*, 23 Jan 1935, p 44.

4 Norman Lindsay, *Bohemians of the Bulletin*, Angus and Robertson, Sydney, 1965, p 19.

5 This was at the instigation of his friend and colleague, the artist William Macleod. Macleod signed the Visitors' Book with another *Bulletin* artist, Hop (Livingston Hopkins) on 23 April 1918.

6 Sylvia Lawson, *The Archibald paradox: a strange case of authorship,* Melbourne University Publishing, Melbourne, 2006.

7 Was the Thomas Roberts from Melbourne who signed the Visitors' Book in 1880 the artist or another individual with that name?

8 'Sydney lady alpine climber', *Tamworth Daily*, 8 Jan 1913, p 2.

9 Teague exhibited alongside Ethel Stephens, Alice Norton, Bernice Edwell and Emily Meston.

10 In 1956 William Dargie won the Archibald Prize with his portrait of Namatjira.

11 'A famous Aussie at last sees Sydney', *Daily Telegraph*, 14 Feb 1954, p 20.

12 'Gallery trustees ignore native art', *Truth*, 28 Feb 1954, p 51.

13 Herbert McClintock, 'Namatjira is popular art', *Tribune*, 21 Jan 1959, p 11 and Missingham 1973, p 69.

14 McClintock 1959, p 11.

15 Missingham, writing in 1973, put the blame on the trustees who refused to 'buy or accept as gifts paintings by Namatjira'. Missingham 1973, p 69. To assuage public criticism, they did, however, agree to the loan of two watercolours from the collection of John Brackenreg.

16 'General news: The Archduke Ferdinand', *Daily Telegraph*, 27 Mar 1893. Perhaps it is this connection that allowed Stockdale to sell '1000 specimens of Aboriginal curios to the Austro-Hungarian government'.

17 Thyra Gebbin, 'Robert Louis Stevenson', *Cosmos Magazine*, vol 1, no 5, 31 Jan 1895, p 255. When Stevenson was in Sydney he stayed at Richmond Terrace, which gave its address as 'The Domain'. The terrace was demolished in 1935 to allow the Mitchell Library to expand.

18 The AGNSW Minutes, 18 Sep 1895, note that Mark Twain was invited to visit: 'The President stated that he had invited Mr S.L. Clemens (Mark Twain) & family to visit the Gallery.'

19 Quoted in Elizabeth Fortescue, 'Paul Gauguin's painting *The three Tahitians* to star in Art Gallery of New South Wales blockbuster', *Daily Telegraph*, 23 Oct 2015. See also Gilbert Ponder, *Mr Goggin comes to town*, A&E Lewis, Adelaide, 1970.

20 Company founder Wassily de Basil, his wife ballerina Olga Morosova, and the prima ballerina Tamara Toumanova.

21 'Woman's letter', *Co-operator*, 2 Apr 1914, p 6.

22 'Rorke's Drift: hero visits Sydney: Rev. G. Smith', *Sydney Morning Herald*, 31 Mar 1913, p 9.

23 The price was reduced from 2500 guineas. Montefiore wrote to Du Faur, 'we *must* have it'. Letter from EL Montefiore to Frederick Eccleston Du Faur, 10 Aug 1881, CF19/1881. Smith noted that 'the Fine Art Society were deriving a good revenue from leasing the picture for exhibitions in the provinces ... The Society reserve the copyright which is naturally to be expected as they have had a very fine etching taken from the picture which they have in course of disposal.' Letter from C Smith to Frederick Eccleston Du Faur, 24 Aug 1881, CF21/1881.

24 Letter from Nicholas Chevalier to Eliezer Montefiore, 2 Nov 1881, CF24/1881.

25 'Victorian favourites: a conversation with Elwyn Lynn and Lloyd Rees', *Art and Australia*, vol 22, no 1, Spring 1984, p 49.

26 The film also used the painting by De Neuville as inspiration for set design and costumes.

27 'Rorke's Drift: hero visits Sydney'', *Sydney Morning Herald*, 31 Mar 1913, p 9.

28 'Mrs Margaret Casey', *Freeman's Journal*, 13 Jun 1907, p 26.

29 Despite being the Gallery's longest employee, her salary reflects the way women were paid at a much lower rate than men. In 1900 this was noted as: the secretary £300, the custodian £224, the senior attendant £170, the frame repairer and attendant £150, the junior attendant £144, and Mrs Casey, the caretaker, £75.

30 Hal Missingham, *They kill you in the end*, Angus and Robertson, Sydney, 1973, p 108.

31 Irene Raper, 'My life with Arthur Raper and our nine boys', 13 Dec 1994, transcript of memoirs, National Art Archive, Art Gallery of NSW.

32 Letter from W Wilkins to Frederick Eccleston Du Faur, 12 Oct 1882, CF37/1882.

33 Mr Coglan to the Public Service Board, 20 Apr 1898, quoted in AGNSW Minutes, 27 Apr 1898, p 542.

34 Letter from F Abigail to Frederick Eccleston Du Faur, 31 Mar 1883, CF15a/1883.

35 Interview between Alan Lloyd and Jack Reid, nephew of William Hall, 14 Sep 1999.

36 He noted that his mother had received seventy-five pounds per annum and five shillings for each Sunday, with quarters, fuel and light. He receives £170, plus an allowance of £20, each year, with quarters, fuel and light. His wife receives 5 shillings for each Sunday for assisting with cleaning the premises before opening. He is on duty every day except Saturday, always available during 'each evening after closing time to answer the watchman's call or other emergencies.' Letter from Thomas Casey to Gother Mann, 18 Jul 1916, CFG105/1916.

37 George A Taylor, 'Those were the days': being reminiscences of Australian artists and writers, Tyrrell's Ltd., Sydney, 1918, p 33.

38 Taylor 1918, p 72.

39 He also commissioned John Longstaff to paint the portraits of King Edward VII and Queen Alexandra, which he presented to the Gallery in 1904.

40 'Lord Beauchamp's cheerful valedictory', *Sydney Mail*, 19 Nov 1930, p 3.

41 'Susan says ...', *Sun*, 9 Nov 1930, p 28.

42 Michael Bloch, *Closet queens: some 20th-century British politicians*, Little Brown Book Group, London, 2015, p 84.

43 William Lygon, 7th Earl of Beauchamp, diary written while governor of New South Wales, 1899–c1900, State Library of NSW, p 40.

44 Missingham 1973, p 98.

45 Missingham 1973, p 99.

46 Missingham 1973, p 100.

47 Missingham 1973, p 100.

12 The Augean stables

Hal Missingham's directorship, 1945–71

> I expect they will have been cleaned up by now, and it must have been a Herculean task.

Sir Kenneth Clark, art historian, 1974

Art historian Sir Kenneth Clark signed the Visitors' Book on 17 January 1949. He had been director of the Ashmolean Museum in Oxford and then the National Gallery in London but was then in his last term as the Slade Professor of Fine Arts at Oxford. He was on an Australian tour, the main purpose of which was to give a lecture on 'The idea of a great gallery' at the National Gallery of Victoria.[1] He wrote: 'Compared to Sydney, Melbourne is rather staid and conventional ... The Gallery, which was the object of my expedition, was badly housed ... Facing the Tiepolo was a stuffed horse named Phar Lap, which was the supreme attraction of the Gallery.'[2] This was an exaggeration. The stuffed horse was visible in the distance through an opening that led into the adjacent science museum. The limitations of shared premises led to repeated criticisms of the Melbourne Gallery and Clark was simply repeating what many had said before him. In less-staid Sydney, 'the favourite exhibit'

Previous page: Court 4 flooded after a heavy storm, c1948. Photographer unknown **Below:** Charles Joseph Watelet *Les félines* 1923

The Exhibitionists

Eric Thake *Gallery Director or This way to Phar Lap* 1954

was not a stuffed horse but a saucy picture by the Belgian painter Watelet. It showed 'a naked young woman with red hair, and cats crawling over her, entitled *Les félines*. As one walked round the gallery visitors from the outback used to say, "Excuse me, can you tell me where I can find *les fellins*?"' Clark's entertaining memoirs are impressionistic rather than factual.[3] Behind the Watelet anecdote one can hear the unmistakable voice of Hal Missingham, director at the time, relating it to Clark with roguish delight.

Missingham had been director for only four years when Clark visited. He had taken over from Will Ashton, who was lured by Charles Lloyd Jones to a more lucrative job in charge of the commercial gallery in his David Jones department store.[4] Australia was still at war, so it was difficult to find an immediate replacement for Ashton. Three acting directors kept the doors open from the beginning of 1944 until September 1945, when Missingham took over.[5] He was persuaded to apply for the position by trustee Sydney Ure Smith. The two met when Missingham was working in Sydney as a radio operator in AIF Signals. He had returned to Australia to join the Forces after fourteen years overseas. A talented artist who had won a scholarship to study full-time at the London Central School of Arts and Crafts in 1930, Missingham was employed by Smith to provide illustrations for his popular publications *Art in Australia* and *Australia National Journal*.[6] A few days before he began as director at the Gallery, he wrote to his wife Esther that he had 'spent a long night with Syd Ure Smith and we discussed the whole gallery set-up. What they want is not so much a director as a tough gent in overalls to clean the place up!'[7]

When Clark visited, the cleaning up had barely begun. He observed that Sydney then 'was full of talented young painters, but the public galleries were Augean stables; I expect they will have been cleaned up by now, and it must have been a Herculean task'.[8] 'By now' referred to 1974, just three years after Missingham had retired from the Gallery, and so Clark's comments roughly cover the period of Missingham's directorship. A 'Herculean task' is in fact what Missingham managed to achieve. When he began, the Gallery was run by a team of fifteen full-time day staff and three nightwatchmen.[9] When he left in 1971 there were fifty full-time staff, including a deputy director, three curators, registrars, an education officer, a librarian and a small team of conservators. He initiated major reforms in collection care and development, public access and education, as well as expanding the exhibition program along with the physical capabilities of the building itself.

His memoirs *They kill you in the end* (1973), published after he retired, detail the opposition he often encountered from government, under the guise of the Public Service Board and the Department of Education, from trustees, staff

The Exhibitionists

and the general public. The last chapter is dedicated to 'The building', which is his most enduring legacy. Although the 'Captain Cook' wing, as it was known, was opened in 1972, eight months after he retired, it would not have been built without his tenacity and vision. When he began at the Gallery, it was the poor state of the buildings that most occupied him. He told a reporter that there was 'no electric light ... and the attendants have to run around taking pictures off the walls to prevent them from getting wet when it rains'.[10] Returning from a study visit to Europe in 1951, he began working on a master plan for 'a first-rate gallery on the present site' which would include flexible gallery spaces, new staff offices, a library, air-conditioned exhibition areas and a restaurant.[11]

Architectural drawings preserved in the Gallery's archive indicate the progress of this masterplan. It was not until April 1960 that the 'preliminary plans of proposed extensions' were drawn up by the Government Architect, Edward Herbert 'Ted' Farmer.[12] Missingham was again overseas in 1961, where he visited art museums in the United Kingdom, Europe, Canada and the United States. The plans were modified throughout 1962–63 and tabled at a board meeting on 25 October 1963. The proposed extension, largely conceived by architect Peter Webber, was to be a multi-storey separate wing at the back of the Gallery, where the conservation laboratories were situated, joined to the existing building at ground level. The Vernon and Hunt buildings would be left untouched. The trustees were informed that the plans

allowed for six galleries each 60 x 50 [feet], one of which could be used as a temporary auditorium to seat 350 people ... The building would be an air-conditioned one and have a lift and a coffee bar. The Government Architect had estimated the cost of £600,000, the preparation of plans taking 18 months and a further 18 months to construct the building.[13]

The plans were approved in April 1964 and construction was set to commence in the middle of 1966. However, in 1965 the Labor government, after twenty-four years in power, narrowly lost the state election to the Coalition. The Gallery's building project fell to the bottom of the new government's priorities. The only construction that occurred at this time was an updating of the Gallery's entrance court. It looked surprisingly fresh and modern despite the modest way this was achieved. The ceiling was covered with plastic boxes, each with a 25-watt globe inside. Grey vinyl tiles were placed on the floor and the wood panels that made up the walls were covered in hessian.

Young architect Andrew Andersons worked on the project before going overseas in 1965 to do his masters at Yale University, taking study leave from the Government Architects Office. His return at the end of 1967 was fortuitous, as by this time the government was looking for a memorial project to mark the Captain Cook sesquicentenary in 1970. Andersons was appointed the project architect.[14] While overseas he had studied numerous galleries, including the Louis Kahn addition to the Yale University Art Gallery (1953), Marcel Breuer's recently opened Whitney Museum (1966) and the Louisiana Museum of Modern Art in Denmark (1958). He sent an article on Louisiana to Missingham in Sydney. Tony Tuckson also travelled overseas in 1967 on a study tour of galleries, visiting their ethnographic collections, but also with an interest in how those with recent additions were designed and run.

Andersons' 1968 designs abandoned the idea of a separate wing and beautifully incorporated the new building within the original ground plan of the old.[15] Tony Tuckson, the Gallery's deputy director, and curator Daniel Thomas worked closely with the architect, with Tuckson becoming Andersons' 'best client' ever.[16] Nonetheless, there were differences of opinion to resolve. A double-height space within the new galleries was initially planned by the architect as an interior courtyard. The National Gallery of Victoria had opened a new building on St Kilda Road, and this incorporated three courtyards –

Westminster Fine China (Australia), Captain Cook bi-centenary celebrations 1770–1970, commemorative plate for the Art Gallery of New South Wales Foundation appeal 1969

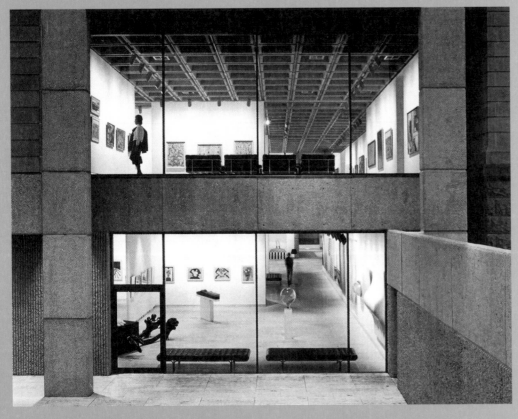

Left: Northern sculpture court of the Art Gallery of New South Wales, 1972. Photograph: Max Dupain
Below: Night view into the Art Gallery of New South Wales from the northern sculpture court, 1972. The first temporary exhibition in the 1972 extensions to the Gallery was the *Power Survey of Contemporary Art*. Some of the 159 works on display from the Power Collection, University of Sydney, are visible in the lower gallery. Photograph: Max Dupain

The Exhibitionists

successfully in Andersons' view.[17] Tuckson insisted that interior hanging space was more urgent. The architect was successful in convincing the curators to allow windows at the corner of the galleries, giving glimpses of Woolloomooloo Bay and anchoring the building within its challenging geographical location. Curator Renée Free recalled that Tuckson was particularly vigilant about minimising 'anything which prevented clear walls – alarm outlets, etc. – and much money was spent on redoing things, such as enlarging doorways'.[18]

When the government officially announced that the extensions would go ahead, it pledged $300,000 towards the project and promised that it would match all donations dollar-for-dollar. As Victoria had spent fourteen million on its new gallery, 'our 2.5 million really only looked like petty cash' to Missingham.[19] However, it was a struggle to raise the money through art lotteries, foundation appeals and the like.[20] A major setback occurred when Peter Huxley, secretary of the Rural Bank of New South Wales and a member of the Finance Committee of the Art Gallery Society, misappropriated funds and gambled them on racehorses.[21] In 1970 he was sentenced to twenty years in jail for fraud. It was never disclosed how much the Gallery lost and staff at the time believed that the government quietly replaced missing funds.

The new gallery opened on 2 May 1972, delayed, like the Sydney Opera House, by 'heavy rains and industrial trouble'.[22] The building had actually been completed the year before, but after the significant Captain Cook memorial date of 22 August 1970 was missed, it was decided to take extra time to ensure that everything was perfect for the official opening. Missingham was glad to have the new building disconnected from the Captain Cook memorial, as he and a few other trustees preferred naming sections of the new gallery after 'artists and other persons prominent in the art history of Australia'.[23] The government had also allocated a further $200,000 for the refurbishment of the old courts to ensure that the new 'would not outshine the old ... as they were to form one integral unit'.[24] The completed building was widely admired and awarded the 1975 Sulman Medal for architecture as 'a bold architectural statement both in the uncompromising way it cross-bred modern architecture with nineteenth-century stock by stark confrontation, and for the purity and understated quality of the modern work itself'.[25]

In a lecture he gave to the Art Gallery Society, Missingham noted that after his 1951 overseas study tour he developed a 'three-pronged' approach to Gallery renewal: 'one was on the administration of the Gallery; one was on a new building, and one was on the staff'.[26] Artist Tony Tuckson was one of his first major staff appointments. Tuckson had joined the Gallery in August 1950 as an attendant.[27] Missingham pushed for his promotion 'in the face of strong opposition from

Above, top: Paper conservation laboratory, c1960. Photograph: Max Dupain
Above: Paintings conservation laboratory, c1960. Photograph: Max Dupain

one or two of the trustees',[28] and two months later Tuckson was made assistant to the director and then in April 1957 deputy director.[29] Daniel Thomas was the first university graduate employed by the Gallery. Art history was not yet offered at Oxford University in the mid 1950s, which Thomas attended when the family farm in Tasmania was unusually prosperous, and so he graduated in modern history.[30] Thomas began at the Gallery as an assistant in April 1958, 'whose duties were primarily to index gallery records and to help with the preparation of exhibition catalogues'.[31] In 1971 his designation was changed to senior curator and curator of Australian art. In 1966 Renée Free was employed. She had trained at the Courtauld Institute of Art in London, where the first art history degree in England had been established

The Exhibitionists

in 1932. Both Thomas and Free were interviewed by Tony Tuckson. Free recalls, 'I became Assistant to the Director, but he never needed one, Daniel did ... Daniel was Curator of everything. It emerged between us I think, that I wanted to be Curator of European, and Daniel could better concentrate on Australian'.[32]

The other professional staff that Missingham had on his team were a librarian, a registrar and small team of conservators.[33] The Gallery's workforce was small enough for everyone to know each other and there was a high level of camaraderie. Many members of staff devoted their lives to the Gallery, such as Bob Ford, the head of the workshop, and Bill Lamont, the mount-cutter. Curator Renée Free remembers the director 'in blue singlet and khaki shorts, sitting on a crate in Fred Galleghan's packing room most afternoons, yarning with packing room staff'.[34]

Missingham was particularly concerned to build up the conservation department. The Art Gallery had employed conservators continually since 1899 but when Missingham arrived Billy Hall, who had been at the Gallery for twenty-eight years, was in a bad way, continually drinking on the job. The other conservators had to lock away the laboratory methylated spirits to stop Hall from consuming it.[35] Missingham suspended him in May 1949 and recommended that the workshop assistant William Boustead be appointed 'assistant conservator' in the interim. For a time, it seemed that a conservator would be enticed from England, but the

salary offered by the Public Service Board was never attractive enough. It was cheaper to send Boustead to train overseas, which happened in 1953. It would take another four years before a complete refurbishment of the Gallery's conservation department was funded.

From the early 1960s it was at the Gallery that many future Australian and international conservators did their apprenticeship. Boustead's first internee was the Colombo scholarship winner Anand Singh Bisht from the National Museum of India in New Delhi. In 1960 Boustead was made a fellow of the International Institute for Conservation of Historic and Artistic Works (IIC) and in the following year attended its inaugural conference in Rome. When two positions of cadet restorer were created, Boustead formulated a course for them based on his own studies and experience. This was well in advance of the establishment of the first materials conservation training course in Canberra in 1978.

The expertise that Boustead and his team had acquired in dealing with mould, a constant challenge in subtropical Sydney, enabled him to establish a paper conservation laboratory at the Biblioteca Nazionale in Florence in the wake of the devastating 1966 floods there.[36] Funding from the Australian Government paid for the equipment and fit-out. An advanced conservation laboratory opened in the Captain Cook wing of the Gallery just before Missingham retired as director in 1971. Alan Lloyd, one of Boustead's cadets who went on to become chief conservator at the Gallery, claimed that Boustead's pioneering efforts had 'directly and indirectly affected all our careers today as conservators'.[37] These efforts would not have been possible without Missingham's support and advocacy.

Another pioneering area for the Gallery at this time, also made possible through the director's support, was the collecting of Aboriginal and Torres Strait Islander and Pacific art. In 1952 Missingham proposed an exhibition of Aboriginal art for the 1952 Venice Biennale, predating the first official Australian representation by two years.[38] He suggested assembling this from the Arnhem Land works that had been included in the 1951 *Jubilee Exhibition of Australian Art*, supplemented by loans from the anthropologist AP Elkin, which he said 'would, I am sure, cause the greatest excitement abroad'.[39] He later supported the intensive collecting by deputy director Tony Tuckson.[40] A key acquisition was a set of Pukumani grave posts created in 1958 by artists Laurie Nelson Mungatopi, Bob Apuatimi, Jack Yarunga, Don Burakmadjua and Charlie Kwangdini from Melville Island. The artists 'did not merely make works' for Tuckson and the Gallery, as curator Cara Pinchbeck has noted, 'they created extraordinary works in a culturally relevant context, designed to heighten understanding, both of the works and of themselves as Tiwi people'.[41]

The subsequent display of the posts in the Gallery in June 1959 unequivocally as art, rather than as ethnographic curiosities, represented a groundbreaking development at the time. The National Art Gallery of South Australia, under its artist–director Robert Campbell, had been the first to collect Aboriginal art. In Sydney, sporadic early acquisitions included a watercolour by Edwin Pareroultja, acquired in 1947, sandstones sculptures by Nora Nathan and Linda Craigie donated by Margaret Preston in the following year, and twenty-four works from the 1948 Australian–American Scientific expedition to Arnhem Land, donated by the federal government in 1956. But from 1958 what had been a trickle became a program of extensive collecting.

The patronage of orthopaedic surgeon Stuart Scougall was critical to this new field of collecting. Between 1957 and 1964 he donated 160 works. He also financed field trips to Melville Island in 1958 and Yirrkala in 1959, where Tuckson met artists and became familiar with the rich cultural context in which the objects acquired were produced. Equally notable as patrons were Stanley Moriarty and his wife Jean, owners of Snaps Ads in Sydney and important collectors of art from New Guinea. Tuckson had begun collecting Oceanic art for the Gallery in 1962, with a focus on the Sepik region. Between 1968 and Stanley Moriarty's death in 1978, 560 works were acquired, many donated, from the Moriarty collection.[42]

Moriarty was a lender to the *Melanesian Art* exhibition that Tuckson organised at the Gallery in 1966.[43] This was the most significant dedicated exhibition of its kind held at an Australian gallery or museum at that time.[44] The enthusiastic reviews signalled a deepening understanding of the traditional arts of the region, away from a European modernist preoccupation with formal qualities alone to what D'Arcy Ryan in *Art and Australia* said involved a real knowledge of 'the artist and his culture … not one item was made purely as an *object d'art*; all were made for purposes, sacred or secular, that had nothing to do, primarily, with aesthetics'.[45]

Six years earlier Tuckson had curated *Australian Aboriginal Art*, which toured to every major Australian gallery during 1960 and 1961.[46] The exhibition became the basis for a book of the same title edited by Ronald M Berndt and published by Sydney Ure Smith in 1964. Tuckson contributed a chapter on 'Aboriginal art and the western world'. The depth of Tuckson's engagement with the First Nations arts of Australia and the region, and the range of his collecting from the late 1950s onwards, was apparent in the exhibition of *Aboriginal and Melanesian Art,* which opened a new dedicated gallery for these works on 18 October 1973.[47] Tuckson had hoped to step down as deputy director when the new building opened and become the full-time curator of Aboriginal, Torres Strait Islander and Pacific collections.[48] However, he was diagnosed with cancer and was too ill to attend even the dedication of this gallery, the first of its kind in Australia. He died a month later.

Missingham included Tuckson's *Australian Aboriginal Art* and *Melanesian Art* on his list of the thirty-eight exhibitions with which he was involved as director. However, he said that his most rewarding work as director was the major

Above left: Hal Missingham numbering paintings before the Dobell retrospective exhibition, 1964. Photograph: Noel Hickey Above right: Gallery attendants keep visitors distanced from the paintings at the Dobell retrospective exhibition, 1964. Photographer unknown Facing page, above: Hal Missingham (designer), poster for the Sidney Nolan retrospective, 1967

The Exhibitionists

Sept 13 to Oct 29

ART GALLERY OF NEW SOUTH WALES

NOLAN
RETROSPECTIVE
EXHIBITION

retrospectives he curated for Russell Drysdale (1960), William Dobell (1964) and Sidney Nolan (1967). Missingham acknowledged Daniel Thomas's contribution, producing catalogues that served 'as a model for almost all Australian retrospectives thereafter'.[49] Each show was successful, but the Dobell exceeded all expectations. In just under seven weeks, 168,362 adults saw it and 25,000 catalogues were sold.[50] A bolstered team of attendants kept viewers two metres away from the works, aware that Dobell paintings had been stolen from Gallery walls in the past. Arrangements for the Nolan exhibition were typically complicated by the personal animosities that always attended this artist.[51] Missingham was increasingly concerned about Nolan's wife Cynthia's reclusiveness and asked doctors for advice. He was assured that her behaviour was simply part of her recovery from tuberculosis.[52]

In 1948, with sympathetic directors Daryl Lindsay in Melbourne and Louis McCubbin in Adelaide, a loose network of state gallery directors had been formed. At the 1952 Adelaide conference all states were represented for the first time. Artist Robert Campbell had replaced McCubbin as director in South Australia and he, Lindsay and Missingham became the most active members of the group. An important aim of the network was, as Daniel Thomas has noted, to facilitate 'exhibitions of new art from Europe and the Unites States, hugely exciting for a local art world which then, before the global village of jet travel, felt extremely isolated.

The first of them was *French Painting Today*, 1953.[53] Missingham, who had worked as a commercial artist in London, designed the exhibition's catalogue, invitation and publicity poster, all of which were typical of the elegant house style he established at the Gallery. Artist John Olsen claimed that this show had as much influence on his generation as the 1939 *Herald* exhibition had had upon the previous one.[54] It included 123 works by seventy-eight artists and received unexpected publicity when the vessel carrying the works ran onto rocks off the coast of Tasmania on Christmas night 1952. The press suddenly became interested in the value of the collection and how many works had been damaged (none). In Sydney, partly because of the publicity, there were 150,000 visitors in a month and nearly 16,000 catalogues sold. The Gallery, however, purchased only two minor works.[55]

The range of exhibitions that this directors' network, a precursor to the Australian Gallery Directors Council (AGDC 1975–81), managed to circulate was a considerable achievement. Assisted by official government agencies, such as the British Council, the United States Information Service and the Empire Art Loan Collections Society, it toured exhibitions across the whole country for the first time, taking them to Brisbane, Sydney, Melbourne, Hobart (and sometimes Launceston), Adelaide and Perth.[56] In the early years of the scheme these exhibitions included *Henry Moore Sculpture and Drawings* (1947), *Eleven British Artists* (1949), *Exhibition of British Watercolours* (1949), *French Painting Today* (1953), *Italian Art of the 20th Century* (1956), *Contemporary Canadian Painters* (1957), *Contemporary Japanese Art* (1958), *Israeli Painters* (1958) and *Recent Paintings: Seven British Artists* (1959). An exhibition on *Pre-Raphaelite Art*, curated by Daniel Thomas, was part of the scheme.[57] As he recalls, this exhibition 'initiated a formula of building on existing strengths in Australia-wide collections and, because the movement was not yet fully rehabilitated in Britain, extraordinary loans were secured from overseas, such as *The scapegoat* by Holman Hunt'.[58]

The preponderance of British contemporary art in these exhibitions reflected the tastes of the Australian Gallery directors and particularly of Hal Missingham himself, who had trained in England and knew some of the artists personally. Out of the *Eleven British Artists* shown in 1949, six were already represented in the collection, and works by

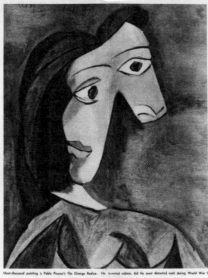

French paintings in Australia

Modern art collection (now in Brisbane) draws fire or rapture from critics—and huge crowds

The Exhibitionists

Edward Le Bas and Ben Nicholson were purchased from the show.[59] Many of the British works already in the collection had been acquired by John Rothenstein, director of London's Tate Gallery, who in 1945 had been appointed to purchase contemporary British works for the Gallery at Missingham's suggestion.

The appointment was controversial. Trustee Lionel Lindsay believed this was undercutting his friend Harold Wright, who had been purchasing prints for the Gallery since 1936. In 1946 he moved that Wright 'be appointed London representative to purchase works for the Gallery … not restricted to any period – understood not to clash with Rothenstein'.[60] Lindsay also sent a nasty letter to Missingham:

As to the appointment of Rothenstein, I think it a calamity. His father was a toady and cordially disliked in London art circles … I trust that the Trust's wish for good modern painting and no theoretic or abstract nonsense will be also communicated to him. Otherwise, I fear that our money will be thrown, if not into the gutter, at least to the Ghetto.[61]

This was Missingham's first encounter with the 'tremendously strong anti-Jewish feeling' of some trustees. 'Not only were paintings by Jewish artists disregarded,' he wrote, 'but gifts or loans offered by Jews were smartly declined.'[62]

As *French Painting Today* had a significant impact on the development of Australian expressionism, the 1967 blockbuster exhibition *Two Decades of American Painting* is considered to have had a similar influence on abstract painting

The Augean stables

167

in Australia. It included ninety-seven paintings by artists such as Roy Lichtenstein, Andy Warhol, Jackson Pollock, Willem de Kooning, Mark Rothko, Frank Stella and Ad Reinhardt, selected by Waldo Rasmussen of MoMA, New York, under the auspices of its International Council. The catalogue included essays by Irving Sandler and Lucy Lippard.[63] Some works were borrowed from MoMa. Others were for sale, supplied by commercial galleries like Sidney Janis and André Emmerich. The Gallery purchased *Homage to the square: early fusion* 1966 by Josef Albers for $5275 and *Ayin* 1958 by Morris Louis for $12,178.[64] Albie Thoms remembered seeing works by most of these artists in reproduction, noting that 'nothing prepared me for their actual impact, their size and physicality, their depth of colour and their assuredness of form'.[65] The opening of this exhibition was the occasion for a great

piece of Missingham cheekiness, in aid of communicating the necessity for a new, expanded building after years of government dithering. As the building had no place for the large crates in which many of the works were shipped, Missingham gave instruction for them to be crowded onto the Gallery's porch, so that guests arriving for the exhibition opening had to squeeze through ugly blue packing crates. He made his point.

By far the costliest exhibition that Missingham organised was the 1968 *Design in Scandinavia*.[66] During the course of the project he became infatuated with the multilingual,

Above: Packing crates from the exhibition *Two Decades of American Painting* stored in the portico of the Art Gallery of New South Wales, 1967. Photograph: Kerry Dundas **Right:** Hal Missingham *A wild party* 1949

The Exhibitionists

unflappable Norwegian Ulla Tarras-Wahlberg, who accompanied it as 'exhibition secretary', confessing 'she was both brilliant as an organiser and beautiful as a person. I adored her on sight'.[67] Missingham's womanising was an open secret in the Sydney arts community. His personal life attracted attention also on account of his politics. In September 1947, Mrs Dongan of the Australian Arts Movement denounced him as a Communist. Against the McCarthyist hysteria of the times, he was asked to declare that he was not a member of the Party and to resign from the committee of all art societies, particularly the 'highly suspect' Studio of Realist Art (SORA). When hostile trustee John Maund tabled an article on 'How Communism is infiltrating cultural organisations', the board asked Missingham 'to make no press statements involving the trustees and to be more circumspect in statements not dealing directly with normal gallery activities'.[68]

He had been indiscreet in the past, with one of his press interviews provocatively titled 'Out of the chilly mausoleum of our Art Gallery comes a brave, new voice'.[69] He believed that the art critic for the *Daily Mirror*, the devout Catholic Mary Corringham, watched him 'like a lynx'.[70] But she was not the only one. When he exhibited a painting entitled *A wild party* at the 1949 Society of Artists, a journalist from *Smith's Weekly* rang him for comment. It must have touched a nerve, as the journalist wrote, 'we're still reeling a little from our impact with Mr. Missingham's urbane public relations manner'.[71]

The journalist then proceeded to write a sanctimonious critique of the painting, which showed 'young men and women in clothing and positions not generally adopted at parties Smith's attends'. When Corringham confronted Missingham at an exhibition opening and said, 'Mr Missingham, there is a great deal of gossip going around the town that you have been seen frequently in the company of a certain girl', he said that he looked her straight in the eye and replied, 'I hate to mention it, but you and the gossips are already four girls behind'.[72]

Such humour deflects from a genuine criticism of Missingham's directorship. His liaisons would not be relevant had they not impinged upon his role at the Gallery. But they did, as they involved subordinate staff and others within the art world. 'The side of Missingham which everybody knows,' according to his friend and fellow gallery director Laurie Thomas, was 'the surfing, happy-go-lucky ... singleted figure with a weekender down the coast where his mates are chaps with nicknames like Wart and Rooster.'[73] Women were auxiliary in this blokey world. Missingham made them even more so through his deaccessions and lack of programming. He purchased fewer works by women artists than any previous director. From the art society exhibitions in summer 1914, for instance, nine works by men and seven works by women

were purchased. Missingham later deaccessioned the works by Evelyn Chapman, Ethel Stephens and Alice Norton. Other women artists who had significant works deaccessioned under him included Mary Stoddard, Edith Cusack, Jane Price, Florence Fuller, Alice Muskett and Ellis Rowan.

Nor was a major exhibition of a female artist programmed under Missingham.[74] An *Exhibition of Australian Women Painters* was hastily put together for the Australian Women's Charter Conference in 1946, drawn from the permanent collection.[75] The official delegates from eleven nations visited the exhibition, hoping to see on display a representative range of work reflecting the contribution of women artists to the cultural life of Australia. Instead, they encountered, in the words of critic and gallerist Harry Tatlock Miller, a few works stuffed in one 'dingy and draughty court of our National Gallery'.[76]

Epigraph

Kenneth Clark, *Another part of the wood: a self-portrait*, Murray, London, 1974, p 150.

Notes

1 The Kenneth Clark lecture was given on 27 January 1949. Republished by the National Gallery of Victoria in 1981.

2 Clark 1974, p 151.

3 See Simon Pierce, 'Sir Kenneth Clark: deus ex machina of Australian art', *Melbourne Art Journal*, no 11–12, 2009, pp 86–103. In the delightful diary he kept of his time as NSW Governor, Lord Beauchamp wrote, 'this diary is to be a record of impressions rather than of facts and a history written with a broad pen'. It is a good description also of Clark's autobiography. See William Lygon, 7th Earl of Beauchamp, diary written while NSW Governor, 1899–c1900, State Library of NSW, p 22.

4 Ashton tendered his resignation in November 1943 but agreed to stay on until a replacement could be found. He left in April 1944. Applications for the position were received from Douglas Dundas, Rah Fizelle, GO Goodwin, EH Hughes, RA Hunt, Frank Medworth, Dr George Berger, DA Bridge, Erik Langker, Charles Meere, Clif Peir, Sali Herman, EM Ostram, NFJ Brown, Ian Fairweather, W Anderson, Ivor Francis, Louis McCubbin, Miss J Blair, Miss N Hennessy and Dr Kurt Rogers. The three interviewed were Fizelle, McCubbin and Medworth, with McCubbin unanimously recommended for the position. However, McCubbin had to withdraw his application because of superannuation complexities. The position was re-advertised, opening it up to the armed forces and overseas applicants. Missingham was chosen from a short list of Erik Langker, Douglas Dundas and Bernard Smith.

5 HP Melville, 1 May – 19 Jun 1944, staff inspector of schools; gallerist John Young, 19 Jun – 25 Aug 1944; and Frank Medworth, 23 Oct 1944 – 3 Sep 1945.

6 From September 1926 to December 1927 Missingham was a full-time student at the School. He studied lithography under Hartrick, etching under WP Robins, book illustration under Noel Rooke, and drawing and painting under James Grant and Bernard Meninsky. He returned as an evening student in August 1928. In July of 1929 he was awarded the London County Council Senior Art Scholarship for 1930–33. In July 1933, he was appointed Noel Rooke's assistant in the Book Illustrating Department and continued to teach at the school until June 1939.

7 Letter to Esther Missingham, 1 Sep 1945, quoted in Lou Klepac, *Hal Missingham: artist, author, photographer*, Beagle Press, Sydney, 2017, p 17.

8 Clark 1974, p 150.

9 The staff comprised the director and his secretary, a clerk and an accountant, an office assistant, conservator, resident caretaker, carpenter and seven attendants, with two full-time nightwatchmen and one weekend nightwatchman.

10 'Advice', *Daily Telegraph*, 11 Sep 1946, p 15.

11 Report from Hal Missingham to the Minister for Education, 10 Aug 1953, National Art Archive, Art Gallery of NSW.

12 In May of that year a building committee was established with trustee and architect Walter Bunning as its president.

13 AGNSW Minutes, 25 Oct 1963.

14 Throughout 1966 and 1967 the trustees had asked the government to place the cost of the new extension on Treasury estimates, but they were continually disappointed when this did not occur. Even as late as September 1968 the Gallery had not received any official communication regarding the building extensions. However, it was reported at the trust meeting on 26 October 1968 that the 'extensions to the Gallery were now on the agenda again, but all speed would be necessary in consideration of the proposals, because the intention was to complete this work by the time of the Captain Cook celebrations. The building needed to be opened in August 1970 ... New plans are being drawn up ... the new scheme provides about the same space as previously envisaged in the 1964 plan.'

15 Andersons' plans were formally approved by the trustees on 22 November 1968.

16 Daniel Thomas, 'Painting forever: Tony Tuckson', *Art Monthly Australia* 136, Dec 2000, p 6. Andersons later found working with Ron Radford, director of the Art Gallery of South Australia and National Gallery of Australia, even more exacting and well informed.

17 History took Tuckson's side in this argument and all three NGV courtyards are now enclosed exhibition spaces.

18 Renée Free, 'JA Tuckson deputy director', in Daniel Thomas, Renée Free and Geoffrey Legge, *Tony Tuckson*, Craftsman House, Sydney, 1989, p 19.

19 Hal Missingham, *They kill you in the end*, Angus and Robertson, Sydney, 1973, p 126.

20 Sali Herman won first prize in the art lottery and donated back to the Gallery half the money raised when the paintings were sold at auction. This was used as a fund from which paintings could be purchased for the new building.

21 Peter Huxley was in charge of several large charity funds, including the Gallery's, all held in trusts by the Rural Bank. He was also director of the Captain Cook Celebrations Art Gallery Foundational Appeal. He admitted to stealing $5.2 million from the Rural Bank and served eight years and nine months of his jail sentence. It is unclear how much money he misappropriated from the Gallery's fundraising.

22 Missingham 1973, p 128.

23 AGNSW Minutes, 27 Jun 1969.

24 Missingham 1973, p 130.

25 Andrew Metcalf, *Architecture in transition: the Sulman award 1932–1996*, Historic Houses Trust of NSW, Sydney, 1997, p 104.

26 Hal Missingham, Lecture to Art Gallery Society, 18 May 1971, National Art Archive, Art Gallery of NSW.

27 The attendants at this time were a small team of seven men. Their duties included front door security, staffing the cloakroom, small cleaning jobs around the gallery and running errands in the city for banking and mail. Many years later in his *Report of the Deputy Director: overseas tour April 1967 – January 1968*, Tuckson listed these duties on page 28 of the report.

28 Missingham 1973, p 12.

29 Across the Tasman, artist Colin McCahon had a similar meteoric rise within the Auckland City Art Gallery, which he joined in 1953 as a cleaner, becoming attendant and then deputy director within a very short period. Some of this chapter repeats material used in Steven Miller, 'Turning on the lights: Tuckson at the Gallery', in Denise Mimmocchi (ed.), *Tony Tuckson*, Art Gallery of NSW, Sydney, 2018, pp 153–63.

30 Both Kenneth Clark and Philip Hendy, his successor as director of the National Gallery in London, studied modern history at Oxford University.

31 Report of the Trustees of the Art Gallery of NSW for 1958, Government Printer, Sydney, 4 Nov 1959, p 4.

32 Email from Renée Free to Steven Miller, 8 Dec 2020.

33 The librarian Paulette Jones had been seconded to the Gallery from the State Library in 1959. She challenged the appointment of Free on the grounds that she did not have enough Gallery experience. The first time a designated registrar appears in the staff lists is in 1963 and this is R McLintock. The annual report simply notes 'a registrar and junior clerk were appointed late in 1963 to replace the previous appointment of a senior Clerk'. In the 1965 annual report, RCD King is listed as 'registrar' and in 1968 WA Schumacher is noted. In the 1969 annual report it is noted that Kevin Powell is appointed registrar (20 Oct 1969) and Schumacher is transferred (27 Oct 1969). These early 'registrars' were not mainly occupied with the documentation, management and movement of the collection and loans, which is the current focus of this position. Kevin Powell, for instance, was head of the Gallery's general administrative staff.

34 Email from Renée Free to Steven Miller, 3 Apr 2021.

35 See Alan Lloyd, 'The Boustead years 1946–1977', in Carl Villis and Alexandra Ellem (eds), *Paintings conservation in Australia from the nineteenth century to the present: connecting the past to the future*, contributions to the 11th AICCM Paintings Group Symposium, National Gallery of Victoria, Melbourne, 2008, pp 51–61.

36 The floods occurred in November 1966. The conservation team worked in Florence for most of 1967.

37 Alan Lloyd 2008, p 59.

38 A group show by Sidney Nolan, Russell Drysdale and William Dobell.

39 Letter from Hal Missingham to Daryl Lindsay, 8 Jan 1952, CFG38b/1952.

40 Boustead claimed that 'without Tony's insistence and tenacity there would never have been' such a collection. Letter from W Boustead to Hal Missingham, 26 Nov 1973, Tuckson personnel file, National Art Archive, Art Gallery of NSW.

41 Cara Pinchbeck, 'To be cultured', in Denise Mimmocchi (ed.), *Tony Tuckson*, Sydney, Art Gallery of NSW, 2018, p 177.

42 See Natalie Wilson, '(Works) of paradise and yet: Stanley Gordon Moriarty, Tony Tuckson and the collection of Oceanic art at the Art Gallery of New South Wales', in

The Exhibitionists

Susan Cochrane and Max Quanchi (eds), *Hunting the collectors: Pacific collections in Australian museums*, Art Galleries and Archives, 2nd edn, Cambridge Scholars, Newcastle upon Tyne, 2011, pp 216–34.

43 The exhibition was held between 20 April and 22 May 1966.

44 In May 1943 the National Gallery and the National Museum of Victoria had held the *Primitive Art Exhibition*, which included Indigenous Australian art and works from Central Africa, Indonesia, Iran, the north-west coast of America, as well as parts of Melanesia and Polynesia. In 1955 the National Gallery of Victoria held the *Exhibition of Works of Primitive Art*, once again including American, African, Polynesian and Melanesian art.

45 D'Arcy Ryan, 'On discussing ethnic art', *Art and Australia*, Sep 1966, p 144.

46 It had been commissioned by the state gallery directors as a major touring exhibition.

47 The exhibition was shown from 19 October 1973 to 1974, where it morphed into a collection hang in the dedicated gallery. The exhibition was curated from the Gallery's permanent collection and the 'loan of a selection from Mr SG Moriarty's collection of New Guinea Highland art.'

48 In 1978 the Australian National Gallery, as it was then known, appointed Ruth McNicoll 'Curator, Department of Primitive Art'. Her title was changed shortly after to include Pre-Columbian art, Indonesian textiles, and so on.

49 Missingham 1973, p 58.

50 *William Dobell: Paintings from 1926 to 1964*, 15 Jul – 30 Aug 1964. Children were admitted free and subsequently not counted in the attendance numbers.

51 *Sidney Nolan Retrospective Exhibition: Paintings from 1937 to 1967*, 13 Sep – 29 Oct 1967.

52 Letter from Hal Missingham to Esther Missingham, 9 Sep 1967, National Library of Australia, Canberra, MS 3940/1/6.

53 Daniel Thomas, 'Hal Missingham', *Art and Australia*, vol 32, no 2, Dec 1994, p 204.

54 *French Painting Today*, 27 Feb – 29 Mar 1953. The exhibition opened at the Tasmanian Museum and Art Gallery, then travelled to the National Art Gallery of NSW, and from there to Brisbane, Melbourne, Adelaide and Perth.

55 Both with the persistent pressure of trustee Douglas Dundas. The works

were Paul Bercôt, *The flute* c1953 and Maurice Estève, *Vivarium* 1947.

56 The Empire Art Loan Collections Society was founded in 1932 by Percy Sargood of Dunedin, New Zealand. On the formation of the Society three Australian galleries and four galleries in New Zealand agreed to contribute twenty-five pounds a year for three years towards the expenses.

57 *Pre-Raphaelite Art*, Art Gallery of NSW, 3–28 Oct 1962, then travelling.

58 Daniel Thomas, 'Being a curator', *Art Monthly Australia*, no 123, Sep 1999, p 5.

59 Already in the collection were Tristram Hillier, Frances Hodgkins, Winifred Nicholson, Victor Pasmore and John Piper.

60 AGNSW Minutes, 22 Nov 1946, p 2890.

61 Letter from Lionel Lindsay to Hal Missingham, 10 Dec 1945, CF122/1945.

62 Missingham 1973, p 27.

63 *Two Decades of American Painting*, National Museum of Modern Art, Tokyo, 15 Oct – 27 Nov 1966, National Museum of Modern Art, Kyoto, 10 Dec 1966 – 22 Jan 1967, Lalit Kala Akademi, New Delhi, 28 Mar – 16 Apr 1967, National Gallery of Victoria, 6 Jun – 9 Jul 1967, Art Gallery of NSW, 17 Jul – 13 Aug 1967. It seems that the Australian leg of the tour was added very late in the planning, with a number of works substituted due to inflexible loan arrangements with India and Japan having already been finalised.

64 *Homage to the square: Autumn echo* 1966 by Albers was purchased by the National Gallery of Victoria, *Homage to the square: impartial* 1966 by Albers was purchased by Harry Seidler and Frankenthaler's *Cape (Provincetown)* 1964 was purchased by the National Gallery of Victoria.

65 Albie Thoms, *My generation*, Media21 Publishing, Sydney, 2012, p 239.

66 *Design in Scandinavia*, 3–28 Jul 1968.

67 Missingham 1973, p 72.

68 AGNSW Minutes, 27 Aug 1948, p 3039.

69 'When a man in a nice job talks straight – that's news', *Daily Telegraph*, 2 Oct 1945, p 8.

70 Missingham 1973, p 10.

71 'Art and Mr Missingham', *Smith's Weekly*, 10 Sep 1949, p 2.

72 Missingham 1973, p 11.

73 Laurie Thomas, *The most noble art of them all: the selected writings of Laurie Thomas*, University of Queensland Press, Brisbane, 1974, p 299.

74 The 1959 *Margaret Preston Survey*, 4 Jun – 16 Sep, was a collection show, that included only nine paintings and thirteen prints.

75 *Exhibition of Australian Women Painters*, 4–18 Aug 1946.

76 Harry Tatlock Miller, 'Sydney spotlight', *Australia: National Journal*, Jun 1947, p 39.

13 Art of the people
Art education and the Gallery

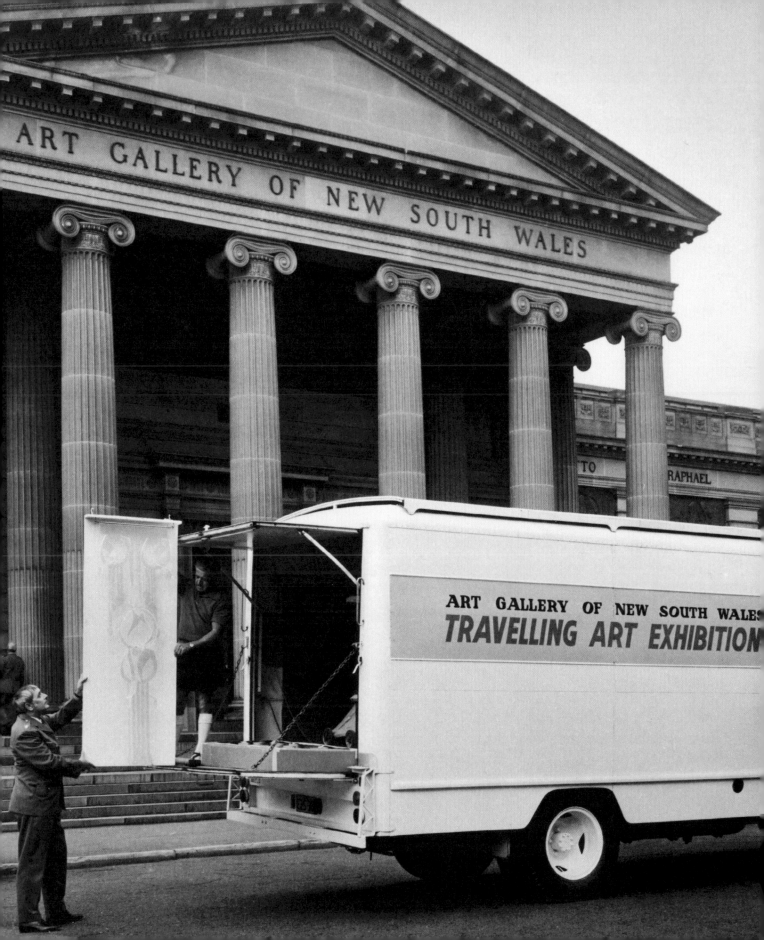

Art culture is an essential branch of education, inasmuch as it tends greatly to the intellectual advancement of the people.

Eliezer Levi Montefiore, 1876

Although Harry Tatlock Miller was critical of the 1946 *Exhibition of Australian Women Painters*, he readily acknowledged the new director's innovations in other areas. He described Missingham as a breath of fresh air in an article he wrote for the Sydney *Sun* newspaper:

> A fresh strong breeze seemed to swish through the National Art Gallery of New South Wales last Monday morning in the wake of a hatless young man in a sports coat. Hallowed canvases in the main courts of the gallery are said to have swayed on the walls as he entered; the *Sons of Clovis* looked even nearer to death, a redcoat's bayonet quivered in *The defence of Rorke's Drift*, and the *Queen of Sheba*, visiting Solomon, is supposed to have murmured 'Comes the Revolution … !'[1]

Many of Missingham's revolutionary proposals detailed in this article, including opening the Gallery at night, establishing a first-class art library, improving the design and content of Gallery publications and making the collection more representative, were made with students in mind, as 'students', Missingham said, 'are the most valuable people we have'. This emphasis on students and art education was a priority of the Gallery from its earliest years. The New South Wales Academy of Art had been founded in 1871 for the purpose of 'promoting the fine arts through lectures, art classes and regular exhibitions' and art education, both in its broadest sense, and for a time the more particular one of training practising artists, remained central to the Gallery's mission.[2] Melbourne's National Gallery of Victoria was initially under the chief secretary, but from its inception until 1971 the Sydney Gallery was responsible to the Minister for Public Instruction or Minister for Education.[3]

Practical art instruction was offered from 1872 until the Gallery moved to its current site in the Domain in 1885. Giulio Anivitti, the Master of the Gallery's School of Drawing, was also designated the Gallery's titular 'Curator of Paintings, Prints and Photographs' and Achille Simonetti, the Master of the School of Modelling, 'Curator of Busts, Casts, Relievi &c'. The Gallery's archive preserves silver medals awarded to former students Emily Maze (1878 monochrome oil study from cast) and Percy Williams (1879 crayon study of *The gladiator*). After training with Anivitti, both exhibited with the Art Society of New South Wales during the 1880s but did not continue with professional art careers. As was common in art schools of the time (and has become increasingly so) women

Previous page: The travelling art exhibition truck being loaded outside the Gallery, c1970. Photograph: Australian News and Information Bureau

The Exhibitionists

made up the larger group of students: nine of the sixteen enrolled in 1879. The Gallery had hoped to continue its art school, but the Outer Domain posed challenges. Offering evening instruction was essential but this required rendering 'access to the Galleries safe for female and youthful students, its hitherto insecure state having been the main obstacle'.[4]

At the beginning of 1900 the trustees commissioned Julian Ashton to write a report on art training being offered by the National Galleries of Victoria and South Australia. Ashton thought Melbourne was a better model for Sydney, with its focus on painting and drawing and 120 enrolled students, rather than Adelaide's wider incorporation of technical arts and its 450 students.[5] It was critical, Ashton said, to establish a travelling art scholarship worth £150 a year for three years. Melbourne had done this in 1888 and it proved successful, already with five distinguished alumni.[6] To facilitate this Ashton thought the trustees needed first to find 'some method for doing away with the friction between the two Societies'.[7] The Society of Artists, he noted, had 'for the last five or six years ... strenuously aimed at establishing some such incentive' as a travelling scholarship.

A subcommittee on education was established in March 1900 and at the end of 1902, members of the committee met with representatives from the Technical College and the Art Society of New South Wales. They decided that 'a comprehensive scheme of Fine Art teaching would be best secured by a Board of Administrators', consisting of one representative from each of their bodies. By 1904 nothing had been achieved and the president and vice-president officially visited the Minister on 5 February 'to emphasise the importance of carrying out the recommendations of the 1902 art education conference'. In 1906 the trustees as a body issued another 'Report on the Question of Art Education' recommending that the *Library and Art Gallery Act* be amended to allow the trustees to conduct an art school and that for the present time this school be run at the Gallery. They asked for an instructor in drawing and one in painting, along with a day and night attendant, and saw that instructors would be needed for modelling and applied arts in the future. They also asked for £1000 to be added to the statutory endowment for the maintenance of the school.

When a portion of the basement was reordered in 1913 for the display of casts, the annual report for that year noted that the trustees were still prepared to run an art school, as they had detailed in 1906, but there had been no concrete government support for the initiative. The Gallery and the Technical College, which had moved to a purpose-built home at Ultimo in 1891, were both branches of the Department of Education, which no doubt influenced the departmental desire to see the Gallery take on practical art education. However, after the opening of the new East Sydney Technical

College, in the buildings of the former Darlinghurst Gaol in 1923, this no longer became a priority.

The only matter that eventually came under the trustees' management was the New South Wales Travelling Art Scholarship. When Ashton wrote his 1900 report, the Society of Artists had just established its travelling scholarship, with George W Lambert the first recipient.[8] In 1934 the government took over the scholarship grants offered by both the Society of Artists and the Royal Art Society of New South Wales to form a single New South Wales Travelling Art Scholarship of £250 per annum, available for two years for figure painting or sculpture. Although representatives from both societies helped judge the award, it was largely administered by the Gallery.

Medals were awarded by the New South Wales Academy of Art to successful artists and art students in a number of categories at the annual exhibitions of colonial art and the student exhibitions held between 1872 and 1879. These two were awarded to (from top) PE Williams in 1879 for his crayon study of the plaster cast *The gladiator* and Emily Maze in 1878 for her oil study of a plaster cast.

By the mid 1930s money from the Carnegie Corporation of New York (CCNY) was beginning to flow into cultural and educational initiatives nationwide throughout Australia. Established by American philanthropist Andrew Carnegie, the CCNY had a capital fund of around US$135 million and was the largest single philanthropic trust ever established. Carnegie earmarked a portion of this endowment for what were then the British Dominions. In 1935, when CCNY president Frederick Keppel visited Australia for three months, the Corporation was spending just under half a million US dollars in the Dominions. A 1933 Carnegie report on Australian museums and art galleries had revealed how poorly resourced these were and presented the corporation with 'more difficult problems of selection and appraisal' than for any other field of activity.[9] In 1936 the corporation allocated US$50,000 to museum development in Australia.[10] The US$6600 received by the National Art Gallery of New South Wales was used to develop educational services.

With this money Margaret Preston was employed to give five lectures at the Gallery in June and July of 1938. She stirred things up by making the topic of her final lecture 'The moderns – to this year, 1938'. German-born sculptor and eloquent art theorist Eleonore Lange was then employed to deliver sixteen lectures from September 1938 to the middle of 1939, many devoted to individual artists. Preston completed the series in August and September 1939 with lectures on art techniques in printmaking, oil painting and pottery, including 'practical demonstrations where possible'. These proved incredibly popular. The Gallery had not offered such a well-organised and widely publicised series of lectures for years.

In 1888 Sidney Dickinson, a journalist and critic, had been invited to give four lectures, all of which were eventually published. He often used a magic lantern to delight his audiences, but his Gallery lectures were more straightforward. Nonetheless, the rather brash American waged into the debate about Sani's sculptures on the GPO, calling for their 'demolition', and said that Australian artists should paint fewer landscapes and more nudes, despite the 'prudery of public taste'.[11] It took another eighteen years before a series of ten 'bi-monthly conversational discussions' were programmed in 1906–07. These informal 'conversations' were Du Faur's initiative, based on individual works in the collection and delivered in the galleries with the works as backdrops where possible. The one on *Chaucer at the court of Edward III* unusually concentrated on conservation issues related to the work. Lecturing then virtually ceased until 1929 when the eloquent and fiery MacDonald was appointed director. He was always a drawcard on radio and at the podium.

The remainder of the Carnegie money that came to the Gallery was spent on art reproductions for teaching purposes, and art books.[12] Libraries were a key priority of CCNY. The Gallery's own library had developed haphazardly. Art books had been purchased from the early 1880s and were listed in the annual reports as acquisitions along with works of art. John Horbury Hunt's first plans for the Gallery included 'a lecture hall, art library and ateliers'.[13] The library was first housed with the collection of prints and drawings in a general study-room in Hunt's 1885 building. Later it was moved to the boardroom as part of the director's office. Both JS MacDonald and Will Ashton were eager to establish a more prominent library, with Ashton in a 1944 report listing this as a priority and recommending that it be open to the public. It was Hal Missingham who actually achieved this, locating the library at the centre of the staff floor in a new building. Missingham had always wanted to 'install a first-class art library'.[14] He was angered when the newly established Art Gallery Society did not seem to share this aim, telling members that if they had 'spent an equivalent amount of money on establishing the Library as had been done with the Promenade Lunch Hour concerts, the Library would now be established'.[15]

The fortunes of museum libraries are uniquely dependent on directorial support, perhaps more so than any other division within the institution. At the Art Gallery of New South Wales this support has been unwavering and consequently the Gallery's library and archive are nationally recognised as first-class resources for research. Edmund Capon, who was the Gallery's longest-serving director, said that at London's Victoria and Albert Museum, where he was a curator before coming to Sydney, he spent most of his time in its National Art Library. When the scholarly but inwardly focussed senior librarian Sam Alcorn retired, he was replaced by Susan Schmocker, who shared Capon's commitment to accessibility and adaptability.

During this time the library moved twice to expanded facilities, took on new staff and was the first to employ a dedicated archivist and later the first to appoint an archivist of Aboriginal and Torres Strait Islander collections, with the support of trustee Geoff Ainsworth and Johanna Featherstone. The collections were also enriched by donations of the personal libraries and archives of both Capon and his successor Michael Brand. From the early 1990s bibliophile and art patron Pat Corrigan donated exceptional collections of rare catalogues, artists' books, monographs and archives, becoming the most generous and long-term supporter of this department of the Gallery. The library was renamed the Edmund and Joanna Capon Research Library when Capon retired, in recognition of the couple's outstanding and sustained support for its collections and services.

Capon's successor as director, Michael Brand, launched the Gallery's archival collections as the National Art Archive in 2015, recognising that these collections had become the nation's richest depository of original documents on

Above: Art Gallery of New South Wales Research library, 1972. Photograph: Kerry Dundas
Right: Rendering by Mogamma of the future Edmund and Joanna Capon Research Library and National Art Archive on Lower Level 3 of the Art Gallery of New South Wales, designed by Tonkin Zulaikha Greer Architects. The project transformed a disused indoor garden into a dramatic double-height reading room.

Art of the people

Australian art – the result initially of historical circumstances and personalities rather than systematic planning.[16] The Gallery at the Domain had, from 1885, kept all its institutional records intact and at hand, cared for by diligent directors, curators and registrars. Bernard Smith remembered conducting his groundbreaking research into Australian artists where 'old minutes of Board meetings and kindred documents lay in heavy leather-bound volumes, shrouded in layers of the silent dust of the past'.[17] Curators in Sydney often acquired archival collections while preparing exhibitions, as Daniel Thomas did with Grace Crowley (1975) and David Strachan (1973), Renée Free with Frank Hinder (1966 and 1980) and Gael Newton with the Sydney Camera Circle (1984). These became foundational collections of the National Art Archive. From 1994, when a dedicated archivist was appointed, this collecting received explicit institutional support and became more wide-ranging and systematic.

Gwen Sherwood, the Gallery director's secretary from 1937, and 'an accomplished histrionic artiste', contributed to the creation of this exceptional historical archive.[18] Her passion was art-related press reviews, which she diligently clipped out from the newspapers and glued into bulging, well-indexed volumes. Her nemesis at the Gallery was the twenty-eight-year-old Bernard Smith, who in mid 1944 was seconded from the Department of Education for six months to organise regional travelling art exhibitions (TAEs).[19] The brilliant Smith was also in the middle of turning a series of lectures he had given into the publication *Place, taste and tradition*, the first Marxist history of a nation state (he claimed) and an important Australian art-historical text.[20] To do this he was pilfering anything of use to him from Sherwood's volumes. She was so angered that she made a formal complaint to the board of trustees that the press-cutting books were 'being depleted by Mr Bernard Smith'.[21]

Sherwood was not the only one who was wary of Smith. Lionel Lindsay wrote to fellow trustee James McGregor that he was 'too cock sure'.[22] Lindsay went further when writing to the print dealer Harold Wright in London, 'that damned understrapper – his name is Bernard Smith – in case you may have dealings in future with him ... I shall not forgive his intolerance, priggishness and vanity'.[23] Lindsay believed that Smith had carefully orchestrated to have himself appointed to the Gallery, with the assistance of sympathetic trustees Mary Alice Evatt and Sydney Ure Smith. He then took credit for the Gallery's travelling art exhibitions, as if these had been entirely his own idea, whereas collections loans had been circulating since the 1890s.[24]

When the committee at Goulburn's art gallery first asked for works on loan in 1895, emboldened by the colonial interchange exhibitions, it received a high-handed rebuttal: the intercolonial exchanges were 'quite on another footing, in

these cases an equally valuable "quid pro quo"' was secured; works were always entrusted to 'the custody of those who have been trained to their care'; insurance would need to be increased if works 'were placed in less desirable buildings'; and, above all, 'such a practice as the constant loaning of pictures from a National Gallery is a thing unheard of in any such Institution in the world ... A National Gallery is necessarily placed in all countries in the capital city and is one of its attractions to visitors from other parts.'[25] This request marked the first significant moment of tension between the Gallery's role as a popular cultural site in Sydney with its wider obligations to the state.

The Minister for Public Instruction, Jacob Garrard, was more alert to these wider obligations and placed pressure on the trustees. They relented, writing to him defensively that 'apart from their special duties in connection with the formation and maintenance of the National Art Gallery, the Trustees have, for some years past, done their best to assist in promoting the interests of Art in this colony'. They agreed to lend 44 pictures to be distributed among Newcastle,

Above: Bernard Smith (left) and Hal Missingham in 1946 inspect a John Skeaping chalk drawing as part of the *Graphic Art Exhibition* that toured the state in 1947 and again in 1950 **Right:** Cover of the catalogue to *Art in the Country*, published in 1946 to promote the activities of the travelling art exhibitions. The cover reproduces *The seed-drill's track* c1939 by Kenneth Macqueen from the Art Gallery of South Australia, Adelaide

The Exhibitionists

Bathurst and Goulburn.[26] From this date, works continually circulated between rural centres. The 1912 annual report, for instance, recorded loans at Bathurst, Goulburn, Newcastle, Condobolin, Armidale, Wollongong, Grafton, West Maitland, Junee and Orange, noting that 'the pictures are exhibited in the Technical Museums and Municipal Buildings of the various towns, where they remain for a term of 12 months, being afterwards removed to other centres provided with suitable buildings'.

In 1939 a Mobile Art Scheme was created by Valentine Crowley and the artist George Finey, circulating works to schools in the metropolitan area.[27] It operated for three years, but Smith completely discounted it. He also ignored the work that Gwen Sherwood had done shortly before he came to the Gallery. She had travelled around New South Wales to make an inventory of works on loan and drew up proposals for how the travelling art program could be more effectively managed. At this time more than five hundred works were circulating. Country loans had in fact increased during the war, as they were seen as serving 'the dual purpose of removing works in the National Collection to centres less vulnerable to air attack, and at the same time allowing them to be seen by the people'.[28]

Despite his failure to acknowledge precursors, Smith's achievements from mid 1944 until September 1948, when he left to take up a British Council Travelling Scholarship, were considerable. He put together nearly twenty exhibitions, which were held in over one hundred different venues

and visited by more than 150,000. Most of the shows were mounted in difficult circumstances. Often the local art teacher was enthusiastic, or the Society of Arts, but town officials much less so. School groups typically counted for half of the attendees, but the success of the schools' program was partly dependent on artists willing to travel as lecturers. Arthur Murch, James Cant, Desiderius Orban, Jean Bellette, Jeffrey Smart and Noel Kilgour all participated.[29]

Initially Smith developed a group of seven separate exhibitions, to be held in forty country centres from July 1944 to June 1945.[30] The first exhibition – *150 Years of Painting in Australia* – was made up of twenty-seven works from the Gallery's collection, three from the Mitchell Library and twenty-one lent by artists and collectors. The second exhibition, *Some Recent Australian Painting*, was shown in Canberra in December of 1944 and included 100 works. Smith deliberately made this second show more challenging, including paintings by Grace Crowley, Ralph Balson, Frank Hinder, James Gleeson, Eric Wilson, Mary Webb and others. Smith's exhibitions highlighted the poor art infrastructure in regional New South Wales compared with that in country Victoria. In Newcastle, where the exhibition was held at the Trades Hall, Smith reported that 'the need for a Newcastle Art Gallery was featured in the press and over the air'.[31] The Department of Education itself noted that 'the success of the [travelling art scheme] has encouraged a number of municipal and shire councils to view favourably the principle of establishing local art galleries in conjunction with libraries and museums'.[32] Rural acquisitive art prizes were also often established in the wake of the travelling exhibitions and these gave further support to the establishment of permanent galleries.[33]

Although the scheme continued for a few years after Smith left in 1948, with Dorothy Lees as 'organiser', it petered out in the mid 1950s. When Smith returned to the Gallery from 1951 to 1953 it was to compile the first scholarly catalogue of Australian oils in the collection. Returning to Australia, he feared that he would be sent by the Department of Education to Newcastle Teachers' College where he would not be able to finish the degree at Sydney University that he had begun in 1945. With support of trustees EB Waterhouse, Mary Alice Evatt and Jack Glasheen, he proposed compiling a scholarly catalogue of the collection, similar to those that Martin Davies was producing for the National Gallery in London. The last catalogue of the permanent collection had been published in 1928, so there was need for an update. Director Will Ashton had made a start in 1941, but nothing had been completed.[34] Smith was appointed on 23 February 1951 with the task of completing the job.

Working from a small alcove at the end of the boardroom, where both the Gallery's library and archive were located

Above, top: Artist Dorothy Thornhill showing schoolchildren in Goulburn a
collection of reproductions of Old Master paintings, reproduced in the 1946
Art in the Country catalogue. Photographer unknown **Above:** Deputy Director
Tony Tuckson talking to school children in Albury during a travelling art
exhibition there, c1952. Photographer unknown

The Exhibitionists

and where all the publications by former trustee Sydney Ure Smith were contained in a 1946 memorial bookcase, Bernard Smith 'combined catalogue worksheets, archival research, and correspondence with living artists, to create one of the most significant documents in Australian art history'.[35] Renée Free built upon this tradition when she later compiled her catalogue of British paintings in the collection.[36] Smith made no attempt to define narrowly 'Australian' painting: 'The inclusion of a painting has been determined by a practical consideration; can it be said to be of Australian interest?'[37] Paintings by artists who had permanently relocated overseas were included, as were works that had been 'transferred' to the Mitchell Library and deemed important by Smith.

Some early colonial watercolours, later paintings of 'old Sydney', portraits, photographs, prints, sculpture and books had made their way to the historical collections of the Mitchell Library from 1911 onwards, with the bulk of transfers occurring in the 1920s.[38] These were made before the Gallery had professional curatorial staff and it is certain that someone like Daniel Thomas, appointed the Gallery's first curator, would not have judged all these works to be of merely 'topographic and anecdotal historical interest', thereby justifying their transfer. William Ifould, state librarian between 1912 and 1942, was appointed a trustee of the Gallery in 1921 and became acting director of the Gallery in 1926.[39] No works of outstanding artistic merit, or indeed of any merit, were transferred from the Library to the Gallery. The traffic was only one way and this despite the deed of gift for some works, such as watercolours by JW Lewin and the Port Jackson Painter, expressly forbidding permanent transfer.[40]

In 1956 Treasury discontinued funding for travelling art exhibitions. The Gallery had asked that a full-time education officer be appointed, with clerical assistance and a van, but this was refused. The 1961 annual report noted that 'trained staff was needed to reconstitute the service'. This did not happen until 1967, when Dennis Colsey was employed.[41] The Department of Education made a gift of a 5-ton truck to facilitate the reconstituted program: 'The air-conditioned vehicle contains seventeen large aluminium wall-panels which when mounted on adjustable legs and clipped together form three sides of a temporary art gallery. This mobile gallery can be erected inside any suitable country civic centre, church or school hall, and each panel has its own adjustable lighting.'[42]

The first exhibition of the reconstituted service was *One Hundred Years of Australian Landscape*. It was attended by more than 73,000 people and Colsey boasted that he delivered 890 lectures in connection with it.[43] The formal establishment of the Gallery's Education Office occurred on 5 June 1972, when Darryl Collins arrived from Adelaide. Gil Docking, Senior Education Officer, was appointed shortly after. Robert Lindsay and Alison Fraser were appointed in November

1973.[44] Unlike their counterparts at the National Gallery of Victoria, all these new staff were employed by the Gallery and not on secondment from the Department of Education.

Lindsay was put in charge of the TAEs and also administered the funding, which came from the government's cultural grants committee, the main source of income for the exhibitions.[45] He and Fraser would alternate on six- to eight-week tours in the country with the shows, which continued to be important throughout the 1970s and '80s. In 1980 *Onsight* was established, a metropolitan travelling art exhibition project, run by Campbell Gray and then Jonathan Cooper, which in many ways revived the Mobile Art Scheme that had been established in 1939.[46]

Although staff were designated to particular services, such as travelling art, they were not restricted to these activities. Robert Lindsay, for example, curated a number of Project exhibitions. These broke down some of the traditional demarcation lines between curatorial and education staff and allowed 'more of an inter-crossing' of expertise and interests, as Bernice Murphy recalled.[47] Murphy moved from being senior education officer in 1974–78 to the Gallery's first curator of contemporary art in November 1979, with a short time at Art Exhibitions Australia in between. Robin Norling, who took over as senior education officer in 1978 and remained in the role until 1986, nonetheless believed that the exhibitions curated by the Gallery's educators 'juxtaposed works no curator would ever juxtapose, and we got a lot of flak'.[48]

The role of educators at the Gallery was transformed in these years. Murphy believed that blockbuster exhibitions played a role in this, opening up 'questions of greater involvement with audiences, with different kinds of audience'.[49] At the same time, more experimental exhibitions often called for increased interpretation and lent themselves to supplementary programs of artists' talks, forums and the like. The role of education staff was amplified and extended. The programs they organised for the 1976 Biennale, for instance, 'really became the first menu of a diverse series of programmes built around an exhibition, instead of the exhibition itself being presented as in some ways self-sufficient'.[50]

In 1982 a dedicated gallery was assigned to the education department and its first exhibition, *Light and Shadow*, was curated by Norling and Alan Krell.[51] *The Printmaker's Studio*, shown the following year, was a three-part exhibition that included studios for silkscreen (Sally Robinson) and relief printmaking (Helen Eager), along with a functioning lithography studio under Idris Murphy, the Gallery's first artist-in-residence.[52] In the same year, a small exhibition of 1982 Higher School Certificate art major works was held, initiating the popular *Artexpress* series of exhibitions.

One of the most unexpected consequences of the Gallery's travelling art program was the impact it had, albeit briefly, upon art acquisitions. Experimental Australian works were purchased because of their educative value. A similar thing occurred at the Los Angeles County Museum of Art, where curator James Byrnes was able to purchase the Gallery's first Jackson Pollock in 1951, provided he use it 'for educational purposes' and store it in his office. In Sydney, when the Gallery did not have representative modern works, Smith initially borrowed them from artists. But in January 1945, trustee Charles Lloyd Jones moved that 'owing to the need to include some examples of recent Australian painting in the exhibitions arranged for country centres ... the Travelling Exhibition Committee [is] empowered to purchase paintings to an aggregate sum of £500'.[53]

This is how the first works by Sali Herman entered the collection. However, the committee's power to purchase was short-lived. The virulently anti-modernist trustee John Maund, whom Smith and Missingham dubbed 'Johnnie the Terror', argued against the legality of the resolution and in April 1945 it was rescinded. From then on, the Travelling Art Sub-Committee could choose work, which was then submitted to the Board for final approval.[54] Nonetheless, Eric Wilson's *Hospital theme – the sterilizer* 1942 was put up and got through in September 1945. It was one of the most abstract works to come into the collection. It was part of a submission of ten works. Others included – but eventually rejected – were Drysdale's *A football game* 1943 (Ballarat Art Gallery) and Gleeson's *The pretext of accident* (National Gallery of Australia).

On Friday 3 September 1971 Hal Missingham retired as director of the Gallery, exactly twenty-six years to the day after his appointment in 1945. He told the press that he was going off, Christ-like, to the desert for twelve months to find himself, with his 'new Queensland blue heeler pup that I'm training up to take round with me ... He's a bloody boomer'.[55] When he was asked about his achievements and whether he had any regrets, he admitted to one: 'the administrative life which prevented him being the painter he was trained as'.[56]

Eric Wilson *Hospital theme – the sterilizer* 1942

The Exhibitionists

Epigraph

E L Montefiore, 'Letter to the editor', *Sydney Morning Herald*, 11 Jan 1876, p 3.

Notes

1 A breeze blew into the gallery', *Sun*, 9 Sep 1945, p 4.

2 *New South Wales Academy of Art first annual report*, Sydney, 1872, p.1.

3 Government departments responsible for the Art Gallery: 1874–80 The Council for Education; 1880–1915 Minister for Public Instruction; 1916–33 Minister for Education; 1933–44 Minister for Public Instruction; 1945–46 Minister for Education; 1946–51 Minister for Public Instruction; 1952–63 Minister for Education; 1964–67 Minister for Education and Science; 1968 Minister for Education; 1969–70 Minister for Education and Science; 1971–75 Minister for Cultural Activities; 1975–76 Minister for Culture, Sport and Recreation; 1976–84 Premier's Department; 1984–88 Minister for the Arts (within the Premier's Department); 1988–2006 Ministry for the Arts; 2006–09 Department of Arts, Sport and Recreation; 2009–11 Communities New South Wales; 2011–14 Department of Trade and Investment, Regional Infrastructure and Services; 2014–19 Justice Department; 2019– Department of Premier and Cabinet.

4 *Report of Committee on the Question of Art Education*, 6 Apr 1906, p 2.

5 He thought the only major omission from the Melbourne curriculum was modelling.

6 John Longstaff in 1888, Aby Altson in 1891, James Quinn in 1894 (incorrectly cited in Ashton's report), George Coates in 1897 and Max Meldrum in 1900.

7 Julian Ashton, *1900 report on art instruction*, Rep1900.2, p 3.

8 George W Lambert in 1900, Roy de Maistre in 1923, Arthur Murch in 1925, Douglas Dundas in 1927, William Dobell in 1929, Harold Abbott in 1931, and Arthur Freeman in 1933.

9 Carnegie Corporation of New York, *1935 annual report*, p 22.

10 It must be remembered that at the same time the NSW government allocated about £3000 to the National Art Gallery of NSW for art purchases and the daily running of the gallery, while the Victorian government gave about £2000 and the South Australian £1480 for the daily running of their state galleries.

11 'The Art Gallery lectures', *Daily Telegraph*, 22 Dec 1888, p 7.

12 AGNSW Minutes, 10 Jul 1936, p 1552.

13 'The new art gallery', *Sydney Morning Herald*, 22 Jul 1884, p 7.

14 'A breeze blew into the Gallery', *Sun*, 9 Sep 1945, p 4.

15 Quoted in Judith White, *Art lovers: the story of the Art Gallery Society of New South Wales 1953–2013*. Art Gallery Society of NSW, Sydney, 2013, p 29.

16 In much the same way that the Archives of American Art began at the Detroit Institute of Arts.

17 Bernard Smith, *A pavane for another time*, Macmillan Art Publishing, Melbourne, 2002, p 458.

18 'Dramatic art', *Hebrew Standard of Australasia*, 13 Mar 1936, p 9.

19 The six months secondment turned into four years. Some of the material in the following paragraphs first appeared in Steven Miller 'Contingency as the guard dog of history: Bernard Smith at the National Art Gallery of New South Wales, 1944–48', in Jaynie Anderson, Christopher R Marshall and Andrew Yip (eds), *The legacies of Bernard Smith: essays on Australian art, history and cultural politics*, Power Publications, Sydney, 2016, pp 217–27.

20 Bernard Smith, *Place, taste and tradition*, Ure Smith, Sydney, 1945.

21 AGNSW Minutes, 27 Jul 1945, p 2803.

22 Letter from LL to JR McGregor, 6 Feb 1945, Mitchell mss 1969/4, p 302.

23 Letter from Lionel Lindsay to Harold Wright, 15 May 1945, Mitchell mss 515/4, p 337.

24 See Bernard Smith, 'Taking art to the country: how it began', in *Cultivating the country: living with the arts in regional Australia*, Oxford University Press, Melbourne, c1988, pp 34–46.

25 AGNSW Minutes, 1 Feb 1895, p 156.

26 AGNSW Minutes, 16 Apr 1895, p 177.

27 The first of these exhibitions opened at Sydney Girls High School on Friday 29 September 1939. It was intended by the state director of education that seven groups of twenty to thirty paintings be circulated continuously in eighteen high schools for one year.

28 AGNSW Minutes, 25 Sep 1942, p 2449.

29 The government in 1944 gave a grant of £500 to pay for guide lectures to schoolchildren.

30 Exhibition 2: *Some Recent Australian Painting*; Exhibition 3: *Since Conrad Martens*; Exhibition 4: *History of American Painting*; Exhibition 5: *A Group of Australian Paintings*; Exhibition 6: *Mortimer Menpes Reproductions of Old Masters*;

Exhibition 7: *Twenty-One Australian Painters.*

31 The *Canberra Times* noted that 'many citizens commented that the exhibition emphasised the need for improved art facilities'.

32 *1948 Report of the Minister for Public Instruction*, p 7.

33 Such prizes included that in Albury, where an acquisitive art prize was established in 1947, eventually leading to the establishment of a gallery. Some young artists living in the country remembered the encouragement they received from Smith's travelling exhibitions, including Earle Backen who saw a few of the exhibitions in Wagga Wagga.

34 From 1883 until 1928 there were four catalogues of the permanent collection published. Each of the four was transformed through a number of editions and revisions. These changes were sometimes major.

35 Joanna Mendelssohn, 'Bernard Smith and the professional art museum' in Anderson, Marshall and Yip 2016, p 237.

36 Renée Free, *Art Gallery of New South Wales catalogue of British paintings*, Art Gallery of NSW, Sydney, 1987.

37 Bernard Smith, 'Introduction', in *A catalogue of Australian oil paintings in the National Art Gallery of New South Wales, 1875–1952: with annotations, biographies and index*, National Art Gallery of NSW, Sydney, 1953, p 6.

38 An early precedent occurred in 1892 when the government offered Oswald Brierly's sketchbooks and journals to the Gallery. The trustees wrote that 'The Minister be informed that the Trustees consider the sketches & accompanying manuscript very interesting & valuable but not fitted for the National Gallery where the public would have no opportunity of seeing them & they recommend their being offered to the Public Library where they would be of especial interest on account of their being records & sketches connected with the early history of the Colony'. AGNSW Minutes, 21 Jun 1892, p 44.

39 Ifould's positions at the Gallery were trustee (1921–39), acting director (1926), honorary director (1936–37), vice-president (1939–57), and president (1958–60).

40 AGNSW Minutes, 25 April 1913, p 285.

41 *Annual report of the Art Gallery of New South Wales for 1961*, p 6.

42 AGNSW news release, Hal

Missingham, Director, 19 Jan 1968, National Art Archive, Art Gallery of NSW.

43 See Georgia Connolly, 'Keeping the show on the road', *Australasian Registrars Committee Journal*, no 78, winter 2020, p 22.

44 Colsey left the Gallery to become manager of Arts Victoria in 1975. Lindsay himself moved to Victoria to become associate curator of contemporary art at the National Gallery of Victoria in 1977.

45 The January 1971 issue of *AGNSW Quarterly* (vol 12, no 2), identifies the 'main funding source of the TAEs as a biennial fund for cultural activities in New South Wales drawn from the Opera House lotteries, which was overseen by a cultural grants committee from January 1966 onwards.

46 Jonathan Cooper took on the role after Gray was appointed founding director of the Penrith Regional Gallery (Lewers Bequest) later in 1980. The Gallery began to withdraw from organising larger country travelling shows in 1987, with this type of work from then on being undertaken by the Regional Galleries Association in NSW and nationally by the Australia Council for the Arts initiative National Exhibition Touring Support (NETS) Australia.

47 Interview with Bernice Murphy by Tamsin Cull, 26 Sep 2002, National Art Archive, Art Gallery of NSW.

48 Interview with Robin Norling by Tamsin Cull, 1 Oct 2002, National Art Archive, Art Gallery of NSW.

49 *The Chinese Exhibition*, 25 Mar – 8 May 1977. Murphy 2002.

50 Murphy 2002.

51 *Light and Shadow*, 10 Mar – 16 May 1982.

52 *The Printmaker's Studio*, 20 May – 20 Aug 1983.

53 AGNSW Minutes, Jan 1945, p 2741.

54 At the 27 April 1945 meeting of the Board 'Mr Maund expressed his disapproval of the formation of the Travelling Art Exhibition Committee and gave notice of his intention to attack the policy of forming a subcommittee to buy modern works as it was found there were not sufficient modern pictures in the gallery.' AGNSW Minutes. p 2760.

55 'Hal Missingham (28 August 1971)' in Laurie Thomas, *The most noble art of them all: the selected writings of Laurie Thomas*, University of Queensland Press, Brisbane, 1974, p 316.

56 Thomas 1974, p 315.

14 The frontiers of conservatism
Peter Laverty's directorship, 1971–78

'These things', as St Francis said, (including Trustees) 'are sent to try us.'

Justice Nagle, trustee, 1973

Peter Laverty, who succeeded Missingham as director, retired after only six-and-a-half years in the job because he too did not want to end his career regretting a lost life as an artist. 'Anyone can be the director of the Art Gallery of New South Wales,' he told his family, 'but only I can paint my works.' Before Laverty was appointed, Margaret Jones in the *Sydney Morning Herald* speculated on 'Who'll run Sydney's Gallery?' Canvassing opinions from a wide range of artists, gallerists and others, she said that they were all wondering 'what sort of man the new director will be. Will he be another artist, like the last three directors? ... Will he be one of the new breed of administrators, hustling and business-oriented? Will he be an Australian, a European, or an American?'[1]

Laverty, born in England and trained at the Winchester School of Art, was a British artist with considerable administrative experience when appointed to the Gallery. He had come to Australia in 1951 to be reunited with fellow Winchester art student Ursula Nathan, whom he eventually married.[2] Teaching at East Sydney Technical College from 1952 he found himself 'being involved in administration' to such an extent that he was made head of school and state supervisor of art.[3] He had also been a guide lecturer at the Gallery from 1954 to 1961, so he knew its collection well.

Donald Brook, then senior lecturer at the Power Institute in the University of Sydney, was quoted in Jones's article. He hoped that the new director 'might push the frontiers of conservatism still further back'. But others thought the new appointment would be 'a "safe" one. A really progressive director would at once fall foul of the trustees.' The perception that Laverty was a safe appointment, who did little more than keep the Gallery ticking over between directors Hal Missingham and Edmund Capon persists to this day. Donald Brook's archive contains a poster that lumps Laverty together with the trustees as an object of contempt. On the back of it, Brook has written, 'Hukimoko is Tim Burns and Laverty was director of the AGNSW at its most conservative time'.

To claim that 1971–78 represented the Art Gallery of New South Wales 'at its most conservative' is ridiculous. If one takes into account exhibitions and programs, the new areas of collecting such as photography or the reinvigoration of older areas like printmaking, the increase of the art purchasing budget from $70,000 to $250,000 and the establishment of an ambitious education department that did more than focus on travelling art shows, these years now seem a high point in the Gallery's history. Talented younger staff employed at

Previous page: Photograph by the artist Tim Burns of visitors viewing his installation *A change of plan* during the 1973 exhibition *Recent Australian Art* at the Art Gallery of New South Wales **Right, above:** Montefiore's 1883 gift of *A study of a boy leaning forward* c1620 by Il Padovanino began the Old Master drawing collection at the Gallery, as did his donation of a companion work to the National Gallery of Victoria **Right:** Tom Arthur *The fertilization of Drako Vülen's cheese pizza* 1975

The Exhibitionists

the time not only transformed the Art Gallery of New South Wales but also went on to make considerable contributions to cultural life nationwide. They included Frances McCarthy (Lindsay), Nicholas Draffin, Eric Rowlison, Joanna Coleman (Mendelssohn), Jackie Menzies, Gil Docking, Robert Lindsay, Bernice Murphy, Gael Newton and David Millar. Laverty pushed through many of these changes, innovations and appointments.

The opening of the new building on 2 May 1972 was a catalyst for re-energising the institution. Its flexible system of partition walls that plugged into grid ceilings enabled a new type of exhibition-making, such as the Project shows initiated by Frances McCarthy. These were small budget, quick lead-time exhibitions, in a dedicated and highly visible exhibition space.[4] Project 1 included just two large works by British-born, Melbourne-based artist Ti Parks.[5] Project 3, curated by Robert Lindsay and entitled *Objects*, included works by John Armstrong, Aleks Danko and Tom Arthur, showing recent transformations in three-dimensional practice.[6] Bold purchases were made from these shows, including *One thousand drawings* 1973 by Parks and *The fertilization of Drako Vülen's cheese pizza* 1975 by Arthur.

Frances McCarthy, who had been associate curator of Australian art at the National Gallery of Victoria before coming to Sydney in 1972 as Daniel Thomas's assistant curator, developed the idea for these exhibitions when at MoMA in New York. Her former colleagues Eric Rowlison and John Stringer were working there at the time of her internship in 1974. She was particularly impressed by MoMA's Projects series, initiated by curator Jennifer Licht, featuring installations by contemporary and emerging artists.[7] McCarthy remembers that at this time there was a rich 'network of inter-connections that occurred between the professional staff of three key art museums; namely the NGV (Melbourne), AGNSW (Sydney) and MoMA (New York).[8]

Nicholas Draffin had worked with McCarthy at the National Gallery of Victoria before transferring, like her, to the Art Gallery of New South Wales. As its first fully assigned curator of prints and drawings, Daniel Thomas recalls that Draffin 'pulled into shape a century of haphazard collecting, treating Australian work as seriously as European'.[9] As his exhibitions and purchases demonstrate, he was as interested in contemporary work as he was in historical.[10] It was Draffin who pushed for the acquisitions of Ti Parks' *One thousand drawings* 1973. He was also the first person to research Eliezer Montefiore, celebrating that director's inauguration of the Old Master print collections in both Melbourne and Sydney with personal gifts of works to the collection, including companion works by Il Padovanino.[11]

In-house exhibitions curated by Gallery staff during Laverty's directorship gave critical focus to many older artists previously neglected, including Grace Cossington Smith (Thomas 1973), David Strachan (Thomas 1973), Grace Crowley (Thomas 1975), John Power (Coleman 1975), Weaver Hawkins (Thomas 1976), Dusan Marek (Murphy 1976), Arthur Murch (Thomas 1977), Napier Waller (McCarthy and Draffin 1977), Carl Plate (Anne Watson 1977) and Hilda

Below: James Mollison (left) and Peter Laverty watching conservator William Boustead examining *Blue poles* 1952 by Jackson Pollock 1974. Photographer unknown **Right:** Photograph by the artist Tim Burns of visitors viewing his installation *A change of plan* during the 1973 exhibition *Recent Australian Art* at the Art Gallery of New South Wales

The Exhibitionists

Rix Nicholas (Draffin 1978). Younger artists Robert Rooney (Lindsay 1975), Dale Hickey (Lindsay 1976), Peter Booth (McCarthy 1976) and Paul Partos (Lindsay 1977) were given their first solo museum exhibitions.[12] Other shows explored creative exchanges between Asia and Australia (Menzies 1976), fabric art (Menzies 1977), and time-based art forms such as film (Thomas 1974) and video (McCarthy 1975). Project 7 in 1975 was devoted to Harold Cazneaux, the first Gallery-initiated photographic exhibition for nearly a hundred years.[13] It was curated by Gael Newton, who had studied art history at Sydney University and majored in photography at the Elam Art School in Auckland, before becoming professional assistant to Laverty.[14]

Laverty had a personal interest in photography. When he joined the RAF at the age of seventeen, he had hoped to fly, but his poor eyesight and hearing, the result of childhood measles, saw him redeployed in the photography division. Many years later, teaching at East Sydney Technical College, he initiated a course in photography there. While working as Laverty's assistant, Newton was de facto curator of photography. She had an ally in Daniel Thomas who was 'on the Australian Centre for Photography (ACP) board,'

Newton recalled, 'and was already strategising on how to get photography into the Gallery'.[15] Very little money, however, was available for acquisitions, at a time when a one-off significant allocation of funds could have purchased a remarkable body of then-affordable world photography. Most of the works Newton brought into the collection were gifts, a tribute to how highly she was regarded by artists and their families. Donated works often formed the core of exhibitions, such as *Norman Deck* (1978), *Australian Pictorial Photography* (1979), *John Cato* (1979) and the *Max Dupain Retrospective* (1980).[16]

One of the most important exhibitions held during Laverty's directorship was *Recent Australian Art*, curated by Daniel Thomas and Frances McCarthy in 1973.[17] It included painting, sculpture, drawing, and conceptual, earth and time-based art from 1969 to 1973 by forty-six Australian artists. It was organised as part of the celebrations for the opening of the Sydney Opera House, as was the inaugural Biennale of Sydney.[18] It, however, eclipsed the Biennale on account of the diversity and contemporaneity of the work included, as well as the controversy generated by an installation by Tim Burns. When Burns was invited to contribute to the show, the plan

was to follow conceptually the *Fences to climb* installation that he had recently shown at Watters Gallery. Instead, he came up with a completely new concept: *A change of plan*. Two nude people were to spend all day in an enclosed box within the exhibition space, seen by the public only through a two-way closed-circuit TV. Viewers thought the figures were pre-recorded or offsite in a studio. 'When people came up to it, they didn't realise that the naked people could see and talk to them,' Burns recalls. 'The idea was to deconstruct the audience.'[19]

The work created tension between the Gallery's curatorial staff and security staff whose task was to keep the audiences under control and age appropriate. Nearby was Ross Grounds' *When I was young*, specifically designed as a child-friendly installation. Daniel Thomas warned Laverty before the exhibition opened 'that children might fall off Ross Grounds's sandbag tower'. Other hazards included 'broken glass in Tony Coleing's work ... and children might be upset by one or two of the more violent pieces of body art contained in the film "Idea Demonstrations"'.[20] He was unsuccessful, however, in making *Recent Australian Art* an adults-only show, as images preserved in the Gallery archive testify.

On the first Sunday of the exhibition, the male model in the enclosed box, gay rights activist Barry Prothero, took a toilet break and strode out of the enclosure without bothering to don the robe provided for such purpose. The head of Gallery security made a citizen's arrest on the grounds of indecency. The various accounts of what happened on the day differ. Laverty's 'confidential memo', dated 22 October 1973, suggests that he was made aware that the work 'could involve nudity' only thirty minutes prior to the exhibition opening.[21] As there was no time to put up signs and a screen, he instructed that 'nudity should not occur on the night of the opening'. Burns, however, recalls that the models intentionally stayed clothed on opening night 'because everyone expected them to be naked'.

Burns, who was present at the time of the arrest, claims that the Gallery security staff were needlessly aggressive. He was struck by one and ordered to leave the building, although he was not personally involved in the performance. Security also smashed the TV monitor before police arrived, thereby cutting off communication between the performers and those outside the enclosure. Some audience members lay on the ground and spoke to the performers through a small opening at ground level. Others 'took off their clothes and were slipped into the room using the inside only access'. When the police arrived, Wal Tiernan, who had made the citizen's arrest, tried to demolish one wall of the enclosure and, when this was unsuccessful, smashed down the door.

None of these details occur in the official statement made by Tiernan on behalf of himself and the 'security and attendants'. It has a procedural flavour to it, ending with 'when the person concerned was removed from the Gallery, I instructed the attendant staff to allow people back into the area and to turn on the TV set again to allow the young lady to continue her performance until the closure of the Gallery at 5pm'. However, it subsequently became clear that although Tiernan was free to take action as an individual in respect of alleged indecent exposure, he had overstepped his authority in damaging a work of art and closing down an exhibition. The episode developed an upstairs–downstairs dimension to it, with all the attendants, security and conservation staff, but none of the curators, signing a petition 'respectfully requesting the full support of the Board of Trustees for the action taken by Supervisor of Security, Mr WM Tiernan'.

Burns felt that the Gallery, and not only the security staff, had failed in its duty towards him as an artist. It was not the public who had objected to his work of art, he claimed, 'but rather the guardians of the work whose job it was to protect it'.[22] Gallerists Frank Watters and Geoffrey Legge secured Prothero's bail of $1000, with the help of Clive Evatt. They also engaged barrister Ken Horler to defend him. Although Thomas 'had to testify in court on behalf of the art and the charge was eventually dismissed', Burns claims this only happened after he personally threatened to dynamite the front door of Thomas's house. For Thomas,

> Peter Laverty and the Board of Trustees were highly professional ... Burns assumes the gallery caved in to threats from other artists, led by Richard Larter, to withdraw their work and thus close down the entire exhibition. Not the whole story. An artist-director is always supportive of fellow artists and of contemporary practice ... We were ambivalently proud of it all.[23]

The artist involved, however, believes this ambivalent pride is misplaced and that what has been written about the episode has been done to suit a 'curatorial position and the benevolence of the Australian art institution'.[24]

It is usually assumed that Burns produced his *Fuck Laverty and the trustees* poster as the result of these bruising events, but it had been made before *Recent Australian Art*. Burns had been arrested outside the Gallery while attaching one to a tree. It gave voice to a more overarching criticism of the Gallery.[25] Just fifteen days into the job, Laverty had used the entire acquisitions budgets for 1972 and 1973 to buy a self-portrait by French artist Pierre Bonnard. The Visual Arts Board of the Australia Council, with Leon Paroissien as director, offered financial support for the purchase but the Sydney trustees would not accept 'tainted funds' from the new federal Labor government. Many were supportive of this acquisition but

FUCK LAVERTY AND THE TRUSTEES

THIS IS A WORK OF ART!
H.HUKIMOKO

Poster by Tim Burns, c1972

younger artists in particular questioned the purchase of a European 'cultural status symbol' made, in their view, at the expense of supporting local contemporary practice.[26] The April 1972 *Broadsheet of the Contemporary Art Society* was entirely devoted to 'the structure of the Art Gallery and past and present policies'. Ian Milliss reviewed its governance and acquisition program in two pieces and Noel Hutchison its often-disastrous history of deaccessions, particularly of sculpture, in another.

Milliss began his reflection on governance by stating that the Gallery 'is completely under the control of its trustees. It is they who are responsible for the Art Gallery's present position.'[27] He said that the 1958 Act under which the Gallery was governed was outdated, that an age limit on trustees should be imposed and that their power 'to meddle' with potential purchases and gifts should be severely curtailed. He argued that as the perceived educative role of the Gallery

had diminished in the eyes of government, the Gallery was increasingly viewed as a place of 'small scale and esoteric public entertainment ... The Gallery tends therefore always to get a raw deal. Which means that everybody in any way involved with art also gets a raw deal.'[28]

The Gallery's archive provides many examples of the trustee's control, from high-level records such as board minutes and more ephemeral documents. On one of Laverty's draft annual reports in 1973, Justice Nagle, a trustee and then president of the board from 1977, scribbled endless minor corrections, ending with a note to Laverty: 'These things,' as St Francis said, (including Trustees) 'are sent to try us.'[29] The tensions were apparent to those outside the Gallery. When Laverty retired, the press commented that the Gallery's director was now little more than 'a messenger boy' and that an increase in salary was needed 'to give the director the stature to stand up to the trustees'.[30]

Broader political tensions at the time also compounded internal politics. When the Gallery reopened in 1972, an entrance charge of twenty cents was introduced.[31] The National Gallery of Victoria had done this in 1968 when it moved into its new building and it was said to have contributed $75,000 annually towards the acquisitions budget. Syd Einfeld, deputy leader of the state Labor opposition, spoke out against this 'further invasion' by Robert Askin's conservative government 'of public rights ... the Government should be subsidising the Art Gallery to keep admission to it free'.[32] The admission charge derailed some of the positive press which was anticipated with the opening of the new building: it made front-page news, with coverage of the new wing reported on page 2 and a review of the works exhibited inside on page 20.

Arts policies and support varied between the different political parties, at both state and federal levels.[33] Although the Australia Council, largely a body then focussed on performing arts, had been established under Liberal prime minister Harold Holt in 1967, the new Labor government of Gough Whitlam reshaped and refinanced the Council and brought it within the responsibility of the Department of Prime Minister and Cabinet in 1975. Appointing Nugget Coombs as Chair, then Jean Battersby as Executive Officer, was decisive in the Whitlam transformation. At the Gallery, pressure from the Askin government for the Gallery to distance itself from proposals involving the increasingly ambitious Australia Council was felt. Later during Laverty's tenure, the political affiliations of state and federal governments were reversed, and the state Labor government under Neville Wran called for an end to entrance fees and the limiting of trustees' powers.

The dismissal of Gough Whitlam on 11 November 1975 was felt keenly in the arts community, which saw him as the first prime minister who believed passionately in the arts, in contrast to those for whom the arts were mere 'after-dinner

The Exhibitionists

1. PUBLIC ACCESS
2. CAMERA
 REMOTE CONTROL SYSTEM
 INSTANT FEED-BACK MONITOR
3. POLITICO TARGET BALOONS
4. VIDEOP PLAY-BACK FACILITY
5. staff & storage

mints'.[34] When Whitlam had earlier faced an election after a double dissolution triggered by a hostile Senate, Clive Evatt, the owner of Hogarth Galleries in Sydney, organised an *Artists for Whitlam* exhibition to support his campaign.[35] The press release claimed that Whitlam had 'done more for the arts in 17 months than all previous governments since Federation'.[36] Artists responded enthusiastically and $50,000 was raised.[37] Evatt was unabashed in naming the few artists who had refused support: Sali Herman, Charles Blackman and Leonard French. In fact, a much smaller *Art Exhibition to Aid Liberal Party Funds*, more of a cocktail party and auction than an exhibition, was held at Barefoot Art Gallery in Avalon.[38] Many paintings were donated to this exhibition from collectors, so it is difficult to say whether the artists themselves supported the show with the same conviction.

Malcolm Fraser, elected prime minister after Whitlam's dismissal, was heckled by three hundred protesters on the steps of the Gallery when he arrived to open the 1976 Biennale.

Paula Latos-Valier, who went on to have a long association with the Biennale as assistant director and executive officer, remembers the 1976 Biennale as the most adventurous in its history, 'full of excitements and the *times they are a-changing* optimism'. When Fraser began his speech, he was booed and then 'about 150 people, including about six with works in the exhibition, walked out of the Gallery ... some were Gallery curators and attendants'.[39]

One of the participating artists who walked out, Michael Nicholson, included a very topical work in the exhibition entitled *Poli-poll-pool-shots*. It was a closed-circuit video installation in which the audience could take pot-shots at images of politicians printed on floating balloons. According to a news report the Malcolm Fraser balloon was shot 389 times, Gough Whitlam 214, Sir John Kerr, the governor general who dismissed Whitlam, 201, and Bob Hawke, then president of the ACTU, 103.[40]

On many levels this work captured something of the

Zeitgeist within the arts community during Laverty's
directorship, when so much was contested, including
the nature of art itself. The memos and manifestos that
proliferated are full of pot-shots taken at perceived enemies
and allies alike. At the *Artists for Whitlam* exhibition, Ian
Milliss contributed an 'open letter', marked 'free – please take
one'. Two years before he had stopped exhibiting to become
an artist activist. His letter, included as part of the exhibition,
challenged the whole system of values that saw artists as
manufacturers of commodities marketed through galleries.
It must have surprised attendees at the exhibition: 'to those
involved in politics: the Labor Party's arts policy is in fact
exactly the policy one would expect of a conservative right
wing party', 'to those involved in art: by your involvement
in art you support anti-human values', 'to artists: culture
and politics are basically antagonistic and though each may
attempt to exploit the other, as is happening in this exhibition,
ultimately only one can succeed.'

The 1970s was an exciting time of new art forms,
including kinetic, computer, earth and performance art.
Some questioned the Gallery's relevance in this environment.
Bruce Adams, in an unusually narky review of the new
building, argued that it was 'tailor-made for cultural limbo'. He
said that the Art Gallery of New South Wales 'will always be
restricted to gold-framed precious objects ... The indulgence
in Victorian nostalgia and the intimacy of the new wing reflect
a sleepy romanticism quite remote from the exploratory,
questioning artistic climate lurking beyond the portico.'[41]

The following years, however, brought exhibitions such
as *Recent Australian Art* and the Project shows, along with
the performative John Kaldor projects, and showed a Gallery
wanting to engage with the questioning world beyond its
walls. Even the sleepy nineteenth-century collections were
re-appraised in two critically acclaimed exhibitions by curator
Renée Free: *Victorian Olympians* and *Victorian Social
Conscience*.[42]

Nonetheless, when Milliss himself put forward a proposal
for an exhibition based upon the work of the Australian
agricultural inventor PA Yeomans, it was rejected. The
exhibition was to question the whole concept of art as
'precious object' and break 'down the barriers between art,
life and nature'. 'Yeomans's Keyline system of irrigation,'
Milliss claimed, 'is "land sculpture" on a large scale ... that
makes the work of American artists Smithson and Serra pale
in comparison'.[43] Frances McCarthy, the exhibition organiser,
was supportive, her boss Daniel Thomas was supportive, and
director Peter Laverty and deputy-director Gil Docking 'both
recommended acceptance of the exhibition'.[44] However, it was
those trustees 'sent to try us' who pulled the plug, reputedly
baffled as to why a 'bloody trade show' should be shown at the
Gallery at all.

Epigraph
Memo from Justice Nagle to Peter Laverty, 21 Sep 1973, National Art Archive, Art Gallery of NSW.

Notes

1 Margaret Jones, 'Who'll run Sydney's gallery?', *Sydney Morning Herald*, 22 May 1971, p 20.

2 There is a nice connection through Ursula Laverty with the early founders of the Gallery. Ursula was related to the composer Isaac Nathan. The Montefiore brothers knew Isaac Nathan well and Jacob Montefiore wrote the libretto for his *Don Jon of Austria*, the first opera to be written, composed and produced in Australia.

3 Interview between Peter Laverty and Hazel de Berg, 19 Aug 1972, 1/5, transcript in ARC359, Peter Laverty Archive, National Art Archive, Art Gallery of NSW.

4 These were held directly opposite the shop in the new building, which was an ideal space to attract an audience.

5 *Ti Parks*, 24 Jan – 2 Mar 1975.

6 *Objects*, 5 Apr – 4 May 1975. Robert Lindsay recalls, 'My first Project show *Objects* included John Armstrong (recent winner of the Gold Medal from the 1973 São Paulo Biennale, Brazil), Aleks Danko recently moved to Sydney from Adelaide and Tom Arthur recently arrived from America. Arthur was represented by Bonython Gallery, while both Armstrong and Danko were represented by Watters Gallery, then a major focus of contemporary art, just as Pinacotheca in Melbourne was the principal focus of contemporary practice in that city, hence the selection of Robert Rooney, Dale Hickey and Paul Partos who were widely recognized in Melbourne as the avant-garde edge.' Email from Robert Lindsay to Steven Miller, 3 Feb 2021.

7 She and Robert Lindsay were also aware of London's National Gallery FOCUS exhibitions, which concentrated on one artwork in great depth.

8 Email from Frances Lindsay to Steven Miller, 11 Dec 2020.

9 Daniel Thomas, 'Nicholas Draffin', *Art and Australia*, vol 33, no 2, Summer 1995, p 244.

10 These included *Indian Miniatures and Kalighat Paintings*, 28 Feb – 28 Apr 1974; *Two Masters of the Weimar Bauhaus: Lyonel Feininger, Ludwig Hirschfeld Mack*, 5 Jul – 18 Aug 1974; *Early Australia*, 14 Mar – 13 Apr 1975; *Sir Edward Poynter PRA*, 20 Jun – 20 Jul 1975; and *Robert Klippel Drawings*, 5 Sep – 9 Nov 1975.

11 Montefiore gave a drawing of a boy leaning forward attributed to Il Padovanino (Alessandro Varotari) to the Art Gallery of NSW in 1883. Earlier in 1869 he had given a companion drawing to the National Gallery of Victoria. The two were probably once joined as a single sheet.

12 Partos had previously shown in 1973 at the Ewing and George Paton Gallery in Melbourne University.

13 *Project 7: Harold Cazneaux 1878–1953*, 30 Aug – 28 Sep 1975. Early exhibitions organised by the NSW Academy of Art in 1875 and 1876 included significant displays by photographers Alexander Brodie, Joseph Bischoff and JW Lindt. The Gallery did not want to show the photographs of Government Astronomer Henry Chamberlain Russell in 1893 but were pressured by the government to provide a venue for the exhibition. In June 1919 Frank Hurley offered for sale to the Gallery a collection of 120 war photographs for £400, but the purchase was declined.

14 Newton had started at the Gallery in 1974 as an education officer. Laverty had her appointed 'professional assistant to the Director'.

15 Email from Gael Newton to Steven Miller, 7 Dec 2020.

16 Email from Gael Newton to Steven Miller, 7 Dec 2020. Newton was officially appointed curator of photography on 9 April 1979. Even gifts needed to be ratified by the trustees and Newton faced opposition particularly over bodies of work. The whole of Max Pam's *Hindustan autobiographies* was rejected, as Newton recalls, 'one didn't buy paintings on mass why get photos that way'. When the new director Edmund Capon arrived at the Gallery, Newton said, 'He walked into my office and said, "I gather you are my personal assistant but you want to be curator of photography don't you?" and released the position from his executive establishment.'

17 *Recent Australian Art*, 19 Oct – 18 Nov 1973.

18 Biennale of Sydney, Sydney Opera House, 23 Nov – 31 Dec 1973. This exhibition was held in the Exhibition Hall of the Opera House. It brought together thirty-seven artists from the Asia-Pacific region.

19 Tim Burns, *I was framed: Tim Burns art practice*, Tim Burns, Perth, 2020, p 34.

20 Memo from Daniel Thomas to Peter Laverty, 17 Oct 1973, National Art Archive, Art Gallery of NSW.

21 Confidential report of the director, 22 Oct 1973, National Art Archive, Art Gallery of NSW.

22 Burns 2020, p 35.

23 See Daniel Thomas, 'Museum pieces 3: 3D TV, 1973', *Art and Australia*, vol 41, no 4, 2004, pp 550–51.

24 The installation continued with Burns signing a six-point agreement on 23 October 1973, containing conditions concerning no use of drugs or alcohol by the actors, that the actors confine themselves to the enclosed room and do not invite members of the audience inside and that Burns would be personally responsible for ensuring that all the conditions were met.

25 Email from Tim Burns to Steven Miller, 21 Dec 2020.

26 Ian Milliss, 'Bonnard and acquisition policy', *Contemporary Art Society Broadsheet*, Apr 1972, p 7.

27 Ian Milliss, 'The Art Gallery and its trustees', *Contemporary Art Society Broadsheet*, Apr 1972, p 2.

28 Millis, 'The Art Gallery and its trustees', p 4.

29 Memo from Justice Nagle to Peter Laverty, 21 Sep 1973, National Art Archive, Art Gallery of NSW.

30 'Two big jobs waiting to be filled', *Bulletin*, 25 Apr 1978, p 21. Joanna Coleman (Mendelssohn) was working at the Gallery at the time and recalls, 'Peter Laverty was a loyal public servant, with an acceptance of authority placed above him. The Trustees made it clear that they were the authority. Until I went through the minutes, I didn't realise how many meetings he avoided through ill-health in the last year of his directorship. It's probably fair to assume that was stress related.' Email from Joanna Mendelssohn to Steven Miller, 15 Sep 2020.

31 Tuesdays were kept as 'free days'.

32 '20c to visit Art Gallery', *Sydney Morning Herald*, 19 Apr 1972, p 1.

33 See GFS Hanly, 'The Askin Government's involvement in the arts 1965–74', BA (Hons) thesis, University of NSW, 1974.

34 John Tasker quoted in Brian Hoad, 'Gough's artistic labor pays off', *Bulletin*, vol 96, no 4906, 18 May 1974, p 27.

35 *Artists for Whitlam*, Hogarth Galleries, Sydney, 6–18 May 1974.

36 *Public notice: Artists for Whitlam*, 29 Apr 1974.

37 In Melbourne, there was an *Artists for Labor and Democracy* exhibition held at the Toorak Gallery, 26–28 November 1975. Various other 'artists for Whitlam' or 'artists for Labor' exhibitions were held in Sydney at the Paddington Town Hall in 1975, 1976 and 1977.

38 *Art Exhibition to Aid Liberal Party Funds*, Barefoot Art Gallery, Avalon Beach, 11 May 1974.

39 'Sydney: Malcolm Fraser arrived at the Art Gallery of NSW to open the Sydney Biennale', *Tribune*, 17 Nov 1976, p 11.

40 'Benelong' [*sic*], *Sunday Telegraph*, 19 Dec 1976, p 112.

41 Bruce Adams, 'Tailor-made for cultural limbo', *Sunday Australian*, 30 Apr 1972, p 22.

42 *Victorian Olympians*, 20 Jun – 20 Jul 1975; *Victorian Social Conscience*, 13 Aug – 19 Sep 1976.

43 AGNSW Minutes, 27 Aug 1975, p 8399.

44 Milliss has since written of his surprise to find how supportive Laverty was of his exhibition proposal. 'The incredible thing about that is that in the preceding years I had waged a very public campaign against the director, Peter Laverty … accusing him of being a timid and unimaginative bureaucrat who was not up to the job. I had such an effect that I was summoned by George Freudenstein, the Minister for Cultural Activities, to a lengthy meeting in his office to explain exactly what my complaints were … If you ever see this Peter accept my genuine thanks even if it is thirty-six years late.' Ian Milliss, *In the archives with Lucas*, 11 Aug 2011.

15 Not the pictures alone
Increasing audiences

It's not the pictures alone that make this Gallery so popular a resort, weekday or Sunday. 'Tis a great meeting place.

Lennie Lower, reviewer, 1941

In October 1972 the 10th International Congress of Accountants was held in Sydney, the first time this five-yearly convention had been held in the southern hemisphere. It was a major event, with more than five thousand delegates, commemorative stamps produced by Australia Post and even an art competition staged at the Art Gallery of New South Wales, won by Lloyd Rees.[1] The Gallery had recently opened a much-acclaimed new wing, which included a large entrance court, and so it was decided to stage the main conference party there. Nearly all of the conference delegates turned up on the night, with only fifteen attendants rostered to ensure the safety of the collection. Bars were set up within the entrance court, as well as in the old courts, decorated with lurid pink and green metallic bunting, and the whole gallery was turned briefly into 'a vulgar dance hall and bar'.[2] Professional staff had not been properly informed about the scale of the event and scrambled to remove fragile works from the walls or cover them with plastic only hours before the opening. Notwithstanding this, some works were damaged, and the Gallery was left littered with cigarette butts, empty wine glasses and vomit.

Previous page: Louis Priou *Satyr's family* c1876 (detail) **Above and right:** Polaroids taken by staff documenting the 'tasteless' commercialisation of the Gallery during the 1972 10th International Congress of Accountants, where unmanageable crowds led to the damage of some works of art

The Exhibitionists

Assistant curator Frances McCarthy was so disgusted that she courageously wrote a hard-hitting statement to management: 'From this date I no longer hold any respect for the Art Gallery of New South Wales as an institution intended for the protection of works of art. The trustees have abused their position and turned this museum into a joke. The staff lack courage and foresight and in compliance with the trustees share the responsibility.'[3] McCarthy's boss was senior curator Daniel Thomas, who was on leave at the time. When informed about the event he sent his own memo to the director:

> I myself feel responsible for the damage that occurred, in that I neglected to keep myself informed about the arrangements for the party; if I had taken proper note of the fact that 5000 people were expected I should have done my utmost to persuade you to cut back the numbers to 1200 or 1500, on record as the estimated safe capacity of the building.[4]

All of the Gallery's professional staff wrote in support of McCarthy that 'this type of affair is an abuse of an institution intended for the protection and display of works of art'.[5] One positive result of the event was that protocols were eventually established to make sure that it was not repeated. It threw a spotlight on the tensions and challenges facing modern art galleries wanting to supplement lean budgets with extra income from venue hire, while at the same time potentially attracting new audiences. In some ways, these issues were not new at all, though the scale of the 1972 event was unprecedented.

In the early years, it was music that divided opinion. The Gallery's first home, Clark's New Assembly Hall, was used as a venue for dance and concerts before it became the home of an art academy. The *salle de danse,* where the Academy's art collection was hung, had a raised orchestral gallery at one end. The acoustics were good, and musicians wanted to continue performing and rehearsing within the space. In 1876 Monsieur Meilhan, for instance, was given permission to conduct classes on two afternoons each week. Herr Josef Kretschmann was later allowed to teach his students on Wednesday evenings from 8 o'clock. Along with a usage fee, these musicians also performed at Academy events, which increased 'interest in the Society' considerably.[6] However, not all were happy. Some believed that music was a distraction from the 'primal objects of the Academy': 'There are many Academies of Music but scarcely one of Painting and Sculpture. The Public, it is well known, are appreciative of music and patronise it better than any other species of entertainment.'[7] Despite these misgivings, musical activities were allowed to continue and when the Academy asked to borrow money from the government on

JS Watkins *The musician (portrait of Josef Kretschmann)* 1911

an interest-free basis to purchase Clark's New Assembly Hall in 1878, it argued that it would pay back the loan through revenue-raising concerts.

When the collections moved to the Fine Arts Annexe in the Botanic Garden and then to the Outer Domain, musical events were discontinued, even though Vernon's suite of grand galleries offered an ideal venue. It was not until October 1919 that a request came from the 'Australia Orchestra' to perform in the Gallery on weekend afternoons. This was flatly refused, probably because of the 'tasty and popular music' that the ensemble proposed performing rather than from opposition to music in principle. The Australia Orchestra regularly played at films and in the Glaciarium and was regarded as one of the 'most up-to-date bands in Sydney of the naughties' and beyond.[8]

Music, in fact, already drifted into the Gallery on weekend afternoons, as the Blue Ribbon Gospel Army Band 'pitched under a large tree in front of the Gallery' and regularly attracted upwards of a thousand spectators.[9]

From its establishment in the mid nineteenth century, the Domain, one of the 'lungs' of Sydney as *Australian Town and Country Journal* described it, was 'a favourite resort ... of the metropolis'.[10] Then covering around 140 acres,[11] it stretched from the gates opposite St Mary's Cathedral to the extreme end of the point jutting into the harbour between Sydney Cove and Woolloomooloo Bay. Nearer the town, the Domain spread out 'into a lightly timbered undulating plain, where stump orators, temperance advocates, religious enthusiasts, and others let off their pent-up thoughts on Sunday afternoons'.

Artist Nancy Borlase recalled that in the 1930s and 1940s there was much more activity in the Domain, 'Sydney's version of London's Hyde Park'. That is where she first saw the trade union leader Laurie Short, whom she eventually married. He was on an anti-war protest, 'one of hundreds of people there. The place was alive with people advertising sanatorium diets, anti-meat eaters, animal rights, but mainly politics. The Communist Party was the largest group.'[12] On the weekends the Gallery sometimes had to close its doors to stop the influx of unmanageable crowds. Rainstorms were a challenge, as poet Kenneth Slessor indicated when he wrote, 'You know Sydney Art Gallery – that's the place where you come in out of the rain when it's too wet to stop in the Domain.'[13] Official events could also necessitate a lockdown, such as the first Anzac Day service in 1920 celebrated as a national holiday.

The popularity of the area began to wane from the 1960s after the construction of the Cahill Expressway. Repeatedly described as a gash or a wound inflicted on 'the people's park', the expressway destroyed what had been a natural connection between the Botanic Garden, the Domain and the Gallery. From the mid 1950s, when plans for the project were first revealed, there was widespread criticism. The plans were pushed through nonetheless, with artist Godfrey Miller commenting, 'Mr Cahill says the expressway is beautiful. His attitude: "You better get along and admire it, for it is what you are going to get."'[14] An elevated section of the expressway was first opened to traffic in 1958 and a sunken section in 1962.

Above: A photograph from around 1920 shows the large crowds that routinely gathered on Sundays in the Domain **Right, above:** George Molnar's 1959 cartoon *'Nice composition. Maybe just a touch more grey – say we add another forty feet width to the expressway'* **Right:** Images taken of the northern elevation of the Gallery after the completion of the Cahill Expressway, such as this one, reveal the 'dislocating gash' that the road made between the Gallery and its original parkland setting. Photograph: Max Dupain

The Exhibitionists

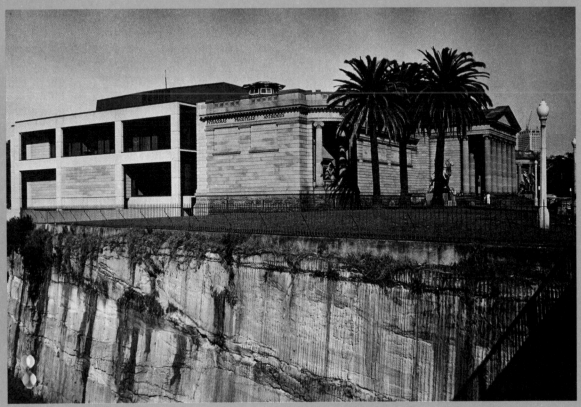

Not the pictures alone

More recently, in 1999, a parkland canopy was built over the freeway in an attempt to restore some of the older connections between Woolloomooloo Bay, the Botanic Garden and the Domain.

In the nineteenth century 'continentals' were held in the evening on the large expanse of greenery in front of the Gallery. Used for cricket matches in the 1850s and 1860s, this area is now more often the site for corporate soccer and touch-football competitions. The evening continentals were 'open-air concerts, where the spectators could stand or walk', taking refreshments 'from booths on the ground'.[15] To some extent they are continued by the summer concerts – the carols, jazz, opera and symphony in the park events that are now regularly held here. Large political gatherings also continue, with the 2019 Global Climate Strike said to have reached the Domain's capacity of eighty thousand.

Not surprisingly, there have occasionally been tensions between the Royal Botanic Garden, which manages the Domain, and the Art Gallery, usually concerning the Gallery's perceived encroachment upon public parklands. In reality, transport developments such as freeways, car parks and train lines have had a greater negative impact on the precinct. When there was a suggestion in the 1880s that the Gallery might move to a site more centrally located in the city, one citizen protested: 'It was an exceedingly happy thought to locate the Gallery even temporarily at the Botanic Gardens gates, for it has become a habit to visit the gallery and the gardens together ... Why abandon this inspiration? Why not wed the gardens and the gallery?'[16] Given their wedded histories over the past 140 years, it was surprising that the Gallery received only a passing mention in the 1999 State Heritage listing for the Botanic Gardens and Domain. It was not included under the social significance of the Domain and only listed only for 'aesthetic significance' with the caretaker's lodge and a statue of Robert Burns.

When music was eventually formally programmed at the Gallery, it was the initiative of the Sydney Conservatorium – another Botanic Gardens neighbour – under its director William Arundel Orchard. An inaugural concert was held on Wednesday 5 December 1923, performed under *The defense of Rorke's Drift*, with the music 'drifting' throughout the entire Gallery, as one reviewer observed.[17] The ensemble was the Conservatorium Ladies String Quartet and the Gallery remained its exclusive gig for the next ten years. In the mid 1930s the music-making ceased, until revived by director Will Ashton in 1937. He used the *Loan Collection of British Masters from the National and Tate Galleries* as an opportunity to bring larger ensembles into the building and to program lighter music.

Ashton told *Smith's Weekly* that in his view 'museums should be brightened up', adding that 'beer and music would be an excellent thing in any art gallery'.[18] He had more success with music than he did with beer. Since the nineteenth century there had been requests for refreshments to be provided in or near the Gallery. Miss Bruce wrote in January 1895 asking for a 'ladies retiring room', but the trustees responded that 'our rules prohibit the bringing of refreshments into the Gallery'. When she explained that she had in mind a building adjacent to the Gallery, they agreed, as long as it was placed 'at sufficient distance from the Gallery'. The following year a tea kiosk was opened on 30 October 1896, 'a handsome looking structure with a roof of shingles' very similar to the kiosk that remains at Nielsen Park today.[19] The press noted that since the Gallery was located 'so distant from the city', having somewhere close by to eat would make a visit to 'the ugly building in the Domain less of a tax than it has been in the past'.[20] The lessees were two enterprising women, the New Zealander Maud Greenlaw, whose husband

The Exhibitionists

was a Sydney-based restaurateur, and Anthonina Pechy, originally from Bathurst. By 1937 the kiosk was looking tired, and it was proposed to replace it with a new building that incorporated a dance floor and served 'light Colonial wines', but this was never realised.[21]

The founding of the Art Gallery Society of New South Wales in 1953 by Sir Charles Lloyd Jones and Professor EG Waterhouse completely transformed how social events were programmed and offered at the Gallery. Mary Corringham from the *Daily Mirror*, the 'lynx' whom Missingham believed was out to get him, complained of the 'misuse of the building during recent months by an organisation known at the Gallery Society'. In her opinion, there was no place for music or 'serving booze in an institution dedicated to the fine arts'.[22] Few agreed with her and by 1957, when the Society was incorporated as a public company, its president Sir Kenneth Street reported that twenty functions had been held that year alone, averaging five hundred attendees each, many of whom, he added, 'would probably not visit the Gallery even once a year in the ordinary way'.[23] Throughout the 1960s the balls and galas held by the Society became key events in Sydney's social calendar.

A series of lunchtime promenade concerts commenced in March 1954, designed by Eugen Prokop.[24] Later in the year a concert in candlelight, which included a formal meal, was served in Court 9. These were ticketed, revenue-raising events. Even more popular than the concerts were the film screenings.[25] The Society's first function was a screening of two films about Albert Namatjira and Maurice Utrillo on 28 July 1953. From 1957 there was a regular cinema program run by Dorothy Holt, assisted by Joan Levy. When the Society bought the Australian rights to *Le mystère Picasso* in 1962 and showed it at the Union Theatre at the University of Sydney, more than fifteen thousand people came to see it. Film became an important part of Gallery programming, particularly after the construction of the 1972 theatrette and the 1988 Domain Theatre and, importantly, with the employment of filmmaker and ikebana master Robert Herbert in 1999 as curator of film, the first such position in an Australian state art museum.

By 1959 events organised by the Art Gallery Society had raised enough money for it to present to the Gallery its first work of art: Godfrey Miller's *Nude and the moon* 1954–59.

Left: The freestanding kiosk on the northern side of the Gallery was opened in 1896, when there were no catering venues inside the Gallery. It was demolished in 1959 as part of the excavations for the Cahill Expressway, as seen in the photograph on the right. **Above right:** Program cover, almost certainly designed by Hal Missingham. Lunchtime 'Prom' concerts commenced at the Gallery in March 1954 and were held every Tuesday. They began with concerts by the Sydney String Players conducted by Czech violinist Eugen Prokop, with 450 people purchasing tickets to the first concert.

When Sir Colin Anderson, a prominent art collector and chairman of the Tate Gallery trustees, lectured in Australia during 1961 he said that groups such as the Art Gallery Society were essential to the transformation of nineteenth-century museums into institutions of relevance to the modern world:

> less conventional conduct should be adopted; laughter certainly, wine served instead of tea; candlelight perhaps ... A gallery that is run unenterprisingly, joylessly and unimaginatively will present these barren qualities to the public. A gallery is supposed not primarily to educate but to delight ... If ever there was an important Art Gallery that cried out to be rebuilt, it is the National Gallery of New South Wales.[26]

This was a significant change of emphasis from the focus on education, moral uplift and social betterment that permeates all the foundational documents of the Gallery. A core justification for the Gallery was that art 'would tend directly to humanise, to educate and refine a practical and laborious people', just as was claimed for the Metropolitan

Museum in New York when it officially opened in its first building on Central Park in 1880.[27] In fact, the very first meeting of the New South Wales Academy of Art in 1871 was reviewed by Sydney *Punch* under the somewhat pretentious heading *Emollit mores nec sinit esse ferus* (learning humanises the character and does not permit it to be cruel). This, according to Ovid, is what the study of the liberal arts achieves. Though sculpture and painting are not part of the classical liberal arts, for the purposes of *Punch* they had the same effect. Indeed, James Fairfax, a founding trustee of the Gallery, even described the establishment of the Gallery as 'creating the beginning of one of our most important educational institutions'.[28]

This emphasis on education to some extent also informed what was collected. Sir Kenneth Clark, in his 1949 lecture 'The idea of a great gallery' at the National Gallery of Victoria, argued that 'public galleries grew up together with the modern conception of education, and it was as a part of education that their support was undertaken by the public authority. This impressed on their directors the idea that such collections must look educational and should, if possible, teach the history of art. So instead of buying pictures because they liked them, they bought them to complete some historical sequence or to illustrate some school or period.' Clark, like Anderson, believed that 'the chief aim of works of art, which is to produce in us a peculiar kind of exalted happiness, was lost sight of'.[29]

Neither Anderson nor Clark was aware that in Sydney there was a long history of debate about the purpose of its Gallery and collection. When 'the Critic' for the *Sydney Morning Herald* asked in February 1887, 'what is the primary purpose of an Art Gallery?' he offered two choices. It could either 'amuse the people who visit it, like an Aquarium or Zoological Garden, leaving them to pick up such useful information as they can about its contents' or it could 'afford them the means of cultivating a knowledge of art, by setting before them the best obtainable models in painting and sculpture'.[30] He argued that the trustees of the Sydney Gallery

Above: Godfrey Miller's painting *Nude and the moon* 1954–59 was the first work purchased by the Art Gallery Society with funds raised through membership subscriptions and social events. **Right:** 'Cushion concerts', such as this one in June 1979, were organised by the Australian Broadcasting Commission in conjunction with the Gallery and proved popular, building upon the Gallery's long tradition of lunchtime 'Prom' concerts.

had chosen the first option, by neglecting the Old Masters and making populist acquisitions of contemporary art 'calculated to catch the vacant eye of the sight-seer'. The 'throngs of visitors on Sundays and public holidays' showed that these purchases were well received, but this only confirmed the Gallery as a 'popular place of resort for idle people'.

The 'critic' was probably one of the Collingridge brothers, either George or Arthur. James Green, writing under his pen-name of JG de Libra, countered that the primary object of the Gallery should be to display works that 'touch the soul with the Promethean spark of courage, veneration, chivalry, or sympathy, of merriment or melancholy, pity or exultation ... To have filled the Art Gallery here with "Old Masters",' he concluded, 'could surely have answered no good purpose.'[31]

The 'critic' then became more combative and described many of the Gallery's most popular acquisitions as works that represented the 'seamy side of human nature'. He particularly despised the *The sons of Clovis II* 1880 by Évariste Luminais and *Satyr's family* c1876 by Louis Priou, as they represented an 'unmistakeable phase of the diseased side of French art'.[32] Just as the universities should insist on teaching Greek and Latin rather than modern literature, he continued, becoming ever more elitist, the Gallery should invest in 'mouldy old

saints and martyrs instead of the charming scenes of everyday life we see about us'.

Surprisingly, the Gallery entered into this debate at a high level. Someone writing to the editor of the *Sydney Morning Herald* officially as 'a trustee' – almost certainly Du Faur – unequivocally asserted that 'the first duty of the trustees is to make the Gallery a place of refreshment and recreation for the people'.[33] Today this would be called a mission statement. It marks a clear demarcation line, on either side of which have stood all the key figures in the Gallery's subsequent institutional life. Hal Missingham would have probably revised it to give greater emphasis to the Gallery's role in supporting and promoting living artists, of whom he was one. Many of his public battles with the Art Gallery Society were because he believed the balance between the Gallery as an organiser of programs and social events and its more traditional role in collecting and preserving art was being tipped in favour of the former.

Missingham could be elitist as well. He saw little value in those who were not artists talking about the Gallery's collection to interested visitors.[34] When Sandra McGrath, an art critic for the *Australian*, suggested setting up a group of volunteer guides based on the docent programs she had seen

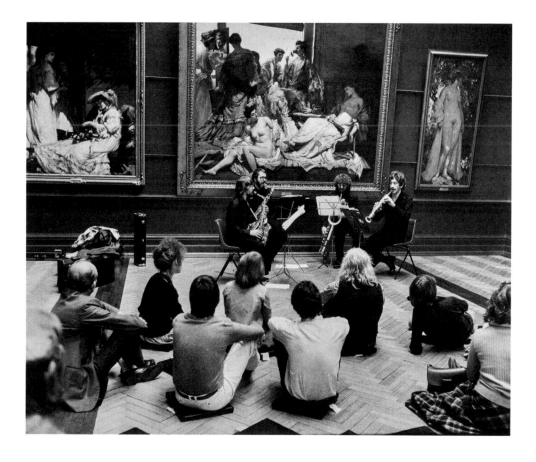

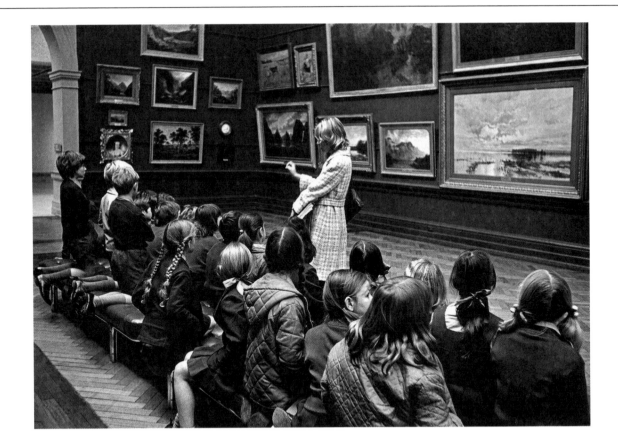

in the States, his response was 'No, no. Absolutely NO.' When she asked why, 'his answer was lengthy and detailed. For one, he said, he didn't want a whole bunch of Eastern suburbs women ... running all over his gallery talking about paintings and art they didn't know anything about.'[35] Of course, many of these women did know something about art and about the collection, as deputy director Tony Tuckson and curator Daniel Thomas were aware. With their support, the trained volunteer guides were established and when the refurbished Gallery opened in 1972, four tours of the collection were programmed for each weekday and two on Saturday and Sunday afternoons.

Daniel Thomas saw that modern museums must adapt to a broadening understanding of what art museums could offer, without diluting core values. He did not view the enthusiastic, and often very knowledgeable, amateurs who increasingly formed part of the Gallery's extended voluntary work force as a threat. As one of the first guides, Judy Friend, recalled,

> it was above all Daniel Thomas who made them feel at home and a part of the Gallery. Whenever there was a new acquisition and a new installation

he would seek out the guides for a discussion. He helped the guides to develop insights into the broader issues of collecting, buying and arranging paintings.[36]

Thomas took long service leave in July 1977 and did not return to Sydney, taking up the position of inaugural senior curator of Australian art at the National Gallery of Australia in Canberra. He left before Edmund Capon began as Director in August 1978. Capon, an art historian and curator and not a practising artist, did more than any other figure in the Gallery's history to extend the ways in which it could be a place of refreshment and recreation for all people. 'No longer can we hide behind our curatorial and scholarly veils in the pretence that research and learning are our only interests,' he wrote in an introduction to a gallery handbook, 'our audiences are an absolutely fundamental part of the dynamic of this institution.'[37]

Trained volunteer guides, including those who specialised in leading children's groups, became an important part of Gallery programming with the opening of the 1972 extensions.

The Exhibitionists

Epigraph
Lennie Lower, 'An artful beer Gallery', *Smith's Weekly*, 15 Feb 1941, p 6.

Notes
1 The 10th International Congress of Accountants Art Competition, 16–25 Oct 1972.
2 Frances McCarthy, statement for 16 and 17 Oct 1972, National Art Archive, Art Gallery of NSW.
3 McCarthy, 16 and 17 Oct 1972.
4 Memo from Daniel Thomas to director, 25 Oct 1972, National Art Archive, Art Gallery of NSW.
5 Memo from staff to director and trustees, 16 Oct 1972, National Art Archive, Art Gallery of NSW.
6 *8th annual report of the New South Wales Academy of Art*, 1879, p 1.
7 Letter from Joseph Rubie to Frederick Eccleston Du Faur, 26 Nov 1878, CF35/1878.
8 Biography of Maria Agnes Teresa 'Dollie' Gilhooley, https://www.geni.com/people/Maria-Gilhooley/6000000167626504967, accessed 5 Nov 2020.
9 'Sunday in the Domain', *Evening News*, 19 May 1884, p 3.
10 'One of the "lungs" of Sydney. The Domain', *Australian Town and Country Journal*, 23 Mar 1889, p 26.
11 It now covers around 84 acres.
12 Nancy Borlase and Laurie Short, interview with Steven Miller, 26 May 1998, National Art Archive, Art Gallery of NSW.
13 Kenneth Slessor, 'A guide to the Gallery', *Smith's Weekly*, 9 Jul 1938, p 4.
14 Godfrey Miller, 'Letters to the editor', *Sydney Morning Herald*, 5 Aug 1959, np.
15 'The continental in the Domain', *Daily Telegraph*, 22 Jun 1897, p 5.
16 'The National Art Gallery', *Daily Telegraph*, 23 Jun 1884, p 4.
17 'Arts all one', *Daily Telegraph*, 6 Dec 1923, p 9.
18 Lennie Lower, 'An artful beer Gallery', *Smith's Weekly*, 15 Feb 1941, p 6.
19 'Tea kiosk in the Domain', *Evening News*, 31 Oct 1896, p 6.
20 'Sydney gossip', *Sydney Mail*, 7 Nov 1896, p 977.
21 Letter from Florence Doherty to Will Ashton, 30 Sep 1937, CF37.100.
22 'Art Gallery guzzle again', *Daily Mirror*, 26 Jan 1956, p 26.
23 Printed appeal for membership, Soc/Gen 54–60 reference folder. Capon Research Library, Art Gallery of NSW.
24 The ABC began broadcasting these concerts on radio in 1956 and contributing to the cost of artists' fees.
25 In 1941 Charles Lloyd Jones, a founder of the Society, had proposed establishing a film library of art, such as he had seen in some American museums.
26 Sir Colin Anderson, lecture delivered to the Art Gallery Society of NSW, 25 Jan 1961.
27 From trustee Joseph Choate's speech on the opening of the Museum on that occasion, quoted in Calvin Tomkins, *Merchants and masterpieces: the story of the Metropolitan Museum of Art*, New York, EP Dutton & Co, 1970, p 16.
28 Letter from James Fairfax to Frederick Eccleston Du Faur, 25 Jul 1881, CF13/1881.
29 Sir Kenneth Clark, *The idea of a great gallery*, National Gallery of Victoria, Melbourne, 1981, p 9. This was a reprint of a lecture Clark gave at the National Gallery of Victoria on 27 January 1949.
30 Critic, 'Art in Sydney', *Sydney Morning Herald*, 12 Feb 1887, p 7.
31 JG de Libra, 'The National Art Gallery of New South Wales', *Sydney Morning Herald*, 28 Feb 1887, p 8.
32 Critic, 'Art in Sydney', *Sydney Morning Herald*, 9 Apr 1887, p 6.
33 A trustee, 'Art in Sydney: to the editor of the Herald', *Sydney Morning Herald*, 10 Mar 1887, p 4.
34 Curators could be tolerated, but art historians were not trusted by Missingham. Missingham's papers in the National Library of Australia, Canberra, contain his candid views on art historians, including his former employee Bernard Smith. These show him to share the same prejudices of former director JS MacDonald, who described these art 'writers' (after Sickert) as 'a voluble tribe of marmosets'.
35 From an interview with Judith White, quoted in Judith White, *Art lovers: the story of the Art Gallery Society of New South Wales 1953–2013*, Art Gallery Society of NSW, Sydney, 2013, p 57.
36 Quoted in White 2013, p 60.
37 Edmund Capon 'Introduction', in Bruce James, *Art Gallery of New South Wales Handbook*, Art Gallery of NSW, Sydney, 1999, p 9.

16 Tasty Tang
Edmund Capon: the first decade, 1978–88

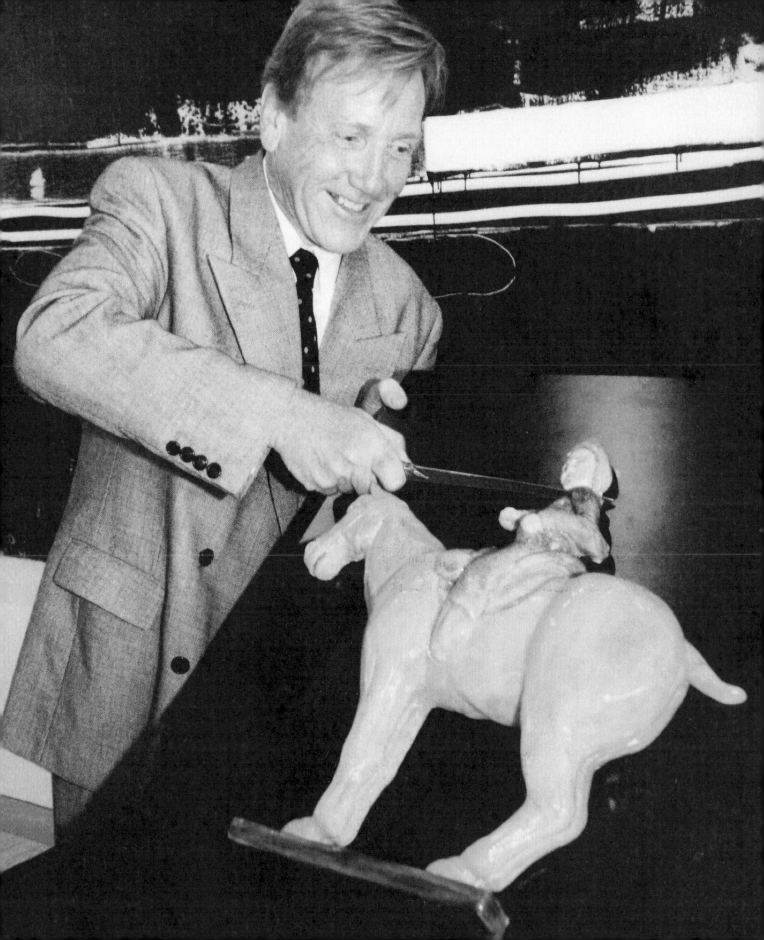

Capon was presented with a cake, modelled on a Tang dynasty sculpture of a horse and rider – the very first piece Capon bought for the Gallery in 1978. Of course, the rider was actually Capon and when asked to cut the cake, the director sliced through his own head and ate it.

Australian, 1998

Edmund Capon vividly remembered his first visit to the Gallery in 1977. 'In one of those encounters that you never forget,' he wrote,

> I walked through the front door and there was this beautiful Vernon vestibule with two great arches and then cutting across it was the concrete beam of the then restaurant. I saw all these legs of chairs, tables and people, and I thought: 'What a weird thing to do with two beautiful classical arches. That was my first image of the Art Gallery of New South Wales.'[1]

At the time he was travelling in Australia with the *Chinese Exhibition*, which opened at the National Gallery of Victoria before being shown in Sydney and then Adelaide.[2] He was the assistant keeper of the Far Eastern section of London's Victoria and Albert Museum. Capon had originally been commissioned to write the catalogue for the exhibition, but the Chinese authorities decided to entrust it to one of their own who could 'make the past serve the present', as Chairman Mao had instructed.[3] Capon was then commissioned by the Australia Council to rework his catalogue research into the accompanying book *Art and archaeology in China*.[4] Because this book was printed in England and there was very little time before publication and the opening of the exhibition in Melbourne, Jim Leslie, chairman of the exhibition sponsor Mobil Oil, asked Capon to fly with the copies to Melbourne. When Capon subsequently travelled to Sydney to visit friends of his wife Joanna, he was asked by Jean Battersby, CEO of the Australia Council, to lecture at the Gallery.

Capon's lectures were popular, and his easygoing manner endeared him to a wide range of people in Australia. When he returned to London, he was invited to apply for the directorship of the Art Gallery of New South Wales by the NSW Agent General there, Peter Valkenburg. Jean Battersby had first sounded him out to see if he would be interested in relocating to Sydney. The Public Service Board, tasked with making the appointment, was nervous about it, as it had been criticised for its 'unimpressive track record' in the past.[5] It appointed a subcommittee to assist, comprising gallery trustees Charles Lloyd Jones, Diana Heath, artist Wallace Thornton and Justice Nagle (who had just completed his major report on prison reform for the Royal Commission initiated by the Wran government). Jones and Heath were

Previous page: Edmund Capon cutting the cake made for his 25th anniversary as director of the Gallery in 2003 **Right, above:** This Tang dynasty equestrian figure c700 CE was presented by the Art Gallery Society in 1979 to the Gallery to mark Capon's commencement as director in the previous year **Right:** Visitors to the *Chinese Exhibition* at the Gallery, 1977. Photographer unknown

The Exhibitionists

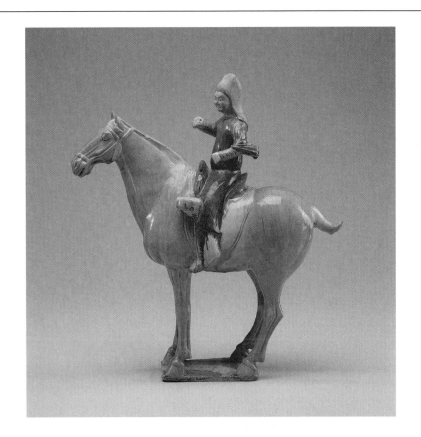

Tasty Tang

The Exhibitionists

convinced that Capon was the right person for the job. No Australian candidates were seriously considered. The only other real contender was Terence Measham, an education officer from the Tate Gallery in London. However, his request for a tenure of eight years, rather than the five offered, effectively destroyed his chance of being appointed.[6] Artist John Olsen was a trustee when Capon was appointed and remembers 'he was flexible, and he was lively and youthful ... somehow that kind of freewheeling personality, a little bit cheeky, is what Sydney understands'.[7] Capon began as director on 27 November 1978.

His first official duty was to attend the final board meeting of that year, on 15 December, the main business of which was the judging of the Archibald, Wynne and Sulman prizes. This was the year that Brett Whiteley won the 'trifecta', becoming the first artist to take out all three prizes. In his Archibald portrait, *Art, life and the other thing*, Whiteley referred to the most sensational event in the prize's history, depicting himself holding a monochrome reproduction of William Dobell's portrait of fellow artist Joshua Smith, which had been awarded the prize in 1943. Some had claimed that Dobell's winning work was a caricature and not a portrait, and therefore ineligible for the award. The ensuing unsuccessful court case became a topic of debate in almost every Australian household. Attendances at the Gallery doubled as a result.

The enormous publicity that the Whiteley trifecta also generated was not lost on Capon.[8] Over the next thirty-three years he used 'the Archibald circus' to ensure that the Gallery

made the mainstream media at least every year. Capon was also adept at generating his own controversies. In 1993 he indiscreetly remarked that the portrait of René Rivkin by Vladas Meškėnas was a 'rotten picture' and was successfully taken to court by the artist.[9] Other court cases during his time involved disputes over the meaning of painted 'from life' (1983) and whether the prize still fulfilled its criteria as 'a good charitable bequest' (1985).[10] The 1985 court case judged that the prize was 'of general public utility' because of the popular interest it generated in art.[11] As a result, the Perpetual Trustees were instructed to transfer administration of the assets to the Art Gallery Trust. Reflecting their constant popularity under Capon, in 1989 the Archibald, Wynne and Sulman Prizes were ticketed for the first time.[12]

Hal Missingham's three-pronged approach to Gallery renewal, which he set forward in 1951, involved a transformation of the building, staffing and governance. Missingham managed to achieve only the first two. Peter Laverty too was unable to resolve issues of governance. He resigned in 1977 after six years, along with a number of professional staff. Joanna Mendelssohn, who had joined the Gallery as a curatorial assistant in 1972, remembered the impact that the death of deputy director Tony Tuckson had upon staff morale in these years. Tuckson had applied for the directorship when Missingham retired, but those who knew him said that this was out of a sense of duty rather than a real desire for the position. Incoming director Laverty then relied heavily upon him, as 'he had been there for so long and he knew so much'.[13] Mendelssohn also believed that Tuckson

> was not intimidated by the trustees in the same way that Peter Laverty was. The Gallery was in trauma for the last months of Tuckson's life; cancer of the spine, which he dealt with by alcohol and endurance. Terrible rages but a determination to get the job done. Then emptiness, as Peter Laverty basically capitulated to the determination of the worst trustees.[14]

When he accepted the directorship, Capon was aware that the need to improve the working relationship between the board of trustees and the Gallery's professional staff was critical. He recalled, 'I had to contend with two slightly – how can I put it? – recalcitrant trustees in the form of dear Franco Belgiorno-Nettis and Harry Seidler, who were quite against my getting this job in the first place.'[15] Belgiorno-

Facing page: Looking through to the entrance court and restaurant above from Vernon's vestibule, 1972. Photograph: Max Dupain **Left:** Edmund Capon straightens a picture with Gallery attendant John Mahony, 1982. One of Capon's earliest acts at the Gallery was the refurbishment of the old courts. Photographer unknown

Nettis and Seidler, both immigrants, disliked the fawning over English experts that they believed was a legacy of Australia's colonial past. At the dinner celebrating Capon's arrival they made it clear to Joanna Capon that they did not approve of her husband getting the job.[16] Although he and Seidler eventually became great friends of the Capons, Belgiorno-Nettis proposed a toast and began it by saying, 'I do not like the British and I did not think Edmund should have been appointed.' Joanna Capon thought theirs might be a very short stay and was relieved that she had not completely unpacked.[17]

While some trustees were hostile, Capon had the support of Premier Neville Wran, who was genuinely interested in the Gallery. Wran received his first inkling that things were not entirely right there when he asked for some works of art to hang in his offices when elected premier in 1976. 'Furnishing loans' were regularly made to the offices of prominent politicians. Jill Wran recalls, 'when these rather pathetic choices arrived it was very disappointing. I happened to mention this to my good friend Rudy Komon, who immediately offered works from his store on loan and was highly critical of the Gallery's administration at the time.'[18] Trustees Diana Heath and Charles Lloyd Jones were also frank with Wran about the problems. Heath detailed these in a letter, too searing to leave on the record: 'After Neville and Charles had read my "problems" letter, Neville said "Well Di, I think Mr Lloyd Jones and I will each place our copies of your letter in the bin."'[19]

Wran appointed talented staff to his office keen on change at the Gallery, including Evan Williams, who became his director of cultural activities in 1977. One of the practical suggestions from Heath's letter that Wran adopted was the 'Premier's Seminar on the Art Gallery of NSW'. This was held on 5 June 1979, with 250 invited guests, to discuss the reform of the Gallery and its future direction. Some trustees thought that the premier was interfering and were nervous about this public scrutiny. Capon told Lady Fairfax that 'he envisaged that the role of the trustees would be a matter for discussion'.[20] On the day, Wran gave the introductory address and announced that his government would abolish entry charges.[21] Capon then outlined his vision for the Gallery, saying that his focus would be 'excellence in limited areas of interest', namely European and American art, Australian art, prints and drawings, contemporary art, Asian art and photography.[22]

Re-introducing free admission to the Gallery, which had ceased only from 1972, was an initiative that Capon wholeheartedly supported, even though door takings were estimated at $40,000 a year. Capon promised the trustees that he would work to secure compensation from Treasury for lost revenue, which he managed to achieve. This issue became a cornerstone of his directorship. He resisted pressure to reintroduce admission fees in 1991, despite the 'economically stringent times', as Minster for the Arts Peter Collins described them.[23] Both the Australian Museum and Powerhouse Museum began charging, as did the Museum of Contemporary Art when it opened in November 1991, but Capon provocatively told a journalist, 'I have proved 199 times that we make more money by letting people in free and charging them to get out – by always having paying shows, two restaurants and a book shop – I'm not going to let those arseholes and dickheads threaten me.'[24] He felt sadly vindicated when he learnt that attendances at the Powerhouse Museum had dropped by 80 per cent in the year following the introduction of admission fees.[25]

When Capon began as director, work was already underway to reform the Act under which the Gallery was governed. Justice Nagle chaired a subcommittee that was given the job of critically examining 'the responsibilities of the Trust, the size of the Trust itself, relationships with staff, particularly the Director and financial matters'.[26] The new Act came into effect on 11 July 1980.[27] At his first meeting with the trustees, Capon 'submitted a brief report on his perusal of the *Art Gallery Act* and suggested amendments'.[28] One of these was a proposal that the director be a formal member of the board, akin to a managing director in a public company. This was rejected.

The new Act was modest in its reforms, reducing the board from thirteen to nine, 'at least two of whom shall be knowledgeable and experienced in the visual arts'. The director was designated 'chief executive officer ... responsible to the Trust'.[29] It directed that trustees be appointed for three years, with the possibility of re-appointment for two terms. It also required the involvement of the trustees in the appointment of a director, whereas previously this had been done by the Public Service Board without consultation. An unauthored, but semi-official, report on the Act in the Gallery's archive noted that its most important innovation was in recognising the Gallery as 'a professional institution' with the director as the head of professional staff, rather than 'merely an arm of the trustees'. The report also advised:

> The professional staff of all museums in the world would agree that artists make the worst trustees. We are quite serious in suggesting that no artist should be allowed on the Board. This would be the major way in which the continuous confrontation of Trustees and Staff could be avoided.[30]

Curatorial staff did not believe 'knowledgeable and experienced in the visual arts' necessarily required the appointment of artists to the board of trustees, although this was how the requirement was subsequently interpreted. Artist trustees had been commonplace at the Gallery since the nineteenth century and this had been problematic at times.

Ethical questions concerning conflicts of interest – not only in relation to the purchase of their own works or those of their friends, but also to their representation in exhibitions – remained unresolved. Some artists made excellent trustees, disinterestedly able to appreciate a wide range of work, but many others did not.[31] It was artist trustee Frank Hinder who steadfastly opposed the purchase of *Eurasia Siberian Symphony 1963* 1966 by Joseph Beuys, a work that had been included in the 1976 Biennale of Sydney, despite the curators (including Hinder's close friend Renée Free) believing that this was a work uniquely suitable to an Australian collection.[32]

It is sometimes suggested that the improvements under Capon in the relationship between the trustees and Gallery staff was the result of legislative reform. The new Act played only a small part in this. Far more significant was Capon's personal touch and the friendships he made with board members. His style was neither adversarial nor servile. David Gonski, who was president for ten years, recalls that his 'enormous strength' was 'in understanding people's feelings and making them feel good'.[33] A former staff member observed that he was able to persuade the trustees 'that the professional staff knew their job and that the trustees' position was to guide policy, not to interfere in the day-to-day running of the institution. Every previous director had found the trustees an insurmountable problem.'[34]

In many ways, Capon returned to older, more personal modes of governance that characterised how the Gallery operated in its foundational years. In no area was this more evident than in his relationship with government. Up until the First World War, the Gallery's board of trustees always included sitting members of parliament, or those with

parliamentary experience. Channels of communication were good. However, when Capon arrived at the Gallery this was no longer the case and the subcommittee reviewing the Act was preoccupied with how the situation could be improved. It suggested including an ex-officio trustee on the board, reporting directly to the Minister. Instead, Capon managed to build these connections at a personal level. Joanna, his wife, described as 'the unsung heroine in the Edmund Capon story', was critical to his success.[35] She had trained as an art historian and the two had met at the Victoria and Albert Museum.

He told the story of being at a dinner party with Neville and Jill Wran, when he complained about access to the Gallery. This had been an issue since the nineteenth century, with various intermittent solutions. In 1915, following increasing calls from 'the public who frequent the baths, Art Gallery, Botanic Gardens and Mrs Macquarie's Chair', a tram line opened at Woolloomooloo Bay, only to close during the Depression.[36] In the 1960s a free direct bus service operated during school holidays.[37] However, nothing sustained had been implemented. Capon wanted a regular bus service. Apparently, Wran picked up the phone that evening and the service was running by the following week.

Premiers Neville Wran and Bob Carr and Minister for the Arts Peter Collins were the three politicians with whom he had the best working relationships. All three became friends. Collins recalled that 'although Capon was a Wran government appointment, he was certainly not a political appointment. He

Flyer produced for the Art Gallery Foundation illustrating its early ambition to fill important gaps in the Gallery's collections

was very much his own man.' Collins also described Capon as 'the greatest entrepreneur for the visual arts that Australia had seen'.[38] But there were inevitable tensions at times, such as the one over gallery admissions. And in 2003 Capon lowered the Australian flag outside the Gallery in protest over the country's involvement in the Iraq war. Opposition leader John Brogden called it a test of leadership for Bob Carr, who rang Capon 'and said the flag must fly immediately or I will be there and raise it with my own hands'.[39]

In line with his focus on 'excellence in limited areas of interest', in 1979 Capon established three new curatorial positions: curator of contemporary art (Bernice Murphy) – the first such position in an Australian public gallery – curator of Asian art (Jackie Menzies) and assistant curator of prints and drawings (Jane de Teliga). Gael Newton was reassigned to become assistant curator of photography. Trustee Robert Haines questioned why a curator of contemporary art was needed, as Sydney already had the Power Institute, where artist Elwyn Lynn had been curator since 1969. Capon, using the same argument he later made when it was suggested that the Gallery should stop collecting contemporary art when the Museum of Contemporary Art was established at Circular Quay, responded that this did not relieve the principal state gallery from its duty to collect the art of its time and that all other collections should be viewed as complementary. Franco Belgiorno-Nettis argued that Gallery staffing levels were already bloated and there were no grounds for appointing curators of photography and Asian art. Capon argued strongly for both.

Capon told the trustees that curators, once appointed, needed 'maximum flexibility and a degree of curatorial independence and responsibility'.[40] He suggested that they be allowed to purchase works of art up to the value of $10,000, requiring only directorial, not board, approval. As the first non-artist director of the Gallery, it is not surprising that Capon argued so forcefully for curatorial autonomy.[41] He himself was a curator and he even unofficially changed his designation at the Gallery to director and chief curator. However, one criticism that was made of him – usually by his own curators – was that despite his arguments for professional autonomy his style of management undermined independent curatorial expertise.

An early disagreement occurred in 1983 over the Brett Whiteley Project exhibition *Another Way of Looking at Vincent Van Gogh*.[42] Barry Pearce, who had been appointed curator of Australian art in 1978 just before Capon came to the Gallery, was not consulted about the exhibition. He raised the concern that the exhibition looked little different to him from the shows that Whiteley was staging at his commercial galleries. He also noted that a commercial publication was being produced in connection with the exhibition, to be marketed

at the same time.[43] Project exhibitions, Pearce argued, should focus on artists 'working in an experimental field which otherwise had little public exposure and did not have the commercial viability which might encourage dealer galleries to show them'. He asked that the exhibition be cancelled and ended a memo to Capon: 'Why bless Brett Whiteley and his dealer with this unprecedented boost for his latest commercial exhibition?'[44]

Capon was furious, particularly as Pearce had discussed the matter with a trustee and had asked him to 'present the concern of the professional staff fairly to the [other] Trustees'. Pearce was not suggesting that Whiteley did not warrant an exhibition. In fact he curated a major Whiteley retrospective in 1995, as well as a few Whiteley-themed exhibitions at the Brett Whiteley studio in Surry Hills.[45] Pearce wrote to fellow curator Renée Free:

> the wider issue is a vital one, which is that an exhibitions policy *does not exist*, and exhibitions seem to be mooted to fill gaps not because it is important to have them, but to keep the programme rolling. Exhibitions must be born out of curatorial discussion, where the museum is conceived as a broker between art objects, art history and the public. The guiding principle must not, however, be public relations for its own sake, in spite of how important that function is.[46]

This episode was significant as it highlighted some of the perceived shortcomings of Capon's directorship. Once he had forged strong connections with the board, it was said that Capon subsequently monopolised access to it. Curators could never be sure if their proposed acquisitions and exhibitions were being supported or undermined at meetings of the trustees. Capon's highly centralised and personalised form of management, coupled with his hatred for bureaucracy and 'red tape', meant that decisions could be made quickly and effectively at the Gallery. Jackie Menzies, senior curator of Asian art, recalled, 'staff wanting decisions knew it was best to waylay him in the corridor as he rushed to his next engagement. Despite the lack of formal procedures, he had his finger on every pulse in the institution.'[47] However, there were few high-level policies setting strategic aims, even in vital areas of collection development, management and care.

These shortcomings were rarely evident, or of much significance, to those outside the Gallery. For the general public, Capon was the genial and accessible face of the Gallery, who had phenomenal success, as Pearce readily acknowledged, in making them 'feel that the Gallery was part of their lives'.[48] Capon recalled that 'about 60 per cent of my role in the first year or two was the impresario. I needed to

galvanise the image of the institution in public life.'[49] A typical Caponesque gesture – calculated, theatrical but also touching – occurred during the 1984 blockbuster exhibition of Picasso. Capon said that many times he had got into a taxi and when he said, 'I want to go to the Art Gallery of New South Wales', the taxi driver had no idea where this was. During the Picasso exhibition he organised a special after-hours free opening of the show for taxi drivers and their families. Their cabs were parked in rows outside the Gallery and inside there were dedicated guides to the exhibition, food and drink.

To some extent Picasso bookended Capon's time at the Gallery. The last major exhibition during his directorship was *Picasso: Masterpieces from the Musée National Picasso, Paris*, in 2011–12. His first important European acquisition in 1981 had been Picasso's *Nude in a rocking chair* 1956. That purchase, only the second Picasso to enter an Australian public collection at the time, exhausted the Gallery's acquisitions fund. Part of the reason why the Art Gallery of New South Wales Foundation was launched in 1983 was to finance such major works.[50]

At a board meeting as early as 1979 Lady Fairfax and Capon had pushed for the establishment of a permanent 'appeals committee'. Mary Fairfax agreed to be active on it but wanted Rupert Murdoch appointed chairman. When the Art Gallery Foundation was constituted, Murdoch was inaugural chair, with Premier Neville Wran as president. Michael Gleeson-White and Max Sandow, trustees of the Gallery, became vice-chairmen and played an enormous role during its first seventeen years.[51] The Foundation was a joint initiative of government and the private sector, with the government matching donations dollar-for-dollar up to $4 million. Funds were invested and the income derived from these investments was used for new acquisitions. Various levels of membership were offered.[52] The first Foundation purchase was made in 1984 for $1,075,480: *Three bathers (Drei Badende)* 1913 by the leading protagonist of Die Brücke, Ernst Ludwig Kirchner. Others in the following years included Max Beckmann, *Mother and daughter* 1946 (1987),[53] Miyagawa Chōshun, *Standing figure of an actor* 1713 (1987), Philip Guston, *East Tenth* 1977 (1988), Vincent Van Gogh, *Head of a peasant* 1884 (1989/90) and *Tomb guardians* from the Tang dynasty

Taxis parked outside the Gallery during the special preview of the Picasso exhibition that director Edmund Capon organised for taxi drivers, 23 October 1984. Photograph: Phillip Lock

Ernst Ludwig Kirchner *Three bathers* 1913

The Exhibitionists

(1989–90). In 1990 the Foundation reached its original target of a capital fund of $8 million.

For Capon, Foundation funds became the primary way to fill gaps in the Gallery's collection. In one of his first interviews as director he remarked on these omissions and the flyer produced to promote the Foundation made some of them explicit: 'Artists such as Rembrandt, Blake, Cézanne, Matisse are all unrepresented. Schools such as German Expressionism, Surrealism and the sources of abstract traditions too are missing from our collections.'[54] The Kirchner filled the German Expressionist gap. The idea of creating a collection that mapped the historic development of Western art was not at all a concern in the first seventy years of the Gallery's history, when, as director JS MacDonald noted, the institution 'wisely confined its purchases (with rare exceptions) to the work of its day'.[55] However, in the 1950s under Hal Missingham, oils began to be purchased that were more than a hundred years old at the time, works like Hogarth's *Dr Benjamin Hoadly MD* (early 1740s), purchased in 1951, and Joseph Wright's *Margaret Oxenden* (c1757), purchased the following year.[56]

The curator of international prints and drawings, Nicholas Draffin, who was well aware of the Gallery's institutional history, questioned this collection strategy. On the whole he did not doubt the quality of the individual works purchased (although he was disciplined for describing the Van Gogh as 'a finger painting in shit' to a group of volunteer guides and saying that the Gallery had spent $1,221,749 on 'a mere name'). Draffin thought it made better sense, and was more feasible, to build a less expensive survey collection of works on paper by canonical artists, while allowing individual curators access to Foundation funds to build upon the particular strengths of their areas of collecting.

Draffin, brilliant but also something of a rogue curator, was a loss to the Gallery when he returned to Melbourne in 1992.[57] It is interesting to speculate on whether he would have revised some of his criticisms had he lived to see the Foundation purchase in 1996 of Bronzino's *Duke Cosimo I de' Medici in armour* c1545. Along with the other Foundation purchases – of *Portrait of a gentleman with a falcon* c1548–50 by Nicolò dell'Abate in 1991 and *Madonna and child with St John the Baptist* c1541 by Domenico Beccafumi in 1992, joining *The deposition* by Prospero Fontana that had been purchased with funds provided by the Art Gallery Society in 1994 – the Gallery now had a group of works that illustrated the rich tradition of Italian Mannerism in the early sixteenth century according to the variant styles of Florence, Modena, Siena and Bologna.

Japanese works of art, rather than Chinese – Capon's particular area of curatorial expertise – dominated Foundation purchases in the first ten years.[58] Capon also built up a strong

Edmund Capon–designed cover for the catalogue to the 1981 Chinese exhibition

network of patrons, almost in parallel to the Foundation, to further support Asian art acquisitions. Many, including Edward and Goldie Sternberg, Fred and Caroline Storch, and Ken and Yasuko Myer, became close friends. In 1980 the Myers donated a seventeenth-century six-fold screen of views in and around Kyoto.[59] They had seen it displayed in an exhibition at the Kyoto National Museum and tracked down the dealer. Capon viewed this purchase, along with a Tang dynasty equestrian figure presented in his honour in 1979 by the Art Gallery Society, as foundational to his ambitions for Asian art at the Gallery. He was devastated when Ken and Yasuko were killed in a light aircraft crash in 1992, during a trip that he had contemplated joining.

Speaking at their funeral in Melbourne, he praised them for their quiet generosity. This is a quality that he also admired in the 'very modest Hepburn Myrtle', whom Capon believed was 'one of the great antipodean collectors of Chinese imperial ceramics who left most of his collection to our Gallery'.[60] When Capon and curator Jackie Menzies began developing the Asian collections, Myrtle's gifts of Chinese porcelain between 1962 and 1995, along with Sydney Cooper's Chinese tomb furniture and ink paintings, donated in 1962, provided an important base upon which to build. The Sternbergs, too, 'were the most genuine of benefactors ... it was not recognition nor praise that they sought, but simply to help our Gallery

acquire great works of art'.[61] They established a Chinese art purchase fund in 1989, which in time purchased around sixty works of 'early Buddhist sculpture, tomb figures (*mingqi*) and expressively fluid painting and calligraphy' that, as curator Jackie Menzies noted, represented Capon's deepest passion for Chinese art.[62] In 1992 the Sternbergs also established a fund for Southeast Asian art, helping to widen the Gallery's collecting focus beyond the arts of China, Korea and Japan. Fred Storch and Alex Biancardi significantly expanded holdings in this area. Further gifts of paintings, ceramics, prints and textiles from Indonesia and India were given by Margaret Olley, John Yu, George Soutter, Ross and Irene Langlands, Jim Masselos and the Christopher Worrall Wilson Bequest.

Capon achieved something of a coup in 1983 when the Art Gallery of New South Wales became the first gallery outside China to secure an exhibition of the entombed warriors of Xian. *Qin Shihuang: Terracotta Warriors and Horses* toured capital cities and attracted more than 800,000 visitors Australia-wide. However, a source of greater pride to him was the exhibition *Treasures of the Forbidden City: Chinese Paintings of the Ming and Qing Dynasties, 14th to 20th Centuries*, which he co-curated with Mae Anna Pang in 1981.[63] Pang had been appointed assistant curator of Asian art at the National Gallery of Victoria in 1972, preceding his creation of a similar position in Sydney by seven years.[64] Her specialty was Ming and Qing paintings. The exhibition was sponsored by the newly established International Cultural Corporation of Australia. It was eventually shown in Sydney, Brisbane, Adelaide, Perth and Melbourne and 45,000 copies of the catalogue were sold. A number of distinguished Chinese artists, including Wu Zuoren and Huang Yongyu, came to Australia for the show, and the symposium attracted specialists from all over the world.

Pang and Capon had gone to Beijing to organise the exhibition in October 1980. Pang was impressed with Capon's energy and unflappability. She recalled, 'Edmund designed the cover of the catalogue while in Beijing. He had a seal carved in Beijing saying 中國明清畫展 (Exhibition of Chinese Painting of the Ming and Qing Dynasties)'. When they arrived in Beijing at midnight, they discovered that the Communist Party officials in charge of their visit had failed to book a hotel. The curator from the Palace Museum 'took us from hotel to hotel and they were mostly booked. Finally, we went to one. I was lucky, I had a room to myself with an en suite, but poor Edmund had to share a big room with the local men and take his shower with them. I really admire him for accommodating himself. He was a pioneer.'[65]

Visitors at the Gallery during the 1983 exhibition *Qin Shihuang: Terracotta Warriors and Horses*. Photographer unknown

The Exhibitionists

Epigraph

'Tasty Tang', *Australian*, 30 Nov 1998, p 18.

Notes

1 'Towards a great general museum: Edmund Capon in conversation with Bob Carr', *Art and Australia*, vol 49, no 3, Mar–May 2012, p 390.

2 *The Chinese Exhibition: a selection of recent archaeological finds of The People's Republic of China*, National Gallery of Victoria, Melbourne, 19 Jan – 6 Mar 1977; Art Gallery of NSW, Sydney, 25 Mar – 8 May 1977; Art Gallery of South Australia, Adelaide, 9–29 Jun 1977.

3 'Foreword', in *The Chinese Exhibition*, The People's Republic of China, printed in Melbourne by Antagraphic, 1976, p 7.

4 Edmund Capon, *Art and archaeology in China*, Macmillan, Melbourne, 1977.

5 David McNicoll, 'Racing control needs a broom', *Bulletin*, 26 Sep 1978, p 48. The article ended 'Why did we have to choose someone from England anyway? Why not someone like Leon Paroissien, director of the Visual Arts Board of the Australia Council?'

6 Trustee Diana Heath recalls 'I was given the task of driving Terry Measham around Sydney for a day to suss him out. Glad I spent that time with him as he was never suitable.' Email from Diana Heath to Steven Miller, 26 Feb 2021.

7 Jenny Tabakoff, 'Straight from the art', *Sydney Morning Herald*, 14 Nov 1998, p 7.

8 More controversial than his depiction of the Dobell portrait, Whiteley's painting *Art, life and the other thing* contained a graphic reference to Whiteley's heroin addiction – 'the other thing'.

9 The reason that Capon was taken to court was that the painting was then rejected for the Archibald Prize. This prize is meant to be judged by the trustees alone. The ruling noted that Capon's intervention, which destroyed the chances of the painting being exhibited, was an example of the director exceeding his authority.

10 *Bloomfield v. Art Gallery of NSW*, CJ, Equity Division, 23 Sep 1983 and *Perpetual Trustee Company Ltd v. Groth & Ors*, Supreme Court of NSW, Equity Division, 8 Jul 1985.

11 Judgement in *Perpetual Trustee Company Ltd v. Groth & Ors*, Supreme Court of NSW, Equity Division, 8 Jul 1985, p 35.

12 Three dollars full price, two dollars concession and six dollars for a family.

13 Peter Laverty quoted in Daniel Thomas, Renée Free and Geoffrey Legge, *Tony Tuckson*, Craftsman House, Sydney, 1989, p 22.

14 Email from Joanna Mendelssohn to Steven Miller, 5 Feb 2021.

15 'Towards a great general museum: Edmund Capon in conversation with Bob Carr', p 390.

16 Helen O'Neill, *A singular vision: Harry Seidler*, HarperCollins, Sydney, 2013, p 266.

17 Email from Joanna Capon to Steven Miller, 18 Apr 2021.

18 Email from Jill Wran to Steven Miller, 9 Feb 2021.

19 Email from Jill Wran to Steven Miller, 9 Feb 2021.

20 AGNSW Minutes, 27 Apr 1979, p 2.

21 'Free Gallery plan', *Sun*, 5 Jun 1979, p 15.

22 Sandra McGrath, 'Rogues stay away from the Gallery', *Australian*, 6 Jun 1979, p 10.

23 Peter Collins, 'Minister's message', *Australian Museum annual report 1991/92*, p 2.

24 'The Capon technique', *Sun-Herald*, 23 Aug 1992, p 17.

25 Fees were introduced on 16 Sep 1991.

26 *1979 report of the Trustees of the Art Gallery of NSW*, Sydney, p 6.

27 *Art Gallery of New South Wales Act 1980* no 65.

28 AGNSW Minutes, 15 Dec 1978, p 2.

29 *Art Gallery of New South Wales Act 1980* no 65, part III, 12.2 and 12.3.

30 'Report on the 1980 Art Gallery Act', typescript, legislative documentation, National Art Archive, Art Gallery of NSW.

31 Fred Williams was well regarded as a trustee at the National Gallery of Australia. In contrast, Russell Drysdale in Sydney was largely interested in work that resembled his own, and attempted to get the Gallery to purchase work by the Adelaide artist David Dridan.

32 It is now in the collection of MoMA, New York.

33 David Gonski, 'Experiencing Edmund: reflections on a retiring art gallery director', *Art and Australia*, vol 49, no 3, Mar–May 2012, p 394.

34 Joanna Mendelssohn, 'Beyond the excitement', *Bulletin*, 20 Aug 1991, p 40.

35 Shelley Gare, 'One last question, Mr Capon', *Sydney Morning Herald*, 24 Nov 2011, p 44.

36 William Norris, 'Woolloomooloo tram: to the editor of the Herald', *Sydney Morning Herald*, 13 Dec 1915, p 12.

37 Route 888 from the Art Gallery to Goulburn Street and from York Street to Sir John Young Crescent.

38 Interview by Steven Miller with Peter Collins, 20 April 2021.

39 'Gallery flag flying again', *Daily Telegraph*, 21 Mar 2003, p 11.

40 AGNSW Minutes, 2 Mar 1979, p 10.

41 Secretary George Layton was not an artist, but he was also not a director in the same way that subsequent holders of this office were.

42 Project 43: *Another Way of Looking at Vincent Van Gogh 1888–1889*, 4 Jul – 21 Aug 1983.

43 Brett Whiteley, with a foreword by Edmund Capon, *Another way of looking at Vincent Van Gogh 1888–1889*, Richard Griffin, Melbourne, 1983.

44 Barry Pearce memo to Edmund Capon, 3 Jun 1983, National Art Archive, Art Gallery of NSW.

45 *Brett Whiteley: Art & Life*, 16 Sep – 19 Nov 1995.

46 Exhibition file, *Another Way of Looking at Vincent Van Gogh, 1983*, National Art Archive, Art Gallery of NSW.

47 Jackie Menzies, 'Edmund Capon AM OBE', *TAASA Review*, vol 28, no 3, Sep 2019, p 24.

48 Barry Pearce, 'Letters to the editor: balancing the scholarly and the popular', *Bulletin*, 3 Sep 1991, p 12.

49 Quoted in Joyce Morgan, 'Edmund Capon, an unlikely choice, was a risk worth taking', *Sydney Morning Herald*, 17 Dec 2011, p 11.

50 The Art Gallery of New South Wales Foundation was constituted by Trust Deed executed on 23 August 1982.

51 Rowena Danziger took over from Rupert Murdoch as chairperson in 2005. Jillian Broadbent had become deputy chair in 2001.

52 When the Foundation was established these were set at Ordinary members ($2000–$10,000 over five years for individuals and $4000–$20,000 for others); Fellows ($10,000–$25,000 over five years for individuals and $20,000–$50,000 for others); Governors ($25,000–$100,000 over five years for individuals and $50,000–$200,000 for others); Founder Benefactors ($100,000 or more over five years for individuals and $200,000 or more for others).

53 Referred to at the time as *Old woman in ermine*.

54 *The first acquisition*, Art Gallery of NSW Foundation, Sydney, 1983, p 1.

55 JS MacDonald, *New South Wales Art Gallery pictures*, National Art Gallery of NSW, Sydney, 1931, np.

56 Capon noted, 'You don't have to be a genius to see that the trustees of the time were not exactly trying to collect a comprehensive history of art or to offer a challenge, but buying pictures which re-affirmed both place and society as they knew it and its values.' Edmund Capon, *I blame Duchamp: my life's adventures in art*, Lantern, Melbourne, 2009, p 254.

57 See Daniel Thomas's tender and well-balanced obituary, 'Nicholas Draffin', *Art and Australia*, vol 33, no 2, Dec 1995, pp 244–45.

58 Capon held a masters in Philosophy in Chinese Art and Archaeology from London University. His thesis was 'The interdependence of Chinese Buddhist sculpture in bronze and stone from AD 386 to 581'.

59 Unknown artist, *Views in and around Kyoto (Rakuchu-Rakugai zu)* c1660.

60 'Towards a great general museum: Edmund Capon in conversation with Bob Carr', p 391.

61 Edmund Capon, *The connoisseur & the philanthropist: 30 years of the Sternberg collection*, Art Gallery of NSW, Sydney, 2014, p 9.

62 Menzies 2019, p 25.

63 Art Gallery of NSW, 1 Apr – 17 May 1981, then travelling to Brisbane, Adelaide, Perth and Melbourne.

64 The Art Gallery of NSW marks the start of its Asian collections with the gift of Japanese works in 1880 at the end of the Sydney International Exhibition. The National Gallery of Victoria had already purchased Chinese enamels, bronzes and jade, for forty pounds in 1867.

65 Mae Anna Pang in correspondence with Yin Cao, curator of Chinese art, Art Gallery of NSW, 12 Jun 2019, National Art Archive, Art Gallery of NSW.

17 Not one square inch

Edmund Capon: new priorities, 1988–2011

Right now there's another aspect of the art institution which is, I admit, much more fun: the buildings.

Edmund Capon, AGNSW Director, 2009

'How perverse we human beings are,' Edmund Capon wrote, reflecting on his own desire to see the Art Gallery of New South Wales constantly bustling with people and activities. This reflection occurred as part of a critique he wrote of the phenomenon of the 'destination' museum building. These buildings, he argued, ran the risk of eclipsing their contents, and the associated emphasis upon ever-increasing visitor numbers ran the risk of transforming the museum from a 'place where people think' to an experience more like a fast-food restaurant, where visitors receive 'instant gratification'. 'But here's another dilemma,' he added, writing candidly as a museum director. 'I fear failure and disappointment when our gallery is quiet and empty but elated and enthused when it is full and bustling!'[1]

Under Capon, attendances at the Art Gallery of New South Wales rose from just over 300,000 when he arrived in 1978, to more than 1.3 million when he wrote this critique. He, more than any previous director, made the Gallery truly popular. He was always looking for new ways to do this. As early as 1979, he proposed opening the Gallery late on Wednesday evenings, with lectures, talks and music to draw diverse audiences. When the trustees said that finances would not allow this, he suggested opening on Saturdays from midday, to allow the one late night a week. The Public Service Association (PSA) intervened and argued that this was not feasible, as a new work agreement with Gallery attendants would need to be negotiated. It was not until 2003 that 'Art After Hours' was finally realised, under the creative direction of Liz Gibson from the Gallery's Public Programs division. In its first year, it attracted just under two thousand visitors every Wednesday evening.[2]

Capon also initiated a number of major building projects at the Gallery. His first was the 1988 Australian Bicentenary extension. In 1990 he moved Asian art, his particular interest, from a small gallery on the top floor of the 1972 additions, to a separate area, the last part of the 1988 extension to be completed. In 2003, he completed the additions with a highly visible and distinctive Upper Asian Gallery replacing an outdoor sculpture garden. His final project was to convert the 1972 basement collection store into a suite of galleries, when all of the collections, apart from works on paper, were moved offsite in 2010–11. Although Michael Brand joked at the start of his directorship, 'Edmund has not left me one spare square inch', this was in fact the case.[3] The possibilities for further development on the site were completely exhausted. The

Previous page: Edmund Capon on the steps of the Gallery with the work of French artist Ange Leccia, exhibited as part of the 1990 Biennale of Sydney *The Readymade Boomerang*, curated by René Block Right, above: Aerial view of the 1988 Bicentenary extensions to the Gallery designed by Andrew Andersons. The four storeys of the extension were built at the rear of the Gallery, with a stepping profile that followed the rake of the land and included a rooftop sculpture terrace. Photographer unknown

Gallery could not go down the hill towards Woolloomooloo, nor sideways, nor up. Capon investigated extending south, but this encroachment upon land owned by the Royal Botanic Garden also had the major obstacle of the eastern suburbs train line.

Capon had begun thinking of ways to extend the Gallery almost as soon as he arrived in Sydney. The 1980 annual report noted that designs had been drawn up for an extension and that 'it would be desirable if [the building] could be completed by 1988'.[4] These designs were presented to the government in 1981, only to be rejected the following year. A feasibility study was commissioned in 1984, with the extensions approved towards the end of that year. Building began in May 1985. An article in the *Canberra Times* noted that the

> new $17.5 million wing should be completed in time for the Bicentenary celebrations ... The new wing's four storeys will increase gallery space by about 50 per cent and enable it to hang more of its collection. The roof will serve as a sculpture garden, with other parts of the wing devoted to Asian art, prints, drawings, photography, education and a new theatre for lectures and films. The ground floor will be given over to twentieth century Australian art.[5]

The four storeys were built at the rear of the Gallery, with a stepping profile that followed the rake of the land. For the first time escalators were used to facilitate the movement of large crowds between levels, despite Capon's initial opposition to them as 'supermarket fixtures'. Andrew Andersons, who had so successfully completed the 1972 extensions, was project architect, from the office of the Government Architect. His Bicentenary building, like the previous extension, won the Sulman Medal for architecture and was praised for the way its links to the earlier extension were so discreet that visitors were unaware of them. Architecture critic Elizabeth Farrelly wrote that Andersons' two major extensions had transformed the Gallery 'into one of Australia's most distinguished buildings ... Other galleries are more virtuosic, turning more tectonic tricks, making more personal statements, more loudly. But the NSW gallery, having rediscovered the great art of understatement, succeeds where they do not.'[6]

Two thousand people were present when Premier Greiner declared the building open on 11 December 1988. The press reported that the extension had cost $25 million. Capon declared that New South Wales now had the 'finest art museum in Australia' and Greiner spoke of 'a new dawn for the Gallery'.[7] A number of less visible changes and expansions had occurred at the Gallery in the lead-up to the opening. Two frame conservators were appointed to the conservation

department.[8] These were the first such roles in an Australian public gallery, continuing the Gallery's pioneering tradition in the field of conservation.[9] Later, Chinese conservators and scroll mounters Sun Yu and his wife Yang Yan Dong (Lily) arrived at the Gallery after the tumultuous events in Tiananmen Square, where they had been part of the 'artists for democracy'. With the support of the Gallery's senior paper conservator Rose Peel, a scroll-mounting studio was established, a rarity within a western museum.[10]

The Gallery also acquired its first computer. In the lead-up to the Bicentennial celebrations Capon was pressured by the Australian Bicentennial Authority and the International Cultural Corporation of Australia to support an exhibition based loosely on Bernard Smith's seminal 1960 publication *European vision and the South Pacific 1768–1850*. Bernard Smith and William 'Bill' Eisler, an American scholar of Pacific exploration, worked with the Gallery's Barry Pearce on *Terra Australis: The Furthest Shore*. The diverse range of work included made it a difficult exhibition to arrange and display. Curatorial assistant Robyn Christie asked for a 'Wang' to assist with preparations. 'I went to see Edmund to ask if we could get one', Pearce recalled,

> and he looked at me with a quizzical grin as if I was referring to some kind of Chinese drug. He signed off on it, and the Gallery got its very first computer. For weeks after, staff would track from all over the Gallery into the Boardroom to check out this strange contraption about the size of a washing machine. Robyn took charge of the Wang and it was the revelation of a beckoning future.[11]

More widely reported was the establishment of the Archibald Prize People's Choice to celebrate the new wing. Despite Capon believing that 'the most awful result would be for the public and the trustees to come up with the same painting', this is exactly what occurred: Fred Cress won both the trustees' and the people's vote for his portrait of fellow artist John Beard.

At the time of the 1988 opening, Capon might have been in London as director of the Victoria and Albert Museum (V&A), had he not narrowly missed out on that appointment. He applied for the position in 1987 when his former employer Sir Roy Strong resigned as director. John Pope-Hennessy, another former director, supported his application. Capon went to London for the interviews and, as Strong noted in his diaries, 'it was a close-run thing between Edmund Capon and Elizabeth Esteve-Coll', but 'Elizabeth got it'.[12] Strong thought Capon 'was no good at his first interview, very thin' and that he had 'been too long out of Britain and away from all the changes'.[13]

Some took this attempt to return to the V&A as an indication that Sydney was only a hiatus in Capon's career and that his real focus was Europe and historical art. Gallerist Ray Hughes told a journalist 'he never turns up here to look at work because he doesn't like contemporary art'.[14] Capon countered this charge many times during his directorship. He noted that he had established the contemporary curatorial department at the Gallery and had supported exhibitions like *Australian Perspecta*. He thought it pointless having to make these justifications in the first place, as he claimed that anyone with a real love for art was interested in it all. Early in his career at the V&A he was spotted looking at contemporary American watercolours. The curator of this collection asked:

> 'What are you doing here?' 'Well,' I said, 'looking at these.' Bewildered, he looked at me intensely and asked: 'But you're Asia, aren't you?' The idea that we in our Asian ivory tower might have the slightest interest in venturing into the Occidental, let alone contemporary, worlds was simply unthinkable.[15]

Bernice Murphy had been appointed the Gallery's inaugural curator of contemporary art and was the initiator of the inaugural *Australian Perspecta* in 1981.[16] Very little experimental Australian work had been shown at the Gallery since the 1973 exhibition *Recent Australian Art*. An unanticipated gap in programming enabled Murphy to put together this important exhibition of sixty-five artists, including twenty-three women, in little more than five weeks. The 1979 *White elephant or red herring?* publication, criticising the 3rd Biennale of Sydney, illustrated that local artists felt that international Biennale artists were being welcomed and displayed by institutions such as the Art Gallery of New South Wales, while their work was ignored. Addressing this wide-spread sense of alienation by contemporary Australian artists, Murphy made the first *Perspecta* as inclusive as possible.

Sensitive to 'the recent emergence of Aboriginal art expression' in the Western Desert, Murphy also included work by Papunya Tula artists Clifford Possum Tjapaltjarri, Tim Leura Tjapaltjarri and Charlie Tjapangati.[17] This was the first time Aboriginal art was included in a general survey exhibition of contemporary Australian art, though Murphy had previously included a Papunya work in the exhibition *Landscape and Image*, which toured Indonesia during 1978.[18] Murphy later became chief curator of Sydney's Museum of

Antony Gormley with his *Field for the Art Gallery of New South Wales* 1989. The 1100 small clay figures, made by local students from earth from the centre of Australia, are arranged in two hemispheres, mimicking the plan of the brain, with a pathway down the middle to a central lobe.

Contemporary Art, with Leon Paroissien as director. Capon was initially critical of the MCA project, but later saw the value in a museum dedicated exclusively to contemporary practice. Murphy recalled a visit he made to the Mapplethorpe exhibition there in 1995:

> Edmund was generous enough to say that the MCA exists to be able to do this kind of brave exhibition. 'I simply couldn't do this at the Gallery,' he stated. 'The trustees and public would be outraged. But you've won the space to be able to do it.' I was touched at the time, as he was serious and genuine in the remarks, not just his famous jocularity and throwaways.[19]

The *Perspecta* exhibitions continued, in alternate years from the Biennale of Sydney and, as curator Victoria Lynn noted, Edmund 'supported its continuation right through to 1999: twenty years'.[20] Lynn curated or co-curated the 1989, 1991, 1993 and 1997 exhibitions and was largely responsible for making these shows 'the feisty, shocking, challenging and nothing-sacred ... *Perspecta* we knew and loved so well'.[21] Lynn believed that Capon's 'enthusiasm for contemporary art grew over time ... I think as he got to know the artists themselves, he also grew to better understand contemporary art in all of its dimensions.' Acknowledging that the *Perspecta* exhibitions were 'a big commitment to Australian contemporary art', Lynn said 'the collection, though, was another matter'.

Tony Bond followed Bernice Murphy as curator of contemporary art in 1984 and eventually became director of collections. While he found Capon 'generally very supportive', at the same time there were 'a few bugbears that he loved to hate and that inhibited acquisitions in those areas. I proposed works by Duchamp twice, very cheap at the time, Beuys twice, not so cheap, and Louise Bourgeois twice, all rejected by Edmund.'[22] Bond believed that the Gallery had a unique opportunity to build a coherent collection of international contemporary art 'from scratch'.[23] Funding came largely from a bequest by Mervyn Horton, a former trustee and president of the Art Gallery Society. In 1983, Horton left the Gallery $890,000, the largest bequest it had received in its history. He instructed that this money should be invested to purchase

works of art *not* 'executed by Australian nationals and/or residents' and on the recommendation of the trustees of the Tate Gallery, London, or the Museum of Modern Art, New York.[24]

Initially Bond always consulted Alan Bowness, director of the Tate, who was supportive of his selections. Nicholas Serota, the next director, found the terms of the bequest embarrassing and volunteered a blanket approval. He even joked that seeing the proposed acquisitions made him regret not getting them for the Tate. Major artists included Anselm Kiefer, Tony Cragg, Rachel Whiteread, Anish Kapoor, Joseph Kosuth, Lawrence Weiner, Stephen Willats, Bob Law, Doris Salcedo and Antony Gormley. Bond was able to acquire a key work by Jannis Kounellis, his *Untitled 1984/87* 1987, as a trade-off for a work that he was not keen on but which Capon admired, *Cordoba* 1984, by Mimmo Paladino.

Gormley made the first of his series of sculptures known as 'fields' for the Art Gallery of New South Wales in 1989, while he was artist-in-residence at the Gallery. This program was a joint initiative of Bond and William 'Bill' Wright, who was employed by Capon as his assistant director in 1982 and served in this role until 1991. Wright, who had trained as an artist and spent many years in London and New York, had been lured back to Australia to direct the 1982 Biennale of Sydney. His devotion to art and artists, as well as his personal warmth, made him a much-loved figure in the art world.

In 1985 Bond and Wright jointly curated *The British Show*, which Wright recalled was 'one of the great pleasures of my curatorial life ... we had a better exhibition than the one in Britain, more replete with key works'.[25] Many of the artists included went on to become artists-in-residence at the Gallery, with the support of the British Council. Although the program lasted for only three years, artists of the calibre of Antony Gormley (1989), Tony Cragg (1990), Alison Wilding (1990), Patrick Heron (1990), Ulrike Rosenbach (1990), Steven Campbell (1990), Richard Wentworth (1990) and Anish Kapoor (1991) all participated. Only one participant, the Scottish artist Steven Campbell, did not enjoy the experience. The Gallery was relieved when he returned home, as he, his wife and two children entirely trashed the studio. Before departing, an exhibition at the Rex Irwin's gallery was planned. Campbell stormed into the show before the opening and cut the paintings out of their frames on the floor, cutting into the carpet during the process and leaving even the unflappable Irwin rattled. Irwin recalled: 'I think all the works produced in Sydney were destroyed and the show went on with very few pictures which had been sent out from London by Marlborough.'[26]

In 1993 Indigenous artists Judy Watson and HJ Wedge were selected by Hetti Perkins for a one-month residency to mark the International Year of the World's Indigenous People. Aboriginal and Torres Strait Islander art began to be given greater prominence at the Gallery from the early 1990s. For Capon it was a learning process. The art of First Nations Australians was not included in the 'areas of interest' he identified as priorities when he first became director. At a board meeting on 2 March 1979 trustee Diana Heath asked him directly what he planned to do with the dedicated 'Primitive Art Gallery' that had been opened in 1973. This had not been altered for five years and barely added to for over a decade. Capon said the Gallery's primary function would be to collect 'western-oriented Fine Arts'.[27] However, he did see some value in displaying the objects that the Gallery already owned in an art context, rather than an ethnographic one. 'I was shocked,' Heath recalled, 'that there was little, or no interest in Aboriginal artists.'[28]

Capon had not been in the country to witness the growth of interest in Aboriginal art that had taken place during the 1970s. The Aboriginal Arts Board of the Australian Council had been established in 1973 'to promote Aboriginal art and culture both in Australia and overseas'. A number of exhibitions showcased the vibrant school of painting that became known as the Western Desert art movement. The Gallery, however, became disengaged at this time, in contrast to the situation during the 1950s and 1960s when Missingham and Tuckson, working closely with artists and patrons, vigorously expanded the collections. Aboriginal art sat awkwardly under the European curatorial department, where it was managed by curator Renée Free, largely out of loyalty to the legacy of Tuckson. In 1984 a subcommittee of trustees was formed 'to review the Gallery's policy on Aboriginal art'.[29] In this year John (later Djon) Mundine was also employed as 'part-time curator of Aboriginal art'.[30]

Mundine had demonstrated his knowledge and skills in 1983 when he curated a display of the Gallery's entire collection of over two hundred bark paintings. The exhibition was extended by two months due to its popularity.[31] Free recalled that Tuckson 'had collected information on each bark, but until Djon came there was no knowledge of how to organise them. Djon arranged the barks according to their major stories.'[32] Under Mundine's direction, 'the Aboriginal section of the Tribal Art Gallery was rehung and further acquisitions of, principally, contemporary Aboriginal art were made'.[33] The first Western Desert painting had been purchased for the collection in 1981 through the efforts of Bernice Murphy. This was *Warlugulong* 1976 by Clifford Possum Tjapaltjarri and Tim Leura Tjapaltjarri. Mundine brought into the collection works from Maninigrida and Ramingining as well as works by young urban artists.

In the early 1990s Aboriginal art was transferred from the European curatorial department to the Australian department. Hetti Perkins was appointed part-time assistant

curator in 1993 following an exhibition by Aboriginal women artists she curated in 1991 for the Gallery's contribution to *Dissonance: Feminism and the Arts 1970–1990*. In late 1993 Daphne Wallace was appointed the first full-time curator of Aboriginal art. These appointments were made in preparation for the opening of a new dedicated gallery for Indigenous art. Called Yiribana, meaning 'this way' in the Eora language, the gallery was on the lowest level of the 1988 Bicentenary extension to the building. It was designed by Andrew Andersons, by then a director of the firm Peddle Thorp and Walker. Capon described it as the largest single space devoted to the permanent exhibition of Aboriginal and Torres Strait Islander art and culture in the world.

In 1997 Perkins took over from Wallace, assisted by Ken Watson and then Cara Pinchbeck, and with sustained financial support for purchasing works from volunteer guide Mollie Gowing.[34] It was Perkins, as curator and later senior curator,

Night view of the exterior of the new Asian gallery, opened in 2003. Designed by Sydney architect Richard Johnson, the gallery evokes features of East Asian culture such as the lantern and the pavilion. More recently it has become known as the Asian Lantern.

who transformed the profile of Indigenous art within the Gallery. Her exhibition *Papunya Tula: Genesis and Genius*, curated as part of the 2000 Sydney Olympics arts festival, was for many the outstanding cultural event of the Games. She had a national profile and, as artist and curator Brenda Croft remarked, was able to use this effectively as a platform 'for artists who don't necessarily have that opportunity'.[35] Whether addressing the double standards that were brought to bear on Aboriginal artists and their personal affairs, the historical appropriation of Aboriginal imagery by non-Aboriginal artists or the impact of cultural theft upon Indigenous communities, her contributions to public dialogue on such issues were always incisive and persuasive.

It was a surprise to the arts community when Perkins resigned in 2011 after thirteen years in the role. On leaving the Gallery, she called for the creation of a national Indigenous art space, remarking that 'the mainstreaming of Aboriginal art and culture has largely failed us'.[36] A significant factor contributing to her resignation was the conviction that the Gallery too had failed Indigenous art. Exhibition proposals had been ignored. The plan to establish Aboriginal and Torres

The Exhibitionists

Strait Islander art as an independent curatorial department within the Gallery had not progressed. The promise of taking Indigenous art out of its 'basement' Yiribana Gallery, which had only partial climate control, and making it the feature of a new building, was being used to canvas support for such a development, but Perkins and her team were excluded from these deliberations. Meanwhile, the space of the Yiribana Gallery had remained unchanged for almost twenty years.[37]

Other areas of the collection had been prioritised. A new Upper Asian Gallery had opened in 2003 with the aim of bringing 'Asian art and culture to the fore of the building and into the consciousness of the people'.[38] It was the first major

extension after those in 1988. The Gallery had submitted plans for the new space in 1996, but it was not until 2000 that the state government pledged $13 million towards the project. Concern over the true cost of the Sydney Olympics was said to have delayed funding. Elsewhere in Australia, other state governments were committing significant resources to cultural infrastructure. The Gallery of Modern Art (GOMA) in Brisbane, scheduled for opening in 2004, was said to cost more than $100 million and the National Gallery of Victoria was undergoing a $146 million redevelopment.

The Upper Asian Gallery was built on top of an existing exhibition space, replacing a poorly visited outdoor sculpture garden. Designed by Sydney architect Richard Johnson, the building was an elegant square within a square, evoking features of East Asian culture and architecture with its references to a lantern and a pavilion on a platform. The pearly walls of the lantern gallery were made entirely of glass, a white layer sandwiched between two clear layers and held together on the exterior by decorative stainless-steel lotuses. The way natural

Left: Exterior view of Richard Johnson's new Asian gallery (above). It was built on top of the existing Lower Asian Gallery (below), which had been opened by Premier Nick Greiner on 25 March 1990 as the last part completed of the 1988 Bicentenary extensions, and is shown here in 2012 during the *Dragon* exhibition.
Below: View of the opening installation of the John Kaldor Family Galleries in 2011, showing *Stone line* 1977 by Richard Long on the floor, and *Southern gravity* 2011 by the same artist on the far wall – the latter work commissioned by John Kaldor for the opening of the galleries

light was brought into this space and directed, depending on differing conservation requirements of the art, was a remarkable feature of the design. Architecture critic Elizabeth Farrelly noted that 'for a century, architects have struggled for new and poetic ways of bringing daylight into galleries'.[39] Over a century before, when Vernon's largest nineteenth-century gallery (Court 9) was opened, the beauty of the natural light filtering in from the glass lanterns on the roof was often noted.

Anne Flanagan, general manager of exhibitions and building, spoke of the Gallery now having three distinct zones: European and historic Australian art within the Vernon building, twentieth-century Australian and international art in the 1972 and 1988 galleries designed by Andrew Andersons, and now Asian art over two floors within its own wing. Flanagan had joined the Gallery in 1992 and became deputy director in 2010. She project-managed not only the Upper Asian Gallery, but also an offsite collection store (2010) and the suite of Kaldor Family Galleries (2011). Capon relied heavily upon her energy and skills. 'Whatever anyone independently or collectively achieved at the Gallery,' he said, 'very little of it happened without Anne.'[40]

The 2003 Upper Asian Gallery was part of a wider building project that included expanded conservation laboratories, an upper-level space for collections and temporary exhibitions (the Rudy Komon Gallery) and a café, restaurant and function area with views extending from Woolloomooloo to the harbour. Capon noted that 'this reshuffle will address another concern of mine – how to re-energise the twentieth century Australian collection, which, because of the dynamics of the present building, has tended to be sidelined'.[41] However, the Australian collection, the Gallery's largest and most important, gained no additional space.[42] When Andrew Andersons' first extension to the Gallery had opened in 1972, Australian art was displayed over two floors. In time this was reduced to one, with the lower floor becoming the Gallery's main temporary exhibition space.

Brett Whiteley's studio in Surry Hills, which was entrusted to the curatorial management of the Australian art department in 1995, could be used only for exhibitions and collection displays that related in some way to Whiteley. Purchase of the studio and ten of Whiteley's works, including the multi-panelled *Alchemy* 1972–73, was the initiative of Minister for the Arts Peter Collins. Arkie Whiteley, Wendy Whiteley and Collins began negotiations in 1994, determining

Brett Whiteley (left) and Peter Collins – NSW Minister for the Arts when this photograph was taken – were in discussions concerning the long-term future of Whiteley's studio in Surry Hills before Whiteley's death in 1992. The studio opened under Gallery management in 1995.

The Exhibitionists

how the studio could be transferred to the New South Wales Government, the constitution of a board of governance with Whiteley family members on it, which works would be included in the arrangement and, above all, how much would be paid to the estate to make all this possible. Capon and curator Barry Pearce were initially cautious. They knew how costly such small museums were to run. Capon wrote that problems for the Gallery 'began to accrue with the opening of the Bicentennial Wing, which increased the Gallery size by some 80 per cent, but which was accompanied by only a 20 per cent rise in government funding for recurring costs'.[43] Although it was envisaged that an entrance fee would be charged to generate revenue, the Gallery could only consider managing the studio, Capon made it known, if additional recurrent funding was made available. The studio opened under Gallery management in 1995. The entrance fee was dropped in 2007 and in 2010 the title for the building was officially transferred to the Gallery.

Capon's senior curators of Asian art (Jackie Menzies), European art (Renée Free), international art (Tony Bond) and Australian art (Barry Pearce) worked with him for almost his entire career at the Gallery, matching his 33-year tenure with 36, 30, 28 and 33 years respectively.[44] Each established their own particular working relationship with him which, despite tensions at times, was necessarily a close one. Exhibitions were often the place where disagreements occurred. Over a

thousand were held during Capon's directorship, four-fifths of which were curated in-house by Gallery staff.[45]

Increasing exhibition activity was a strategic decision made by Capon and those close to him, including Anne Flanagan. Throughout the 1970s and 1980s the Gallery averaged twenty-five exhibitions a year. This increased to forty a year in the 1990s and 2000s. Exhibitions curated by the Gallery's educators, for instance, became more ambitious with the support of department heads Linda Slutzkin and then Brian Ladd. Slutzkin's popular *Bohemians in the Bush* was based on the artist camps at Sirius Cove and included a two-week re-creation of the Curlew camp, where Tom Roberts, Arthur Streeton and other artists had lived.[46] Ursula Prunster and Terence Maloon co-curated *Classic Cézanne*, the first solo exhibition of this artist in Australia.[47] Maloon's series of critically acclaimed summer shows included *Michelangelo to Matisse: Drawing the Figure* (1999–2000) and *Camille Pissarro* (2005–06), both with Peter Raissis, and *Picasso: The Last Decades* (2002–03) and *Paths to Abstraction* (2010).[48]

The publications that accompanied these exhibitions turned the Gallery into a de facto publishing house. The catalogues of the senior curator of Australian art,

Frames conservator Malgorzata Sawicki with assistant director Alan Froud, 1988. The Gallery, a national leader in art conservation since the nineteenth century, created two full-time positions for frame conservators in the lead-up to its 1988 Bicentenary extensions. Photographer unknown

Deborah Edwards, drew upon Gallery-wide scholarship and were a model of collegiality: along with art-historical essays by Edwards and other curators, conservators were invited to write about the materiality of works of art, photographers contributed photographic essays and librarians detailed chronologies. The publications for her Margaret Preston and Robert Klippel retrospectives each included a catalogue raisonné for the artist on CD-ROM, the first time this had been done in Australia.[49]

Under Capon the Gallery's bookshop moved twice. The first was to a space off the central court where a modest counter selling postcards and Gallery publications had been established in the 1950s. Trustee Carla Zampatti insisted that this central location would make the shop more profitable, but this did not prove to be the case. It moved back to its current location and doubled in size, as the small theatrette originally adjacent to it had been removed. Sales from the shop became an important stream of Gallery revenue. Exhibition merchandise was often more lucrative than catalogues. The Henry Moore 'sheep' T-shirt, for instance, made a $12,000 profit during his 1992 exhibition, double that of the catalogue sales. The growth of an in-house design department fostered a broadening of Gallery publications beyond catalogues and collection handbooks. Publications such as the Kevin Connor sketchbook led to direct collaboration between designers and artists, a new approach for the Gallery.[50]

Jackie Menzies' exhibitions *Buddha: Radiant Awakening* (2002) and *Goddess: Divine Energy* (2006), both of which involved unprecedented levels of community-based public programming, found wider audiences than was common for Asian art publications. And in just over twenty years as the Gallery's curator, then senior curator, of photography, Judy Annear averaged nearly two exhibitions a year, considerably increasing public awareness of that medium's diverse history and forms. She curated the first Australian monographic shows of Len Lye (2002) and Man Ray (2004), as well as the comprehensive *The Photograph and Australia* (2015). The publications that accompanied the small and vibrant, mostly contemporary, exhibitions that the Gallery held from 1989 onwards have become an important record of the evolution of contemporary art practice.[51]

Curatorial priorities for exhibitions did not always align with directorial ones. Retrospectives were one example. Among those organised by the Australian department were particularly successful surveys for Arthur Boyd, Margaret Preston and Sidney Nolan. Boyd had not been the subject of a major exhibition since Bryan Robertson's show at London's Whitechapel Gallery in 1962. Capon, however, had no interest in the artist and the exhibition would not have happened had not Pearce and the artist Tim Storrier, a trustee at the time, pushed for it. Although Capon saw the

Cy Twombly *Three studies from the Temeraire* 1998–99

potential of the Margaret Preston retrospective, his working relationship with the Gallery's senior curator of Australian art, Deborah Edwards, was always strained, despite her track record of scholarly and beautiful exhibitions. Capon thought Nolan 'the great Australian painter of the twentieth century'.[52] It was his initiative to hold a retrospective on the ninetieth anniversary of the artist's birthday in 2007. Pearce initially had 'grave misgivings about Nolan's gross over-production' but was eventually happy with the show and the accompanying catalogue.[53]

Pearce and Capon had clashed over Nolan at the very beginning of their careers at the Gallery. When it was suggested that the Gallery sponsor a tour of nine paintings by Nolan to China, linked to Capon's exhibition *Treasures of the Forbidden City*, Pearce questioned the quality of the work.[54] He thought the selection 'thin ... with a thematic aim to bolster the atrocious Chinese paintings ... a very expensive public relations exercise for Sid Nolan'.[55] Such outspoken

criticism by a bolshy antipodean curator was a surprise to Capon, schooled as he was in the V&A tradition, where 'the Pope', as director John Pope-Hennessy was known to staff, expected unconditional obedience to his infallible decrees. Although he was irritated at times by this push-back, on another level Capon respected it. Artist friends of both Capon and Pearce believed that they were a good match and that their differences eventually enriched the Gallery.

Capon's last major building project at the Gallery was the transformation of basement storage into a new floor of 3300 square metres of exhibition space, designed by its original architect Andrew Andersons from PTW Architects. The basement was repurposed when the state government provided funds to enable the Gallery to build a $27.6 million collection store offsite. The Belgiorno-Nettis family also contributed $4 million at this time, additionally providing galleries for contemporary art and photography and a refurbished works-on-paper study room. The suite of

galleries was opened in May 2011 by Premier Barry O'Farrell. The inaugural hang showcased John Kaldor's gift of more than two hundred international works of art, with an estimated value of $35 million.

Kaldor had been a trustee when Capon was appointed director in 1978. Prior to this, he had worked closely with Daniel Thomas, the Gallery's first curator. A number of the Kaldor Public Art Projects were held at the Gallery before Capon arrived, including *Gilbert and George: Living Sculpture* (1973), *Antoni Miralda: Coloured Bread* (1973), *Moorman and Paik* (1976), *Sol LeWitt Wall Drawing* (1977) and *Richard Long* (1978). Reaching back even further, Kaldor helped establish and judge the 1966 and 1967 *Alcorso-Sekers Travelling Scholarship for Sculpture*.

Journalists were often unaware of this history when they expressed surprise that Kaldor, a former MCA chairman, made his gift to the Art Gallery of New South Wales rather than to the Museum of Contemporary Art. Critic

John McDonald said that 'the entire centre of gravity at the AGNSW began to shift on 21 May last year when the John Kaldor Family Gallery was opened in the former storage area', suggesting an institutional move from a focus on the historical to the contemporary.[56] This centre of gravity had changed many times since the Gallery was established principally as a museum of contemporary art in the nineteenth century.

If the Kaldor gift marked any shift at the Gallery, it was a geographic focus away from Europe, and Britain in particular, towards America. The Gallery's holdings of American artists Sol LeWitt, Donald Judd, Robert Rauschenberg, Richard Prince, Jeff Koons and Bill Viola suddenly became the most significant in Australia as a result of the donation. It established a new collection focus upon which incoming director Michael Brand was determined to build. He chose a work by Ed Ruscha to mark his inauguration as director of the Gallery, as Capon had chosen a Tang dynasty equestrian figure. 'I thought, the gallery hasn't been as strong in American contemporary art as European,' he explained. 'Tony Bond and Edmund Capon [assistant director and director respectively] were very strong on Europe. I thought I might re-orient a bit towards the US, having just finished living and working in Los Angeles.'[57]

Capon felt no need to justify his – or the Gallery's – credentials for accepting the Kaldor gift. When MCA director Elizabeth Ann Macgregor put a question to Capon as part of a valedictory profile in the *Sydney Morning Herald* – 'What do you really think of contemporary art?' – he answered testily: 'That's actually a silly question. I don't care whether art is ancient or contemporary.'[58]

In the same article he was asked what work from the Gallery he would take with him if able. His choice was not the Tang dynasty equestrian figure presented in his honour in 1979, nor Paul Cézanne's *Bords de la Marne* c1888, which he had laboured so vigorously to acquire in 2008, but Cy Twombly's *Three studies from the Temeraire* 1998–99. Acquiring these paintings had been a struggle. Capon visited Twombly in his studio in Italy and persuaded him to send the panels to Sydney on approval. Not everyone was as enthusiastic about them as he was. His close friends Margaret Olley, Jeffrey Smart and Barry Humphries all questioned his judgement. Olley dubbed the triptych 'Edmund's wobblies' and Jeffrey Smart, scornful of Cy Twombly's skill as a draughtsman, dismissed them as the work of 'sly Cy'. As a result, Capon found that 'the funds were not readily forthcoming. After some months I had to return the triptych to London. The moment they left the building I knew I had made a mistake. Within another month they were on their way back again and I was determined not to let them go a second time.'[59]

Kenneth Clark, lecturing in Australia after the Second World War on 'The idea of a great gallery', said that museum directors were misguided if 'instead of buying pictures because they liked them, they bought them to complete some historical sequence or to illustrate some school or period'.[60] Works like Cézanne's *Bords de la Marne* could do both. But Capon made it clear that the Twomblys were not such a purchase: 'to rationalise such an acquisition in terms of "gap-filling", or "representation" or "contextual relevance" is unnecessary. This is simply a great and independent work of art by an artist of, I believe, immense significance.'[61] It is not difficult to see why Capon was so attracted to this work. Its calligraphic qualities, lyricism and playful but intelligent dialogue with the art of the past appealed to him, so too did the prospect of an image with such a distinctive maritime inspiration finding a home in the harbour city of Sydney, which he had come to love. But perhaps above all, like Capon himself, Twombly and his art remain 'something of a mystery ... redolent with contrasting qualities ... grand and intimate; direct and elusive; austere and sensual ... playful and serious'.[62] Both defy easy categorisation.

Epigraph

Edmund Capon, I blame Duchamp: my life's adventures in art, Lantern published by Penguin, Melbourne, 2009, p 263.

Notes

1 Capon 2009, p 255.
2 The Gallery was the first museum in Australia to introduce these regular late-night openings.
3 Matthew Westwood, 'Brand new art gallery on the way', Australian, 13 Feb 2012, p 17.
4 Annual report of the trustees of the Art Gallery of New South Wales for 1980, The Trustees, Sydney, 1981, p 6.
5 'Arrivals', Canberra Times, 12 May 1985, p 83.
6 Elizabeth Farrelly, 'Understatement shows the genius,' Sydney Morning Herald, 4 Mar 1989, p 89.
7 Angie Kelly and Anne Jamieson, 'Greiner opens "new dawn" of masterpieces', Australian, 12 Dec 1988, p 5.
8 See Malgorzata Sawicki, 'New challenges for frames conservation in Australia: a pragmatic vision of future hands-on training', AICCM Bulletin, vol 41, no 1, 2020, pp 61–68.
9 Along with their routine work on the wide range of frames in the Gallery's historic collections, important research began to be generated in the field of frame conservation and history and many students completed their professional internships in the laboratory.
10 See Rose Peel, 'Sun Yu obituary', Australian Institute for the Conservation of Cultural Material (AICCM) National Newsletter, no 114, Mar 2010, p 5.
11 Email from Barry Pearce to Steven Miller, 11 Apr 2021.
12 7 Jul 1987, The Roy Strong Diaries 1967–1987, Phoenix, London, 1998, p 417.
13 17 Jun 1987 and 11 May 1987 entries, pp 416, 414.
14 Quoted in Rosalind Reines, 'The masks of Edmund Capon', Bulletin, 20 Aug 1991, p 40.
15 Capon 2009, p 360.
16 Made possible by a bequest of $30,000 from Ona Salkauskas, mother of the late artist Henry Salkauskas. Murphy also curated the second Perspecta in 1983.
17 Bernice Murphy, Australian Perspecta 1981: a biennial survey of contemporary Australian art, Art Gallery of NSW, Sydney, 1981, p 11.
18 Ron Radford, upon taking up the position of curator of paintings at the Art Gallery of South Australia in August 1980, included Clifford

Possum Tjapaltjarri's Man's love story 1978 in his rehang of the contemporary Australian courts.
19 Email from Bernice Murphy to Steven Miller, 18 Mar 2019. The exhibition was Robert Mapplethorpe: The Perfect Moment, Museum of Contemporary Art, Sydney, 23 Feb – 30 Apr 1995.
20 Email from Victoria Lynn to Steven Miller, 23 Feb 2021.
21 Bruce James, 'Give me big, bad and ugly', Sydney Morning Herald, 11 Sep 1999, Spectrum p 12.
22 Email from Anthony Bond to Steven Miller, 22 Feb 2021. See Anthony Bond, The idea of art: building a contemporary international art collection, NewSouth Publishing/Art Gallery of NSW, Sydney, 2015.
23 The appointment was made on 27 April 1984.
24 The last will and testament of Mervyn Emrys Rosser Horton, 14 Jan 1983, pp 8, 10, National Art Archive, Art Gallery of NSW.
25 William Wright, 'On being a curator', Australian Art Collector, accessed online 7 Nov 2020.
26 Email from Rex Irwin to Steven Miller, 4 May 2021.
27 AGNSW Minutes, 2 Mar 1979, p 11a.
28 Email from Diana Heath to Steven Miller, 26 Feb 2021.
29 AGNSW Minutes, 16 Mar 1984, p 42.
30 AGNSW Minutes, 19 Apr 1985, p 22.
31 Aboriginal bark paintings, 12 Dec – 4 Dec 1983.
32 Email from Renée Free to Steven Miller, 3 Apr 2021.
33 1985 annual report of the trustees of the Art Gallery of New South Wales, The Trustees, Sydney, 1985, p 12.
34 Watson began at the Gallery as assistant curator in 1995. Under his initiative, the first work by Brook Andrew was purchased for a public collection.
35 Brenda Croft quoted in Joyce Morgan, 'Sister act', Sydney Morning Herald, 10 Oct 1998, p 7.
36 Quoted in Ashleigh Wilson, 'Perkins quits state gallery position', Australian, 20 Sep 2011, p 1.
37 Joyce Morgan, 'Perkins takes parting shot: stop sidelining indigenous art', Sydney Morning Herald, 26 Sep 2011, p 1.
38 Edmund Capon, 'Director's statement', Art Gallery of New South Wales annual report 2004, The Trustees, Sydney, 2004, p 12.
39 Elizabeth Farrelly, 'An impossible lightness achieved', Sydney Morning Herald, 28 Oct 2003, p 12.
40 Quoted in media release 'Deputy Director Anne Flanagan to retire from the Gallery', 7 May 2015.

41 Quoted in Peter Cochrane, '"Add-on" expansion plan for Art Gallery', Sydney Morning Herald, 28 Sep 1996, p 6.
42 The galleries on Lower Level 3, built as part of the 1988 extensions, were originally used by the Australian curatorial department for exhibitions and collection hangs, but this space became the dedicated Yiribana Gallery in 1994.
43 Letter from Edmund Capon to Evan Williams, 23 Mar 1994, National Art Archive, Art Gallery of NSW.
44 Jackie Menzies 1976–2012 (curator of Asian art 1979–2012); Renée Free 1966–96; Tony Bond 1984–2012; Barry Pearce 1978–2011.
45 There were around 1060 exhibitions: the Australian department organised 21%; contemporary art 20% (including contemporary Australian art among them); externally curated 20%; photography and film 10%; Asian art 8%; co-curated across diverse departments 6%; historical European art 6%; education department 5% and Aboriginal and Torres Strait Islander art 4%.
46 Bohemians in the Bush, 6 Jun – 25 Aug 1991. The exhibition was co-curated by Barry Pearce and Albie Thoms, who had researched a film on the subject many years earlier.
47 Classic Cézanne, 28 Nov 1998 – 28 Feb 1999.
48 Only Paths to Abstraction was not programmed as the Gallery's major summer show that year, being held instead between 26 June and 19 September 2010.
49 Deborah Edwards, Robert Klippel, Art Gallery of NSW, Sydney, 2002; Deborah Edwards with Rose Peel and Denise Mimmocchi, Margaret Preston, Art Gallery of NSW, Sydney, 2005.
50 Sketchbook drawings by Kevin Connor in Sydney, Paris and London, Art Gallery of New South Wales, Sydney, 2006. This was designed by Mark Boxshall.
51 Such as the Level 2 Contemporary Projects, the Balnaves Foundation Sculpture Projects and the Anne Landa Awards. For many of the artists, this was the first time they had exhibited in a major public art museum. Acquisitions that resulted from these exhibitions were often also their first works to be acquired by a public collection.
52 Shelley Gare, 'One last question, Mr Capon', Sydney Morning Herald, 24 Nov 2011, p 44.
53 Email from Barry Pearce to Steven Miller, 4 Mar 2021.
54 Robert 'Bob' Edwards from the

International Cultural Corporation of Australia also pushed for the Gallery to be the organising body, with some support from the Australia-China Council and the Department of Foreign Affairs.
55 Memo from Barry Pearce to Edmund Capon, 10 Apr 1981, National Art Archive, Art Gallery of NSW.
56 John McDonald, 'AGNSW: a new hang', Sydney Morning Herald, 23 Jun 2012.
57 Luke Slattery, 'Collection point', Wish, 30 Apr 2020, p 68. The work Brand chose was the painting Gospel 1972.
58 Gare 2011, p 44.
59 Capon 2009, p 163.
60 Sir Kenneth Clark, The idea of a great gallery, National Gallery of Victoria, Melbourne, 1981, p 9. This was a reprint of a lecture Clark gave at the National Gallery of Victoria on 27 January 1949.
61 Capon 2009, p 164.
62 Capon 2009, p 158.

18 The Benefactors' Book
A history of giving

When I have been overseas looking at great paintings. I often notice they have been given by so and so, then I think that if it hadn't been for those people, I would not have had the wonderful experience of seeing that work.

Margaret Olley

In August 1919 medical authorities in Australia officially declared that the 'Spanish flu' pandemic was over. Although cases were still occurring, by October admissions to hospital had greatly reduced, as had the death toll. A sense of the sombre mood of the times and the exhaustion felt after years of war and contagion is evident even in the procedural minutes of the meetings of the Gallery trustees. Memorialisation became a preoccupation of the board, as they commissioned portraits of military figures and organised exhibitions of war artists. In the midst of all this, at the October meeting, the director was 'instructed to prepare a list of donors with full particulars of their gifts to be inserted into a specially made artistic book to be called 'The Benefactors' Book'.[1]

If the war and pandemic were not the direct cause for this memorial to past donors, the recent death of one of their own members, JF Archibald, was certainly significant. Archibald had bequeathed to the Gallery a number of works of art, including a work that particularly spoke to the aspirations of the time, *Peace* by William Gilbert Foster, along with a portion of his estate to establish the now-famous Archibald Prize for portraiture. His was one of only a handful of bequests recorded in the book. Another was from Richard Wynne, who in 1895 had left £1000 for the establishment of the Wynne Prize.[2]

As commentators from other states eagerly pointed out, no unencumbered bequest had been made by a citizen of New South Wales to their Gallery since the young merchant Charles Smith left £1000 to the Academy in 1882. This contrasted with the Felton and James McAllan bequests in Melbourne, the Thomas Elder, Thomas Morgan and David Murray bequests in Adelaide and the Joseph Darnell bequest in Brisbane. It took a New Zealander, ARD Watson from Auckland, to make the first unconditional bequest of £4000 to the National Art Gallery of New South Wales in 1917, made in memory of the kindness he had been shown in Sydney.[3]

The Benefactors' Book, which was kept until the early 1930s, reveals how small was the community of art patrons in Sydney and how modest their fortunes in comparison to America, where gifts of money, antiquities and Old Masters to institutions like New York's Metropolitan Museum of Art became a torrent from the 1880s onwards.[4] The few 'Old Masters' given in Sydney, such as Rubens's *The tribute money*, donated by president Du Faur, invariably proved to be copies.[5] A group of neo-classical marble statues by John Gibson, Hiram Powers, Harriet Hosmer, Benjamin Spence and Scipione Tadolini, partly donated and partly purchased from Judge Josephson in 1892, were genuine, as was a small painting

Previous page: James Sant *Lesbia* c1884 (detail), purchased for 100 guineas from the very first bequest to the Gallery by Charles Smith in 1882 **Right, above:** William Gilbert Foster *Peace* c1880s, one of a number of works bequeathed to the Gallery by JF Archibald after his death in 1919, along with funds to establish the Archibald Prize

The Exhibitionists

of San Rocco by Tiepolo, which was lent to the Gallery in 1905 by JS Heron and then donated in 1912 after it remarkably survived a shipwreck and was washed ashore.[6] Heron wrote that the Gallery was 'the most suitable resting place for it and as a memento of the fact that the wreck of the *"Pericles"* ... was unattended, mercifully, by any loss of life'.[7]

Some works listed in the Benefactors' Book are no longer in the Gallery's collection, having been deaccessioned or 'misplaced'. Three of Melvin Vaniman's panoramic photographic views of Hobart and Launceston were donated in July 1904 by the manager of Tasmanian Railways. The firm of H Billington & Co presented a volume of twenty-four photographs of the northern districts of New South Wales at the same time. None of these were in the collection in the 1970s when curators Gael Newton and Daniel Thomas revived an interest in photography.[8] In 1902 Nicholas Chevalier's widow donated Sir Edwin Landseer's easel and George Morland's palette, both of which had been used by her husband. Only the palette survives in the Gallery's archive. A 'head of a girl', attributed to Jean-Baptiste Greuze, was donated by Rebecca Martens in 1904. It possibly sits today among a small group of unattributed works that have few provenance details, the 'orphans' that are found in all institutional collections.

Entries in the Benefactors' Book rarely supply any details about the history surrounding benefaction. But some stories can be traced in related correspondence. Behind Grace Joel's gift of three portraits in 1923 is a familiar story of the obstacles facing women artists. She was in London when Gallery director Vic Mann visited in 1914 and had intended to see him. However, 'most of the artists seem to have seen you at the Chelsea Arts Club,' she wrote, 'where women are not admitted'.[9] Mann had told Joel that he would like to purchase a work of hers for the Sydney Gallery, so she sent him a photograph of *Divine love*. This work had been exhibited in the 1915 exhibition of the Royal Academy and the same year in Paris at the Salon des Artistes Français as *L'amour maternelle* (it is now in the collection of Te Papa in Wellington, as *Mother and child* c1910).[10] She noted that the photograph did not do justice to the 'subtle colours' of the original but was also aware that the Gallery had purchased James Quinn's *Mother and sons* in 1914 on the basis of a black-and-white photograph. When Quinn won the Melbourne Travelling Scholarship in 1893, Joel was given first prize for the nude in an ancillary award. She did not compete for the time-consuming Travelling Scholarship as she needed to work to raise the money to study overseas. Both artists left Australia at the same time.

Joel offered *Divine love* for £180. This is the price the Gallery routinely paid for works by male artists, such as *The broken vase* by Muir Auld (purchased 1917). Her offer was declined. The Gallery never purchased a work by Joel. When she died of cancer six years later, she left three portraits: two she had painted, of Arthur Streeton and GP Nerli, and a self-portrait by Nerli. Joel's own paintings were accepted because they were portraits of prominent male artists.[11]

A surprising number of 'war relics' – medals, flags and insignia, and so on – appear in the Benefactors' Book. Such items were accepted on the condition that they 'could be transferred to a more suitable collection for this class of exhibit'.[12] The 'Johnston family relics' were presented to the New South Wales Government by Mrs Esther Johnston and transferred to the Gallery in 1888. Lieutenant Johnston accompanied Governor Phillip to New South Wales and was 'the first officer to land in the colony. He was also the first man to undertake the work of exploration'.[13] He is best known for being the one who deposed Governor Bligh, holding him under arrest until he could be exiled to the Vandemonian coast before being sent back to England. The relics included the sword Johnston wore when he made this coup d'état.

Another similar gift is simply listed: 'Family of the late Major James Henry Crummer, 28th Regiment, donated December 1907'.[14] Major Crummer's daughter Augusta had married Frederick Eccleston Du Faur and died shortly after the birth of their premature son in 1867. Although Du Faur eventually remarried, it was said that he never recovered from this loss. Mother and child were buried at Port Macquarie and the inscription that Du Faur wrote – 'She lies here beloved by me for nine years, alas as a wife for nine months, and a mother for nine hours' – reveals a tender side to the aloof man of public affairs that Du Faur became.

The Crummer relics included various mementos of the Battle of Waterloo and, most interestingly, a Victoria Cross. This had been awarded to Private Timothy O'Hea in 1866 for single-handedly putting out a fire on a train loaded with gunpowder which was travelling between Quebec and Montreal.[15] The train was carrying eight hundred German immigrants. Had the gunpowder caught fire, everybody would have been killed. The VC is normally awarded for bravery in wartime, so the inscription on O'Hea's was modified to 'conspicuous courage under circumstances of great danger'.

O'Hea had moved to Sydney in June 1874, where he became involved in an expedition to find the alleged survivor from Ludwig Leichhardt's fatal expedition across the Simpson Desert in 1848. The survivor was reported to be living with Indigenous Australians in northern Queensland. A shady character named Andrew Hume, who had recently been released from prison, claimed to have spoken to this 'wild white man'. Du Faur financed the expedition, which

Above left: Court 2 of John Horbury Hunt's original 'art barn', shown here around 1919, housed the family 'relics' that had been left to the Gallery over the years, including those of the Johnston and Crummer families. Photographer unknown
Above right: Timothy O'Hea wearing the Victoria Cross that had been awarded to him in 1866. Photographer unknown

The Exhibitionists

Right: Luncheon given in honour of benefactor Howard Hinton, 8 December 1938. Photographer unknown **Below right:** Douglas Fry *My best friend* 1910 was the first work donated to the Gallery by Howard Hinton, in 1915. Hinton was a trustee and one of the Gallery's most generous donors.

was as ill-fated as Leichhardt's original one and on which both O'Hea and Hume perished.[16] Before he left on the expedition, O'Hea placed his VC in the safe keeping of Du Faur at the Gallery, where it remained largely forgotten until the Canadian government formally asked for it, as it was the only VC ever awarded on Canadian soil. A second claim was received from O'Hea's regiment. In 1950 it was sent to Winchester in England, where it now forms part of a display in the Royal Green Jackets Museum. A further twist to this story came when it was recently suggested that Timothy O'Hea had in fact died in Ireland, shortly after his discharge from the British Army in 1868. His identity and VC annuity were then assumed by his brother John, and it was this man who actually died in Australia.[17]

Howard Hinton, a trustee of the Gallery for twenty-nine years, recorded the greatest number of entries in the Benefactors' Book. His gifts were hung together in the Australian courts with a plaque: 'Presented by Howard Hinton Esq, one of the Gallery's most munificent benefactors'.[18] By the time of his death in 1948 he had presented 120 works of art, including many by his favourite artists Elioth Gruner, JJ Hilder, George W Lambert, and the Lindsay brothers, Lionel and Norman. His first gift in 1915 was Douglas Fry's *My best friend* 1910. The bulk of Hinton's collection of over a thousand works, however, was donated to Armidale Teachers' College in northern New South Wales. Hinton started to direct gifts away from the Gallery when a few were rejected in the late 1920s. Some suggested that the Art Gallery of New South Wales

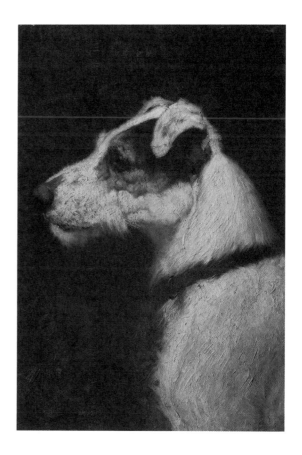

was trying to claw back key works when in 2006 it offered to buy a half share in *Mosman's Bay* 1894 by Tom Roberts.[19] The New England Regional Art Museum (NERAM) was in crisis, needing to repay a debt owed to the Armidale Dumaresq Council. Funds raised by the proposed deal would have resolved the situation and enabled NERAM to establish a small foundation. The Supreme Court, however, blocked the deal, as the original deed of gift did not permit the work's sale.

No entries were recorded in the Benefactors' Book after the start of the Second World War in 1939. Thirty years later a similar book was established to record the 'Art Gallery of New South Wales Foundation Appeal List of Donors'. The Foundation Appeal raised funds for both the 1972 extensions as well as works purchased for the opening of the new building. A number of those listed in this book became long-term Gallery supporters, none more so than Susan and Isaac Wakil. In June 2017 the Wakils contributed $20 million to the Sydney Modern Project, the largest monetary gift in the Gallery's history. When the gift was announced, John Richardson, who had joined the Gallery in 2014 as director of development, noted that Susan and Isaac had quietly supported the Gallery for over half a century. Their names were not only recorded in the 1969 List of Donors but also in 'The Friends of the Foundation' memorial volume, as they had become high-level supporters of the Foundation from 1988.

Artists have always been among the most generous supporters of the Gallery. Sali Herman's name is recorded in the 1969 List of Donors, as he won first prize in the $100,000 art lottery that was held in aid of the building extensions. He immediately declared that he would consign all the works to auction, along with a few additional paintings of his own, and donate half of the proceeds to the Gallery for art purchases. A significant portion of the Gallery's art collection has been donated by artists, and many have left bequests of property and money to support acquisitions and programs. Tom and Hilda Marshall, for instance, left six cottages to the Gallery in 1929. She was a painter and photographer. Florence Turner Blake's bequest of £54,000 in 1959 was the largest received at that time. In the same year Anthea Dyason left funds to support artists on travelling scholarships. In 2005 the Gleeson O'Keefe Foundation was set up in memory of artist James Gleeson and his life partner Frank O'Keefe. The entire estate of around $16 million was dedicated to Australian art acquisitions.

So too was the bequest of $6.5 million from budding artists Stephen and Essie Watson. The Watsons visited the Gallery almost every weekend and were members of the Art Gallery Society and well known to staff. Nonetheless, the generous provisions of their will came as a surprise. Sydney stockbroker John Fairlie Cuningham informed the Foundation that he would be leaving a bequest but wanted no particular recognition of this while he was still alive. He was motivated to do this when he learnt that the state government had ceased funding acquisitions in 1992. All Gallery purchases after that time were made from funds raised or donated. He bequeathed over $16 million to the Foundation in 2015, the largest ever received, placing no strings on how the money was to be used and not asking that the bequest carry his name. Wendy Whiteley has been another exceptional patron of the Gallery, donating funds and works to the Whiteley Foundation; the Foundation benefits both the Whiteley Studio and the Gallery, as well as external Whiteley projects.

Gifts were often made in memory of artists by their family and friends, usually with the purpose of encouraging younger talent. Robert Le Gay Brereton was an art student at East Sydney Technical College before being killed in a flight over Germany during the Second World War. In 1954 his father established a prize in his name to promote the study of drawing. Recipients included Ron Lambert (1955), Elisabeth Cummings (1956), Brian Dunlop (1958), Margaret Woodward (1959), Jude Rae (1983) and Wendy Sharpe (1992). Friends of Moya Dyring raised funds in 1968 for the Gallery to purchase a studio in the Cité internationale des arts in Paris for the use of Australian artists. Later another studio was purchased in memory of art educator and trustee Denise Hickey. The Eva Breuer and Barbara Tribe Travelling Art Scholarships assist winners of these residencies with flights and other expenses. Prior to this, Beryl Whiteley allocated funds for a travelling art scholarship in the name of her son Brett Whiteley. Lloyd Rees's son Alan and daughter-in-law Jancis donated their father's archive along with funding to preserve and digitise it, as did the artist Michelle Collocott. Alan and Jancis also donated a large collection of Rees drawings over many years.

Eva Breuer was an energetic and popular Sydney dealer. Her gallery made a point of showcasing the work of women artists and so the Travelling Scholarship established in her name was founded to assist women artists. Other art dealers have been generous Gallery patrons. Rudy Komon and Lucy Swanton were two of the best known. Swanton bequeathed works originally shown at her Macquarie Galleries, including key paintings by Ian Fairweather. When Komon died in 1982, his wife Ruth established a memorial fund in his name to purchase works by 'up-and-coming local artists'. She later bequeathed many works to the Gallery, along with property. Ray Hughes opened his first Sydney Gallery in 1985 in a space once owned by Komon. When Hughes died, his son Evan donated a large part of his collection of drawings along with the Ray Hughes archive. Much-loved gallerist Frank Watters, on closing Sydney's iconic Watters Gallery, donated over thirty works of art from his personal collection. Watters, with his co-directors Geoffrey and Alexandra Legge, also donated their gallery archive.

The National Art Archive at the Gallery has the largest collection of gallery-related archives in Australia, all of which were donated, including those of the Macquarie Galleries, by Eileen Chanin and Adrian Morris; Rex Irwin and Roslyn Oxley galleries by their eponymous owners; Woolloomooloo Art Gallery by Elinor and Fred Wrobel; Stills Gallery by Kathy and Laurence Freedman; the Sherman Contemporary Art Foundation by Gene and Brian Sherman; and many individual collections by Pat Corrigan.[20] These donors also enriched the curatorial holdings with works from their personal collections.

One of the best known of the Gallery's artist patrons was Margaret Olley. She had the honour of being included in a chapter on 'The true eccentric' in Edmund Capon's autobiography:

> She is a real eccentric, if an eccentric is, as I believe, a person of absolutely independent views and arcane tastes, and with a complete and utter indifference towards prevailing attitudes and fashions. She is also a complete tyrant. Many are the politicians who, spotting her entering the room, will hasten furtively out of a back door to avoid a blast from the indefatigable Oll.[21]

Olley made her first gift of four *kamana* (eating bowls) from Papua New Guinea to the Gallery in 1984. She attributed her inspiration for becoming a patron to Howard Hinton, whom she met in 1944 and described as 'the very first person I knew who bought art and gave it away'.[22] In 2008 she happily contributed $1 million towards the $16.2 million needed to purchase Paul Cézanne's *Bords de la Marne* c1888.[23] Flustered while she was signing the cheque by the photographers, she accidentally added another zero to the amount. 'Olls,' Capon asked, 'do you really have that much in the bank?' Her gifts and purchases for the Gallery included paintings and works on paper by favourite Europeans Giorgio Morandi, Bonnard, Vuillard, Picasso, Lucian Freud and Degas, as well as Australian works by her contemporaries David Strachan, Jean Bellette, Donald Friend, Anne Wienholt and Justin O'Brien.

From the 1990s the Gallery began celebrating its supporters on a donors' board located near the building's entrance, rather than in memorial volumes. An exhibition *Great Gifts, Great Patrons* was held in 1994, surveying half a century of private patronage.[24] Previous exhibitions had celebrated individual donors, such as the Marshall Bequest Fund in 1954, the Gladys Allen (Mrs Arthur Acland Allen) donation of JWM Turner's 1806–24 series *Liber studiorum* in 1949, George Sandwith's gift of Indian miniatures of the Madrasi School in 1959, James Hayes' Chinese calligraphic collection in 2005 and the Christopher Worrall Wilson Bequest in 2019, to name but a few.[25]

The Gallery's photographic collections, more than those of other curatorial areas, have benefited from corporate sponsorship. Between 1978 and 1985, CSR

Limited commissioned twenty-four of Australia's leading photographers to make work related to the company's activities in Melbourne, Sydney, Kangaroo Island and Tumut. This resulted in a collection of 340 images, all of which were donated to the Gallery in 1988 as the CSR Photography Project Bicentennial Collection. Hallmark Cards of Australia established a collection fund for photography between 1987 and 1992, which enabled the acquisition of nearly one hundred images. In 1985 Polaroid imported into Australia one of the five large-format Polaroid cameras then in existence, commissioning works from eight Australian photographers in a 50 by 60 centimetre format. Many of these commissioned works were then presented to the Gallery in 1988. In 1996 Edron Pty Ltd, through the auspices of Alistair McAlpine, donated a large body of Australian and international photographs.

A dedicated photography gallery was opened in 2011 at the same time as the Photography Endowment Fund (PEF) was launched as a capital fund within the Foundation. This had been a desire of the Gallery's photography curators Gael Newton, Sandra Byron and Judy Annear. Their exhibitions, publications and acquisitions established photography within the mainstream of the Gallery's collecting and exhibiting. A wall plaque placed in the gallery recognised the outstanding support of the Women's Art Group, John Gillespie, Rowena Danziger and Ken Coles.

Two membership groups established by and for women – Fearless, and the Women's Art Group (WAGS), an initiative of former trustee Anne Fulwood – have provided support for projects rather than art acquisitions, in the areas of conservation, public engagement, curatorial services and library and archive. In 2015 a conservator of time-based art was appointed to the Gallery, funded by the Conservation Benefactors and WAGS. The first such specialist position in an Australian public gallery, this conservator established protocols for how video and audio, installations and technology-based works should be cared for and made accessible. The Edmund Capon Fellowship, facilitating the exchange of professional staff between the Gallery and cultural organisations in Asia, was an initiative of Neil Balnaves and launched with funding from his Foundation. Neville Grace's bequest of $14 million in 2018 enabled the establishment of an exhibition fund, equivalent to the Foundation's acquisition fund, realising a long-term ambition of the Gallery's curators. The support of such uniquely targeted philanthropy enabled significant institutional change at the Gallery.

The Gallery's archive reveals the particular role of trustees in supporting behind-the-scenes programs, from Charles Lloyd Jones and his Saturday morning sessions for school students in 1942 to Gretel Packer funding modern education

Above: Mollie Gowing at the opening of the exhibition *Gifted: Contemporary Aboriginal Art* in 2006 **Right, above:** From left: Edmund Capon, James Fairfax and Peter Collins in the galleries named after Fairfax in 1994, celebrating his exceptional gifts of Old Masters to the Art Gallery of New South Wales. Photographer unknown **Right:** John Kaldor in front of Ugo Rondinone's *SIEBTERJULIZWEITAUSENDUNDNULL (SEVENTHOFJULYTWOTHOUSANDANDZERO)* 2000 at the opening of the John Kaldor Family Galleries in May 2011

The Exhibitionists

The Benefactors' Book

programs or Geoff Ainsworth the position of an archivist of Aboriginal and Torres Strait Islander collections or Ashley Dawson-Damer a children's art library. It has become a cliché in Australia to assert that the trustees of Australian cultural institutions are not as generous as their American counterparts. In Sydney, the trustees who left a significant portion of their estate to the Gallery, such as Thomas Marshall, Howard Hinton and Mervyn Horton, possessed only a fraction of the wealth of their American counterparts. Notwithstanding this, the Gallery's trustees have been among its most generous benefactors. In recent times this has included major support from Max Sandow, Michael Gleeson-White, Andrew and Cathy Cameron, David Gonski, Mark Nelson and Ashley Dawson-Damer.

Government initiatives promoting philanthropy have had an enormous impact. Former lord mayor of Sydney, Nelson Meers, with his daughter Sam Meers, established Australia's first charitable Prescribed Private Fund (PPF) in 2001, under one such initiative. From this, they committed to purchasing five major works by Sidney Nolan for the Gallery. A federal Tax Incentives for the Arts Scheme was established in 1978 under prime minister Malcolm Fraser and continues as the Cultural Gifts Program. Nearly seven thousand works have been donated to the Gallery under the scheme, with a cumulative value of over $192 million. Another $18 million in gifts were made to the Gallery's National Art Archive.[26]

Many donors are passionate supporters of particular divisions of the Gallery or specialist areas of the collection. James Agapitos and Ray Wilson worked tirelessly in enlisting Foundation members to support the Gallery's conservation department and the library and archive. Other Foundation focus areas include the Aboriginal Collection Benefactors (ACB), of which the late Mollie Gowing was an exceptional patron; the Contemporary Collection Benefactors (CCB), which was the first group to be established and remains one of the most vibrant and successful in fundraising; the Photography Collection Benefactors; the Atelier, for younger benefactors; and the recently established FoNZA, the Friends of New Zealand Art. VisAsia, the Australian Institute of Asian Culture and Visual Arts, was established in 1999 with its own board of directors and prioritises the funding of exhibitions and education.

Most prominent among ways of recognising major patrons are physical spaces named in their honour. In 1894 it was reported that 'one of the courts in the National Art Gallery will be called the Montefiore Court in memory of the deceased gentleman'. Unfortunately, this did not occur.[27] It would have been the first instance of this happening at the Gallery. The director and trustees did not approve of the 1972 wing being named after Captain Cook (it was subsequently referred to as the 1972 extension) and wanted artists' names

given to particular galleries. However, it was not until the directorship of Edmund Capon that naming galleries after patrons occurred. Dedicated areas within the building now include the Franco & Amina Belgiorno-Nettis & Family Contemporary Galleries; the Dorothy Street Galleries of Twentieth Century Australian Art, established by Fred Street in memory of Dorothy; the John Schaeffer Gallery, celebrating this former trustee and benefactor; and the recently dedicated entrance court, the John Kaldor Family Galleries.

The James Fairfax Galleries house many of the Old Master paintings that Fairfax donated from 1992 onwards, by artists such as Tiepolo, Boucher, Rubens, Jacopo Amigoni, Claude Lorrain and Canaletto. Unfortunately, *A cavalier* by Frans van Mieris, donated by Fairfax in 1993, was stolen in 2007 and never recovered. Director Edmund Capon recalled, 'you feel that you've let everybody down. That was probably one of my lowest points.'[28]

For those working at the Gallery, it is sometimes the smaller, less-celebrated acts of philanthropy that make the deepest impression, whether it be the family that parts with a much-loved work of art, the person who sends in a donation year after year, or the artist who gives generously of themselves in support of a Gallery program. Such acts have been the lifeblood of the Gallery over 150 years and reveal the place it has come to hold in people's affections. As Gallery archivist I will always remember collecting one gift from the widow of artist Weaver Hawkins. Rene Hawkins had donated works of art to the collection and allowed me to take anything of interest from her husband's studio for the Gallery's archive. But there was something she held back, unable to part with it. When she eventually had to leave the family home she phoned and sheepishly told me that she had something of great importance that she knew must now come to the Gallery. I was expecting something very grand but was handed three small watercolours on card.

Weaver Hawkins had painted them in France during the First World War, with the watercolours and collapsible brush his mother had smuggled to him at the Front inside a box of cigarettes. They show the beauty of the French landscape in the summer of 1916 and give no indication of the surrounding carnage. Hawkins was badly injured in the Battle of the Somme two months later. When he painted these works, he knew what was ahead. Rene believed that he had painted them as if seeing the world for the first time, in the face of losing everything. To her they were objects of immense power, and also love, and it was both humbling and moving to receive them on behalf of the Gallery.

Right: From left: Weaver Hawkins *Halloy* May 1916, *Near Ailly* March 1916 and *Halloy* May 1916. Hawkins painted these three small watercolours shortly before he was severely injured in the Battle of the Somme.

The Exhibitionists

Epigraph
Quoted in *Margaret's gift*, SH Ervin Gallery, Sydney, 2020, p 65.

Notes

1 AGNSW Minutes, 24 Oct 1919, p 260.

2 A 'prize for a Landscape Painting of Australian Scenery in Oils or Water Colours or the best production of Figure Sculpture' by an Australian artist.

3 See William Moore, 'Art and artists', *Brisbane Courier*, 14 Mar 1931, p 18. The 1904 Felton Bequest at this time was averaging an income of around £27,000 a year. James McAllan had bequeathed £35,000 to the National Gallery of Victoria, preferably to assist with the building of additions to the Gallery. In Adelaide, Thomas Elder had bequeathed £25,000, Thomas Morgan £16,000 and David Murray £3000 for the establishment of a print room, along with a large collection of prints. Joseph Darnell bequeathed £10,000 to the Queensland Art Gallery. In 1929 Thomas Marshall, who had been a trustee of the Gallery, bequeathed six cottages situated in Redfern to the Gallery. An annual income from their rent, estimated at around £200, was dedicated to art purchases.

4 See Calvin Tomkins, *Merchants and masterpieces: the story of the Metropolitan Museum of Art*, EP Dutton & Co, New York, 1970.

5 The original is in the Fine Arts Museums of San Francisco.

6 AGNSW Minutes, 5 Apr 1892, p 29, clearly states what was donated and what was purchased.

7 Letter from JS Heron to Vic Mann, 8 Jan 1912, CF13/1912.

8 The Billington volume of photographs may be the 'Souvenir volume' (919.444/4) that is now in the State Library of NSW.

9 Letter from Grace Joel to Gother Mann, 29 Aug 1918, BF60/1919.

10 In 1920 the Royal Scottish Academy asked for the work to be shown in their annual exhibition, and Joel sent Mann a press clipping showing its 'place of honour in the long room'.

11 She also bequeathed £500 to the National Gallery School in Melbourne for a prize every second year for a painting from the nude.

12 AGNSW Minutes, 26 Nov 1915, p 499. Some gifts were rejected. In 1896 the NSW Cricket Association asked the Gallery to be the custodian of the silver Sheffield Shield.

13 'The Johnston family', *Illustrated Sydney News*, 19 Dec 1891, p 21.

14 Donated were a peninsula war medal, 1793–1814, with clasps; a Waterloo medal, 1815, with brass clasp; two gold Masonic emblems; a Waterloo trophy (flag); the fragment of a regimental flag; three family seals and the Victoria Cross of Timothy O'Hea. Everything, except the Victoria Cross, was returned to the Crummer family on 23 November 1926.

15 Timothy O'Hea was born in Bantry, County Cork, in 1846. He was a private in the Prince Consort's Own Rifle Brigade and went to Canada during the Fenian uprising.

16 Du Faur was made a Fellow of the Royal Geographical Society for his part in financing the expedition.

17 See Elizabeth Reid, *The singular journey of O'Hea's Cross*, Leamcon Press, Yale BC, 2005.

18 Letter from Gother Mann to Howard Hinton, 19 Nov 1926, CF1402/1926.

19 Barry Pearce, 'The man in a room', in *Munificence: the story of the Hinton Collection*, New England Regional Art Museum, Armidale, 2014, p 17.

20 Others include Coventry Gallery, donated by the family of Chandler Coventry; Mori Gallery by Stephen Mori; Notanda Gallery by the family of Carl Plate; Gallery A by Ann Lewis and Clune Galleries; and Thirty Victoria Street by Frank McDonald and Philippa McDonald.

21 Edmund Capon, *I blame Duchamp: my life's adventures in art*, Lantern published by Penguin, Melbourne, 2009, p 361.

22 Meg Stewart, *Margaret Olley: far from a still life*, Vintage, Sydney, 2012, p 109.

23 It was purchased with funds provided by the Art Gallery of NSW Foundation, the Art Gallery Society of NSW, and donors to the Masterpiece Fund in joint celebration of the Foundation's twenty-fifth anniversary and Edmund Capon's thirtieth anniversary as director of the Gallery.

24 *Great Gifts, Great Patrons*, AGNSW, 17 Aug – 19 Oct 1994.

25 *The Marshall Bequest*, 23 Jun – 11 Jul 1954; *Turner's Liber Studiorum*, Oct 1949; *Indian Miniatures of the Madrasi School*, 11 Feb – 9 Jun 1959; *The Poetic Mandarin: James Hayes Calligraphy Collection*, 23 Sep – 27 Nov 2005; *Ancestral Art of the Indonesian Archipelago*, 18 Nov 2017 – 6 Jan 2019.

26 Both estimates represent valuations current in 2021, not values at the time of donation. The value of the Gallery's collections is revised every three years by an independent valuer according to government protocols.

27 'Funeral of the late Mr. E L Montefiore', *Daily Telegraph*, 24 Oct 1894, p 5.

28 Shelley Gare, 'One last question, Mr Capon', *Sydney Morning Herald*, 24 Nov 2011, p 44.

19 Building the future
Michael Brand's directorship, 2012–

When the public get to understand what the trustees have laid out there is little doubt universal approval will exist, of course with a small sprinkling of dissatisfied ones.

John Horbury Hunt, Art Gallery of NSW architect, 1887

The 1967 annual report of the Art Gallery of New South Wales was the most despondent official document that the Gallery had ever produced. It opened with a strongly worded statement by the trustees that they were 'disappointed and alarmed at the apparent failure of the Government to realise the real difficulties under which they and the staff of the Art Gallery are labouring'.[1] Inadequate staffing meant that core Gallery work was being left undone and because of 'the very onerous exhibitions programme, the professional and attendant staffs were unable to properly manage Gallery affairs'.[2] Most importantly, the buildings were no longer fit for purpose. Although the recent exhibition *Two Decades of American Painting* had set a record in attendances, with a quarter of a million visitors in three months, the Gallery could no longer be sure of attracting similar international shows.[3] The lack of climate-controlled exhibition spaces, transit and conservation areas, along with inadequate storage facilities, had caused the Gallery to fall far below international museological standards. The trustees noted that in August of 1968 Victoria would open 'a magnificent new art gallery', while 'New South Wales, although having the largest population and by far the largest attendances, has to make do with a building erected in the late 1800s and early 1900s'.[4]

Hal Missingham, director for twenty-two years, was worn down by the continual petty battles waged with his own board of trustees concerning exhibitions and programming, with the Public Service Board and the Department of Education. He would shortly retire, entitling his memoirs *They kill you in the end*. The institution was poised for major change, but at the time it was not certain how or when this would occur. The trustees ended their statement by saying that without a 'proper building and sufficient staff provided to maintain it, the Sydney Gallery would be inferior to most of the art galleries in other Australian cities'.[5]

A major transformation did occur, spearheaded by a new building. Perhaps the reference to the National Gallery of Victoria, whose new building was then under construction in Melbourne, fired up interstate rivalry, as funding for a 'proper building' in Sydney came through in the following year. When this new building opened in 1972, it represented much more than additional wall space for the Gallery's permanent collection and visiting exhibitions. The headlines of newspaper reviews – 'A new lease of life', 'A place for works of art to sing', and so on – showed how the extensions had become a platform for rethinking the entire role and direction of the Gallery.[6] By the 1970s it was recognised that

Previous page: The Sydney Modern Project construction site in June 2021. This project involves the most significant transformation of the Gallery in its 150-year history. **Right:** Michael Brand, appointed director of the Gallery in 2012, speaks at his first Archibald Prize dinner, shortly after arriving at the Gallery. A detail of Tim McMonagle's portrait of Michael Buxton is visible in the background.

people visited galleries to socialise and shop as well as to look at art, so the new building had a prominent restaurant and bookshop, and areas where the public could sit and relax, even a designated 'smoko' area overlooking the harbour.[7] Art education was made a priority, with a theatre for lectures and films and a public library. Flexible exhibition spaces could be reconfigured for smaller project-style exhibitions and performances. The following years saw the Art Gallery transformed from an institution that felt 'inferior to most of the art galleries in other Australian cities' to one that felt it was a leader.

Exactly forty years after the despondent 1967 annual report, Edmund Capon penned a director's foreword to the 2006–07 annual report in which he complained that

> this year we really have been confronted with managing a building that is bursting at the seams. The combination of ever-increasing levels of activity in terms of changing displays, growing collections, exhibitions, public programs, late openings, evening and weekend events ... with a limited budget and increasing audiences, is placing huge strain on our resources.[8]

Capon, who had then been director for twenty-nine years, was also feeling the burden of running a modern public art museum with its 'whole parade of bells and whistles'. Despite his considerable achievements at the Gallery, Sydney was increasingly being compared unfavourably with the National Gallery of Australia, which had opened in Canberra in 1982; the National Gallery of Victoria, which had undergone a second expansion in 2001; and Brisbane's Gallery of Modern Art, which had been added to the Queensland Art Gallery in 2006. It was noted that the Art Gallery of New South Wales was now just half the size of these three sister institutions.[9]

It is natural for institutions to go through cycles of growth and decline. Edmund Capon retired in December 2011, after thirty-three years at the Gallery, as the longest-serving director in the institution's history. He told an interviewer not long before he left that 'the trouble with this job is that you can't do it half-cocked. It's either 100 per cent or no per cent.'[10] His 150 per cent unstinting dedication to the Gallery was widely recognised and admired. But as in 1967, in 2007 the Gallery was again poised for change. Gallerist Rex Irwin gave some indication of how difficult this change would be when he suggested that someone 'very old, all but retiring' should be appointed in succession to Capon. 'This might give the

person who takes over from Edmund more of a chance than if he comes in and everybody says "Oh, he's not as pretty as Edmund, as amusing as Edmund or as clever as Edmund.'"[11] Not only would an incoming director have to contend with comparisons to Capon, but there was also the Gallery's institutional history, which suggested that a new director following a long-serving one would only last six-and-a-half years in the job. This had been the case with JS MacDonald (6½ years) who followed Vic Mann (24 years), and with Peter Laverty (6½ years) who followed Hal Missingham (26 years).

Michael Brand was appointed director in 2012 and safely crossed this historical boundary in December 2018. From his final formal interview with the trustees, Brand knew that the delivery of a new building for Sydney would be a major focus for him in his new position, and one that would be taken as an indicator of the success, or otherwise, of his directorship. It was also part of the attraction and challenge for him of returning to Australia and being able to make a significant contribution to his new city. Although born in Canberra, the United States has been a second home to him. He completed his last four years of high school there, when his father represented Australia at the International Monetary Fund in Washington DC.

He returned to Australia to undertake his undergraduate degree in South Asian studies at the Australian National University in Canberra, and then headed off again to study for his masters and doctorate at Harvard University in the field of Indian and Islamic art history. After a stint in Pakistan as co-director of the Smithsonian Institution Mughal Garden Project (this landscape experience would later become relevant to the Gallery's upcoming expansion[12]) he was appointed by James Mollison as the first permanent curator of Asian Art at the National Gallery of Australia back in Canberra (1988–96).

After Canberra, Brand went to the Queensland Art Gallery as assistant director (1996–2000), before taking his first job as director, at the Virginia Museum of Fine Arts in Richmond, just 150 kilometres south of his former home in Washington DC. While there he successfully led the design and fundraising stages of a US$125 million redevelopment and the capital campaign to fund it. His next appointment, as director of the J Paul Getty Museum in Los Angeles (2005–10), attracted considerable attention in Australia, with commentators noting that he faced 'an uphill battle to restore faith in one of the world's richest but most troubled art institutions'.[13]

The previous director was said to have resigned over disagreements with the president of the overarching Getty Trust, Barry Munitz, and the Getty was the target of a series of investigative reports in the *Los Angeles Times*. Also, the museum's senior curator of antiquities, Marion True, had been formally accused by the Italian and Greek governments of purchasing antiquities that had been looted or illegally exported. It was a difficult time to take over the directorship, but Brand skilfully negotiated resolutions with Italy and Greece, thereby restoring the reputation of the wealthy but troubled museum, and attracting a series of long-term loans from Italy at the reopened Getty Villa. Eventually, Brand, like the previous director, found it impossible to work within the difficult Getty structure, and he left in 2010. He then took a position as inaugural director of the Aga Khan Museum, which was under construction in Toronto.

At the same time as the Art Gallery of New South Wales was looking for a new director (during which time Anne Flanagan acted as interim director), so was the National Gallery of Victoria, 'potentially fishing from the same pool', as one journalist commented.[14] Unlike the prevailing attitude when Edmund Capon had been appointed, it was assumed that this appointee would be Australian, with the press speculating on a wide range of candidates working within the country and overseas. Michael Brand was always considered a strong contender, given his experience driving two major art museum expansions and his curatorial expertise in Asian art. Brand was appointed in February 2012 and began in June of that year.

As Rex Irwin had predicted, the comparisons started immediately, with no grace period granted. Amid the predictable observations that Brand seemed more reserved than Capon, less comfortable sparring with the media, was journalist Katrina Strickland's account of an Archibald Prize dinner that she attended. Brand spoke first and joked that surviving the Archibald would be his true induction to Gallery life. Then he did 'something surprising', Strickland wrote, 'he throws to the gallery's head of Australian art, Wayne Tunnicliffe. Capon rarely shared the spotlight, and it epitomises just how far in style Brand is from his predecessor.'[15]

This change was more than stylistic. It heralded a significant shift in Gallery management. The retirement between 2011 and 2016 of senior curatorial staff in Australian art (Barry Pearce), Asian art (Jackie Menzies), photography (Judy Annear), European art pre-1900 (Richard Beresford) and international art (Tony Bond) meant that generational

Right, above: From left: Leila Gurruwiwi, Brendon Boney, Elaine Crombie, Steven Oliver (host), Daniel Browning, Ursula Yovich and Ben Graetz are filmed in front of a live audience at the Gallery for the *Faboriginal* Indigenous art quiz, with Jakayu Biljabu's 2008 painting *Minyi Puru* in the background. The quiz took its cues from the art and artists in the Gallery's Aboriginal and Torres Strait Islander art collections, using humour to provide insight into Indigenous experiences, perspectives and values. **Right, below:** Verushka Darling leads a tour of the collection for Queer Art After Hours as part of the 40th anniversary Sydney Gay and Lesbian Mardi Gras celebrations in 2018. This event saw the largest evening attendances in the Gallery's history.

The Exhibitionists

Building the future

change became possible and presented 'a remarkable opportunity to refashion the AGNSW', as those outside the institution noted.[16] The old curatorial departments, which were awkwardly divided according to geography, media and chronology, were reassigned under the two broad strands of Australian Art, with Wayne Tunnicliffe as head of department, and International Art, with Justin Paton as head.

The new position of director of collections no longer had responsibility for a specialist collecting area within the Gallery. Suhanya Raffel held this post from 2013 until she left in 2016 to become the director of M+ in Hong Kong. Her role in Sydney was strategic and structural, ensuring that the various parts of the division worked together to further the broader priorities as the Gallery prepared for a major expansion. The work of creating those key policies that curator Barry Pearce regretted the absence of when he began at the Gallery back in 1978, was continued from 2016 onwards under Maud Page in areas of art acquisitions, research, conservation, archives, Aboriginal and Torres Strait Islander engagement, provenance and – to Capon's horror, who said 'no doubt we shall soon have a corporate plan for exhibitions too' – exhibition development.[17]

Although Capon joked that 'today we have audit and risk committees. Personally, I'm for more risk. I want a pro-risk committee', the absence of these policies left the institution vulnerable.[18] In no area was this more evident than in that of provenance. When Indian-born dealer Subhash Kapoor, who ran a commercial gallery in New York, was arrested for the alleged illegal export of antiquities from India, museums all over the world took note. Following his extradition to India in 2012, the Art Gallery of New South Wales was among the first to reveal details of the six works that it had purchased from him between 1994 and 2004, publishing them online and working with the Indian High Commission in Canberra and the Consulate General in Sydney. One sculpture, a thousand-year-old South Indian stone image of the Hindu deity Ardhanarishvara, was returned to India by the Australian Government in 2014, along with a bronze Shiva Nataraja purchased from the same dealer by the National Gallery of Australia. The Gallery significantly improved its approach to provenance and due diligence and continued to research and publish the provenance of works of art in the collection.

Michael Brand directed these negotiations, drawing upon his experience dealing with these issues at the Getty. Staff at the time, and subsequently, benefited from the strong network of international connections he brought to the Gallery, not only with Asia and America, which might have been expected given his professional history, but also across Europe and beyond. As an active member of the Bizot Group, the International Group of Organisers of Major Exhibitions, he facilitated the Gallery's participation in international museological initiatives concerning sustainability. At the Council of Australian Art Museum Directors in March 2019, for instance, he formally committed the Gallery to the Bizot green protocols for the loans of works between museums.[19] His membership of the Hermitage International Advisory Board gave the Gallery access to a network of leading international art museum directors, which in turn benefited its Sydney International Art Series (SIAS) of summer blockbuster exhibitions.

A sense of the Gallery extending itself beyond the familiar Australia–United Kingdom axis was particularly evident during 2018. In this year French President Emmanuel Macron visited *The Lady and the Unicorn* exhibition – with the famous tapestries on loan from the Musée de Cluny in Paris – and was guided around it by Brand and the French-born Maud Page. *Masters of Modern Art from the Hermitage* brought an extraordinary group of Russian museum professionals to Sydney from St Petersburg, which would not have occurred without Brand's personal friendship with the director of the Hermitage, Professor Mikhail Piotrovsky, another specialist in Islamic art.[20] Former US president Barack Obama also visited in this year to give a speech and requested a tour afterwards of the Gallery's Indigenous art collections.

These collections, along with the staff who care for them and provide access to them, have been a priority for Brand. The Gallery's Aboriginal and Torres Strait Islander engagement policy was established in 2015. Shortly after, an archivist of Aboriginal and Torres Strait Islander collections was appointed, supported by trustee Geoff Ainsworth, the first such position in an Australian art museum. The wider team of curators and educators expanded from three full-time positions in 2013 to five in 2020. Two part-time program assistants were also appointed, supported by the Nelson Meers Foundation, to ensure that all public tours of the Yiribana Gallery were led by Indigenous educators.[21] In 2018 an Indigenous Advisory Group was established with deputy director Page and in 2020 its inaugural chair, artist Tony Albert, became the first Indigenous member of the board of trustees.

Older artists often recall that they felt particularly at home in the Gallery during the directorship of Hal Missingham, when artists were unambiguously at the heart of everything that happened there. As activities and programs diversified and became more ambitious in the ensuing years, they believe a little of this unique connection was lost. A Community Advisory Group was established in 2020 to forge stronger links with artists and foster diversity. An annual artists' party had been inaugurated in 2015 by Brand, recognising the role of artists as leaders in their communities and also to thank them for being among the Gallery's most generous supporters. In 2017 the Gallery initiated the first in a series of three biennials of Australian contemporary art, shared with the

Museum of Contemporary Art and Carriageworks. Known as *The National*, these exhibitions built upon the legacy of the Gallery's immensely popular *Perspectas*, providing young artists with a platform to reach broader audiences.

The Gallery's historical collections continued to be the basis for major exhibitions, including *John Russell: Australia's French Impressionist* (2018) and *Streeton* (2020), both curated by Wayne Tunnicliffe. Even John McDonald called the first a 'definitive show … that features original research' and claimed that the latter 'makes the previous Streeton retrospective of 1996 look woefully perfunctory, being bigger and better in every way, accompanied by a brick of a catalogue packed with brief, informative essays'.[22] The Gallery's senior curator of Asian Art, Melanie Eastburn, presented the largest and most complex exhibition of Japanese art the Gallery had ever staged, over the summer of 2019–20. *Japan Supernatural* included paintings, prints, objects and film from the Edo period (1603–1868) to the present.[23] The innovative ways it used collections, both its own and those of overseas institutions with which the Gallery had forged strong links, drawing upon the Gallery's wide range of curatorial, design, programming, marketing, communications and social media expertise, gave audiences a taste of a new type of exhibition making.

A counterpoint to these complex, multi-lender exhibitions, were a number of smaller shows that had a resonance that extended beyond their modest size. The senior curator of Aboriginal and Torres Strait Islander art, Cara Pinchbeck, working with Amanda Peacock, presented a moving exhibition entitled *When Silence Falls* (2016), featuring the work of artists, both Indigenous and non-Indigenous, that gave voice to those silenced by massacres, ethnic cleansing and cultural displacement.[24] Later Pinchbeck worked closely with the community at Milingimbi to showcase works acquired from them in the exhibition *Art from Milingimbi: Taking Memories* (2017).[25]

Exhibitions at the Gallery often resulted in acquisitions. Takashi Murakami's enormous painting *Japan Supernatural: Vertiginous After Staring at the Empty World Too Intensely, I Found Myself Trapped in the Realm of Lurking Ghosts and Monsters* 2019, was commissioned for the Sydney Modern Project, but also with the public unveiling of the *Japan Supernatural* exhibition in mind. *Seven Sisters*, another monumental painting, won the 2016 Wynne Prize and was purchased from that exhibition. It was a joint work by artists

Takashi Murakami's enormous painting *Japan Supernatural: Vertiginous After Staring at the Empty World Too Intensely, I Found Myself Trapped in the Realm of Lurking Ghosts and Monsters* 2019, commissioned for the Sydney Modern Project, was a central work in the Gallery's *Japan Supernatural* exhibition. The innovative audio guide for this exhibition was recorded in English and Japanese, and the explainer video accompanying the show won the Gold award for Education & Infographics at the Australian Animation and Effects Awards and was nominated for a prestigious Webby Award.

The Exhibitionists

Tjungkara Ken, Yaritji Young, Maringka Tunkin, Freda Brady and Sandra Ken, working as the Ken Family Collaborative.

Other acquisitions were made with the purpose of extending the collections in poorly represented or entirely new areas. New Zealand–born curator Justin Paton, head of International Art, established the Friends of New Zealand Art (FoNZA). Although many prominent Australian artists in the Gallery's collection had actually been born in New Zealand, including Elioth Gruner, Rosalie Gascoigne and Roland Wakelin, when Paton arrived the art of New Zealand was represented by only a handful of paintings and a stronger group of photographs, purchased by New Zealand–born curator Judy Annear. Paton had strong support from Brand and Maud Page (when she arrived in 2016) to develop the Gallery's holdings in this area. In 2010 Page, deputy director at QAGOMA in Brisbane, had curated *Unnerved: The New Zealand Project*, the first large-scale New Zealand exhibition in Australia since the Museum of Contemporary Art's *Headlands* in 1992. By purchase and donation, significant works quickly came into the collection, including *The English Channel* 2015, a larger-than-life, stainless-steel sculpture of Captain James Cook by Michael Parekowhai, acquired in 2016 with funds provided by Peter Weiss. The first works by Colin McCahon also entered the collection: *Teaching aids 2 (July)* 1975 was purchased in 2014 and *Clouds 5* 1975 was donated by John Sharpe in 2018.

A willingness to share the spotlight, which Strickland noted was a feature of Michael Brand's style, has had an impact both within the institution and externally. Within, it has significantly changed the relationship between trustees and staff. Curator Renée Free recalled that 'in my thirty years, there was absolutely no communication between curators and trustees ... You wrote your report, and the so-called independent umpires made the decisions.'[26] These days, Gallery staff are regularly invited to engage with trustees concerning their areas of expertise and at least three of them attend all meetings of the Acquisitions and Loans subcommittee. Externally, it has meant that the public is introduced to a wider range of voices from within the Gallery and the museum's workings are made more transparent. This was particularly evident in 2020 during the COVID-19 pandemic when programs such as Together in Art and Archie Plus, the initiative of curator Justin Paton, showcased content curated by conservators, educators, installers, visitor experience staff and many others. These cross-disciplinary initiatives, which included art, music, performance and dance,

The English Channel 2015, a larger-than-life, stainless-steel sculpture of Captain James Cook by Michael Parekowhai, was acquired in 2016 with funds provided by Peter Weiss.

revealed a Gallery wanting to offer, in the words of Brand, 'new, more fluid, types of engagement with art – experiential, speculative and responsive'.[27]

The Together in Art platform was favourably reported in the *New York Times* and elsewhere. However, few of these positive institutional changes had previously made the press in Sydney. A small group of reporters preferred to report only on perceived negative changes at the Gallery.[28] This reporting coalesced around three main issues: staffing changes within the Gallery after a restructure; the relationship between the Gallery and its membership group, the legally separate Art Gallery Society; and the new building (its footprint and funding).

The Art Gallery Society, founded in 1953, was incorporated under the Companies Act in 1957. Members of the public usually think it is a division of the Gallery, particularly as it has its offices within the building and a version of the Gallery's name in its title.[29] But it is in fact a separate organisation with its own board, staff and (to some extent) culture. It has been vital to the life of the Gallery for over half a century, sponsoring acquisitions, exhibitions and programs, and running the most successful art gallery members' group in the country. The history of the Art Gallery Society was written by Judith White on the occasion of its fiftieth anniversary in 2013.[30] White had served as its director from 2000 to 2008.

She knew better than anyone the history of the Society's often turbulent and strained relations with the Gallery. Hal Missingham, who was director of the Gallery when the Society was formed, recalled that 'from the beginning there were strong differences of opinion between the committee [the Society] and myself over procedures and programmes'.[31] The Society was a victim of its own success. Its early programs were so well attended that Missingham, fearing they would swamp other activities, set an annual cap on them. At one point, the relationship deteriorated to such an extent that Missingham gave an ultimatum. As he recalled, 'either they ran the Gallery or I did'.[32]

White returned as director of the Society for a brief period in 2014–15, during one of these turbulent and transitional moments. Not long after she returned, three Gallery staff members left after a restructure. At the same time, the newly created Visitor Experience division of the Gallery was entrusting key activities, such as ticketing, to paid staff, when previously they had been undertaken by volunteers. A Gallery-wide review of stakeholder relationships undertaken in 2013 recommended, among other things, that the Society and Gallery enter into a Memorandum of Understanding. White arrived at the start of this process but left the Society in December 2015. The MOU was signed by her successor, Ron Ramsey.

Two years later White published a hastily written book about the Gallery.[33] Laced with criticisms of neoliberal politics and the alleged effects of corporatisation on cultural organisations such as the Art Gallery of New South Wales, and nostalgic for a golden age of support for the arts under Gough Whitlam and Neville Wran, it seemed to suggest that Michael Brand and the Gallery's trustees and executives were singularly responsible for the geopolitical climate of twenty-first-century Australia. There was no acknowledgement that they too were negotiating this new world, doing everything possible to ensure that the Art Gallery remained relevant, vibrant and sustainable. As Brand wrote: 'I am leading the gallery in a very different world from the one my predecessor, Edmund Capon, faced when he started his tenure in 1978. We are well into a new century that has brought significant changes to the way we work, relax, learn and communicate.'[34]

As Gallery archivist, such discussions immediately reminded me of the 1887 debate in the press about the purpose of the Gallery.[35] 'The Critic', writing for the *Sydney Morning Herald* in those early days, said that the Gallery could either 'amuse the people who visit it, like an Aquarium or Zoological Garden' or could 'afford them the means of cultivating a knowledge of art'.[36] The Critic thought the Gallery was choosing mere entertainment and waged a debate with James Green (writing under his pen-name of JG de Libra) until Du Faur, president of the trustees, intervened. 'The first duty of the trustees,' he wrote, 'is to make the Gallery a place of refreshment and recreation for the people.'[37] When Brand asserted that the Gallery must remain popular – 'I don't mean popular in a light way. Museums are meant to be popular' – he was not out of kilter with the history of the institution and its place in public life but speaking in a way that was entirely consistent with it.[38]

Planning for a new building began under Capon. A master plan was presented to the trustees as early as mid 2005 but progress was slow as various stakeholders, the most important of which was the Royal Botanic Gardens and Domain Trust (RBGDT), needed to be thoroughly consulted before work could progress. The site would include the 1999 land bridge over the Cahill Expressway, owned by the state Roads and Maritime Services, and the land on top of two underground decommissioned Second World War navy oil tanks that had since been transferred to the Royal Botanic Garden (one of which would be repurposed as a gallery space as part of the expansion). Steven Lowy, president of the board of trustees between 2007 and 2013, said that by the time Brand arrived the master plan 'was not quite in the drawer or on the shelf, but it was close to that'.[39]

Brand was given the task of overseeing everything needed to make the project a reality, from securing government funding and private philanthropy, selecting architects,

finalising designs, obtaining planning approvals and generally advocating for the building to the wider community. Compared to the history of the original Gallery building – two years of debate about a potential site in 1882–84, ten years of debate about the architecture in 1886–96, thirteen years of construction from 1896 to 1909 and almost the whole of Hal Missingham's tenure advocating for the 1972 expansion – this project started to move ahead remarkably swiftly and smoothly.

The Sydney Modern Vision was launched by Lowy and Brand on 6 March 2013. The aim was 'to create a truly great art museum which can take its place in the Asian century, in an interconnected and digitised world'. Central to this ambition was setting the new building alongside the current one, making the most of the Gallery's unique physical site overlooking the harbour but also expanding and facilitating wider access to its collections and programs. A few argued that the project should not have been launched without first securing private and public funding to realise it. But Brand countered that the funding campaign required 'very, very careful planning supported by very, very detailed research', an approach that proved successful.[40] The state government committed $10.8 million over two years for a feasibility study, which allowed the Gallery to proceed with engineering studies and to develop a brief for the international design competition.

A further $4 million was given for this process in 2014. Under the new president Guido Belgiorno-Nettis (2014–15), Brand chaired the architectural competition jury that included Seattle- and Paris-based landscape architect Kathryn Gustafson, CEO of the West Kowloon Cultural District Authority Michael Lynch, Harvard professor of the practice of architecture Toshiko Mori, Australian Pritzker Prize–winning architect Glenn Murcutt, Finnish architect and writer Juhani Pallasmaa, and the Gallery's former senior curator of Aboriginal and Torres Strait Islander art, Hetti Perkins.

The award-winning Japanese architectural studio SANAA (founded by Pritzker Prize winners Kazuyo Sejima and Ryue Nishizawa) was chosen by the jury in 2015. They then worked tirelessly with the Gallery to finesse their designs for the new building. They could have been justifiably cautious about working again in Sydney, given they had been chosen by a jury in 1997 to design an extension to the Museum of Contemporary Art and then unexpectedly dropped. But they worked on the Sydney Modern Project with an enthusiasm and professionalism that gave no indication of that history. Design workshops in both Sydney and Tokyo, with the Gallery represented by both Brand and the head of the Sydney Modern Project Sally Webster, along with other colleagues, brought myriad refinements and readjustments to their original designs, incorporating new priorities determined by budgets and other factors, including public feedback.

In December 2020, students at Wilcannia Central School worked with the Gallery's Aboriginal and Torres Strait Islander team and artist Badger Bates as part of the Gallery's Djamu Regional Program to revive the cultural tradition of making and floating a tree canoe on the Barka (Darling) River for the first time in seventy years. **Right:** Barkandji artist and elder Badger Bates (at right) leads the Wilcannia site visit to the canoe tree, with Michael Brand (centre) and Wesley Shaw, the Gallery's Aboriginal and Torres Strait Islander art programs producer (left). **Below:** Badger Bates with Gallery director Michael Brand.

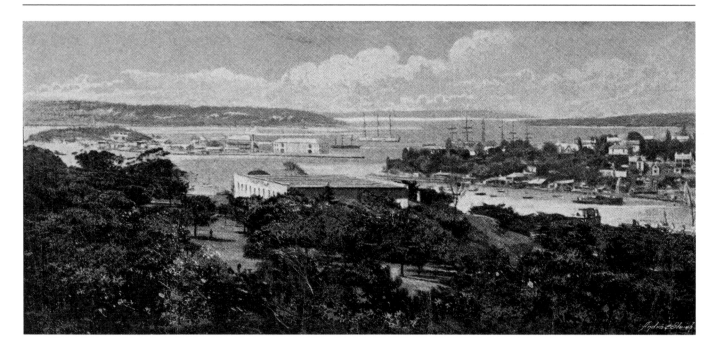

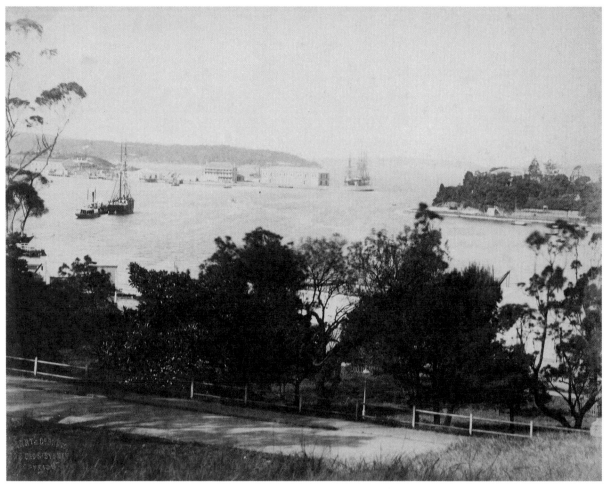

The Exhibitionists

The Gallery's historical buildings had been constructed amid controversy: Colonial Architect James Barnet fell out with the trustees, who narrowly escaped being sued by the architect they employed as his replacement, John Horbury Hunt. Sydney's track record of working with international architects was just as fraught. It was the Gallery's former director Hal Missingham who led a major protest in support of Jørn Utzon when he resigned from his position as supervising architect of the Sydney Opera House. But the productive and collaborative relationship between client and architect that characterised the Sydney Modern Project took it from under 'Utzon's shadow', offering a new model for both the Gallery and the city of Sydney.[41]

At the beginning of 2016, David Gonski returned for a second tenure as president of the board of trustees and soon afterwards the state government announced $244 million of support for the project as its extraordinary contribution to an ambitious public–private partnership. By the end of 2018, the Gallery could announce that it had just surpassed its $100 million target of private support for the Sydney Modern Project, making it the most successful capital campaign of its kind in Australia. John Richardson, who had been appointed

the Gallery's director of development in 2014, attributed this success to 'board president David Gonski, Gallery director Michael Brand, and Mark Nelson, chair of the campaign committee', modestly omitting his own contribution. Richardson said that the campaign result clearly indicated broad support for the Sydney Modern Project, despite a small, but vocal, 'sprinkling of dissatisfied ones'.[42] Matthew Westwood, writing in the *Australian* in 2017, agreed: 'It's time to see the project for what it is: a potentially stunning new addition to the city.'[43]

Among that small band, however, was former prime minister Paul Keating, who had written a typically vigorous and opinionated, but not quite factual, criticism of the Sydney Modern Project on page 1 of the *Sydney Morning Herald*. There he characterised it as a 'gigantic spoof against the civic core of Sydney's most public and important open space'. He accused Michael Brand of building 'a large entertainment and special events complex masquerading as an art gallery'.[44] Once again, many of the issues he raised had been fully aired long ago, when a site was being determined for the Gallery in 1882–84. If such things were possible, the Gallery could have conjured up to its defence its feisty first president Sir Alfred Stephen (1875–89), who would have relished the exchange:

KEATING, 2015: The logical solution of building [is to locate it] to the immediate south over the existing Domain car park.
STEPHEN, 1884: Differences of opinion, which the selection of a site is certain to create for us, [will occur]; each having its advocate, and each perhaps having some recommendation. I myself heard of half a dozen such.
KEATING, 2015: The new building will wipe 'out a substantial chunk of the Botanic Gardens'.
STEPHEN, 1884: Well, I claim to be quite as much interested in the preservation and beautifying of the parks, and retaining them for their appropriate purposes, as any man in the community can be. But I am not inconsistent, in urging nevertheless the adoption of our building scheme. We look at the question on all sides – not on one only; and we would abstract a portion of land, not used for purposes of exercise, except by quadrupeds, and in its present state far from being ornamental, in order to create on it sources of gratification for the public, intellectual and elevating.[45]

The site of the new building is actually adjacent to, and totally outside the boundary of, the Royal Botanic Garden, but Keating continued by characterising the Gallery's desire to locate the new building to the north of its existing building rather than on top of the Domain car park to the south as mere 'institutional conceit and cultural snobbery about the harbour'. There was, in fact, a much deeper element to this decision articulated in the Gallery's original master plan.

When the Gallery first moved to its current site in the Outer Domain, the architect and the trustees wanted the buildings to face the harbour. John Horbury Hunt wrote:

> When the position of the Gallery was laid down by those in authority, most earnestly did I beg to be allowed to place my building due north and south, but not withstanding the strong support of the trustees, I was unable to carry this point, and the building was placed so as to be parallel with the Domain (central) avenue.[46]

Even when the current alignment had been established, architects competing to finish the building were told that 'the situation of the Art Gallery will render the north end conspicuous to persons on vessels entering or leaving the harbour and the special attention of architects is directed to this'.[47] As events transpired, this side of the Gallery remained makeshift and neglected for over eighty years.

It was Andrew Andersons who completed the Gallery's northern elevation as part of his 1972 extensions. But by this time, the violent severance of the precinct by the Cahill expressway, which ran east–west through the centre of the Domain, had the effect of isolating the Gallery from the foreshore at Woolloomooloo Bay. Nineteenth-century images of the Gallery and its site, such as *Sydney Harbour from the Art Gallery, Sydney* by Charles H Kerry or *Sydney Harbour from the Domain (showing the Art Gallery in the middle foreground)*, which was published in the international *Magazine of Art*, showed the earlier connection between the two.[48] But by the 1960s the expressway made it almost impossible to see and access the Gallery from the harbour.

Andersons' 1972 wing incorporated a northern outdoor sculpture court that provided glimpses of the harbour. His 1988 extension reached down towards Woolloomooloo and had another sculpture terrace on the roof. 'For the first time at the Art Gallery of NSW,' an architectural historian noted, 'the outside world became connected to the somewhat intimate world of art display.'[49] But these apertures to landscape were short-lived. Windows were eventually closed up to provide extra hanging space, terraces built over, and outdoor galleries replaced by interior rooms as the institution retreated within the confines of its walls.

The history of the Art Gallery of New South Wales is evident, above all, in its buildings. Unlike other galleries that decamped from where they were founded and refashioned themselves with new buildings on new sites, the Sydney Gallery has grappled with expanding collections, and shifts in institutional aspirations as well as community expectations, on the same parcel of land pegged out for it 137 years ago. Argentinian artist Adrián Villar Rojas remarked upon this.

Visiting the Art Gallery of New South Wales for the first time in 2017, he was confused by the competing messages of its architecture: the nineteenth-century classical building with its aspirations of European culture rooted in the Greco-Roman tradition, so emphatic from the street, was countered immediately upon crossing the threshold by uncompromising twentieth-century modernism. Villar Rojas said that he began to understand the Gallery only when he saw an aerial photograph of it. It was like peering into someone's brain: the European colonial project, the new internationalism that looked towards America, a lantern for the Asian century. Its orientation, determined by government in the nineteenth century, turned the building's face towards the seats of power and its backside to Woolloomooloo, the place where so many Australian immigrants first arrived and an area rich in pre-colonial Indigenous history. All of this is built on Gadigal Country.

The Sydney Modern Project transforms the Gallery into an art museum campus with two buildings, with landscape features designed by Kathryn Gustafson running along Art Gallery Road, and an extraordinary art commission to be unveiled. It also reorients the Gallery, opening it out to the harbour and beyond, as the early architects had wanted, as well as to Woolloomooloo. The project should also be read as a symbol of new ambitions and priorities. When Capon told former premier Bob Carr that 'we have had well over a century of evolution and now it is the time to make a big bold step', he did not have in mind an annexe over a car park.[50] This would have been an easy solution, but against the grain of Sydney's public imagination and a retreat from the Gallery's history. The Sydney Modern Project sees the Gallery jumping the ugly barricades that had been placed between it and Woolloomooloo Bay to reclaim the site 'adjoining the steps leading to the Woolloomooloo wharf' that parliament first chose for it.

The founders of the Gallery were full of optimism for the project that they launched in 1871, despite having no building, collection or funding at the time. There was uncertainty about how they might achieve their aims but absolute confidence in one thing: the power of art to enrich and change lives. They looked to the future as much as their own needs. 'The gathering of the grain may not be permitted to those present,' Thomas Mort told them at their first social event in August 1871, 'but we may rest content in the satisfaction that it will be reaped in all its fullness by those who may come after us. For let the love of art once take firm root among us and it will go on bearing increased supplies of fruit year by year.'[51]

The Exhibitionists

Epigraph

John Horbury Hunt, 'National Art Gallery: To the editor of the Daily Telegraph', *Daily Telegraph*, 21 Jun 1887, p 3.

Notes

1 *1967 report of the trustees of the Art Gallery of New South Wales*, Art Gallery of NSW, Sydney, 1968, p 1.

2 *1967 report of the trustees of the Art Gallery of New South Wales*, p 5.

3 *Two Decades of American Painting*, 17 Jul – 13 Aug 1967.

4 *1967 report of the trustees of the Art Gallery of New South Wales*, p 2.

5 *1967 report of the trustees of the Art Gallery of New South Wales*, p 1.

6 'Art Gallery of NSW: new lease of life', *Sydney Morning Herald*, 3 May 1972, p 13; Laurie Thomas, 'A place for works of art to sing', *Australian*, 2 May 1972.

7 'It is no longer sufficient to provide a building with enough wall space to hang a certain number of paintings in near permanence. An art gallery today should be a place of entertainment and education in the deepest sense of these terms.' Hal Missingham, Lecture to Art Gallery Society, 18 May 1971, p 3, National Art Archive, Art Gallery of NSW.

8 *2006–07 annual report of the trustees of the Art Gallery of New South Wales*, Art Gallery of NSW, Sydney, 2007, p 16.

9 AGNSW footprint 23,000 square metres; NGA footprint 50,000 square metres; NGV footprint 54,000 square metres; QAGOMA footprint 44,000 square metres.

10 Andrew Taylor, 'For the love of art', *Sun-Herald*, 16 May 2010, p 2.

11 Quoted in Joyce Morgan, 'Finding a gallery director is quite an art', *Sydney Morning Herald*, 4–5 Feb 2012, p 8.

12 As part of the Sydney Modern Project, and for the first time in its history, the Gallery acquired a large outdoor space that needed to be designed and managed.

13 Paige Taylor, 'Rising Aussie heads museum', *Australian*, 17 Aug 2005, p 5.

14 Morgan 2012, p 8.

15 Katrina Strickland, 'Brand renewal', *Financial Review Magazine*, 28 Jul 2013, p 32.

16 Michael Young, 'New direction for Australia's state galleries', *ArtAsiaPacific* online news, 14 Nov 2011.

17 Edmund Capon, *I blame Duchamp: my life's adventures in art*, Lantern published by Penguin, Melbourne, 2009, p 255.

18 Quoted in Joyce Morgan, 'Edmund Capon, an unlikely choice, was a risk worth taking', *Sydney Morning Herald*, 17 Dec 2011, p 11. In another interview it was noted that 'the most vehement Capon gets in our interviews is when he expounds on the culture of accountability. "My instinct for invention and for risks has been completely compromised by accountability. I can say that. It truly has!"' Shelley Gare, 'One last question, Mr Capon', *Sydney Morning Herald*, 24 Nov 2011, p 44.

19 This was a joint commitment that also included the National Gallery of Australia, the National Gallery of Victoria and Queensland Art Gallery| Gallery of Modern Art.

20 *Masters of Modern Art from the Hermitage* was curated by the Hermitage's Mikhail Didenkin, with Peter Raissis curating its installation at the Art Gallery of New South Wales. The exhibition was organised with the assistance of Art Exhibitions Australia.

21 Other Indigenous educators were also employed on a casual basis to assist with a variety of programs.

22 John McDonald, 'Australia's only genuine impressionist John Russell in focus', *Sydney Morning Herald*, 10 Aug 2018, p 14; John McDonald, 'Streeton exhibition is a textbook study in what it means to be a local legend', *Sydney Morning Herald*, 5 Nov 2020, p 10.

23 *Japan Supernatural*, 2 Nov 2019 – 8 Mar 2020.

24 *When Silence Falls*, 19 Dec 2015 – 1 May 2016.

25 *Art from Milingimbi: Taking Memories*, 12 Nov 2016 – 29 Jan 2017. Cara Pinchbeck worked with Lindy Allen and Louise Hamby on this exhibition.

26 Email from Renée Free to Steven Miller, 8 Feb 2021.

27 James Riley, 'Michael Brand's art of innovation', *InnovationAus*, 16 Apr 2018, online journal.

28 Andrew Taylor, 'Art Gallery of NSW: visitor vandals and staff damage art', *Sydney Morning Herald*, 2 Feb 2014; Andrew Taylor 'Crisis deepens at Art Gallery of NSW as volunteers "sacked"', *Sydney Morning Herald*, 16 Sep 2014; Andrew Taylor, 'NSW Art Gallery loses major donor because "process too complicated"', *Sydney Morning Herald*, 4–5 Oct 2014; Michael Evans and Andrew Taylor, 'Waiting game and whispers at gallery', *Sydney Morning Herald*, 23–24 Jul 2015; Andrew Taylor, 'Fears for future of NSW's Art Gallery Society', *Sydney Morning Herald*, 3 Mar 2017; Andrew Taylor, '"It's a total mess": government risks delay by standing up to developer', *Sydney Morning Herald*, 4 Aug 2019.

29 When someone rang the Gallery in 1984 to give the location of William Dobell's painting *The souvenir*, which had recently been stolen, they accidentally rang the offices of the Society rather than the Gallery's director Edmund Capon, who they wanted to contact. When the painting was found unharmed at the State Library of NSW, some joked that the painting had been taken by a disaffected Society member wanting to make a point.

30 Judith White, *Art lovers: the story of the Art Gallery Society of New South Wales 1953–2013*, Art Gallery Society, Sydney, 2017.

31 Hal Missingham, *They kill you in the end*, Angus and Robertson, Sydney, 1973, p 103.

32 Missingham 1973, p 57.

33 The timeline of the book is particularly confusing, with some key changes at the Gallery reported as though they were the initiative of Brand, when they had in fact occurred under his predecessor Edmund Capon.

34 'No stone unturned', *Sydney Morning Herald*, 29–30 Jun 2013, p 10.

35 White argued that 'the choice facing public galleries, to put it starkly, is between preserving their role as places to contemplate art and becoming branches of the entertainment industry'. White 2017, p 52.

36 Critic, 'Art in Sydney', *Sydney Morning Herald*, 12 Feb 1887, p 7.

37 A trustee, 'Art in Sydney: to the editor of the *Herald*', *Sydney Morning Herald*, 10 Mar 1887, p 4.

38 Elizabeth Fortescue, 'Interview with Dr Michael Brand', 11 Feb 2012, Artwriter.com.au.

39 Quoted in Strickland 2013, p 34.

40 Strickland 2013, p 34.

41 See Louise Schwartzkoff, 'In Utzon's shadow: the other architects shunned by the city', *Sydney Morning Herald*, 3 Jul 2009, p 8.

42 'In conversation with John Richardson', *Artshub*, 26 Sep 2019.

43 Matthew Westwood, 'A thoroughly modern extension', *Australian*, 25 Apr 2017, p 14.

44 Paul Keating, 'Gallery plan shows a harbour snobbery', *Sydney Morning Herald*, 24 Nov 2015, p 17.

45 Alfred Stephen, 'National Art Gallery', *Daily Telegraph*, 15 Jul 1884, p 5.

46 Hunt 1887, p 3. Vernon, who succeeded Hunt, was required to keep this orientation, but when he later designed the Mitchell wing of the State Library of NSW he showed his real preference. The classical portico there faced north, the only building on Macquarie Street to do so.

47 National Art Gallery of NSW conditions of competition and instructions to architects, 10 Jun 1889, article 21, p 8. Included as part of correspondence CFG91/1889.

48 May L Manning, 'Art in Australia', *Magazine of Art*, 1895, p 217.

49 Andrew Metcalf, *Architecture in transition: the Sulman Award 1932–1996*, Historic Houses Trust of NSW, Sydney, 1997, p 123.

50 'Towards a great general museum: Edmund Capon in conversation with Bob Carr', *Art and Australia*, vol 49, no 3, Mar–May 2012, p 393.

51 'The inaugural *conversazione* of the New South Wales Academy of Art', *Empire*, 8 Aug 1871, p 2.

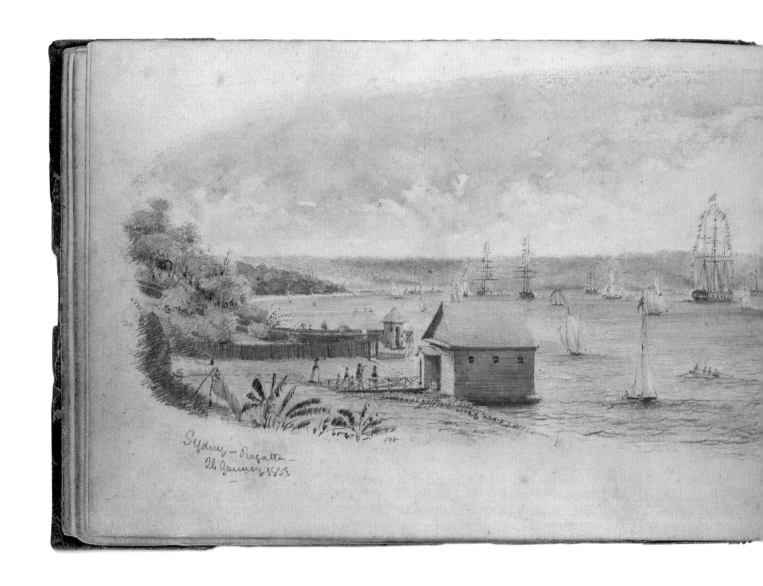

Eliezer Montefiore *Sydney Regatta* 26 January 1853.
This watercolour, by the Gallery's first director, was
made on a working visit to Sydney from Adelaide,
where he was based at the time. The outlook onto
Woolloomooloo Bay from the Domain will be shared by
some of the terraces of the Gallery's new building.

The Exhibitionists

Director's afterword

On Monday, 23 March 2020, I closed the doors of the Art Gallery of New South Wales to the public for an unknown period. Nothing this drastic had happened since the Gallery closed for three months in 1919 due to the Spanish influenza. Even during the Second World War, when prime minister John Curtin thought government agencies which served 'no basic war purpose' could temporarily be closed, the Gallery resisted. 'Whilst it may not be claimed that Gallery activities have a basic war purpose,' our trustees at the time wrote, 'the Gallery's valuable contribution to the cultural needs of the community, which are of equal importance in peace and war, cannot be overlooked.'

In fact, the Gallery saw its role in connecting and uplifting people through art as even more critical during a time of crisis like war. When most of the collection had to be packed away and sent to regional centres because of the imminent threat of bombing in Sydney, the Gallery worked energetically and innovatively with local artists so that sustaining encounters with art were still possible. Exhibitions by artists such as Margaret Preston, William Dobell, Roland Wakelin and Lloyd Rees were organised and proved extremely popular. Realising that children are particularly vulnerable at such times, the Gallery teamed up with the *Sunday Telegraph*, a popular newspaper with a wide readership, to hold the *Children's Art Show* in 1944. Over eleven thousand entries were received from children under seventeen and a huge number were exhibited, with prizes awarded. The Gallery's archive preserves touching letters related to the show. A Miss Grace Tasker, from Yass, a small town near Canberra, wrote that fourteen Indigenous students from her school had happily sent in work, having 'had no opportunity of studying art except at this small school'. At Beckom in the central Riverina where there was a mice plague, the children's notebooks had been eaten and they had to improvise surfaces on which to draw.

I thought of these much-appreciated initiatives from our past when we closed the doors in March 2020. Once again, we had the challenge of showing what defines the spirit of an art museum when access to the physical works of art is restricted. One initiative was an online collaborative platform entitled Together in Art, where artists, performers and musicians offered a daily dose of art and imagination to a world in desperate need of it. As in 1944, children were a priority. For them we commissioned artist-led projects and artmaking videos, and worked with physician and broadcaster Norman Swan and the ABC, to stage the online Together in Art kids' exhibition. Entries flowed in from as far away as Estonia.

It was heartening to see how widely appreciated these efforts were, not only by our national and international audiences but also by the artists and performers at the heart of them. These actions were commended by our state government too. It was noted that the Gallery was making a major contribution to both the state's economy and communal wellbeing, as a place of 'inspiration, refuge and recreation'. The timing of the coronavirus crisis was especially significant for the Gallery, as it occurred on the threshold of our 150th anniversary in 2021, while construction was well underway for our Sydney Modern Project.

This transformative project will see the Gallery become an art museum campus, of two buildings set within an extraordinary natural setting with sweeping views of the harbour. I cannot help but see a timeline trajectory stretching directly from the reopening of our front doors in June 2020 after a ten-week lockdown to the completion of our magnificent SANAA-designed building in late 2022. During this time, we will be working to ensure that the identity of the expanded Art Gallery of New South Wales continues to develop in a manner that ensures we remain a public art museum of both national and international relevance to an altered, post-coronavirus world.

I am particularly delighted to have this history of the Gallery written by its long-serving archivist, Steven Miller, at this momentous time. I firmly believe that knowledge of our history is essential to the current transformation of the Gallery: it helps us to understand how and why we have arrived at where we are today and how we should build for our future. No general history of the Gallery has been published to date, which is surprising given the richness of the material available. We are particularly fortunate to have a comprehensive institutional archive from which to draw, as well as the collected archives of artists, allowing many of the voices from our past to speak for themselves. Naturally, much had to be left out, as an exhaustive account of our first 150 years would need a publication of multiple volumes.

What has been included tells the story of a public art museum that has played a vital role in the cultural life of the city of Sydney, our state and the nation. Many of the founders of the Gallery established other core institutions of civic life, as this history shows – in parliament and on the judiciary, campaigning for workers' rights, for national parks or for the welfare of animals. At the same time, they believed that art and creativity were foundational to human flourishing and had an important role to play in social advancement and change.

The societal and political challenges we currently face are enormous, from the COVID-19 pandemic (and our prolonged second Sydney lockdown as I write) and code red alerts on climate change to the legacy of colonialism, gender inequity and racism. How do we collectively navigate these major upheavals and become a force for positive change? Artists reflect, question, and offer us new ways of being, and their contributions have never been more critical. The same holds true for the Art Gallery of New South Wales. We must support all voices of reason, compassion and generosity and continue to provide a civic forum for art and ideas for the broadest possible audience. We must be a place of optimism where our shared cultural heritage is set in dialogue with our creative present and our dreams for the future.

Michael Brand

This illuminated address, prepared by George Relph, was presented to Governor Lord Loftus by the trustees of the Art Gallery of New South Wales on its opening on 22 September 1880, giving 'a brief account of the origin and progress of the Collection now for the first time brought together'.

Directors of the
Art Gallery of New South Wales

Sydney Modern design workshop at the Gallery, 2016: Ryue Nishizawa (left) and Kazuyo Sejima (right), architects and founders of SANAA, with Michael Brand (centre). Sally Webster, Head of the Sydney Modern Project, and Suhanya Raffel, former Deputy Director and Director of Collections, are in the background. Photograph: Luke Johnson

Eliezer Levi Montefiore	Director 1892–94
George Edward Layton	Secretary and Superintendent 1895–1905
Gother Victor Fyers 'Vic' Mann CBE	Secretary and Superintendent 1905–12
	Director and Secretary 1912–29
James Stuart 'Jimmy' MacDonald	Director and Secretary 1929–36
Sir John William 'Will' Ashton OBE, ROI	Director and Secretary 1937–44
Hal Missingham AO	Director and Secretary 1945–71
Peter Laverty	Director 1971–77
Edmund Capon AM OBE	Director 1978–2011
Dr Michael Brand	Director 2012–

Trustees of the
Art Gallery of New South Wales

Trustees, 2020, from left: Andrew Cameron, Sally Herman, Tony Albert, Lucy Turnbull, Anita Belgiorno-Nettis, Ben Quilty, Ashley Dawson-Damer, S Bruce Dowton, Gretel Packer and David Gonski (not pictured: John Borghetti). Vincent Namatjira's *Stand strong for who you are* 2020 is in the background. Photograph: Michael Brand

Image credits

Front cover

Mieko Shiomi cello sonata 1972
performed by Charlotte Moorman
on the roof of the Art Gallery of New
South Wales, 1976
gelatin silver photograph
19.8 x 24.6 cm
National Art Archive, AGNSW
© AGNSW, Kerry Dundas
ARC30.1098.1

Back cover

Aerial view of the Art Gallery of
New South Wales and the Sydney
Modern Project construction site
in the Domain (bottom, centre),
August 2021
Photograph: Craig Willoughby,
SKYview Aerial Photography

Chapter 1

Page 11

The Unbound Collective
Sovereign acts IV: Object 2019
performance documentation
*The National 2019: New Australian
Art*, Art Gallery of New South Wales,
Sydney
© the artists

Page 13

Top:
Tom Roberts
The Golden Fleece 1894
oil on canvas
104 x 158.7 cm
Art Gallery of New South Wales
Purchased 1894
648

Bottom left:
The Unbound Collective
Sovereign acts IV: Object 2019
performance documentation
*The National 2019: New Australian
Art*, Art Gallery of New South Wales,
Sydney
© the artists

Bottom right:
The Unbound Collective
Sovereign acts IV: Object (still) 2019
performance documentation
*The National 2019: New Australian
Art*, Art Gallery of New South Wales,
Sydney
Video and image courtesy the artist
and Museum of Contemporary Art
Australia
© The artists; videography: Tristian
Derátz/Museum of Contemporary
Art Australia

Page 14

BE Minns
*Heads of Australian Aboriginal
people (a. Merriman, King of
Bermagui; b. Coonimon, Bermagui;
c. Droab, Bermagui)* 1894
pencil, watercolour
30 x 22 cm each sheet
Art Gallery of New South Wales
Purchased 1894
34

Page 15

Top, clockwise from top left:
Bodalla/New South Wales/Australia,
Yuin/Manaroo
Cheryl Davison
Guunyu 2007
lino print, black ink on paper
30 x 30 cm
Art Gallery of New South Wales
Gift of Christina Kennedy 2012
© Cheryl Davison
253.2012

Bodalla/New South Wales/Australia,
Yuin/Manaroo
Cheryl Davison
Bangu 2007
lino print, black ink on paper
30 x 30 cm
Art Gallery of New South Wales
Gift of Christina Kennedy 2012
© Cheryl Davison
256.2012

Bodalla/New South Wales/Australia,
Yuin/Manaroo
Cheryl Davison
Gulaga 2007
lino print, black ink on paper
30 x 30 cm
Art Gallery of New South Wales
Gift of Christina Kennedy 2012
© Cheryl Davison
252.2012

Bottom right:
Tom Roberts
Charlie Turner 1892
oil on canvas on paperboard
39.4 x 29.8 cm
Art Gallery of New South Wales
Purchased 1892
664

Page 16

Front cover of *Oscar's sketchbook*
National Musuem of Australia

No 27 *Another Cooktown steamer*
from *Oscar's sketchbook*
National Musuem of Australia

Page 17
Top:
EL Montefiore
Bushmen preparing to fire on a camp of Aboriginal people c1850
State Library of New South Wales
SSV*/Bush L/4

Bottom:
EL Montefiore
From Vaucluse c1840
Dixson Library, State Library of New South Wales
Bequeathed by Sir William Dixson, 1952
DL PXX 60

Page 18
National Art Archive, AGNSW:
ARC2.9.1

Page 20
Karla Dickens
Looking at you VI 2017
inkjet print
© Karla Dickens/Copyright Agency, 2021
Photograph: Mick Richards

Chapter 2

Page 26
Mitchell Library, State Library of New South Wales
Purchased from the Bush Burke Club through Miss Windeyer
PXB 851

Page 27
John Lane Mullins
School of Arts c1881
Mitchell Library, State Library of New South Wales
PXA 420

Page 29
Top left, right: National Art Archive, AGNSW: ARC5.1.1; ARC5.1.3

Bottom:
Achille Simonetti
Edward Combes CMG c1883 (detail)
terracotta
83 x 61.3 x 34.2 cm
Art Gallery of New South Wales
Gift of Mrs AE Ivatt 1928
9942

Page 30
Top left, middle: National Art Archive, AGNSW: ARC13.6.5

Top right:
Benjamin Spence
Highland Mary 1854
marble
113 cm height
Art Gallery of New South Wales
Gift of Lady Lloyd Jones 1982
136.1982
Photograph: Johan Palsson

Page 32
Top:
Maurice Felton
Fancy self-portrait c1840
oil on wood panel
44 x 35 cm
Presented to the Art Gallery of New South Wales by his daughter Myra Felton
On loan from the Art Gallery of New South Wales, 1922
Mitchell Library, State Library of New South Wales
ML 457

Bottom:
Myra Felton
Spiritualist (possibly the artist) on a Sydney rooftop 1910
oil on canvas
60 x 50 cm
Private collection

Page 33
Top left: National Art Archive, AGNSW: ARC10.4.3
Bottom right:
Messrs Coombes & Montificore [*sic*], late trustees, Art Gallery 1920
Government Printing Office
glass negatives (7/15973) st 7107
GPO1-14143
NSW State Archives & Records
NRS 4481

Page 34
Top:
Medal, New South Wales Academy of Art Exhibition for oil painting, awarded to William Charles Piguenit 1875
Museum of Applied Arts and Sciences, Sydney
Gift of the Australian Museum 1961
N12651
Photograph: Janine Thompson

Bottom:
WC Piguenit
Mount Olympus, Lake St Clair, Tasmania, the source of the Derwent 1875
oil on canvas
69 x 107 cm
Art Gallery of New South Wales
Gift of fifty subscribers 1875
6141

Page 36
Top:
Conrad Martens
Apsley Falls 1874
watercolour, opaque white, gum on paper
54.2 x 76.9 cm
Art Gallery of New South Wales
Commissioned by the Trustees and purchased 1874
117

Bottom: National Art Archive, AGNSW: ARC1.58.56305

Chapter 3

Page 39
National Art Archive, AGNSW:
ARC2.1.162

Page 41
Kerry & Co.
Elizabeth St at Hunter St c1880
Mitchell Library, State Library of New South Wales
DL PX 163

Page 42
Adelaide Ironside
The marriage at Cana of Galilee 1861, reworked 1863
oil on canvas on hardboard
106.1 x 147.7 cm
Art Gallery of New South Wales
Gift of the Warden and Fellows of St Paul's College, University of Sydney 1992
74.1992

Page 44
Ford Madox Brown
Chaucer at the court of Edward III 1847–51
oil on canvas
372 x 296 cm
Art Gallery of New South Wales
Purchased 1876
703

Page 45
Frank Mahony
Signor G Anivitti: a sketch from life 1880
Mitchell Library, State Library of New South Wales
Purchased from MH Mahony, 1940
P2/255

Page 46
Top:
Charles Nettleton
Gallery of casts from the studio of Brucciani, London, 1869
albumen silver photograph
23.8 x 29.7 cm
Commissioned by trustees of the Library, 1869
State Library of Victoria
H12957

Bottom: National Art Archive, AGNSW: ARC2.1.119

Page 47
National Art Archive, AGNSW:
ARC80.1.4

Chapter 4

Page 51
National Art Archive, AGNSW:
ARC2.2.1

Page 52
National Art Archive, AGNSW:
ARC13.6.6

Page 53
JT Richardson
Garden Palace, Sydney 1879–82
ink and watercolour drawing, cardboard mounted
56 x 82 cm
Mitchell Library, State Library of New South Wales
Purchased from the artist's son, 1957
XV1/Pub/Gar P/2

Page 54
Top: National Art Archive, AGNSW: ARC2.2.2

Page 55
National Art Archive, AGNSW:
ARC2.1.120

Page 56
Top:
Richards & Co
British court in the art section, in the Sydney International Exhibition c1880
National Library of Australia
PIC/12254/964 LOC Album 1136

Bottom:
Keeley Halswelle
Non angli, sed angeli 1877
oil on canvas
161.2 x 252.9 cm
Art Gallery of New South Wales
Purchased 1879
791

Page 57
Eugene von Guérard
Milford Sound, New Zealand 1877–79
oil on canvas
99.2 x 176 cm
Art Gallery of New South Wales
Purchased 1970
OA1.1970

Page 58
Top:
Angelica Kauffman
Nymphen schmücken Pan c1870
porcelain
Museum of Applied Arts and Sciences, Sydney
On loan from the Art Gallery of New South Wales
2436
Photograph: Michael Myers

Bottom: National Art Archive, AGNSW: ARC2.1.82

Page 59
Top:
Alfred Tischbauer
Interior of the Art Gallery of New South Wales c1882
oil on canvas

Bottom: National Art Archive,
AGNSW: ARC2.1.98

Page 62
JC Hoyte
*The burning of the Garden Palace,
seen from the North Shore* 1882
Mitchell Library, State Library of
New South Wales
V1/Har/1880-1889/7

Chapter 5

Page 65
Sydney/New South Wales/Australia,
Wiradjuri, Southern Riverine region/
Kamilaroi, Northern Riverine region
Jonathan Jones
barrangal dyara (skin and bones) 2016
gypsum, audio of Sydney Language
and Gamilaraay, Gumbaynggirr,
Gunditjmara, Ngarrindjeri, Paakantji,
Wiradjuri and Woiwurrung
languages, installation dimension
variable, approximately 4,000 shields
Art Gallery of New South Wales
Gift of John Kaldor and the artist
2017, donated through the Australian
Government's Cultural Gifts Program
© Jonathan Jones
334.2017
Photograph: Peter Greig

Page 67
National Art Archive, AGNSW:
ARC2.1.24

Page 69
John Lane Mullins
*In the Domain looking towards St
Mary's and the Museum* c1881
Mitchell Library, State Library of
New South Wales
PXA 420

Page 70
Top, bottom: National Art Archive,
AGNSW: ARC1.76.1; ARC1.76.81

Page 71
National Art Archive, AGNSW:
ARC2.2.14

Page 72
Bottom right: National Art Archive,
AGNSW: ARC2.1.22

Page 73
Photograph: Manfred Gottschalk/
Alamy

Page 74
William Henry Playfair
*Edinburgh Castle and the proposed
National Gallery* c1857
pencil and watercolour on paper
26.6 x 36.1 cm
Scottish National Gallery of Modern
Art

William Finlay Watson Bequest 1881
D 2419
Photograph: Graeme Yule

Page 75
Top, bottom: National Art Archive,
AGNSW: ARC1.76.3; ARC1.76.4

Page 76
Arthur Streeton
Fireman's funeral, George Street
1894
oil on canvas
45.3 x 38.2 cm
Art Gallery of New South Wales
Purchased 1980
43.1980

Chapter 6

Page 79
National Art Archive, AGNSW:
ARC2.1.14

Page 81
Theo Cowan
Frederick Eccleston Du Faur FRGS
1897
marble
64.7 x 50 x 30.5 cm
Art Gallery of New South Wales
Purchased 1897
3268

Page 82
National Art Archive, AGNSW:
ARC60.5.21

Page 83
Arthur Streeton
*'Still glides the stream, and shall for
ever glide'* 1890
oil on canvas, later mounted on
hardboard
82.6 x 153 cm
Art Gallery of New South Wales
Purchased 1890
859

Page 84
Top:
Jean Patricot
Charles Ephrussi 1905
drypoint
26.99 x 17.78 cm
The Phillips Collection, Washington,
DC
Museum Purchase, 2016

Bottom: National Art Archive,
AGNSW: ARC60.4.3

Page 85
Jules Adolphe Goupil
La villageoise (*The village girl*) 1878
oil on canvas
120.5 x 77 cm
Art Gallery of New South Wales
Purchased 1894
926
Photograph: Brenton McGeachie

Chapter 7

Page 89
National Art Archive, AGNSW:
ARC2.2.8

Page 91
Left, right: National Art Archive,
AGNSW: ARC13.5.3; ARC13.5.5;
ARC13.5.6

Page 92
Top, bottom: National Art Archive,
AGNSW: ARC1.76.6; ARC1.76.11;
ARC1.76.20

Page 93
Banner made for the Operative
Stonemasons Society by Althouse &
Geiger, Sydney 1904
Photograph: Sydney Trades Hall
Collection, Unions NSW

Page 94
NSW State Archives & Records,
IE13723

Page 95
Top: NSW State Archives & Records,
IE73596
Bottom left, right: NSW State
Archives & Records, IE13885;
IE133660

Page 96
National Art Archive, AGNSW:
ARC1.76.30

Page 97
Top: National Art Archive, AGNSW:
ARC2.1.115

Bottom, from left:
Amy Vale
Bowl with lillypilly design c1897
hand painted porcelain with
overglaze decoration
12.5 x 24.2 cm diam
Art Gallery of New South Wales
Purchased 1913
2186

Margaret Alston
*Book cover for 'Hand and Soul' by
Dante Gabriel Rossetti* c1923
red hand tooled leather venetian
design
14.6h x 10.9 cm
Art Gallery of New South Wales
Purchased 1923
2335

Delia Cadden
Vase with cicada design 1917
hand painted porcelain with
overglaze decoration on matt ground
10.2 x 16.5 cm diam
Art Gallery of New South Wales
Purchased 1917
2197
Photograph: Joy Lai

Page 98
Top, bottom: National Art Archive,
AGNSW: ARC30.44.2; ARC30.44.1

Page 99
Left, right: National Art Archive,
AGNSW: ARC1.76.40; ARC1.76.82

Page 100
National Art Archive, AGNSW:
ARC2.1.102

Chapter 8

Page 103
Julian Ashton
The prospector 1889 (detail)
oil on canvas on hardboard
213.4 x 116.9 cm
Art Gallery of New South Wales
Purchased 1889
4554

Page 105
National Art Archive, AGNSW:
ARC60.4.2

Page 106
National Art Archive, AGNSW:
ARC10.5.1

Page 107
National Art Archive, AGNSW:
ARC30.192310.1

Page 109
National Art Archive, AGNSW:
ARC30.1965.3

Page 110
Victoria/Australia, Melbourne/
Victoria/Australia
Lin Onus
Fruit bats 1991
polychromed fibreglass sculptures,
polychromed wooden disks, Hills
Hoist clothesline
250 x 250 x 250 cm overall
Art Gallery of New South Wales
Purchased 1993
© Lin Onus Estate/Copyright
Agency, 2021
395.1993

Chapter 9

Page 115
National Art Archive, AGNSW:
ARC2.1.15

Page 117
Top, bottom: National Art Archive,
AGNSW: ARC2.10.1; ARC2.7.5

Page 118
National Art Archive, AGNSW:
ARC1.76.80

Page 119
Top, bottom: National Art Archive,
AGNSW: ARC2.2.211; ARC2.1.243

Page 121
Edward William Cooke
Mont St Michel shrimpers 1842
oil on canvas
97 x 142.5 cm
Art Gallery of New South Wales
Purchased 1887
4530

Page 123
National Art Archive, AGNSW:
ARC2.11.2

Chapter 10

Page 125
Percival Ball
Phryne before Praxiteles 1900 (detail)
bronze relief
2620 x 3440 cm
Art Gallery of New South Wales
Purchased 1903
3257

Page 126
Clockwise from top left:
Charles Camoin
La cabaretière 1899
oil on canvas
73.3 x 57.7 cm
Art Gallery of New South Wales
Purchased 1939
© Charles Camoin/ADAGP/Copyright
Agency, 2021
6926

Albert Marquet
The Pont Neuf in the snow late 1920s
oil on canvas
78.2 x 64.7 cm
Art Gallery of New South Wales
Purchased 1939
6927

André Derain
Landscape c1928
oil on canvas
46.3 x 65.1 cm
Art Gallery of New South Wales
Purchased 1942
7197

Page 129
Top:
JS MacDonald
Self portrait c1921
lithograph, printed in black ink on off
white wove paper
40.1 x 37 cm
Art Gallery of New South Wales
Gift of The Hon J Lane Mullins MLC
1923
209

Bottom: National Art Archive,
AGNSW: ARC11.1.1

Page 130
Top, bottom: National Art Archive,
AGNSW: ARC5.1.48; ARC80.1.5

Page 131
Top left: National Art Archive,
AGNSW: ARC2.8.2
Top right: Percival Ball *Phryne before
Praxiteles* 1900 (see full caption page
125, above)

Page 132
National Art Archive, AGNSW:
SID17111. Photograph: Joy Lai

Page 135
National Art Archive, AGNSW:
ARC366.1.17

Page 136
Clockwise from top left: National
Art Archive, AGNSW: ARC2.5.1;
ARC2.5.2; ARC2.5.3; ARC1.77.1

Page 137
National Art Archive, AGNSW:
ARC1.76.65

Page 138
Top, bottom: Photographs of a
preparatory clay sketch and final
plaster cast of William Reid Dick's
1930/1 commission for the Sydney
Gallery of a bronze bas relief showing
Augustus at Nimes
Presented by Lady Catherine Reid
Dick, May 1981
Sir William Reid Dick Collection, Tate
Archive
© Estate of Sir William Reid Dick

Chapter 11

Page 141
John Mulligan
US President Lyndon B Johnson
surrounded by security personnel
arriving at the New South Wales
Art Gallery on a visit to Sydney, 22
October 1966 (detail)
National Library of Australia
PIC/3661/1502

Page 143
National Art Archive, AGNSW:
ARC5.1.25

Page 144
National Art Archive, AGNSW:
ARC3.641.1

Page 145
Top:
Hubert Pareroultja
*Tjoritja (West MacDonnell Ranges,
NT)* 2020
acrylic on canvas
183 x 244 cm
© Hubert Pareroultja/Copyright
Agency, 2021

Bottom:
Vincent Namatjira
Stand strong for who you are 2020
acrylic on linen

152 x 198 x 3 cm
Art Gallery of New South Wales
Mollie Gowing Acquisition fund for
Contemporary Aboriginal art 2020
© Vincent Namatjira
159.2020

Page 146
Left, right: National Art Archive,
AGNSW: ARC1.78.1

Page 147
Alphonse de Neuville
The defence of Rorke's Drift 1879
1880
oil on canvas
181.4 x 301.5 cm
Art Gallery of New South Wales
Purchased 1882
735

Page 148
Top, bottom: National Art Archive,
AGNSW: ARC5.6.1; ARC2.2.5

Page 150
Clockwise from top left: National
Art Archive, AGNSW: ARC2.1.212;
ARC2.1.245; ARC2.1.246; ARC2.1.250

Page 152
Top:
George Molnar
*'Trying to popularise the Art Gallery,
I see'* 1966
pen and ink on paper
24.2 x 32.2 cm
National Library of Australia
PIC/7345/880

Bottom:
John Mulligan
Unidentified man and a police
officer carrying a protestor from a
demonstration during US President
Lyndon B Johnson's state visit to
Sydney, 22 October 1966
National Library of Australia
PIC/3661/1509

Chapter 12

Page 155
National Art Archive, AGNSW:
ARC2.1.253

Page 156
Charles Joseph Watelet
Les félines 1923
oil on canvas
103.2 x 127.6 cm
Art Gallery of New South Wales
Purchased 1923
915

Page 157
Eric Thake
*Gallery Director or This way to
Phar Lap* 1954
linocut, printed on paper
20.6 x 15.2 cm

Art Gallery of New South Wales
Gift of Hal Missingham 1967
© Estate of Eric Thake
DA56.1967

Page 158
Top, bottom: National Art Archive,
AGNSW: ARC3.613.57; ARC2.1.108

Page 159
National Art Archive, AGNSW:
ARC13.7.1

Page 160
Top, bottom: National Art Archive,
AGNSW: ARC2.4.19; ARC2.4.87

Page 161
Top, bottom: National Art Archive,
AGNSW: ARC5.5.3; ARC5.5.2

Page 162
National Art Archive, AGNSW:
ARC4.659.8

Page 163
National Art Archive, AGNSW:
ARC2.1.36

Page 164
Left, right: National Art Archive,
AGNSW: ARC3.613.30; ARC2.7.9

Page 165
National Art Archive, AGNSW:
ARC1.79.1

Page 166
Bottom: National Art Archive,
AGNSW: ARC30.396.1

Page 167
National Art Archive, AGNSW:
ARC2.7.10

Page 168
National Art Archive, AGNSW

Page 169
Hal Missingham
A wild party 1949
oil on canvas
91.5 x 71 cm
Kerry Stokes Collection, Perth
© Peter Missingham
Image: courtesy Deutscher and
Hackett

Chapter 13

Page 173
National Art Archive, AGNSW:
ARC2.2.12

Page 175
Top, bottom: National Art Archive,
AGNSW: ARC13.1.3; ARC13.1.4

Page 177
Top: National Art Archive, AGNSW:
ARC2.1.255

Bottom: Image produced by Mogamma for Tonkin Zulaikha Greer Architects © Mogamma, 2021

Page 178
National Art Archive, AGNSW:
ARC11.2.1

Page 179
National Art Archive, AGNSW:
ARC10.3.1

Page 180
Top, bottom: National Art Archive, AGNSW: ARC10.3.1; ARC3.861.4

Page 182
Eric Wilson
Hospital theme – the sterilizer 1942
oil on hardboard
81.3 x 47 cm
Art Gallery of New South Wales
Purchased 1945
7577

Chapter 14

Page 185
Tim Burns
A change of plan 1973
installation at the Art Gallery of New South Wales
National Art Archive, AGNSW
© Tim Burns/Copyright Agency, 2021

Page 187
Top:
Il Padovanino
A study of a boy leaning forward c1620
chalk
39.5 x 26.1 cm
Art Gallery of New South Wales
Gift of EL Montefiore 1883
474

Bottom:
Tom Arthur
The fertilization of Drako Vülen's cheese pizza 1975
wood, brass, glass, silk, neon, sand
340 x 720 x 480 cm overall
Art Gallery of New South Wales
Purchased 1975
© Tom Arthur
50.1975

Page 188
National Art Archive, AGNSW:
ARC5.2.1

Page 189
Tim Burns
A change of plan 1973
installation at the Art Gallery of New South Wales
National Art Archive, AGNSW
© Tim Burns/Copyright Agency, 2021

Page 191
Tim Burns

Fuck Laverty and the trustees c1972 poster
31.5 x 40.7
National Art Archive, AGNSW
Gift of Donald Brook 2018
© Tim Burns/Copyright Agency, 2021
ARC417.4.4

Page 192
National Art Archive, AGNSW:
ARC40.30.2

Page 193
Michael Nicholson
Illustration and plan for 'Poli-poll-pool-shots' 1976
Xerox photocopy on paper
21.6 x 27.9 cm
National Art Archive, AGNSW
Gift of Biennale of Sydney 2015
© Estate of Michael Nicholson
ARC375.202.8

Chapter 15

Page 197
Louis Priou
Satyr's family c1876 (detail)
oil on canvas
147.8 x 173 cm
Art Gallery of New South Wales
Gift of Messrs. Wallis and Sons, the French Gallery, London 1885
732

Page 198
Left, right: National Art Archive, AGNSW: ARC4.700.1; ARC4.700.2

Page 199
JS Watkins
The musician (portrait of Josef Kretschmann) 1911
oil on canvas
61.2 x 45.5 cm
Art Gallery of New South Wales
Purchased 1911
960

Page 200
Fairfax Photos, FXT284769

Page 201
Top:
George Molnar
'Nice composition. Maybe just a touch more grey – say we add another forty feet width to the expressway' 1959
pen and ink on paper
24.5 x 27.3 cm
National Library of Australia
PIC/7345/2419

Bottom: National Art Archive, AGNSW: ARC2.4.47

Page 202
Left: National Art Archive, AGNSW: ARC385.1.239

Right: City of Sydney Archives, 010\010969

Page 203
National Art Archive, AGNSW:
ARC75.1.1

Page 204
Godfrey Miller
Nude and the moon from the series *Nude and the moon* 1954–59
oil, pen and black ink on canvas
61.6 x 104.2 cm
Art Gallery of New South Wales
Gift of the Art Gallery Society of New South Wales 1959
© Estate of Godfrey Miller
OA25.1959

Page 205
National Art Archive, AGNSW:
ARC2.7.46

Page 206
National Art Archive, AGNSW:
ARC5.7.1

Chapter 16

Page 209
National Art Archive, AGNSW:
ARC5.2.4

Page 211
Top:
Tang dynasty 618–907/China
China
Horse and rider c0700
earthenware with sancai (three colour) glaze
40.6 x 39.5 x 12.5 cm
Art Gallery of New South Wales
Purchased with funds provided by the Art Gallery Society of New South Wales 1979
83.1979

Bottom: National Art Archive, AGNSW: ARC2.7.37

Page 212
National Art Archive, AGNSW:
ARC2.4.88

Page 213
National Art Archive, AGNSW:
ARC2.7.59

Page 215
All images: National Art Archive, AGNSW: ARC70.2.1

Page 217
National Art Archive, AGNSW:
ARC2.7.71

Page 218
Ernst Ludwig Kirchner
Three bathers 1913
oil on canvas
197.5 x 147.5 cm

Art Gallery of New South Wales
Art Gallery of New South Wales Foundation Purchase 1984
158.1984

Chapter 17

Page 223
National Art Archive, AGNSW:
ARC5.2.5

Page 227
Photograph: Ray Woodbury

Page 229
Photograph: Eric Sierens

Page 230
Top: Photograph: Eric Sierens

Bottom: Artwork:
Song dynasty 960–1279/China
China
Guanyin, bodhisattva of compassion c12th–13th century
wood, pigment
114 x 60 x 52 cm
Art Gallery of New South Wales
Bequest of Sydney Cooper 1982
138.1982

Page 232
National Art Archive, AGNSW:
ARC3.880.1

Page 233
National Art Archive, AGNSW:
ARC2.7.104

Pages 234–35
Cy Twombly
Three studies from the Temeraire 1998–99
oil on canvas (triptych)
265 x 761 x 5.6cm
Art Gallery of New South Wales
Purchased 2004 with funds provided by the Art Gallery Society of New South Wales and the Art Gallery of New South Wales Foundation, with the assistance of the following major donors: Kerry Packer AC & Roslyn Packer, Jillian Broadbent AO, Peter Weiss AM, Ginny & Leslie Green, Geoff & Vicki Ainsworth, Catriona & Simon Mordant, Susan Rothwell, Ann Corlett, Rowena Danziger AM & Ken Coles AM, Energy Australia, Brian France AM & Philippa France, Chris & Yvonne Gorman, John & Inge Grant, Penelope & Harry Seidler AC OBE, John Symond AM, Isaac & Susan Wakil, and a number of other private individuals.
© Cy Twombly Foundation, courtesy Gagosian Gallery, London
239.2004.a-c

Chapter 18

Page 239
James Sant
Lesbia c1884 (detail)
oil on canvas
61.1 x 51 cm
Art Gallery of New South Wales
Charles David Smith Bequest Fund
1884
6121

Page 241
William Gilbert Foster
Peace c1880s
oil
76.3 x 127.4 cm
Art Gallery of New South Wales
Bequest of JF Archibald 1919
5765

Page 242
Top left: National Art Archive,
AGNSW: ARC2.1.29

Page 243
Top: National Art Archive, AGNSW:
ARC5.1.54

Bottom:
Douglas Fry
My best friend 1910
oil on wood
33 x 24 cm
Art Gallery of New South Wales
Gift of Howard Hinton 1915
592

Page 245
Photograph: Nadine Saacks

Page 247
Bottom: Photograph: Nadine Saacks

Page 249
Weaver Hawkins
Halloy from the *Weaver Hawkins
archive* May 1916
watercolour on cream paper
15.4 x 11.5 cm
National Art Archive, AGNSW
Gift of Rene Hawkins 1996
© Estate of HF Weaver Hawkins
ARC117.17.3

Weaver Hawkins
Near Ailly from the *Weaver Hawkins
archive* March 1916
watercolour on cream paper
15.4 x 11.5 cm
National Art Archive,|Art Gallery of
New South Wales
Gift of Rene Hawkins 1996
© Estate of HF Weaver Hawkins
ARC117.17.2

Weaver Hawkins
Halloy from the *Weaver Hawkins
archive* May 1916
watercolour on cream paper
15.4 x 11.5 cm

National Art Archive, AGNSW
Gift of Rene Hawkins 1996
© Estate of HF Weaver Hawkins
ARC117.17.4

Page 253
Photograph: Nadine Saacks

Chapter 19

Page 255
Top:
© Photo: Noble Savage Pictures/
Kelly Gardner
Artwork:
Jakayu Biljabu
Minyi Puru 2008
Art Gallery of New South Wales
© Jakayu Biljabu/Copyright Agency
2021
350.2008

Page 257
Installation view of artworks
by Takashi Murakami in *Japan
Supernatural* exhibition at Art Gallery
of New South Wales, 2 November
2019 – 8 March 2020

Takashi Murakami
Embodiment of 'Um' 2014
© 2014 Takashi Murakami/Kaikai Kiki
Co Ltd All Rights Reserved

Takashi Murakami
*Japan Supernatural: Vertiginous
After Staring at the Empty World Too
Intensely, I Found Myself Trapped
in the Realm of Lurking Ghosts and
Monsters* 2019–21
© 2019–20 Takashi Murakami/Kaikai
Kiki Co Ltd All Rights Reserved

Takashi Murakami
Embodiment of 'A' 2014
© 2014 Takashi Murakami/Kaikai Kiki
Co Ltd All Rights Reserved

Page 258
Michael Parekowhai
The English Channel 2015
stainless steel
257 x 166 x 158 cm
Art Gallery of New South Wales
Purchased with funds provided by
Peter Weiss AO 2016
© Michael Parekowhai
432.2016
Photograph: Jennifer French

Page 261
Top: Photograph: Amanda Peacock

Page 262
Top: National Art Archive, AGNSW:
ARC7.2.2.1

Bottom:
Charles H Kerry
*Sydney Harbour from the Art Gallery,
Sydney* c1885

albumen photograph
15.2 x 19.8 cm
National Library of Australia
PIC Box J3 #P802/42

Page 263
Photograph: Belinda Rolland
Photography

Pages 266–67
EL Montefiore
Sydney Regatta 26 January 1853
State Library of Victoria
H84.459/1-44

Endmatter

Page 271
George Relph
Illuminated address (*Report
presented to His Excellency The
Right Honorable Lord Augustus
Loftus, GCBPC, by the trustees of
the Art Gallery of New South Wales
on the occasion of its opening, on
Wednesday, the 22nd September,
1880*) 1880
illuminated ink lettering on paper
90 x 42.5 cm
National Art Archive, AGNSW
SID17108

Page 273
Artwork: Vincent Namatjira *Stand
strong for who you are* 2020 (see full
caption page 145, above)

Select bibliography

Alfonso, Cecilia. 'The Art Gallery of New South Wales: changing shape, changing function 1871–1978', BA thesis, University of New South Wales, Sydney, 1988.

Anderson, Jaynie, Christopher Marshall and Andrew Yip (eds). *The legacies of Bernard Smith: essays on Australian art, history and cultural politics*, Power Publications, Sydney, 2016.

Annear, Judy. *Photography: Art Gallery of New South Wales collection*, Art Gallery of New South Wales, Sydney, 2007.

Benjamin, Rodney. 'Eliezer Montefiore (1820–94): artist, gallery director and insurance pioneer; the first significant Australian Jewish artist', *Australian Jewish Historical Society Journal*, vol 17, no 3, November 2004, pp 311–40.

Bond, Anthony. *The idea of art: building a contemporary international art collection*, NewSouth Publishing/Art Gallery of New South Wales, Sydney, 2015.

Bond, Anthony and Wayne Tunnicliffe. *Contemporary: Art Gallery of New South Wales contemporary collection*, Art Gallery of New South Wales, Sydney, 2006.

Boyd, Noni. 'No sacrifice in sunshine, Walter Liberty Vernon: architect 1846–1914', PhD thesis, RMIT, Melbourne, 2010.

Bridges, Peter and Don McDonald. *James Barnet: colonial architect*, Hale and Iremonger, Sydney, 1988.

Capon, Edmund. *I blame Duchamp: my life's adventures in art*, Lantern, Sydney, 2009.

Cochrane, Susan and Max Quanchi. *Hunting the collectors: Pacific collections in Australian museums, art galleries and archives*, Cambridge Scholars, Newcastle upon Tyne, 2011.

Cox, Leonard B. *The National Gallery of Victoria, 1861 to 1968: a search for a collection*, National Gallery of Victoria, Melbourne, 1970.

Cull, Tamsin. 'Public programmes at the Art Gallery of New South Wales: education, access and interpretation', MA thesis, University of New South Wales, Sydney, 2002.

Dickinson, Sidney. *Art lectures delivered by Sidney Dickinson at the National Art Gallery of New South Wales*, John Sands, Sydney, 1889.

Draffin, Nicholas. 'An enthusiastic amateur of the arts: Eliezer Levi Montefiore in Melbourne 1853–71', *Art Bulletin of Victoria*, no 28, 1987, pp 92–108.

Du Faur, Frederick Eccleston. *Bi-monthly conversational discussions, 1906–7*, National Art Gallery of New South Wales, Sydney, 1910.

——. *"The light of the world" by W. Holman Hunt temporarily on view at National Art Gallery of NSW: paper read by the president, Tuesday, 4th Sept., 1906*, National Art Gallery of New South Wales, Sydney, 1906.

——. *'Notes respecting the origin and the progressive development of the building of the National Art Gallery of NSW'*, National Art Gallery of New South Wales, Sydney, 1909.

Edwards, Zeny. *A life of purpose: a biography of John Sulman*, Longueville Media, Sydney, 2017.

Free, Renée. *Art Gallery of New South Wales catalogue of British paintings*, Art Gallery of New South Wales, Sydney, 1987.

——. *Salon and académie: the charm of tradition: a catalogue of nineteenth-century European salon works*, Art Gallery of New South Wales, Sydney, 1984.

Freeland, JM. *Architect extraordinary: the life and work of John Horbury Hunt 1838–1904*, Cassell Australia, Melbourne, 1970.

Hutchison, Noel. 'The establishment of the Art Gallery of New South Wales: politics and taste', BA thesis, University of Sydney, 1968.

Irish, Paul. *Hidden in plain view: the Aboriginal people of coastal Sydney*, NewSouth Publishing, Sydney, 2017.

James, Bruce. *Art Gallery of New South Wales handbook*, Art Gallery of New South Wales, Sydney, 1999.

Johnson, Heather. *The Sydney art patronage system 1890–1940*, Bungoona Technologies, Sydney, c1997.

Klepac, Lou. *Hal Missingham: artist, author, photographer*, Beagle Press, Sydney, 2017.

Lindsay, Norman. *Bohemians of the Bulletin*, Angus and Robertson, Sydney, 1965.

Meek, Jan and Edmund Capon. *Portrait of a Gallery*, Art Gallery of New South Wales, Sydney, 1984.

Mendelssohn, Joanna, Catherine De Lorenzo, Alison Inglis and Catherine Speck. *Australian art exhibitions: opening our eyes*, Thames and Hudson, Melbourne, 2018.

Missingham, Hal. *They kill you in the end*, Angus and Robertson, Sydney, 1973.

Montefiore, Eliezer Levi. *Catalogue of the Art Gallery of New South Wales with 94 illustrations drawn by E L Montefiore*, John Sands, Sydney, 1883.

Morrow, Carol. 'Meiji period ceramics from the Sydney International Exhibition of 1879', MA thesis, University of Sydney, 1998.

Pearce, Barry. *Australian art in the Art Gallery of New South Wales*, with contributions by Helen Campbell, Deborah Edwards, Ursula Prunster, Anne Ryan, Vivienne Webb and Natalie Wilson, Art Gallery of New South Wales, Sydney, 2000.

——. *100 moments in Australian art*, NewSouth Publishing/Art Gallery of New South Wales, Sydney, 2014.

Perkins, Hetti. *Art + soul: a journey into the world of Aboriginal art*, Miegunyah Press, Melbourne, 2010.

——. *One sun, one moon: Aboriginal art in Australia*, Art Gallery of New South Wales, Sydney, 2007.

Perkins, Hetti with Ken Watson and Jonathan Jones. *Tradition today: Indigenous art in Australia*, Art Gallery of New South Wales, Sydney, 2004.

Proudfoot, Peter, Roslyn Maguire and Robert Freestone (eds). *Colonial city, global city: Sydney's International Exhibition 1879*, Crossing Press, Sydney, 2000.

Reed, Stuart. 'Policy, taste or chance? Acquisition of British and foreign oil paintings by the Art Gallery of New South Wales from 1874 to 1935', MA thesis, University of New South Wales, Sydney, 2013.

Reynolds, Peter, Lesley Muir and Joy Hughes, *John Horbury Hunt: radical architect 1838–1904*, Historic Houses Trust of New South Wales, Sydney, 2002.

Russ, Vanessa. 'A study of the Art Gallery of New South Wales and Australian Aboriginal art: Aboriginal perspectives and representations in state art galleries', PhD thesis, University of Western Australia, Perth, 2014.

Smith, Bernard. *A catalogue of Australian oil paintings in the National Art Gallery of New South Wales 1875–1952 with annotations, biographies and index*, National Art Gallery of New South Wales, Sydney, 1953.

Taylor, George A. '*Those were the days': being reminiscences of Australian artists and writers*, Tyrrell's Ltd, Sydney, 1918.

Thomas, Daniel. *Recent past: writing Australian art*, Art Gallery of New South Wales, Sydney, 2020.

Thomas, Laurie. *The most noble art of them all: the selected writings of Laurie Thomas*, University of Queensland Press, Brisbane, 1974.

Tunnicliffe, Wayne. *John Kaldor family collection*, Art Gallery of New South Wales, Sydney, 2011.

Villis, Carl and Alexandra Ellem (eds). *Paintings conservation in Australia from the nineteenth century to the present: connecting the past to the future*, contributions to the 11th AICCM Paintings Group Symposium, National Gallery of Victoria, Melbourne, 2008.

Waterfield, Giles. *The people's galleries: art museums and exhibitions in Britain 1800–1914*, Yale University Press, New Haven, CT, 2015.

Webb, Joan. *Frederick Eccleston du Faur: man of vision*, Deerubbin Press, Sydney, 2004.

White, Judith. *Art lovers: the story of the Art Gallery Society of New South Wales 1953–2013*. Art Gallery Society of New South Wales, Sydney, 2013.

Index

Bold page numbers indicate illustrations.